Indiewood, USA

INTERNATIONAL LIBRARY OF CULTURAL STUDIES

Indiewood, USA

Where Hollywood meets Independent Cinema

Geoff King

I.B. TAURIS

LONDON · NEW YORK

Published in 2009 by I.B.Tauris & Co Ltd
6 Salem Road, London W2 4BU
175 Fifth Avenue, New York NY 10010
www.ibtauris.com

In the United States of America and Canada distributed by Palgrave
Macmillan, a division of St. Martin's Press, 175 Fifth Avenue,
New York NY 10010

International Library of Cultural Studies: 2

ISBN: (HB) 978 1 84511 826 6
ISBN: (PB) 978 1 84511 825 9

A full CIP record for this book is available from the British Library
A full CIP record is available from the Library of Congress

Library of Congress Catalog Card Number: available

Designed and Typeset by 4word Ltd, Bristol, UK
Printed and bound in India by Thomson Press (India) Limited

Contents

Illustrations

Acknowledgements

Thanks to Paul McDonald and Thomas Austin for reading part or all of the manuscript before publication and for offering useful support, observations and suggestions. Also to Philippa Brewster at I.B. Tauris for backing this project, which marks the completion of something of a trilogy of works on recent and contemporary American cinema, following *New Hollywood Cinema: An Introduction* (2002) and *American Independent Cinema* (2005). Completion of the book was made possible by a grant of research leave by Brunel University.

Introduction

Indiewood in contexts

At one end of the American cinematic spectrum is the globally dominant Hollywood blockbuster. At the other is the low-budget independent or 'indie' feature and, beyond that, various forms of avant-garde, experimental, no-budget or otherwise economically marginal production.[1] In between lie many shades of difference. There are lower-budget Hollywood features, including traditional star vehicles and genre pictures. There are more substantial and/or more commercially oriented independent productions, of various kinds. In the middle, however, is a particular territory that constitutes the focus of this book: the zone that has become known as Indiewood, an area in which Hollywood and the independent sector merge or overlap. Films produced and distributed in this domain have attracted a mixture of praise and controversy. From one perspective, they offer an attractive blend of creativity and commerce, a source of some of the more innovative and interesting work produced in close proximity to the commercial mainstream.[2] From another, this is an area of duplicity and compromise, in which the 'true' heritage of the independent sector is sold out, betrayed and/or co-opted into an offshoot of Hollywood.

The aim of this book is to offer a more objective examination of the Indiewood sector, as a distinctive region of the recent and contemporary American film landscape. A number of detailed case studies are employed to offer an understanding of Indiewood at several different levels. Indiewood is considered, throughout this book, as an industrial/commercial phenomenon, the product of particular forces within the American film industry from the 1990s and 2000s. This includes close focus on the specifics of the film industry and its situation within the wider context of certain tendencies in contemporary cultural production in late twentieth- and early twenty-first-century capitalism. Indiewood is considered from the perspectives of both production/distribution (the strategies of industry players) and consumption, the latter including an attempt to locate Indiewood cinema in the wider social sphere of cultural-taste preferences and some consideration of viewer responses to the case-study films examined.[3]

Direct connections are made between these dimensions and the particular textual qualities offered by films produced, distributed and consumed in this part of the cinematic spectrum. A central characteristic of Indiewood cinema, this study argues, is a blend comprised of features associated with dominant, mainstream convention and markers of 'distinction' designed to appeal to more particular, niche-audience constituencies. Close textual analysis is employed to examine the extent to which examples mobilize or depart from formal and other norms associated with the Hollywood mainstream. The dominant Hollywood aesthetic is understood here as providing a point of comparison, as a set of historically and institutionally grounded norms; not a fixed and rigid set of procedures but, as David Bordwell puts it, a repertoire of alternatives that is bounded by particular limitations (for instance, that formal flourishes are usually expected to be given some narrative- or character-based motivation).[4] Against the Hollywood norm, to varying degrees, can be measured a range of more or less distinctive alternatives that might be understood in some cases as constituting institutionally grounded norms of their own (including those variously described as the norms of 'avant-garde', 'art', 'indie' or 'independent' cinema, none of which have entirely fixed or uncontested definitions). One of the issues addressed by this book, to which I return in the conclusion, is whether a distinct and

identifiable set of norms can be associated with Indiewood as a hybrid location. Textual analysis is accompanied, in this study, by consideration of distribution strategies and extra-textual discourses such as promotional materials, reviews and the manner in which Indiewood production is positioned by practitioners and industry figures. The case-study approach employed here provides scope for detailed and in-depth analysis, chosen in preference to a wider survey of the field. Two chapters focus on the work of individual filmmakers: Steven Soderbergh and the screenwriter Charlie Kaufman. Two focus on Indiewood distribution and/or production companies: Miramax, the single biggest influence in the establishment of Indiewood, and Focus Features, the 'speciality' arm of Universal Pictures (speciality – or 'specialty' in the American English rendition – being the term often used within the industry to describe a range of less mainstream products that include American independent films, documentaries and overseas imports). Another chapter examines *American Beauty* (DreamWorks, 1999) and *Three Kings* (Warner Bros, 1999) as two indie-influenced films produced not by the speciality divisions but by the main arms of the Hollywood studios. Broadly the same combination of analytical perspectives is employed in each chapter, although some specific dimensions are highlighted to a greater extent in certain cases (for example, viewer responses in relation to *Kill Bill: Volume 1* [2003], one of the Miramax films considered in chapter 2, and analysis of the positioning signified by trailers and posters for the Soderbergh features in chapter 3).

Indiewood origins and background

The term 'Indiewood' was coined in the mid-1990s to denote a part of the American film spectrum in which distinctions between Hollywood and the independent sector appeared to have become blurred.[5] It suggests a kind of cinema that draws on elements of each, combining some qualities associated with the independent sector, although perhaps understood as softened or watered-down, with other qualities and industrial practices more characteristic of the output of the major studios. The term is often used as a disparaging label by those involved in, or supportive of, the independent sector, as a way of

marking off certain types of cinema deemed to be too close to the activities of the studios to be deserving of the label 'independent'.[6] For those who use the term more positively, it signifies an upsurge of more creative filmmaking that has found space inside, or on the edge of, the Hollywood system, a development interpreted by some (often rather hyperbolically) as a return to something like the situation of the late 1960s and early 1970s, the so-called Hollywood 'Renaissance' period, in which a number of less conventional, sometimes more challenging films were produced or distributed within the confines of the major studios.[7]

The most clear-cut institutional base of Indiewood is constituted by indie/speciality-oriented distributors and/or producers owned by the major studio companies: either studio-created subsidiaries (such as Sony Pictures Classics, Fox Searchlight and Paramount Classics) or formerly independent operations taken over by the studios (Miramax under the ownership of Disney from 1993, or Good Machine, taken over by Universal Pictures in 2002 as part of the basis of its subsidiary, Focus Features). Indiewood is located as a cross-over phenomenon, a product of the success of a number of 'breakout' features that marked the indie sector, especially from the early 1990s, as a source of interest to the big studio players. An earlier and abortive wave of studio involvement in the speciality market at the start of the 1980s (the formation of 'classics' divisions by United Artists, Twentieth Century Fox and Universal) was followed by a more concerted move into independent cinema and some parts of overseas 'art-house' cinema during the 1990s and into the early 2000s, a move spurred by the Hollywood-scale box-office success of films such as *Pulp Fiction* (1994) and *The Blair Witch Project* (1999), and the very healthy profit-to-cost ratio of a number of lower-grossing indie features.

If Indiewood is defined most clearly at this industrial/institutional level, my argument is that an equation can be made between this dimension and the particular qualities offered by many of the films produced and distributed within its orbit. In this conjunction of industrial location and textual definition, Indiewood can also include certain films made or distributed by the major studios themselves, rather than their speciality divisions; films such as *American Beauty* that appear to have been confected consciously to buy into the market

opened up by the independent sector and others that include radical components less often associated with the mainstream, substantially budgeted examples such as *Three Kings* and *Fight Club* (Fox, 1999). It might also embrace some features from institutionally non-studio-affiliated directions that appear designed specifically with potential indie/mainstream cross-over in mind. The indie sector itself, in its commercially distributed forms (that is, not including more abstract, experimental, politically radical or otherwise economically marginal work), often involves hybrid forms that draw on a number of different inheritances, including those associated with notions of 'art' cinema and more mainstream narrative feature traditions.[8] Indiewood, in this context, would signify a particular region of the hybrid spectrum: that which leans relatively towards the Hollywood end of a wider compass that stretches from the edges of Hollywood to the less commercially viable margins.

The release slates of the speciality divisions tend to contain a mixture of films that might be defined, from their textual characteristics, as indie or Indiewood, along with overseas imports (issues considered in more detail in chapter 5). While some more distinctively indie films might be produced or acquired in the hope of achieving cross-over beyond the restricted confines of the art-house market, the term Indiewood is used at the textual level to distinguish examples in which such an aim or strategy appears to be embodied more fundamentally in the fabric of the production itself. The term can have slightly different implications, then, when used to characterize the qualities of individual texts rather than the institutional realm of the speciality divisions, the latter not being exclusively limited to the distribution of the former (or vice versa, although in this case the correlation is likely to be closer). There is, however, a significant and often causal link between the two, all the more so in cases in which the studio subsidiary has the greater stake that results from being producer as well as distributor.

The use of subsidiary arrangements such as semi-autonomous Indiewood divisions is typical of the operations of the Hollywood studios as part of global entertainment corporations. Specialist entities permit larger operations most effectively to exploit particular sectors of the market, alongside their chief priority of attracting mass-number

audiences to the blockbuster-scale and/or star-led productions around which the fortunes of the studios primarily revolve (a parallel elsewhere would be the designer boutique operated as a niche outlet inside the walls of a larger chain store). Indiewood divisions gain from expert knowledge of the speciality market by recruiting notable figures from the independent sector such as Harvey Weinstein, until the departure of the Weinsteins from the Disney fold, and James Schamus, former joint head of Good Machine, at Focus Features. They are usually given a significant degree of autonomy from their studio/ corporate parents, often including the power to green-light production or make acquisitions up to a particular financial ceiling. Their operations remain subject more broadly to the dictates of their owners, however, as evidenced by the most likely underlying reasons for the break-up of the Disney/Weinstein relationship. Particular controversies might have been stirred by individual episodes, such as Disney's much-publicized forcing of Miramax to abandon its stake in Michael Moore's *Fahrenheit 9/11* (2004), the last in a series of Miramax provocations to Disney shareholders before the Weinsteins were bought out and left to create a new operation, The Weinstein Company, in 2005. Much was also made of cultural clashes between the working practices of the subsidiary, which built its reputation on the creation and exploitation of controversy around its early breakthrough hits, and its in some ways unlikely-seeming parent. More significant, however, was the fact that Harvey and Bob Weinstein had ambitions for Miramax (including very large budget production and expansion into other media) unlikely to sit easily within the subordinate role granted to subsidiary divisions; the post-Weinsteins Miramax was designed to be a smaller and less autonomous part of the Disney empire.[9]

Involvement in the Indiewood/indie/speciality sector has a number of potential advantages for the studios, in addition to the ability to share in the windfalls that accrue to occasional large-scale independent hits and to broaden their overall portfolios more generally. It can enable them to bring emerging new filmmaking talent into their orbit, potentially to go on to serve mainstream duty, while also supplying attractive vehicles for existing star performers, enabling the studios to maintain valuable relationships while providing different or more

challenging work than the roles with which stars are usually associated (the presence of Jim Carrey in *Eternal Sunshine of the Spotless Mind* [2004], one of the case studies considered in chapter 1, is a good example). Pressure resulting from the desire of stars to work with a new generation of filmmakers is identified by Sharon Waxman as one of the factors that drew the majors towards the indie sector in the second half of the 1990s, a development that coincided with the rise of a small but significant group of executives committed to creating some space for less conventional approaches within or on the margins of the studio system.[10] Associations with this kind of cinema can be of prestige value to the studios and their corporate owners, an intangible factor – how much is prestige really worth, compared to hard box-office or DVD dollars? – that is, nonetheless, not without significance, both for companies often accused of lowering standards of public taste and faced on occasion with the prospect of tighter regulation and for the self-image of individual executive figures. Films that can be located in the Indiewood zone have been particularly prominent in the achievement of Academy Awards and nominations in recent years, one source of prestige that tends to translate quite readily into cash and good reputation. Prizes of this kind are, as James English suggests, 'the single best instrument' for negotiating transactions between cultural

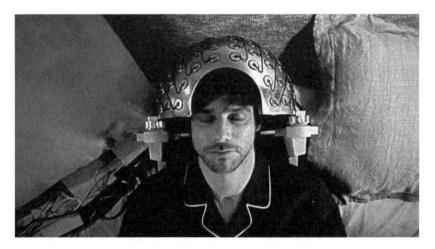

1. Stars in less conventional positions: Jim Carrey gets the treatment in *Eternal Sunshine of the Spotless Mind* © Focus Features

and economic capital; that is to say, in this case, for converting prestige into financial returns.[11] There is also value for the studios in creating the impression that they are not just involved in the business of maximizing revenues through the production of globally dominant franchise and star-led operations, but can also claim some involvement in the propagation of more 'elevated', challenging or ambitious work. They sought from the 1990s to buy into some of the currency gained by the term 'independent' at a time when it had come to signify something of greater cultural worth than what was usually associated with the Hollywood mainstream.[12] This included the creation of speciality divisions in which the identity of the studio parent was clearly advertised in the name of the subsidiary. Where this was not the case (Miramax, say, as opposed to Sony Pictures Classics, Paramount Classics or Fox Searchlight), the existence of a multitude of production and distribution entities could have the advantage, from a different perspective, of making the business appear more plural and open to competition than was really the case.

Indiewood as subsidiary capitalism

The Indiewood divisions of the major studios can be understood as a manifestation of a wider trend in contemporary capitalism towards what Mike Wayne terms 'subsidiary and subcontractor capitalism'.[13] The shift of this kind of operation to a position of prominence in the economy is usually associated with a move from Fordist (mass production/mass consumption) to post-Fordist (more flexible and fragmented production/consumption) regimes of accumulation. Although sweeping claims of epochal shifts from one to the other are in many ways problematic, it is widely accepted that Fordism, as a central feature of western economies, ran into difficulties by the 1970s, leading to numerous and far-reaching changes, including increased tendencies in some sectors from the 1980s onwards to target smaller and more exclusive niche markets, of which speciality cinema can be seen as one local example.[14] There is, certainly, an historical coincidence of these broader trends and the period in which the American independent sector came to fruition in its current institutionalized form, even if the latter was also driven by a number

of more specific economic forces such as the demand for product and availability of finance for low-budget productions created by the 1980s video boom.[15] The media and communications sector is seen by Martyn Lee as particularly prone to the tendency to focus on niche audiences, as evidenced by massive investments into a wide diversity of specialist periodicals and journals, and the proliferation of cable, satellite and terrestrial broadcasting (narrowcasting) networks, driven by 'the imperatives of advertising to address the now divergent and highly segmented tastes, needs and sensibilities of the modern marketplace'.[16]

Speciality cinema and other such media products also fit into Lee's suggestion that these transitions have included 'a marked demateralization of the commodity-form', a shift in emphasis from the characteristically durable and material commodities of Fordism (cars, washing machines, etc.) to a greater role for non-durable 'and in particular, experiential commodities which are either used up during the act of consumption or, alternatively, based upon the consumption of a given period of time as opposed to a material artefact'.[17] Such markets have the advantage, for late twentieth- and early twenty-first-century capitalism, of being less prone to exhaustion and saturation (chronic threats to capitalist stability) than markets for material goods, creating potential for the continued expansion of the consumer economy into new and more finely distinguished realms. The 1980s is described by Lee as a period that saw 'an enormous increase in the commodification and "capitalization" of cultural events',[18] another process in which the institutionalization of indie and the development of Indiewood cinema can be seen as component parts; a move, especially as it developed through the 1990s, in which significant portions of an 'independent' cinema defined previously as more separate, alternative or in some cases oppositional, became increasingly commodified and brand-marketed, and thereby penetrated by the prevailing forms of contemporary capitalism.

These developments can also be linked to understandings of the audiences targeted by Indiewood, and how these might be attracted by particular kinds of textual material. But first some qualifications are necessary. Whatever moves towards an increased emphasis on niche marketing have been involved in developments in the capitalist

economies of recent decades, larger or 'mass' markets have not been abandoned. The continued dominance of mainstream Hollywood cinema is an obvious example of this, targeting very large global audiences for its blockbuster products (even if the 'mass' audience is often a product of emphasis on particular constituencies, especially of relatively younger viewers). The speciality market is clearly of some interest to the studios but it is very much a secondary part of the business, the strictly commercial motivations for which are less obviously compelling than those found in many other niche media. Specialized television and magazine publishing, for example, are often founded on the economics of advertising revenues, as suggested in one of the above quotations from Lee. The fact that higher rates can be charged by programmes or publications that reach high-spending specialist audience fragments permits them to thrive on the basis of relatively small audiences (or, in a case such as the 'quality' television output of HBO, relatively small numbers of subscribers). The equivalent does not really exist in the case of speciality cinema, which makes its situation potentially more fragile, although niche broadcasters such as the Independent Feature Channel have become involved to a limited extent in production funding and theatrical distribution. Indiewood operations offer some commercial and less tangible benefits, as suggested above, but they are not in a position to gain obvious extra value from the relatively upscale markets they target, because they do not benefit from premium-rate advertising in their most important release windows (theatrical and home video/DVD). Higher prices are not usually charged for viewing and although an affluent 'connoisseur' audience might be more inclined to invest in 'special edition' DVDs, this is also a market heavily exploited in the mainstream. 'Added-value' prices might be set for the 'fancy coffees', mineral waters and cakes typically associated with art-house theatre concession stands, but, again, it seems doubtful that these offer higher margins than those charged for carbonated sugar-waters and popcorn at the multiplex. The screening of full-motion commercials other than trailers – as opposed to static advertising slides – was a new phenomenon in US cinemas of the early to mid-2000s, but seen as of primary benefit in reaching the mainstream 18–35 and young male demographics in the face of the increased fragmentation of television audiences.[19]

The American film industry continues, primarily, to revolve around a hit-based economy at all levels – Hollywood, Indiewood and indie; domestic cinema and overseas imports – that has lagged behind some other aspects of cultural production in its ability to take advantage of the growing potential for the exploitation of more extensive niche markets created by the era of broadband internet distribution in the early 2000s. It has invested relatively little to date in the phenomenon known as the 'Long Tail', popularized by Chris Anderson, the substantial market that can result from the aggregation of large numbers of much smaller niches.[20] The development of studio speciality divisions is consistent with Anderson's argument that investment in both mainstream and niche markets is important to the future of larger companies operating in this context, in which a relative democratization of access and the existence of new customer feedback mechanisms can make it possible for a diversity of smaller products to gain attention and find their audience. Distribution direct to the internet or DVD offers potential outlets for films beyond the gatekeeping networks of the studios and larger independent operations. The studio speciality divisions remain primarily focused on fewer and larger niches, however, in the theatrical and DVD businesses, their function largely being to cherry-pick limited numbers of films for promotion and release, a process probably more likely to reduce than to increase the total number of non-studio productions that gain commercial distribution. The other important qualification required in any account that draws on notions of post-Fordism or the importance of niche markets, some of which include a utopian vision of decentralized operations, is that there has been no significant fragmentation of ownership and control, in the film business or more generally in niche-market-oriented capitalism, as indicated above in the case of the Indiewood speciality divisions of the studios and their corporate parents.[21]

Niche-market audiences, Indiewood and taste cultures

What, then, of the audiences for Indiewood productions? How might they be conceptualized? Is it possible to suggest particular kinds of

viewers who are likely to be attracted by such material? This issue will be addressed here at two principal levels. It will be considered first in terms of what is implied more broadly in the marketing of and to particular cultural-taste formations. This requires quite lengthy consideration of the processes through which consumption of particular kinds of cultural goods might be associated with particular social groups. Secondly, but linked to this in the kinds of qualities likely to be highlighted, the identification of potential audiences for Indiewood films can be understood through the notion of the 'implied audience' for which the texts themselves appear to have been designed,[22] a framework that leads more directly into the analysis of examples of Indiewood cinema that comprises the main body of this book.

Niche marketing involves a much closer breakdown of the categories into which products can be sorted and sold than is usually implied in the mass-consumption associated with Fordist regimes of accumulation (the latter involving the sale of vast numbers of broadly standardized − if often far from identical − products). Niche-based outfits offer products quite specifically tailored to relatively narrow market segments, usually those prepared to pay extra for what are perceived to be higher-quality and more exclusive goods or services. They offer a finer-grained approach than mass-market strategies, enabling the penetration of the logic of commodification into the smaller capillaries of culture. If speciality films offer no obvious source of the premium prices that characterize many such products, they can be understood as offering appeals to the consumer of a kind similar to those provided by other niche-market materials: not just any objectively higher quality in the product (on whatever grounds that might be judged or contested in one case or another), but the marketing of a subjective impression of difference, distinction and superiority on the part of the viewer. By choosing to view speciality rather than mainstream films, the argument goes, consumers are associating themselves (consciously or unconsciously) with a particular social-cultural domain based on varying degrees of differentiation from mainstream cinema, culture and society.

At work here is the expenditure of what Pierre Bourdieu terms 'cultural capital', the resources and disposition required for the ability to gain access to (and, importantly, to take pleasure from) more specialized

realms of cultural production. Patterns of cultural consumption are, from this perspective, tied up with the processes through which distinctions are made between and within different social classes, groups or milieux, cultural capital being gained through a combination of formal education and informal upbringing. This can be seen as part of a wider system in which the consumption of goods can be understood not just in material terms but as a dimension of the social mechanism by means of which distinct senses of self- and group identity are constructed and asserted. For commentators such as Bourdieu and the early Jean Baudrillard, consumption is understood as a way of *establishing* differences as much or more than as a way of signifying distinctions that already exist on other grounds.[23] The essential point of Bourdieu's argument, and that of others coming to these issues from the perspective of sociology or social anthropology, is that preferences for particular kinds of products – among which speciality cinema can be included – are not individual choices that exist in isolation, but the outcome of wider and more objective fields of forces. A key dimension is what Bourdieu terms the 'habitus', a durable matrix of shared dispositions, perceptions and appreciations into which the members of particular social groups or classes are socialized and from which their taste preferences are drawn.[24] The habitus, for Bourdieu, is a crucial link between the objective conditions of existence of particular groups or classes and the schemes of classification and taste that lead to the generation of particular lifestyles.[25] Each habitus, and the lifestyle to which it leads, is a particular historical construct, the product of objective historical conditions and the field of relations in which one set of schemes is related to another. It is experienced by its occupants, however, as 'natural' and immediate, which gives it an ideological function in the naturalization of social differences.[26] The result is that socially shaped acts of consumption are often experienced as the exercise of personal, individual preference. As Nikolas Rose puts it, in a different context:

> Leisure has been invented as the domain of free choice *par excellence*.
> However constrained by external or internal factors, the modern self is
> institutionally required to construct a life through the exercise of
> choice from among alternatives. Every aspect of life, like every

commodity, is imbued with a self-referential meaning; every choice we make is an emblem of our identity, a mark of our individuality, each is a message to ourselves and others as to the sort of person we are, each casts a glow back, illuminating the self of he or she who consumes.[27]

Pleasurable consumption of works for which higher than usual reserves of cultural capital are required is likened by Bourdieu to an act of 'deciphering' and 'decoding' for which particular competences are required.[28] In the case of the avant-garde or experimental, this might be a very specialist knowledge, without which individual products are unlikely to make much sense – or have much appeal – to the viewer. For the more commercially-oriented speciality market, including Indiewood, the requirements are less exclusive or involve extra dimensions of pleasure available to those able to pick up particular nuances, resonances or references. In some cases, it might be a matter of relatively more complex narrative structures or more challenging material, although the bounds of difference vary from one example to another and are likely to be more limited than those found in the wider indie or art-cinema sectors. For Jeffrey Sconce, for example, the key line of demarcation in what he terms 'smart cinema', which includes titles from the indie and Indiewood sectors, is established through the use of an ironic *tone* that divides the audience into those who do or do not 'get it'.[29] In some cases markers of distinction might include the employment of an identifiably different *style*, or just the use of small stylized touches, in keeping with Lee's argument about the importance of style or aesthetics as a primary ground for the distinguishing of one commodity from another in a diversified niche-market economy. The making of distinctions based on an ability to appreciate such dimensions is a process that can be detected in responses to the examples of Indiewood cinema examined in this book, as evidenced in postings on websites cited in the chapters that follow. The establishment of such capabilities, differentially distributed in society, might always have been the case in the consumption of cultural works, but is a process seen as of increased importance in aspects of the cultural economy viewed as operating according to the logic of post-Fordist niche-marketing. As Nick Heffernan puts it:

'[T]he search for higher rates of profitability has shifted the emphasis from Fordist forms of standardized mass consumption to new forms of customized or "niche" consumption which revolve around notions of difference and distinction and imply new kinds of status gradation and social exclusion.'[30]

An important aspect of this process, of direct relevance to the indie/Indiewood market, is the commodification of cultural products understood (or constructed) as alternative to the mainstream in a manner that is experienced or sold as 'hip' and 'cool'. This is a phenomenon that dates back to the 1960s and in which, as Thomas Frank argues, the 'bohemian' counterculture and the American business ethic to which it was offered as a contrast were always more closely interwoven than is often implied.[31] The result was the widespread development of a form of 'hip consumerism' reinvented ('almost mechanically repeated') in 1990s incarnations such as the notion of the existence of a coolly disaffected 'Generation X' demographic, with which indie production has often been associated.[32] The Indiewood sector fits into this framework very clearly, as part of a tendency of mainstream industry (not just the marginal) to buy into and exploit aspects of what is understood to be the 'cool', 'hip' and 'alternative'. What is involved here for viewers, and that is sought to be commodified, can be a mix of cultural and *sub*-cultural capital, the latter suggesting forms that can carry cachet as a result of not being officially sanctioned but seen as existing in some kind of opposition to the mainstream.[33] The 'cool', 'hip' and 'alternative' can also become the 'cult' favourite. The opposition between mainstream and alternative is often asserted rhetorically, however, greatly oversimplifying a range of differences on all sides, while the co-optation of 'cult' or other such niche products by mainstream institutions can serve to undermine the process of distinction through which such status is maintained.[34] Cult movie fandom, as Mark Jancovich argues, did not develop in opposition to the commercial but as a result of specific factors in the postwar decades that created 'selective film markets' (urban art cinemas, repertory, the 'midnight movie') driven by their own economic imperatives;[35] the same can be said of the indie and Indiewood sectors more generally. The question of co-optation is a potentially tricky one for Indiewood,

especially, in which a close line is often walked between more and less distinctive qualities, and in which the basis on which differentiation from the mainstream is measured can easily be challenged.

Concern with gradations of culture/taste status are seen particularly prominently in middle- and upper-middle-class cultures, the principal territories on which Indiewood is generally likely to draw (selectively) for its audiences. Cultural capital can become especially important as a source of distinction in regions in which economic capital is relatively evenly distributed, as Lee suggests might be the case, drawing on Bourdieu's empirical research, in the class fractions of the petite bourgeoisie. Occupations such as clerical work, junior management, teaching and work in the media exist in broadly the same socio-economic terrain, but analysis of taste preferences in spheres such as photography suggests significant differences in access to cultural capital (higher in the cases of teachers and media workers) and resulting patterns of consumption.[36] Research into audiences for speciality films conducted in the UK from 1984 to 1986 confirmed the expectation that such viewers can be differentiated from the general population, particularly on the basis of class and education.[37] Activities such as regular visits to art cinemas or exhibitions are a cost-effective source of distinction for those higher in cultural than economic capital, Bourdieu suggests, 'governed by the pursuit of maximum "cultural profit" for minimum economic cost'.[38] 'Symbolic profit' here is restricted to the consumption of the work itself, and its discussion afterwards, as opposed to the ostentatious display involved in more upmarket attendance of forms such as 'bourgeois' theatre or opera by those higher in economic but lower in cultural capital, instances in which the emphasis might be less on the work than what is signified by conspicuous dress and seats in expensive theatres and restaurants. Cinematic distinction might be established by patronizing an art theatre, or a metropolitan art-complex such as the Angelika Film Centers in New York, Houston and Dallas, rather than a multiplex; or, as is often the case for Indiewood films that gain access to mainstream sites of exhibition, by what is experienced as a more 'discerning' choice of film within a multiplex environment.[39]

The entire social field of preferences – ranging from products such as art, film and literature to choices of food, newspapers or holidays –

offers 'well-nigh inexhaustible possibilities for the pursuit of distinction', Bourdieu suggests, although the arts are singled out as 'explicitly pre-disposed to bear such a relationship' because of the removal of their consumption from the immediately practical requirements of life.[40] The less materially necessary our forms of consumption, the more exclusively they can function as markers of distinction (this need not be a conscious, overt or cynical process of positioning-through-consumption, however, an assumption of which is the basis of some criticism of Bourdieu's approach). Janet Harbord suggests that film occupies an especially privileged position as a vehicle for contemporary 'lifestyle consumption' as a result of both its own status as a primarily dematerialized, experiential commodity and the ability of the text to function as an advertisement for a range of additional lifestyle products.[41] The domain of the symbolic is particularly important to the middle classes, in Bourdieu's account, because of the uncertainty and anxiety of their ambiguous position in relation to the upper and lower classes and, it might be added, among the various shadings that exist within their own territory: 'Torn by all the contradictions between an objectively dominated condition and would-be participation in the dominant values, the petit bourgeois is haunted by the appearance he offers to others and the judgement they make of it.'[42] Artistic/cultural products also permit forms of appropriation other than material possession that are translatable into the realm of off-mainstream cinema. As Bourdieu suggests, in a formulation that might apply particularly well to the development of subcultural investments:

> Liking the same things differently, liking different things, less obviously
> marked out for admiration – these are some of the strategies for
> outflanking, overtaking and displacing which, by maintaining a
> permanent revolution in tastes, enable the dominated, less wealthy
> fractions, whose appropriations must, in the main, be exclusively
> symbolic, to secure exclusive possessions at every moment.[43]

Distinct taste-preferences are also found in different fractions of the middle classes, however, as might be evidenced by some of the range of qualities found in films distributed in the Indiewood sector as well

as elsewhere. At the more 'intellectual' end of the scale we might place narratively complex or unconventional films scripted by Charlie Kaufman, considered in chapter 1; products designed, to some extent at least, to challenge the viewer. Some Indiewood products fit more closely with Bourdieu's version of what is sometimes viewed as a more complacent 'middlebrow' culture, examples such as literary-oriented dramas that present themselves as belonging to the 'quality', 'respectable' part of the spectrum, 'combining two normally exclusive characteristics, immediate accessibility and the outward signs of cultural legitimacy'[44] (for example, *Shakespeare in Love* [1998], one of the case studies in chapter 2, and probably a better example of this conception of the middlebrow than some more direct adaptations of literary 'classics'[45]). Others offer relatively modest touches of distinction within otherwise familiar/conventional frameworks. How such qualities are manifested in particular examples will be considered in detail in the chapters that follow.

As in the case of approaches related to Fordism and post-Fordism, some qualifications are required in the use of Bourdieu. A number of commentators have questioned the immediacy of the link suggested between cultural-taste formations and class, in addition to Bourdieu's somewhat reductive models of different parts of the class–taste spectrum (considered further below).[46] Michele Lamont suggests that he overstates the importance of specifically *cultural* markers of status, generally and particularly in relation to the US context (his work being based on his own and other research on taste-culture preferences in France). In a comparative study of French and American upper-middle-class culture (college-educated professionals, managers and business people), Lamont finds cultural boundary markers slightly less important to American interviewees than to the French, but in both cases accuses Bourdieu of greatly underestimating the importance of moral grounds for expressions of distinction (on the basis of qualities such as honesty, sincerity and respect for others).[47] Members of the American upper-middle class 'stress socioeconomic and moral boundaries more than they do cultural boundaries; and this is not the case in France, where moral and cultural boundaries are slightly more important than socioeconomic boundaries'.[48] If the role of cultural capital in general can be overstated, it is always easy to exaggerate the

likely importance of any particular acts of cultural consumption such as the patronizing of particular forms of speciality cinema. If such acts of consumption play a part in the constitution or reinforcement of particular notions of the self, individually or collectively, it is important to remember that they are only ever one among many other dimensions of experience that might perform such a role.[49] It is also easy to use Bourdieu in a manner that over-simplifies the way cultural consumption might exist in practice. Viewers of art, indie or speciality cinema might *also* view highly formulaic mainstream Hollywood blockbusters, for example (although such exchanges might be relatively one-way: a higher proportion of consumers of independent cinema might be expected also to consume blockbusters than the proportion of blockbuster viewers who also go to indies). Bourdieu often gives the impression that particular sets of dispositions are more exclusive to particular groups than might always be the case, or that they are more unified than might be found in practice (he refers to the lifestyle resulting from the habitus and its classificatory grid as 'a unitary set of distinct preferences', which risks overstating the degree to which all of its elements might hang so coherently together[50]).

There is no guarantee that every occupant of a particular habitus will have exactly the same cultural preferences. The concept is designed to offer an alternative to two extremes: taste preferences understood as either fully determined by objective circumstances or as matters of purely individual subjective agency. It is offered as a ground that mediates between the two, as the outcome of an objective social position but in the form of collective sets of dispositions and tendencies rather than a direct one-to-one determinant of each act of taste discrimination or judgement. Some freedom can be ascribed to individuals, in this account, but within socially determined parameters. Exactly which products might do the work of establishing particular distinctions within the habitus is subject to variation. The concept of habitus need not be read as collapsing back into a simple mechanical determinism, in other words, as is suggested by Martin Barker and Kate Brooks.[51] But additional considerations are necessary if we are to understand how exactly individual cultural products might be 'taken up' by specific groups or individuals. A useful concept suggested by Barker and Brooks, resulting from research on audiences of the

Hollywood feature *Judge Dredd* (1995), is to differentiate participation in leisure activities such as film-going on the basis of the degree of 'investment' involved on the part of the viewer. 'People do not "belong" within a habitus in some mechanical, even manner', they suggest: 'Fields generate possibilities of, even genres of, responses to which people orient themselves. The manner of their orientation will be a function of their history and class situation, of course, but also of their individual and collective investments in the situation. How important is it to them, and why?'[52] Some viewers of Indiewood films might invest quite strongly in the notion of consuming products perceived to be in some way different from those of the mainstream, for example, while for others this might be far less (if at all) important as a determining factor in their choice of viewing, a position supported by audience responses considered in the chapters that follow (they might also make distinctions *against* Indiewood, in cases where the investment is in a notion of greater independence in relation to which Indiewood is perceived as a betrayal). The line of demarcation between different kinds of cinema might be more or less in play, depending on the basis on which a particular film or type of film has been chosen. Exactly what is signified by the consumption of particular products – cinematic or otherwise – is also subject to variation. If cultural differences function as signs, they often function 'polysemically', as Jim Collins suggests, both across and also sometimes within taste communities.[53] This is particularly the case in the media-proliferating post-1990s context, Collins argues, in which the kind of holistic classificatory system outlined by Bourdieu, and striven for by past upholders of high/low culture boundaries, is undermined by a greater pluralization of taste hierarchies.[54]

The relationship between mass/popular and 'higher' reaches of the American cultural landscape has undergone a number of historical shifts. The widely cited work of Lawrence Levine suggests that strong distinctions between popular and elite cultural products were established in America towards the end of the nineteenth century, displacing an earlier regime in which the two were far more closely blended (where the work of Shakespeare, for example, had a familiarity that made it part and parcel of the broader American culture).[55] The resulting 'sacralization' of culture was, for Levine, only partially

undermined by the growing eclecticism and flexibility of culture in the second half of the twentieth century. Collins suggests a four-phase relationship, building on the first two stages identified by Levine (although, as he suggests, these should be seen as tendencies rather than universal or unilateral shifts).[56] The third phase for Collins is the era of Pop Art, from the late 1950s, in which the separation of artistic/cultural realms came under attack, but according to a particular dynamic that sought to move the popular into the world of what was recognized as 'legitimate' culture. The direction of flow is reversed in Collins' fourth phase, which he terms 'high-pop', in which aspects of officially recognized high culture are 'desacralized' by being transformed into mass entertainment. This is a formulation that includes aspects of Indiewood, as understood in this book, the main cinematic example cited by Collins (alongside others such as 'block-buster' museum shows and mass-marketed designer interiors) being the adaptation of literary classics under the auspices of corporate entities such as Miramax and Sony Pictures Classics.

Different degrees of distinction and exclusion are implied by different kinds of (relatively) non-mainstream cinema. The greatest quantities of cultural capital (and the greatest investment on the part of the viewer) are generally required for the pleasurable/meaningful consumption of the most 'difficult' abstract and avant-garde works. A spectrum then exists between this extreme and a range of other alternatives to the most accessible and broadly marketed mainstream, including the commercially distributed 'art', 'indie' and 'Indiewood' sectors. These labels are no more than rough approximations, with plenty of overlap between them, but they might be taken as indicating, in general, progressively wider potential audience constituencies. If the audience for abstract and avant-garde cinema is very exclusive, 'art' and 'indie' forms appear designed to offer a marked degree of distinc-tion within considerably more accessible frameworks. Indiewood, then, would constitute a point at which some markers of distinction often remain present but in combination with more mainstream/accessible characteristics than might generally be associated with examples of art or less conventional indie film (it would exclude some of the more challenging work that gains commercial distribution in the independ-ent sector – the films of Todd Solondz, for example – which would

be seen as risky because of their greater potential to alienate many viewers). Indiewood cinema is, generally, accessible to viewers without the necessity for a high degree of personal investment, but can offer additional pleasures for those sufficiently invested and inclined to pick up its more distinctive qualities. (The same could be said of other forms of investment found in Indiewood and also in some mainstream Hollywood productions; investment in the notion of the director as 'auteur', with distinctive trademarks, is one example found across the divide, although perhaps more often in the indie or Indiewood regions of the spectrum, an issue to which we return in some of the chapters that follow.) This has to be seen as a question of relative degrees, rather than clear-cut differences. It is quite possible for some features produced in the indie realm beyond the institutional confines of Indiewood to display characteristics that might seem more mainstream/ conventional than some of those produced/distributed within the orbit of the studio divisions, and vice versa. There is no one-to-one match, but it is possible to identify broad areas of correspondence.

Locating the Indiewood audience

So, how might we locate, in the wider social-cultural landscape of the recent/contemporary period, the potential audience for the specific Indiewood blend of (relatively) distinctive and more familiar/ mainstream characteristics? To whom might this most characteristically appeal, on the broader rather than the more individualized scale? Some have argued that taste boundaries and distinctions in the USA have become increasingly blurred and fluid in recent decades, particularly as a result of a widening of access to higher education and an increase in the numbers employed in professional and technical occupations that require college or postgraduate degrees.[57] Increased investments in sources of cultural distinction are necessary, in Bourdieu's account, for those challenged by the entry of new groups into competition for academic qualifications.[58] Others argue that developments such as these are part of a process in which cultural taste has become less clearly associated with social class.[59] Lee suggests that symbolic competencies have become increasingly important as markers of prestige in a postwar context in which, in most 'advanced' industrial societies, there has been

'a genuine effacement of many of the economic differences by which class distinctions have traditionally been signalled'.[60] Numerous interventions were made into this debate in the late 1980s and early 1990s, particularly among theorists seeking to provide a wider grounding for cultural products of the period described as embodying qualities associated with the postmodern. One version of the postmodern of particular relevance to this discussion suggests that the term can serve to highlight certain tendencies in postwar consumer-oriented capitalism in which consumption has gained increased prominence as a medium through which social identities can be constructed and reconstructed, a process that results in some blurring of boundaries between different cultural categories and products.[61] The American context, in which consumer capitalism first came to fruition, is often seen as one in which such tendencies are especially to the fore. For Richard Peterson and Michele Lamont, a particular characteristic of social distinction in the American context more generally is that it is marked by access to a range of products that spreads wider than elite arts to include aspects of popular culture.[62] Members of the American upper-middle class tend to have 'a wide range of cultural repertoires', Lamont suggests, 'within which they can encompass much of main-stream culture'; a 'pervasive, explicit nonexclusiveness' that most clearly differentiates them from their French counterparts.[63] Americans make fewer cultural distinctions and the boundaries they establish are more blurred in what Lamont terms a 'loose-bounded' culture, the kind of territory in which the Indiewood combination of more and less mainstream ingredients – the product of specific developments at the industrial level – might be expected to thrive.[64] Maximum credit in the US context goes to what Peterson terms 'the inclusive yet discriminating *omnivore*',[65] a formulation that might be applicable to the viewer of products found in the indie/Hollywood overlap.

It is not possible to assert with confidence that viewers for Indiewood films come from any one clearly identifiable class or class fragment. Life is not that simple, for any acts of cultural consumption. It is possible, however, to suggest that films produced/distributed from a particular part of the spectrum are designed, if only implicitly at some levels, with specific kinds of audiences broadly in mind, and that these audiences are likely to exist primarily within particular regions

of the landscape of social class, gender, age and ethnicity (although the emphasis in most of the work cited here has been on class). A number of efforts have been made to suggest particular qualities in cultural products that are most likely to appeal to specific taste cultures. Representative of these is the outline of five 'taste publics' offered by Herbert Gans.[66] Innovation and experiment at the level of form are seen by Gans as characteristics of the domain of 'high' culture, populated primarily by highly educated members of the upper and upper-middle classes employed in academic and professional occupations. These qualities do not, generally, appeal to the rest of the taste-culture spectrum, in this account. In the move from upper-middle to lower-middle and 'low' cultures, Gans suggests, there is an increasing preference for emphasis on substance rather than form. This involves fiction with an emphasis on plot more than mood or character-development, for what Gans sees as the growth area of upper-middle culture, and more melodramatic assertions of dominant values at the lower-middle and low ends of the spectrum. Bourdieu makes similar distinctions between what he terms the 'aesthetic disposition' of class fractions high in cultural capital ('intellectuals' and artists, in particular) and the 'popular aesthetic' of the lower classes. Distinction is marked in the former by 'displacing the interest from the "content", characters, plot, etc., to the form, to the specifically artistic effects which are only appreciated relationally, through a comparison with other works which is incompatible with immersion in the singularity of the work immediately given'.[67] Where the aesthetic distances the work from substance, in its emphasis on form, the popular is based on 'the affirmation of the continuity between art and life, which implies the subordination of form to function'.[68] In place of detachment, the popular is founded on a sense of audience involvement and participation.[69] In both cases (each of which might be accused of over-simplification), these preferences are directly linked by Bourdieu to the life-circumstances of those involved: a concern with pragmatic factors on the part of the lower classes contrasting with the desire of the aesthete to mark a distance from necessity. In Bourdieu's terms, Indiewood might again be seen as offering hybrid products, combining popular dynamics with more distinctive, sometimes more formally oriented, dimensions.

Specific class/taste schemas such as those offered by Gans and Bourdieu can be useful but should only be seen as highlighting certain broad tendencies, within which many complications and/or contradictions are likely to arise.[70] Distinctions other than those related specifically to demographic factors such as class background can also come into play, as suggested, for example, by Matt Hills' study of fans of horror fiction. Products that would, conventionally, be ascribed primarily to the 'lower' cultural reaches, horror fictions generate responses within fan forums a key aspect of which is a marking of distinction on the grounds of connoisseurship. A key marker of fandom, for Hills, is an articulation of appreciation at the levels of form and craftsmanship – precisely, a detached, relational appreciation – instead of at the 'immersive' level of emotional fear or disgust.[71] This is another indication of the importance of different levels of investment in the consumption of cultural products, in this case in the deployment of a subcultural capital that might be accessible to a wider constituency than those associated by Gans and Bourdieu with such a mode of consumption/appreciation.

The mixing of elements of high and popular culture identified by Lamont and Peterson as a distinctively American phenomenon has been associated with the development in recent decades of new middle-class fractions. These have been variously described in this context in formulations such as the 'professional-managerial class' (Fred Pfeil), the 'new bourgeoisie', 'new petite bourgeoisie' and 'new cultural intermediaries' (Bourdieu) or new 'knowledge-based' middle-class formations (John Frow).[72] Many of these accounts, the full details of which are beyond the scope of this book, suggest that broader social-economic developments (often associated with or including elements of transition to post-Fordist economic practices) have created a context in which consumption of symbolic goods plays an increased and (for some) increasingly flexible role in the construction and articulation of markers of identity and distinction. Another dimension is the increased role played in the broader economy, especially in the USA, by the 'creative industries', a development viewed by Richard Florida as an important part of the material ground for a fading or blurring of markers of distinction such as those established between 'alternative' and 'mainstream'.[73] The result, for Florida, is the transcendence for

many of a previously long-standing opposition between the distinct ethics of the bourgeois (rooted in the Protestant work ethic) and the bohemian (artistic, creative, expressive, hedonistic). A similar argument is made by David Brooks, who describes the emergence of a 'Bobo' (bourgeois bohemian) complex resulting from a combination of the 1960s' counterculture and the business/profit-oriented culture often associated with the 1980s.[74] For Brooks, this is a generational phenomenon, related to the mutual implication of counterculture and commerce described by Frank. Florida suggests that its roots are somewhat different, in the openness to creativity and cultural difference of the 1960s computer pioneers of Silicon Valley, and the outcome of 'deep economic shifts' rather than 'primarily a lifestyle-and-consumer thing'.[75] Whatever their differences, the accounts of Florida and Brooks are suggestive in terms of both industrial and potential-audience conjunctures relevant to the development of Indiewood cinema, among other cultural trends. They describe an arena in which the creative and the commercial blend very much as is the case in Indiewood, the creative forming a substantial part of the *basis of* rather than just an accommodation with 'the bourgeois realm of ambition and worldly success'.[76] They help – along with some of the other accounts cited above – to suggest a broader cultural context with which the development of Indiewood is consonant.

In each of these cases, the kinds of social/class or generational formations described might provide fertile ground for the products of Indiewood, in which elements of more and less distinctive/mainstream cinema are mixed in varying quantities and in which plenty of scope exists for symbolic appropriation by those who select them as sources of taste–cultural investment. This might be the case regardless of whether any particular commitment is made to the notion of the 'postmodern' as a broader cultural conjuncture or a way of describing any particular qualities of artistic/cultural products. Other demographic factors such as age, gender and ethnicity also need to be considered. Age might be a significant factor, for example, along with class location, in the case of production that aspires to the status of a 'quality' defined in literary or quasi-literary terms, as is the case in a variety of Indiewood output associated particularly with Oscar-garnering Miramax releases from the mid-1990s (examined in more

detail in chapter 2). Such films are targeted primarily at an audience of older viewers, usually defined in industry terms as the 40+ market. This is a niche audience, relatively speaking, in Hollywood terms, compared with younger audience groups that comprise a larger share and also tend to attend more frequently. But it is a substantial niche and one that grew significantly in the period in which Indiewood took shape, from the early 1990s to the later 1990s and the early 2000s; from the low 30s to 40 per cent of the US cinema audience in 2000 and 43 per cent in 2004.[77] This might also be seen as a kind of production targeted at female more than male audiences. Other kinds of Indiewood product, such as those aspiring to 'cool' or 'cult' qualities, however exactly these might be defined, appear to be aimed at segments of the younger audience that is also the main target of Hollywood. In most cases, along with indie cinema more widely, the primary audience is also probably a white as well as a middle-class entity, of whatever age or gender.

But how consciously do the producers and distributors of such forms design them for particular types of audience constituencies, however these might be understood as the product of specific social or historical conjunctures? The answer to this question depends on the point in the process at which we direct our focus. At the production and post-production end of the Indiewood business, notions of what might be seen as a cynical audience-targeting approach are often disavowed in favour of an emphasis on the individual filmmaker (or filmmaking team) as creative artist, even if working within the constraints of studio subsidiaries. A lack of internalization of an image of the intended audience is typical of those at the media-production end more generally, according to studies cited by James Ettema and Charles Whitney: 'writers, whether newspaper reporters or television scriptwriters, along with most other creators of symbolic materials, learn and practice their craft not by internalizing an audience image but by acquiring and maintaining a "product image"', a shared vision of how the work itself should be rather than the audience for which it is designed.[78]

Images of the intended audience reappear, however, 'if we look for them, not in individual daily work routines but in organizational strategies and interactions within the overall arrangements of the

institution'. In the case of the speciality film industry, this is a question of the considerations taken into account by those involved in activities such as finance, distribution and marketing (particularly the latter two), the more immediately economic sharp ends of the business, in which audience targeting figures quite explicitly. In addition to traditional demographics (social class, age, gender, ethnicity, geographical location) and more vague impressions of 'sophisticated' or 'upscale' audiences (terms that occur quite frequently in interviews with distributors and marketers), Indiewood marketing and distribution campaigns also draw on 'attitudinal' descriptions of their target constituencies when deciding where to spend their usually limited advertising and promotional budgets. These include 'psychographics', a form of consumer segmentation derived from social psychology, and 'lifestyles' research, 'based upon more descriptive accounts of attitudes, opinions and beliefs', forms of market segmentation that date back to the same 1960s context as the hip consumerism analysed by Frank.[79] The more discriminating and fine-tuned nature of the breakdown of the market suggested (or created) by such approaches is of particular value to the speciality sector, as well as to niche-oriented business more generally, producing 'both a more intensive individualization of consumers than demographics and emphasiz[ing] the differences between groups of consumers in more explicitly cultural terms'.[80] Particular target areas for speciality cinema are 'sophisticated' urban communities in major metropolises (the standard locations for platform release openings, in which films are distributed initially to a limited number of key cities, usually starting with New York), along with college towns and inner-city 'bohemian' or upscale enclaves. Neighbourhood communities such as the latter are specifically defined in lifestyle marketing conducted on the basis of a classification by zip-code, a significant part of the armoury of speciality marketers since the 1970s.[81]

The Indiewood field of cultural production

A challenge to the 'charismatic ideology' surrounding the figure of the creative artist, taken out of such industrial/economic contexts, is also offered by Bourdieu.[82] Rather than the products of individual 'genius', Bourdieu suggests, artistic-cultural works are the outcome of objective

relations within a wider 'field of cultural production' such as that
occupied by Indiewood in its particular location between the
dynamics of the mainstream and the more independent sectors.
Indiewood is defined, that is, not as a 'thing in itself' but through its
relative position in a wider field. Indiewood products might not be
written or produced consciously *in order to* play into this field (although
that remains a possibility), but it is the existence of the objective forces
of the field that creates a context in which they are likely to be funded,
produced and distributed. The manner in which production and
consumption come together is seen by Bourdieu as a product of the
shared habitus, the wider configuration of taste-culture in which each
end of the process is embedded:

> the matching of supply and demand is neither the simple effect of
> production imposing itself on consumption nor the effect of a
> conscious endeavour to serve the consumers' needs, but the result of
> the objective orchestration of two relatively independent logics, that
> of the field of production and that of the field of consumption.[83]

This is one way of addressing the question of which comes first, in
the various accounts cited above: the push resulting from industrial
imperatives to combine larger-scale with specialist niche-targeting
strategies or a pull from consumer demands that might be associated
more or less specifically with the taste/distinction preferences of
particular class fractions or other social groups in particular historical
contexts. Both can be seen as products of a larger configuration of
socio-economic forces, perhaps relatively less independent from one
another in this particular conjuncture than Bourdieu suggests; quite
strong links between the two are certainly implied by many of the
commentators cited above. For Bourdieu:

> The producers are led by the logic of competition with other
> producers and by the specific interests linked to their position in the
> field of production (and therefore by the habitus which have led
> them to that position) to produce distinct products which meet the
> different cultural interests which the consumers owe to their class
> conditions and position, thereby offering them a real possibility of
> being satisfied.[84]

The fact that the particular qualities of a given habitus are experienced by its occupants as natural and self-evident makes both production and consumption within any particular sphere seem spontaneous rather than deliberately contrived. Practical mastery of the field 'gives its possessors a "nose" and a "feeling", *without any need for cynical calculation*'.[85] This helps to explain the fact that figures such as the heads and leading executives of Indiewood divisions tend to present themselves as enthusiasts for the films they handle, lending their skills in business or marketing to the support of a creative enterprise, rather than as more detached and purely commercially minded. They situate themselves within the habitus, as sharers of the values considered to be embodied in the kinds of films produced or distributed, rather than as external figures seeking to exploit a particular market, even while conscious of using individual skills to do exactly that. They fit quite well, in this respect, with the merging or transcendence of bourgeois and bohemian distinctions described by Florida and Brooks.

Indiewood can be located, in this sense, within broader dynamics characteristic of the overall field of cultural production, as a product of the rival pulls identified by Bourdieu (in all artistic and literary endeavour) between larger-scale, more commercial and smaller-scale, less commercial operations.[86] At one extreme is production operating according to what Bourdieu terms the 'heteronomous principle', in which creative work is subject to the ordinary prevailing laws of the market, as just another commercial product. At the other is the 'autonomous principle', in which total freedom is achieved from the laws of the market and all that counts is artistic prestige.[87] Indiewood clearly exists nearer to the former than the latter, being required to produce works that are marketable to particular audiences in order to earn profits (or, at the very least, to avoid making losses) for its corporate parents. It remains a sector in which part of the emphasis, however, is on the production of cultural capital of value to the speciality divisions of the major studios for the reasons discussed above, even if we conclude that the primary motivation is the capacity for this particular form of cultural capital to be converted – via particular audience constituencies – into its economic equivalent. The cultural capital produced by this kind of cinema also appears to be significant

to many of the executives involved in the sector, for their own personal investments and the articulations through which they distinguish themselves from their colleagues in the commercial mainstream. The aspirations of Harvey Weinstein at Miramax, as considered in chapter 2, are a case in point, as might be those of some of the executives who played key roles in shepherding 'maverick' studio productions such as *Three Kings* and *Fight Club*, considered in chapter 4. Economics set limits – the imperative to make profits, if modest compared with the stuff of the Hollywood blockbuster – but the context is one in which a lower scale of financial gain might be accepted, in some if not all cases, as the price of a higher return at the cultural level. Profit might also be deferred, to a later moment at which films that do not achieve great initial box-office success gain 'cult' or other forms of delayed critical and/or audience recognition that can be converted into substantial ongoing revenues, particularly in video/DVD, as proved most notably to be the case with *Fight Club*. The 'genuine' nature of the personal investments of those involved in the processes through which such works gain space in the orbit of the studios need not be doubted for this process to be understood effectively as serving more practical and functional (commercial and ideological) purposes for the studios and their preferred self-images.

Empirical audience studies are the best way to sample who really does consume films such as the Indiewood products under consideration here, although such work remains thin on the ground. A small-scale study by Martin Barker of viewers of *Being John Malkovich* (1999), one of a number of films scripted by Charlie Kaufman considered in chapter 1, is broadly, if tentatively, supportive of the approach outlined above, in which Indiewood films of this kind are seen as establishing particular demands on viewers in return for giving them a sense of belonging to a particular kind of interpretive community.[88] Similar conclusions can be drawn from many responses found in online forums such as 'customer reviews' on the Amazon.com website, examples of which are considered in the chapters that follow. Some evidence for different orientations towards film consumption of the kind implied in the accounts of Bourdieu and others is also found in Barker and Brooks' *Judge Dredd* project, even if developed in the context of audiences for a very different type of film. On the one

hand, Barker and Brooks identify action-adventure-oriented viewers whose attitude fits with aspects of Bourdieu's 'popular aesthetic', in which the overwhelming emphasis is on the experience of the thrills offered by the film in the present tense. What the film has to offer is 'obvious, it's all there on-screen', and a marker of distinction in this case is 'to separate yourself from the "analysts"'.[89] Among other orientations, however, are those defined as 'film-follower' and 'culture-belonging'. In the former case, elements of which Barker and Brooks found in many of their interview-responses, the film-going experience is important to viewers in the context of the organization, rehearsal and display of 'expert' knowledge. In the latter, acknowledged at some level by 'just about every single interviewee', the key dimension is the contribution film consumption offers to the individual's feeling of belonging to particular groups; the cinematic experience is 'a continuous process of belonging, gathering up appropriate materials as cultural "coinage", and making the appropriate knowing use of them'.[90] Each of these two orientations entails a mobilization of some form of cultural or subcultural capital as a significant aspect of investment in the consumption of particular types of film, the film-follower orientation including potential interest in a wider range of cinema (and likely to figure at least as prominently, if not more so, among viewers of Indiewood productions).

As far as seeking to establish who such films are *designed for*, however, the motivating force for their distribution and/or creation/production/financing, we can have recourse to the texts themselves, as well as to their economic and social-cultural contexts. No one can guarantee which films reach exactly which audiences, and there is always likely to be an imperfect match between target and actual audiences (as manifested by some of the negative Amazon responses cited in the chapters that follow), but all films entail in some sense what Barker terms an 'implied audience', based on the set of particular skills and knowledges required 'if the film is to be made sense of and related to'.[91] What exactly such a viewer orientation comprises is variable, however. As Janet Staiger suggests, film theorists have often greatly simplified the likely orientations of spectators to films, including an undue assumption that viewers are 'knowledgeable and cooperative' in relation to what are often assumed to be primary

dimensions of the film-going experience (particularly, in the case of 'classical' Hollywood cinema, an emphasis on narrative and character as opposed to dimensions such as spectacle and excess).[92] Reception activities presumed to be 'normative' for narrative features encompass only a narrow range of the kinds of responses made by viewers, Staiger argues (so many alternatives, she suggests, as to expose the status of the 'normative' as a narrowly grounded construct).[93] The extent to which viewers of Indiewood films might be 'knowledgeable and cooperative' in relation to the specific qualities highlighted in such products is another factor likely to depend on the level of investment on the part of any particular groups or individuals. Those who invest relatively highly in such films, as sources of cultural distinction, might be expected more closely to fit the requirements of a specific type of implied viewer, choosing Indiewood or other such products specifically on the basis of what they offer beyond or alongside more conventional/mainstream characteristics. In such cases, a relatively good 'fit' would exist between the orientations of viewers and the distinctive qualities according to which products are defined by filmmakers, distributors or other intermediaries. This, again, appears to be supported by some of the audience responses considered below. Allowance always has to be made for the fact that what viewers take from any kind of cinema cannot entirely be determined, however, even where particular features are foregrounded by the text and/or surrounding promotional or critical discourses.

Mainstream Hollywood films have culturally specific requirements of their own, if they are to achieve certain minimal levels of legibility, but are designed to be accessible to a very large constituency. Indiewood films are not generally designed to be difficult to access but also offer some more distinctive features, implying an audience role that can differ in some respects from that associated with 'the mainstream', or that can include particular kinds of viewer appropriations, in the sense suggested by Bourdieu. The term 'mainstream' can easily become a rhetorical construct that obscures numerous forms of differentiation, as suggested above, a risk I run in its repeated use in this book (as can other terms such as 'dominant', 'commercial', 'alternative', 'distinctive', and so on). But it is also an *operative* construct, a discursive category in widespread use, explicitly or implicitly, in

the articulation of a range of points of distinction (as are the other terms listed above). It is used as shorthand for what can be understood to be a specific set of historically and institutionally grounded norms against which other practices can be measured. The formal dimension of this study is an exercise in what has become known as historical poetics, in which, as Henry Jenkins suggests, stylistic choices 'are understood not simply as a means of individual expression by exceptional artists, but rather as grounded in institutional practices and larger aesthetic movements'.[94] A key aspect of this approach is the concept of the aesthetic norm, as developed in greatest detail in David Bordwell's analysis of the classical Hollywood style, which should be taken to suggest a relatively stable paradigm characteristic of mainstream Hollywood production, although one that permits variation within and the possibility in some cases of pushing beyond the usual limitations.[95]

Notions of the mainstream or the 'popular' are often taken as a reference point against which other forms are defined. For Lee, Bourdieu's popular aesthetic serves as 'the primary benchmark against which the remainder of all other taste formations, which have at their heart a systematic exclusion of popular forms and the denial of popular modes of consumption, may be fixed and consumed'.[96] This may be the case regardless of the oversimplified nature of prevalent understandings of what exactly is constituted by the popular/mainstream (oversimplified versions are likely to be more functional, for this purpose of articulating distinctions, than more complex or nuanced accounts that might do better justice to the reality). Each position in the field is a social construct, defined, as Bourdieu argues, in terms of its relationship with other positions. A similar point is made by Janet Harbord, in a context more directly related to the subject of this book. The film cultures surrounding the multiplex and the art-house cinema mark a polarity of positions, as Harbord suggests, the latter often seen as threatened with extinction by the expansion of the former: 'Yet this gloss evades the central dynamic at work in the relationship between these cultures, one in which positions are both carved out in relation to the other and also in dynamic structural play.'[97] Implicit in the definition of art-house cinema is that from which it marks its separation and independence. The position of Indiewood is one in

which some distinction is marked, but the degree of separation can be significantly less than that implied by the material exclusively of the art-house.

Some of the formulations employed by Bourdieu and Lee quoted above do not apply in the case of Indiewood, the hybrid nature of which is far from systematically excluding or denying popular forms or modes of consumption. Indiewood films do not, generally, displace interest from elements of 'content' such as character and plot to issues of form, even if they might sometimes offer distinctive formal appeals to those sufficiently invested to find these a source of distinction-marking pleasure. Character and plot remain dominant, as will be seen in the examples examined in the rest of this book, even those that appear more formally innovative or challenging in some respects. It is also rarely if ever the case that Indiewood films can be associated with an aesthetic disposition that 'tends to bracket off the nature and function of the object represented and to exclude any "naïve" reaction – horror at the horrible, desire for the desirable, pious reverence for the sacred – along with all purely ethical responses, in order to concentrate solely on the mode of representation [...]'.[98] If its output is largely built around character and plot, Indiewood also remains a realm of cinema founded on appeal to the emotional reactions of viewers, in much the same way as Hollywood, if sometimes in a more nuanced tone. Emotional reactions are not bracketed, certainly not entirely, even where formal devices or issues relating to the broader mode of representation are highlighted. The same is true of much of the commercially distributed indie sector, even if the bounds of possibility here are generally drawn more widely.

The implied audience for Indiewood cinema, then, would be an audience receptive to the presence of some markers of difference or distinction within the context of frameworks broadly familiar from the Hollywood mainstream. It would, in at least some instances, be able to find pleasure in the specific difference constituted by examples such as the complex or self-referential narratives scripted by Charlie Kaufman or the stylized touches often associated with the films of Steven Soderbergh. But it would also take pleasure from more mainstream/familiar articulations in dimensions such as plot, character and emotional engagement and response. That such a combination of

orientations exists among a significant number of viewers of the films considered in this book is supported by responses taken from online sources, principally reviews posted on the Amazon.com website, even where these are found amid a wider spectrum of reactions. A word is required here on the use of such sources as a way of considering viewer responses. Given the centrality to this study of notions of audience targeting and the potential of particular kinds of texts to provide sources of distinction-marking for viewers, it is necessary to make some attempt to 'test' these approaches against the responses of actual viewers, even if no methods of audience research can be said to provide definitive or unmediated answers to questions such as why particular viewers choose, enjoy or react otherwise to particular films. Online sources such as Amazon reviews are a useful resource for this purpose, particularly in the case of films that are no longer on theatrical release and therefore beyond the reach of audience research based on the distribution of questionnaires to those attending or who have recently attended the cinema (one of the prevailing forms of audience research on film to date). They also have the merit of not focusing exclusively on the theatrical experience, frequently offering a combination of reactions to a film generally – regardless of where seen – and comments relating more specifically to a particular release for home viewing.

Amazon reviews also offer sizeable samples, as many as 1,000 or more in the cases of *Kill Bill: Volume 1*, considered in chapter 2, and *American Beauty*, considered in chapter 4, a scale difficult to achieve (without very substantial resources) through more traditional research methods. Like all research samples, qualifications are required, however, in regard to any claims that might be made to more broadly representative status. Amazon reviews have the benefit of appearing to canvas a fairly wide range of opinion, including many viewers of the films considered in this book who would not, from their reactions, appear to be among the obvious target market.[99] Such samples are self-selecting, however, and cannot be considered representative in any strict sense (although the same can be said of other audience research samples such as those based on the limited number of respondents who complete and return questionnaires or agree to take part in activities such as focus group sessions or interviews). The major drawback of the use of online postings, perhaps, is that they do not

enable specific questions to be put to viewers, directly to test particular hypotheses. The upside is that the opinions expressed are generated by the respondents themselves, as their 'own' reactions, prompted by their response to the film in the context provided by other reviews and circulating discourses. The latter can, of course, play a substantial role in shaping what are presented as viewers' own subjective opinions, as can recourse to certain formulaic varieties of response, as will be seen in the chapters that follow. It is also important to note that statements made in such fora do not provide unmediated access to viewer responses. They must be considered, as Thomas Austin puts it, as 'performative acts made about feelings and engagements, rather than as transparent reproductions of these'.[100] For a study that includes a focus on degrees of articulation of distinction and the employment of particular forms of cultural/subcultural capital, however, the performative dimension of such responses is one of the main objects of interest, regardless of the extent to which the performative is believed to mask or express the 'real' thoughts and feelings of the respondent.[101]

Sources such as Amazon reviews also play an active part in the public mapping of taste cultures, which gives them added resonance for my purpose. Bottom-up consumer feedback of this kind is a key component of an 'amplified word of mouth' considered by Anderson to play an important role in helping to match supply and demand in the world of escalating choice created by the huge inventories of stock made available by online retailers such as Amazon.[102] Amazon reviews are part of the broader phenomenon examined in this book, components in a feedback system (in this case, particularly related to DVD releases) that can help to shape as well as to reflect patterns of consumption and distinction-marking, rather than existing in a vacuum as tends to be the case with data generated specifically for academic research. These sources do not help directly to answer questions about the social-class or other status of viewers, however, as no such information on respondents is provided (it might be possible to speculate about such status from the nature of the discourse employed by individual examples, but such an interpretation would risk the employment of a circular logic).

The primary focus of the remainder of this book remains textual, but with the industrial and potential-audience contexts, and some

viewer responses, very much to the fore; how certain features are structured in a manner that locates them in a particular region of the marketplace, offering qualities likely to be of primary appeal to particular audience segments. The first chapter focuses on three films scripted by Charlie Kaufman, starting with *Adaptation* (2002), a feature that explicitly figures the Indiewood tension between more and less conventional textual qualities in its tale of a screenwriter (a fictionalized Kaufman) attempting to adapt a book to the screen. The films of Kaufman can be situated at the more indie/alternative end of the Indiewood spectrum. Far more mainstream in its orientation was the strategy of Miramax Films, the speciality arm of Walt Disney since 1993 and one of the key architects of the Indiewood blurring of distinctions between Hollywood and the independent sector, before the departure of the Weinsteins in 2005. This is considered in chapter 2 through an analysis of films that mark two ends of a Miramax spectrum that ranges from articulations of quality/prestige (*Shakespeare in Love*) to a more youth-oriented mainstreaming of pulp and/or cult film traditions (*Kill Bill*). Chapter 3 returns to a focus on the individual filmmaker in the shape of Steven Soderbergh, a figure whose work has demonstrated an ability to straddle as well as to work on both sides of the indie/Hollywood line, exemplified here in case studies of *Traffic* (2000) and a remake of the science-fiction art-cinema classic *Solaris* (2002). The latter was produced within the borders of one of the main studio divisions, Twentieth Century Fox, a dimension of Indiewood considered more directly in chapter 4 via case studies of *American Beauty* and *Three Kings*, two films that demonstrate the nature and (often limited) scope for relatively alternative kinds of production at the heart of the studio sector. The final chapter moves towards a conclusion but also widens the range of the book by considering a larger body of 34 films, the US distribution slate of Universal's Focus Features from 2002 to 2005, before returning to some of the broader issues raised in this introduction.

Notes

1. I am using the term 'independent' here to suggest the part of the film landscape to which the term became most prominently attached in the 1980s and 1990s, the domain signified by the names of institutions such

as the distributor Miramax and the Sundance Film Festival, and by the work of filmmakers such as Jim Jarmusch, John Sayles, Kevin Smith, Richard Linklater and Quentin Tarantino. The term 'indie' is often used to distinguish this particular range of independent cinema from what is signified by wider or more literal uses of the term.

2. For an example of praise, in an often informative but also relatively superficial account, see James Mottram, *The Sundance Kids: How The Mavericks Took Over Hollywood*.

3. In its consideration of broader social and economic contexts in relation to both indie and Indiewood production and consumption, this book attempts to provide more in the way of background explanation than my previous book, *American Independent Cinema*. Some of this contextual material is of relevance to the broader independent as well as the specifically Indiewood sector, although the main focus here is on the specific hybrid location of the latter.

4. 'Part One: The classical Hollywood style, 1917–60', in Janet Staiger Bordwell and Kristin Thompson, *The Classical Hollywood Style: Film Style and Mode of Production to 1960*, 5.

5. Peter Biskind, in *Down and Dirty Pictures: Miramax, Sundance and the Rise of Independent Film*, 194, suggests that the term was coined in 1994. One of the locations in which it gained increased currency was the online newsletter/website *indieWIRE*, which gives a later date, attributing the coining of the term to a 1997 article by the filmmaker Sarah Jacobson that celebrated the virtues of lower-budget do-it-yourself production; see Eugene Hernandez, 'First Person: indieWIRE @ 10, And Counting...', *indieWIRE*, 15 July 2006, accessed via www.indiewire.com, and Sarah Jacobson, 'Understanding D.I.Y.' *indieWIRE*, November 1997, exact date not provided.

6. A view commonly expressed in indie-oriented sources such as *indieWIRE* and *Filmmaker* magazine and very much the context in which the term was used by Jacobson.

7. A distinctly hyperbolic, celebratory note is struck, among some more nuanced observations, as evidenced by the subtitles of journalistic works such as Mottram, *The Sundance Kids*, and Sharon Waxman, *Rebels on the Backlot: Six Maverick Directors and How They Conquered the Hollywood Studio System*.

8. For more on this see my *American Independent Cinema*. For more on recurrent characteristics of art cinema, and its institutional basis, see Steve Neale, 'Art Cinema as Institution', *Screen*, 22/1 (1981). As Barbara Wilinsky suggests, the category has had ambiguous and flexible

meaning in its uses at different times within the film industry: *Sure Seaters: The Emergence of Art House Cinema.*

9. David S. Cohen and Ian Mohr, 'Disney minis its "Max"', *Variety*. Posted at www.variety.com, 10 April 2005.

10. *Rebels on the Backlot*, xviii.

11. *The Economy of Prestige: Prizes, Awards, and the Circulation of Cultural Value*, 10.

12. For more on the way the particular meanings of 'independent' have changed, and can best be understood at the level of the discourses surrounding the term, see Yannis Tzioumakis, *American Independent Cinema: An Introduction*, 13.

13. Mike Wayne, *Marxism and Media Studies: Key Concepts and Contemporary Trends*, 77; the same can be said of the wider postwar tendency for the studios to contract out much of the process of film production to independent and semi-independent companies involved in the making of mainstream features.

14. For useful surveys of different ways in which post-Fordism has been conceptualized, and some of the over-simplifications that often result, see Ash Amin, 'Post-Fordism: Models, Fantasies and Phantoms of Transition', and Mark Elam, 'Puzzling out the Post-Fordist Debate: Technology, Markets and Institutions', both in Ash Amin (ed.), *Post-Fordism: A Reader.*

15. For more of this background, see my *American Independent Cinema*, chapter 1.

16. Martyn J. Lee, *Consumer Culture Reborn: The Cultural Politics of Consumption.*

17. *Consumer Culture Reborn*, 135.

18. *Consumer Culture Reborn*, 135.

19. Gail Schiller, 'Alarm sounded on overuse of preshow ads', *The Hollywood Reporter*, 25 March 2004, accessed via www.hollywoodreporter.com; Nicola Sperling, 'Cinema advertising exhibits growth', *The Hollywood Reporter*, 14 June 2004, accessed via www.hollywoodreporter.com.

20. *The Long Tail: How Endless Choice is Creating Unlimited Demand.*

21. Even if the production process has been decentralized in the postwar period in a manner consistent with accounts of post-Fordism, this is far from the case when it comes to the crucial process of distribution, the real source of overall power and control in the industry; see Asu Askoy and Kevin Robins, 'Hollywood for the 21st century: global competition for critical mass in image markets', *Cambridge Journal of Economics*, 16 (1992).

22. Martin Barker, with Thomas Austin, *From Antz to Titanic: Reinventing Film Studies*, 48. Barker draws for his articulation of this concept on notions of the 'implied reader' in literary theory, 42–8.

23. For Baudrillard it is 'sign exchange value' that is fundamental to the world of consumption, rather than 'use value', the more practical uses to which products might be put; *For a Critique of the Political Economy of the Sign*, 30. For an account that seeks to bring the perspective of social anthropology to bear on the issue of consumption and the manner in which 'goods are coded for communication', see Mary Douglas and Baron Isherwood, *The World of Goods: Towards an Anthropology of Consumption*, xxi. Useful surveys of these issues are found in Lee, *Consumer Culture Reborn*, and Robert Bocock, *Consumption*.

24. For a full account of this process see Bourdieu, *Outline of a Theory of Practice*, 73–88.

25. *Distinction: A Social Critique of the Judgement of Taste*, 171.

26. *Distinction*, 68.

27. *Governing the Soul: The Shaping of the Private Self*, 231.

28. *Distinction*, 2.

29. Jeffrey Sconce, 'Irony, nihilism and the new American "smart" film', *Screen*, 43:4 (Winter 2002), 352.

30. Nick Heffernan, *Capital, Class and Technology in Contemporary American Culture*, 7.

31. *The Conquest of Cool: Business Culture, Counterculture, and the Rise of Hip Consumerism*.

32. *The Conquest of Cool*, 31, 233; Sconce, 'Irony, nihilism', 355–7. For an account that relates its primary understanding of the kind of cinema considered in this book, and that of some more mainstream contemporaries, directly to production inspired by the life experiences of members of the 'Generation X' demographic, see Peter Hanson, *The Cinema of Generation X: A Critical Study*. Another version with a similarly generational orientation is Jesse Fox Mayshark, *Post-Pop Cinema, The search for Meaning in American Film*.

33. A concept developed by Sarah Thornton, *Club Cultures: Music, Media and Subcultural Capital*.

34. Thornton, *Club Cultures*; Mark Jancovich, 'Cult Fictions: Cult Movies, Subcultural Capital and the Production of Cultural Distinctions', *Cultural Studies*, 16:2 (2002).

35. Jancovich, 'Cult Fictions', 315–17.

36. *Consumer Culture Reborn*, 36; *Distinction*, 35–47.

37. More than one-third of audiences at Britain's 37 Regional Film Theatres were in full-time education, a figure that rises to more than

half if the numbers of teachers and lecturers are added, according to data compiled for David Docherty, David Morrison and Michael Tracey, *The Last Picture Show? Britain's Changing Film Audiences*. The study also showed, as would be expected, that this audience had other distinct cultural leanings such as much higher than average tendencies to read newspapers such as *The Guardian* and to listen to Radio 4.

38. *Distinction*, 270.
39. A similar argument is made by Wilkinsky in relation to patrons of art cinemas during their period of growth in the postwar decades in the USA.
40. *Distinction*, 226, 227.
41. *Film Cultures*, 89.
42. *Distinction*, 253. In *Fear of Falling: The Inner Life of the Middle Class*, Barbara Ehrenreich suggests that the professional middle class is particularly subject to anxiety because of the evanescent nature of its principal source of capital (knowledge and skill), which must be renewed in each individual (15).
43. *Distinction*, 282.
44. *Distinction*, 323.
45. See Claire Monk, 'The British heritage-film debate revisited', in Claire Monk and Amy Sargeant (eds), *British Historical Cinema*, for a critique of a dominant manner in which British 'middlebrow' literary adaptations have been disparaged under the label of the 'heritage film'. Jim Collins, in *High-Pop: Making Culture into Popular Entertainment*, makes a distinction between literary texts characterized as middlebrow in the era following the Second World War and what he terms contemporary 'high-pop', which includes Indiewood adaptations of highbrow classical authors such as Austen and Shakespeare: 7–9.
46. For a good example, see John Frow, *Cultural Studies and Cultural Value*.
47. *Money, Morals and Manners: The Culture of the French and the American Upper-Middle Class*.
48. *Money, Morals and Manners*, 5.
49. These include work roles, which remain likely to play an important part in conceptions of self-identity, despite the claims of some that these have been displaced in favour of an emphasis on consumption in a move towards a 'postmodern' condition; Bocock, Consumption, 4.
50. *Distinction*, 173.
51. 'On looking into Bourdieu's black box', in Roger Dickinson *et al.* (eds), *Approaches to Audiences*.
52. 'On looking', 228–9.

53. *Architectures of Excess: Cultural Life in the Information Age*, 195.
54. *Architectures of Excess*, 193–4.
55. *Highbrow/Lowbrow: The Emergence of Cultural Hierarchy in America*.
56. 'High-Pop: An Introduction', in Collins (ed.), *High-Pop: Making Culture into Popular Entertainment*.
57. See Michael Kammen, *American Culture, American Tastes: Social Change and the 20th Century*, and Herbert Gans, *Popular Culture and High Culture: An Analysis and Evaluation of Taste*.
58. *Distinction*, 133.
59. George Lewis, 'Taste cultures and their composition: towards a new theoretical perspective', in E. Katz and T. Szecsko (eds), *Mass Media and Social Change*; Judith Blau, *The Shape of Culture: A Study of Contemporary Cultural Patterns in the United States*; Frow, *Cultural Studies and Cultural Value*.
60. *Consumer Culture Reborn*, 34.
61. Bocock, *Consumption*, 78–81.
62. Richard Peterson, 'Measured markets and unknown audiences: case studies from the production and consumption of music', in J. Ettema and D. Whitney (eds), *Audiencemaking: How the Media Create the Audience*, 180; Lamont, *Money, Morals and Manners*, 113.
63. *Money, Morals and Manners*, 104, 105.
64. *Money, Morals and Manners*, 115.
65. 'Measured markets', 180.
66. *Popular Culture and High Culture*.
67. *Distinction*, 34.
68. *Distinction*, 32.
69. For a critique that argues that Bourdieu's account lacks a full consideration of the potential for genuinely 'artistic' creation within popular culture, see Bridget Fowler, *Pierre Bourdieu and Cultural Theory: Critical Investigations*.
70. For a critique of Bourdieu's version, see Frow, *Cultural Studies and Cultural Value*, 29–47.
71. Hills, *The Pleasures of Horror*.
72. For a number of sociological sources on the rise and composition of new middle classes, see Mike Featherstone, *Consumer Culture and Postmodernism*, 43. For other accounts and/or questioning of the nature of this process, see Fred Pfeil, '"Makin' Flippy-Floppy": Postmodernism and the Baby Boom Professional-Managerial Class', in Fred Pfeil (ed.), *Another Tale to Tell: Politics and Narrative in Postmodern Culture*; Bourdieu, *Distinction*, 304–70; Frow, *Cultural Studies and Cultural Value*, 124–5; Scott

Lash and John Urry, *The End of Organized Capitalism*; David Harvey, *The Condition of Postmodernity*.
73. *The Rise of the Creative Class*.
74. *Bobos in Paradise*.
75. *The Rise of the Creative Class*, 206, 199.
76. Brooks, *Bobos in Paradise*, 11.
77. Figures from reports by the American film industry body the Motion Picture Association of America, '1999 Motion Picture Attendance' report and '2004 US Movie Attendance Study', accessed via mpaa.org.
78. James Ettema and D. Charles Whitney, 'The Money Arrow: An Introduction to Audiencemaking', in Ettema and Whitney (eds), *Audiencemaking*, 8.
79. Sean Nixon, 'Circulating Culture', in Paul du Gay (ed.), *Production of Culture/Cultures of Production*, 202. Examples of the use of some of these approaches in the indie and Indiewood sectors are provided in Tiiu Lukk, *Movie Marketing: Opening the Picture and Giving it Legs*. See, for example, chapters on *Four Weddings and a Funeral* and *Pulp Fiction*.
80. Nixon, 'Circulating Culture', 203.
81. Michael J. Weiss, *The Clustering of America*.
82. 'The Production of Belief: Contribution to an Economy of Symbolic Goods', in Bourdieu, *The Field of Cultural Production*.
83. *Distinction*, 230.
84. *Distinction*, 231.
85. 'The Production of Belief', 95; original emphasis.
86. 'The Production of Belief', 81. For critiques of Bourdieu for tending to polarize the opposition between the two extremes, instead of seeing it as a broader spectrum, as fits my analysis of Indiewood, see Fowler, *Pierre Bourdieu and Cultural Theory*, and Hills, *The Pleasures of Horror*, 169–70.
87. 'The Field of Cultural Production', in Bourdieu, *The Field of Cultural Production*, 39.
88. Martin Barker, 'Betokening John Malkovich'.
89. Barker and Brooks, *Knowing Audiences*, 157.
90. *Knowing Audiences*, 175, 173.
91. *From Antz to Titanic: Reinventing Film Studies*, 70.
92. *Perverse Spectators: The Practices of Film Reception*.
93. *Perverse Spectators*, 38; for a chart of 'presumed normative reception activities' against which Staiger argues, see 34–5.
94. 'Historical Poetics', in Joanne Hollows and Mark Jancovich (eds), *Approaches to Popular Film*.

95. Bordwell, 'Part One: The classical Hollywood style', 4–6. The concept of the aesthetic norm is taken by Bordwell from Jan Mukarovsky, 'The Aesthetic Norm', in John Burbank and Peter Steiner (eds), *Structure, Sign and Function.*

96. *Consumer Culture Reborn*, 36.

97. *Film Cultures*, 40.

98. Bourdieu, *Distinction*, 54.

99. I have also chosen Amazon reviews rather than those posted on the otherwise most obvious alternative, the Internet Movie DataBase, on the basis that the general consumer-oriented site is likely to include a broader constituency than a film-specific forum. They also include a range of international as well as primarily US-based responses.

100. *Watching the World: Screen Documentary and Audiences*, 112.

101. And, as Austin suggests, the fact that no entirely non-performative 'raw' or 'pure' data can ever exist does not mean that all data is essentially dishonest or unreliable. See *Watching the World*, 85, and Austin, *Hollywood, Hype and Audiences: Selling and Watching Popular Film in the 1990s*, 25–6.

102. *The Long Tail*, 107.

1

Being Charlie Kaufman

A hidden doorway leads to a portal into the mind of the actor John
Malkovich; a hirsute woman and a man raised as an ape become
entangled in relationships with a repressed psychologist who is trying
to teach table manners to mice; a struggling screenwriter writes
himself, and himself writing himself, into his own script; a love-sick
character travels inside his own memories in a desperate attempt to
prevent all traces of a relationship from being erased. Films scripted by
Charlie Kaufman are located at the more complex, strange and
sometimes challenging end of the Indiewood spectrum, as suggested
in the introduction. They offer very distinct pleasures, sometimes
bizarre and on occasion disturbing, although such dimensions are, in
characteristic Indiewood fashion, balanced by more familiar, comic
and conventional qualities. Kaufman himself has gained recognition
and a degree of creative autonomy unusual for screenwriters on the
basis of a series of scenarios marked by tendencies towards the weird,
in terms of subject-matter, and in some cases unusual or non-linear
narrative structure.

Each of the Kaufman-scripted films cited above falls into Indiewood
territory in industrial/institutional terms.[1] The production companies

involved in *Being John Malkovich* include Gramercy Pictures, at the time connected to Universal in a joint venture with PolyGram Filmed Entertainment (a subsidiary at the time of the Dutch electronics company Philips); the film was distributed by USA Films, a division of the former studio head Barry Diller's USA Networks, of which Gramercy subsequently became a part before all of these entities (after production of *Malkovich*) were united under the Universal banner. *Human Nature* (2001) was co-produced by Good Machine, a notable indie outfit based in New York, and distributed by a combination of Good Machine and Fine Line Features, the speciality division of New Line Cinema, itself part of the Time-Warner empire. The coalition of production companies involved in *Adaptation* also includes Good Machine, while US theatrical distribution was handled by various entities within the Sony Pictures empire (including Columbia Pictures and Screen Gems, the latter name resurrected after various past incarnations in 2001 as the speciality arm of Columbia). The producers and distributor of *Eternal Sunshine of the Spotless Mind* include Focus Features, the indie/speciality entity upon which Universal eventually settled in a reorganization in 2002 in which Good Machine was folded into the former Universal Focus, which included the above-mentioned USA Films.

Kaufman's films to date (collaborations chiefly with directors Spike Jonze and Michel Gondry) are a useful place with which to begin the detailed case studies of this book, marking as they do some of the more alternative dimensions of Indiewood cinema. This chapter begins not at the start of his screenwriting career but with *Adaptation*, an example that has the virtue not only of manifesting but of explicitly and self-referentially figuring and laying bare the characteristic Indiewood dynamic of rival pulls between more and less conventional approaches, particularly at the level of narrative form and content. The main focus of the rest of the chapter is on *Being John Malkovich* and *Eternal Sunshine of the Spotless Mind*.

Adaptation: having it both ways

The key distinguishing characteristic of *Adaptation* is the hyper-reflexive nature of its narrative: a film about a screenwriter (with the same name as the actual screenwriter of the film) and his troubled

2. 'I just don't want to ruin it by making it a Hollywood thing': the *cri de coeur* of the indie screenwriter in ***Adaptation*** © Columbia Pictures

experience of seeking to adapt a book to the screen; a film that includes explicit attention to the nature of more and less mainstream films and that eventually not only describes but itself *enacts* a process in which the former comes to compromise the latter. The fictional incarnation of Charlie Kaufman (Nicolas Cage) starts from a quintessentially independent filmmaker stance, determined to be honest to his source material (also the source material of the film we are watching). Offered the task of adapting Susan Orlean's *The Orchid Thief*, a piece of 'great, sprawling New Yorker stuff', his concern is 'to let the movie exist, rather than be artificially plot driven':

> I just don't want to ruin it by making it a Hollywood thing. You know? Like an orchid heist movie or something or, y'know, changing the orchids into poppies and turning it into a movie about drug running, you know? ... I don't want to cram in sex or guns or car chases. You know? Or characters learning profound life lessons. Or growing, or coming to like each other, overcoming obstacles to succeed in the end. You know? I mean, the book isn't like that, and life isn't like that. It just isn't.

He struggles with various ways of approaching the material, trying an array of different starting points (presented to us in a number of

rapid-fire sequences) before eventually deciding to focus on his own experience of adapting the book (very much the focus of the film we are watching). At this point the film goes into hyper-reflexive overdrive: the fictional Kaufman dictates into his tape machine a scene in which he is given the assignment (a scene we have already witnessed in *Adaptation*), followed, with another turn of the screw, by Kaufman dictating a scene about himself dictating a scene about the scene in which he is given the assignment. His response, though, is one of disgust: 'It's self-indulgent. It's narcissistic. It's solipsistic. It's pathetic', each comment increasing the extent to which *Adaptation* itself might potentially be accused of such offences.

It is shortly after this point that Kaufman attends a screenwriting seminar run by (the real life figure) Robert McKee (played by Brian Cox), on the recommendation of his twin brother Donald (also Cage), whose absurd and cliché-ridden serial-killer-thriller script has just been received with enthusiasm by Kaufman's agent. McKee's comments about the importance of 'a good story well told' and the need for the protagonist to 'pursue the object of his conscious or his unconscious desire' are interwoven with Kaufman's disdainful voice-over stream-of-consciousness. What if a writer is attempting a story where nothing much happens, more a reflection of the real world, asks Kaufman during a Q&A session, to which McKee replies with a tirade of abuse. Afterwards, Kaufman collars McKee and explains his dilemma, a desire to stay true to a story about disappointment (the fact that, in the book, as a symbol of a wider malaise, Orlean never gets to see a flowering ghost orchid). 'You gotta go back, put in the drama', McKee declares, adding:

> I'll tell you a secret. The last act makes the film. Wow them in the end and you got a hit. You can have flaws, problems, but wow them in the end and you've got a hit. Find an ending. But don't cheat. And don't you dare bring in a *deus ex machina*. Your characters must change. And the change must come from them. Do that and you'll be fine.

And the film we are watching does exactly that. *Adaptation* shifts gear and comes up with a big ending, although still closing on a highly reflexive note. Donald helps Kaufman to discover a hidden story behind the Orlean book: a secret affair between Orlean and the primary

subject, the 'orchid thief' John Laroche (Chris Cooper), and the fact that the fabulous ghost orchid that figures centrally in *The Orchid Thief* is being propagated as the source of a drug to which she has become addicted. We are given a scene from the narrative strand devoted to the experiences of Orlean with Laroche and the writing of the book in which she reveals a change in her character that was concealed in the book, resulting from the fact that she did get to see a ghost orchid after all. The film moves into suspense-thriller mode; as the Kaufman twins investigate, Charlie is apprehended and threatened at gunpoint before a dramatic night-time chase into a Florida swamp, the wounding of Donald and his subsequent death in a violently unexpected car crash. All the ingredients previously listed by Kaufman as anathema, in other words, including the obligatory 'learning of profound life lessons' when Donald tells a childhood anecdote to support his guiding philosophy that 'you are what you love, not what loves you'. The film moves towards a close with Kaufman meeting the former girlfriend Amelia (Cara Seymour) he had neglected through his timidity, and mutual (if on her part hesitant) declarations of love. We then see Kaufman driving home in his car, recounting in voice-over that he now knows how to end the script: 'It ends [as *Adaptation* itself ends] with Kaufman driving home after his lunch with Amelia, thinking he knows how to finish the script.'

What *Adaptation* offers, then, is an extremely reflexive, metafictional narrative, in large part focused on what appears to be its own process of gestation (a mixture, it seems, of reflection on the process through which the real-world Kaufman went in adapting *The Orchid Thief* and more fantastic invention[2]). The film follows the advice given by one of its own characters (McKee), turning itself inside-out in the latter stages and offering a range of conventional/mainstream ingredients. It enacts a shift from a celebration of narrative qualities more likely to be associated with the independent or art-film sectors (in which de-dramatized, downplayed narrative forms are frequently used, making claims to more adequate representation of the contingencies of real life[3]) to the stuff of familiar over-the-top cliché, while remaining highly reflexive throughout the process.

How might this be related to particular kinds of audience pleasure? Extreme self-reflexivity can be found in various parts of the cinematic spectrum, from works associated with 'serious' art cinema to more

popular products. The latter include many varieties of parody, in which case the operative modality of comedy tends to defuse any questions of serious interrogation of form (an unusual case, in which a sustained parodic reflexivity is combined with the simultaneous maintenance of many of the dynamics of the original format, is found in the *Scream* series [1996–2000][4]). At the more serious end of the spectrum would be an example such as Jean-Luc Godard and Jean-Pierre Gorin's *Tout va bien* (1972), the reflexivity of which draws attention to the industrial and political dimensions of cinema. *Adaptation* seems to sit somewhere in between, but much closer to the mainstream in tone, a characteristic position for Indiewood products. The implied audience likely to take pleasure from the reflexive dimension of the film is one that is open to an exploration of issues of narrative form and less insistent on more conventional varieties of substance (towards the upper end of the taste-culture spectrum in schemes such as those suggested by Bourdieu and Gans). The extreme nature of the film's reflexivity is likely to alienate many potential viewers by denying the conventional/mainstream pleasure of being 'taken into' a primarily self-sufficient fictional universe rather than regularly and explicitly being obliged to acknowledge the film's status as more or less arbitrary construct. And, yet, *Adaptation* offers reflexivity in a very witty and dynamic form, rather than the more austere textures found in Godard/Gorin. Its brief dramatizations of various false starting points for the fictional Kaufman's narrative, for example, are fast and eye-catchingly mounted, stylistically in keeping with more mainstream forms such as the music video that constitutes the career background of the director, Spike Jonze, and has become an influential source of stylish flourishes in both Hollywood and the independent sector. Such touches of visual style provide one of the film's claims to the status of the 'cool' and the 'hip', important marketing factors as considered above, making it potentially attractive to a wider audience than might otherwise be the case.

The same can be said of the way the film changes gear and direction in the latter stages. *Adaptation* does not just present this change as an absurdity, as would have been possible. It is absurd in the context of the preceding material and its mockery of the jargon and cliché-ridden portrait of Hollywood presented largely through the figures of Donald and Kaufman's agent. The film *itself* really changes, though, rather than

more distantly observing or commenting on the kind of change advocated by McKee. The sequences in which the Kaufman twins unearth the 'hidden truth' and their dramatic encounters with Orlean and Laroche are not presented as parodic but played straight, offering at least some of the same kinds of pleasures as they would in a more conventional context. We are invited to be emotionally engaged in these on-screen events, even if from one perspective they have been flagged to us as an over-the-top confection. An illustration of this is the car crash that results in Donald's death, which comes brutally and suddenly out of nowhere in a high-impact and shocking manner that directly replicates a similar sequence in the earlier body of the film, before the imposition of the 'absurd' dramatic climax (an insert, coded as 'serious' and 'sincere', in which the film dramatizes Laroche's story to Orlean about a car crash that led to the death of his mother and divorce from his wife). *Adaptation* manages here to have it both ways: to have its cake and eat it; to be mercilessly reflexive and yet also to mobilize conventional dynamics even when it has been made quite clear that they are merely imposed conventions, and even when the film returns to highly reflexive meditation in its final moments.

This is a recipe that demonstrates explicitly a combination of qualities, and of potential audience appeals, found more widely in the Indiewood sector. It is not just in the final stages, though, that *Adaptation* makes some more conventional appeal, to balance its extremes of reflexivity. Some of what finally flowers most conventionally towards the end comes from seeds planted earlier. McKee comments during his seminar on the importance of having protagonists with desire, a line that plays over images of a bereft Kaufman, who *is* already established as a character with desire, even if he is too introverted and insecure to voice the longing the film clearly attributes to him to make a connection with Amelia. The same goes for Susan Orlean, established as a sad and soulful character, envious of the focused passion of those obsessed with the collection of orchids or other such pursuits. The film contains plenty of familiar/conventional character-based narrative components. And if *Adaptation* is characterized on occasion by touches of visual panache, it also demonstrates virtuoso control of its own narrative structure, assuredly orchestrating an array of temporal shifts and changes of character focalization. The dynamic and heightened

form of elements of the film, the narrative shifts and the inventive flourishes that celebrate what is presented as a seemingly almost limitless visual and narrative scope (right back to the origins of humanity in one early series of inserts), marks *Adaptation* as something vividly 'entertaining' in places as well as vertiginously reflexive or sometimes more downbeat. It is not simply a question of an embodiment of the more exclusive and unconventional that shifts later towards the mainstream, in other words; it is a more complex blend of qualities that makes the film symptomatic of a variety of cinema that wants to present itself as 'smart', 'intelligent' and for the discriminating, while also offering pleasures accessible to a wider audience.

Compare, for example, the treatment of the issue of star-presence in *Adaptation* and *Tout va bien*. The final words of *Adaptation* include gentle, relaxed musing by Kaufman on the question of who will play him in the film (picking up a line of thought established earlier by Laroche). The opening of *Tout va bien* offers a far more cold and objective consideration of such issues. As the names of the two stars, Yves Montand and Jane Fonda, come up on screen (following a sequence in which we have seen a series of cheques written out, ostensibly to pay for various aspects of the film) we are given the lines: 'If we hire stars, we'll get money' and 'OK, we'll hire stars', followed by two more cheques. In *Adaptation*, the issue is designed to be a source of reflexive humour, a comic modality very different from the direct and avowedly serious posture of the Godard/Gorin text. The star is really the star, and centre-stage, in *Adaptation*, Kaufman providing a 'big performance part' (in fact, two parts) for Cage, even if more downbeat and 'pathetic' than the usual leading role. In *Tout va bien*, the figures of Montand and Fonda are often pushed to the margins amid lengthy commentary on post-1968 French industrial relations and politics. At the end, some reconciliation is suggested after an argument between the principals, but this is distanced from the viewer and shown up as a construct. They come together in a sequence in which the Fonda character joins Montand at a café table and the action is repeated but with him joining her, suggesting the arbitrary nature of the proceeding.[5] Accompanying voice-over commentary makes reference to the endings of other films and concludes, in a mode of political reflexivity very different from anything found in *Adaptation*,

that: 'In this film we leave him and her silently, silently gazing at each other. And we will simply say that he and she have begun to rethink themselves in historical terms.' This is a radically Brechtian approach, keeping the viewer at a critical distance and offering no sense at all of sharing in an emotional pay-off.[6] *Adaptation*, by contrast, leaves its romance subplot in a typically Indiewood limbo: no unqualified 'happy-ever-after' for the couple, but more than a hint that it remains a distinct possibility in the diegetic near-future.

If *Tout va bien* is an example of a politically oriented modernism, in the analytical position constructed for the implied audience and its denial of the melodramatic demand for emotional identification with central characters, *Adaptation* might deserve the label 'postmodern', however confused a term that might have become as a result of its multiple and often very different uses by different commentators.[7] 'Postmodern' aspects of the film include its mixture of potentially 'serious' metafictional strategies with the more playful visual and narrative flourishes described above (particularly as it draws occasionally, via Jonze, on a music-video style often associated with the postmodern), but particularly its double movement of deconstructing and reinscribing mainstream narrative conventions. In this respect, the film has much in common with the version of the postmodern described by Linda Hutcheon as a simultaneous installation and subversion of dominant conventions and institutions.[8] Or, in this case, subversion first, followed by installation-and-subversion.

Adaptation can be understood in a longer context of reflexive, metafictional texts that dates back at least as far as Cervantes. In literature, an explosion of metafictions, especially in American writing from the 1960s, has often been interpreted as a response to a perceived crisis in the status of the novel. Radical auto-deconstructing metafiction can be viewed as a symptom of exhaustion, or of renewal.[9] In the American context of the 1960s, metafiction was interpreted by some commentators as a reaction to a broader social-historical context in which reality sometimes seemed to outweigh fiction in its extreme, outlandish or unlikely events; as it was put most famously by the novelist Philip Roth: 'The actuality is continually outdoing our talents.'[10] Whether or not a film such as *Adaptation* can be understood in any direct way as a product of a particular larger social-cultural context is questionable, however.

Exactly what kind of mechanism might operate to create such an effect is less clear than is often assumed in relation to any single text or group of texts, and this is an arena in which it is easy to slip into rather broad and simplistic generalizations.[11] Two more immediate 'sources' for such work might be suggested, for the purposes of this study. One would be the author, as conventionally conceived; the creative artist exploring issues of very personal-artistic concern, in this case the adequacy and effect of the prevailing conventions within which the creative artist is expected to work. At the same time, however, a work such as *Adaptation* can be understood as a *product* that owes its existence – certainly its existence as a funded, completed and distributed entity – to the kind of broader field of forces outlined by Bourdieu. The point to stress here is that it can become both, whatever protestations might sometimes come from the creative end of the business.

Kaufman's attitude seems symptomatic of a wider tendency in this regard, expressed in one interview in the comment that: 'I'm not interested in it as a product, not interested in trying to figure out how this movie will attract a certain demographic, not interested in fitting into a genre.'[12] And, of his own viewing, he adds: 'I'm not interested in watching films right now that feel like a product ... But everything seems to be a package. I'm on edge, I don't want to feel like someone's sort of presenting me with something and I'm supposed to appreciate it.' At work here, implicitly, is an idealized notion of both the artist and the discriminating viewer as free individual subjects, untrammelled – or resistant to being trammelled – by the marketing/packaging system dominant in Hollywood and increasingly applied to parts of the indie sector since the mid-1990s. A distinct sense of discomfort, even disgust, flavours Kaufman's reported experience of, on occasion, being involved in the more conventional process through which many Hollywood or Indiewood films are initiated. In the case of *Eternal Sunshine of the Spotless Mind*, for example, a 'pitch' was made to potential backers, the type of encounter quintessentially associated with a superficial Hollywood manner of processing potential feature material. The initial germ came from a friend of Michel Gondry, the director, who took the idea to Kaufman, from which point the two came up with the basic scenario. As Kaufman puts it: 'We went out with it and my agent was, like, "Oh my god, oh my god, you've got gold here!" And I

thought, whatever, I don't know. I was doing a bunch of stuff, and in a way, I really didn't want to do this movie.'[13] Or, as he puts it in another interview: 'I hate pitches, didn't want to pitch, won't pitch, refuse to pitch, but everyone was so ... ahhhhhhhhhh! So Michel and I put some material together, and went out and pitched it. I wasn't expecting anything to happen.'[14] Although Kaufman was at the time busy with other projects, the impression given from such comments is an attempt to remain distanced from or reluctant to engage in anything that smacks of being sucked into the conventional system through which film products are processed.

Films such as *Adaptation* or *Eternal Sunshine* owe their realized existence to their ability to occupy a particular market niche, but this does not negate the fact that they are also, in some sense, 'artistic' products driven by agendas that are 'creative' as well as 'commercial'. The whole point of this niche is, in some cases, the selling of a particular notion of 'the creative/artistic' as a source of product and, consequently, viewer distinction. In this case, the disavowal by the filmmaker of the notion of 'product' to be packaged and sold is itself, however genuinely meant, functional to the selling of particular varieties of product (ultimately, the selling of a romantic impression of escaping the nexus of target-marketing and selling; in reality, the selling of a different product in an only partially different manner). Metafictional texts imply an audience seeking something more than just a straightforwardly compelling and immersive narrative fiction, an audience likely to be characterized along the kinds of lines explored in the introduction. They invite, at least in part, a more distanced and 'intellectual' approach in which attention is called to the status of the fiction as a constructed artefact. Metafictional writing 'takes the reader's sophistication and complete absorption of genres from the past for granted', as Elizabeth Dipple puts it.[15] It presumes both a familiarity with convention and an interest in work that throws convention into question. Metafictions can be understood, however, as niche-market products as much as they might ever be seen as reflections of particular social-cultural conjunctures, 'postmodern' or otherwise, a dimension that has traditionally been given less emphasis in literary study.

In some cases, to engage in radically deconstructive manoeuvres is to destroy the central dynamics, and pleasures, of the conventional text.

The dislike of the 'popular audience' for formal experiment springs, Bourdieu suggests, 'from a deep-rooted demand for participation, which formal experiment systematically disappoints, especially when, refusing to offer the "vulgar" attractions of an art of illusion, the theatrical fiction denounces itself, as in all forms of "play within a play"'.[16] This is not the case with the 'play within a play' of *Adaptation*, however, which maintains a sense of participation with or allegiance to the central character in the midst of its deconstruction/reconstruction of conventional narrative form.[17] A similar contrast can be made between the way *Adaptation* works and the notion of postmodern culture described by Fred Pfeil. For Pfeil, one of the ingredients of the postmodern experience, particularly rooted in the professional-managerial class, is a movement of 'deoedipalization', 'pitting the heroic, oedipalized self-versus-the-world alongside postmodern work where selfhood is portrayed as at best the most liminal possibility on the veriest edge of dispersion in a maelstrom of fragmented, ceaselessly circulating codes'.[18] Whatever we might make of the latter characterization – somewhat familiar and overblown rhetoric about the alleged nature of a postmodern experience – the concept only goes part-way towards capturing the nature of a text such as *Adaptation*. There is a sense of dispersal in *Adaptation*; of narrative, in the numerous false starts envisioned by the fictional Kaufman, and to some extent of a central character struggling to hold himself together. But this is combined with a much more 'oedipal' dynamic, in the sense in which Pfeil uses the term here (whatever questions might be asked of the Freudian assumptions on which it is based): a drama centred on the heroic, if somewhat downbeat, struggle of the fictional Kaufman against the world. That is precisely what continues to drive the narrative, throughout the process of auto-deconstruction and eventual reconstruction.

For Robert Stam, in a study of reflexive strategies in literature and film, this is a mark of the most successful reflexive texts. They 'conserve both diegesis and identification, but undermine them from within. While assuming the pleasures of conventional narrative, they mobilize the spectator to interrogate those pleasures and furthermore they make that interrogation *itself* pleasurable.'[19] One of the novelties of *Adaptation* is a reversal of the usual order in which this process is unveiled, as

suggested above; instead of offering the promise of the convention, and then denying its fulfilment, as is the case in many of the texts examined by Stam, *Adaptation* moves from undermining to mobilizing the clichés of mainstream cinematic narrative. The effect is an unusual one. An ambiguous mixture is offered by the climactic moves of the film. Viewers who buy into the initial distancing from convention, as a marker of distinction from mainstream material, might be expected to be discomforted by the extraordinary manner in which the narrative finally turns itself inside out and offers all of those familiar ingredients earlier bemoaned by the fictional screenwriter (that was my initial response). In one respect, this might seem more radical than simply maintaining an 'alternative' de-dramatized or downbeat quality. What *Adaptation* offers is less easy to resolve than either straightforward convention or its straightforward denial.

A survey of 'customer reviews' of *Adaptation* on the Amazon.com website reveals a range of responses. Among a total of 279 reviewers, 61 (21.5 per cent) comment explicitly on this aspect of the film (this and other statistics from Amazon reviews cited in this book should be interpreted in the context of research samples in which many responses are very brief and undeveloped; this adds, arguably, to the weight that might be attached to the relatively small numbers in which particular issues are explicitly addressed or articulated without prompt).[20] Of these, 32 make it clear that they 'get' the point of the device and respond to it positively, in many cases using this as a basis for explicit distinction between themselves and those perceived as missing the point. As one puts it: 'Anyone who does not like the ending of this film, does not understand anything this film is saying' (VIDEO ROBOT, Melbourne, Australia, 5 July 2003).[21] Particular judgements of taste (whether the film is 'liked') are directly associated here, as is the case with a number of other such responses, with a particular level of intellectual capacity. Many respondents suggest, more generally, that the film is only likely to appeal to a certain kind of viewer, especially those prepared to invest more effort in the process of consumption either through having to think harder than is the case with most films or having to watch more than once. A smaller group of Amazon reviewers (eight respondents) express dislike for the ending while making it clear that they get the point, a manoeuvre that seeks to

separate out the dimensions of 'understanding' and critical opinion conflated by VIDEO ROBOT. One is worth quoting in full:

> The first 3/4 of this movie are superb. You're sitting there and you're thinking, "Yes.. this is why I love movies."
>
> And then it turns into a standardized piece of crap.
>
> Now, I understand what the writer/director are doing here.. I get that that's a conscious decision.. that the "other" writer is writing that last part, and that it's almost a parody of all the things the "first" writer didn't want in his movie.. there's a car chase, guns, drugs, sex, straightforward narrative, etc.
>
> But, what I don't get is, why not make the whole movie great, instead of going to all the trouble of making the first 75% so good, only to cop out on the ending? Why do that??? (GLBT, Arlington, VA, 18 August 2003)

This viewer's pleasure in the distinctly alternative qualities of the film is undermined by the ending, even if the motivation for the shift of modality is understood. Investment in the former is such that the latter proves an annoyance – so much so, it appears, that the reviewer's response is couched in language more dismissive than seems consistent with a real 'understanding' of the logic of the film; that understanding does not seem to reach what might be termed the 'gut' level response of the viewer. The second largest category of reviewers who comment on the ending (15) more or less simply dismiss it, without displaying any appreciation of the point being made. As one, who otherwise likes the film, puts it: 'I only gave it four stars out of five because at the end I felt that it got a bit cheesy and "Hollywood style" and thus slightly ruined the plot' (Paolo Vaglietti, Limassol, Cyprus, 16 June 2003).

Those who appreciate the film, in general, tend to describe it in terms such as 'clever', 'brilliant', 'original', 'inventive' and 'thought-provoking' (terms used by 89 out of a total of 279 reviews, or 31.8 per cent) that can be taken to suggest something about the self-positioning of the reviewer. This is often implicit, but sometimes spelled out more explicitly. A common formulation, here and in Amazon reviews of other Kaufman features, is of the 'if you are the kind of person who likes x ...' variety, clearly articulating a range of different positions in a

cultural-taste hierarchy. Similar formulations are found in many positive responses to the other case-study films examined in this book, one of the formulaic varieties of response to which reference was made in the introduction.[22] One typical example is as follows: 'If your tastes run more to the conventional, this definitely isn't for you. If you like to be challenged with fresh, original work, it's worth a try' (Scipio, Chicagoland, USA, 8 January 2004). Others put it more strongly: 'If you crave mindless entertainment, look elsewhere. But if you're prepared to engage the movie on its terms, to reflect on its themes and layers of meaning, you will find it an immensely rewarding experience' (James See, Turlock, CA USA, 22 June 2003). Or even more so, in examples in which reviewers directly confront those who express dislike or what is perceived as lack of understanding of the film. *Adaptation* is 'for intelligent people', as one headlines a brief account that begins: 'some "reviewers" here should really stick to the blockbusters and not risk overloading their frail mental capacities with complex storylines and stylish filmmaking' (Mark, Montreal, Canada, 23 June 2003). In all of these formulations, the reviewers clearly locate themselves in the favoured group. The 'you' form of address employed by many invites the reader to take up a position in the cultural-taste spectrum. The manner in which this is done is clearly slanted, one position being affirmed while the other is rejected through the use of pejorative terms such as 'mindless entertainment'. The formulation is one that seeks to generalize and objectify the response, however, via the second person formulation, rather than creating an impression limited to the subjective opinion of the writer.

A substantial number of reviewers (53, or 18.9 per cent) dismiss the film more or less offhand, some of these describing it as 'boring' (nine respondents, or 3.2 per cent) and making statements such as that it sent them to sleep and/or left them uninvolved. This is the kind of reaction to which some of those quoted above respond, a recurrent claim being that the film is 'boring' or unengaging only to those who fail to understand it. Many reviewers are clearly annoyed by the film, which a number declare, rhetorically, to be the worst of the year. That it failed to provide what they expect from more conventional Hollywood-style entertainment is clear, and it is not the case that such reviewers are turned around in their opinion by the more conventional

aspects of the latter stages; by then, it appears, they had already been lost and had in some cases given up viewing. This is explicitly so in one instance:

> I have attempted to watch this movie twice. After getting part way through it both times, longer through the second time just to force ourselves to give it more of a chance, we shut it off due to the fact that we were so incredibly bored. (Kerri, Seattle, 23 May 2004)

Another set of responses seeks to turn the tables on those perceived as using the film to display their cultural/intellectual capital. A recurrent theme among some of those who dislike *Adaptation* is that both it and its admirers are 'pretentious'. As one puts it:

> The joke is not on the people that didn't get that this movie's point was failure; the joke is on the people that think this movie had some masterful point. People who loved the movie laugh at the 'naïve' people who hated it; meanwhile Kufman [sic] is laughing at all the people that think he is making any statement at all! (Katherine Weber, Fairfax, VA, USA, 20 June 2003)

How *Adaptation* might be understood in more overtly political terms is open to question. It is a much less politically radical film, in any explicit sense, than *Tout va bien*. It might be argued that this is a function of its location in the Indiewood zone, close to the studio system, rather than fully independent. That such an industrial location might set limits on what is recognized as 'political' content seems highly likely, an argument made more explicitly by Mike Wayne in the case of the operations of the British production house Working Title within the orbit of Universal.[23] The same might be said of the majority of independent films that gain commercial release, however, regardless of any subcontracted affiliation with the studios. Films with overtly political agendas, particularly of a socialist/Marxist leaning, very rarely gain any commercial presence, an issue on which I have written elsewhere.[24] The deconstruction, challenging or highly ambiguous employment of dominant conventions can be understood as 'political' in a broader sense, however, if such conventions are

understood – as they often are – as significant components of the dominant ideological formulations of the cultures in which they are found.

From *Being John Malkovich* to *Eternal Sunshine of the Spotless Mind*

Exactly what balance Indiewood features offer between more and less widely accessible qualities varies from one example to another, including those from the same source. The kind of blend that is made so explicit in *Adaptation* can also be detected in other films scripted by Kaufman, including the use of quite substantial stars in unusually downbeat or prickly roles (John Cusak and Cameron Diaz in *Being John Malkovich*, on the set of which *Adaptation* begins, for example, or Jim Carrey and Kate Winslet in *Eternal Sunshine of the Spotless Mind*). *Malkovich* is a darker work than *Adaptation*, although more conventional in narrative form; strangeness lies more in the subject–matter, the notion of being able to occupy the perspective of another person and the effect it has on the protagonists, than the manner in which it is deployed. *Being John Malkovich* also establishes an opposition between the realms of art/independence/authenticity and commercial exploitation that can be read back into the film itself, if not as explicitly as *Adaptation*.

The central character, Craig Schwartz (John Cusack), is a puppeteer with leanings towards the 'high' culture end of the spectrum. The film opens with his 'Dance of Despair and Disillusionment', a balletic piece featuring a tormented marionette. We also see part of his version of 'Abelard and Heloise', filled with erotic angst and earning Craig a beating from an outraged passer-by whose young daughter stops innocently to watch. Craig is a frustrated artist, somewhat like the fictional Kaufman of *Adaptation*, contrasted with his rival, the 'gimmicky bastard' Derek Mantini, whose 'Belle of Amhurst', featuring recitals by a 60ft Emily Dickinson puppet, is reported as 'thrilling onlookers' on the television news. Craig's take on life, expressed through his art, is the typical stuff of the dour, serious 'art' movie or play, the kind of production in which Malkovich himself might be expected to appear (during the course of the film, we see him

rehearsing for productions of *The Cherry Orchard* and *Richard III*).
Consciousness is a terrible curse, Craig muses: 'I think. I feel. I suffer.'
His first response to the discovery of the portal into the mind of
Malkovich is intellectual: 'it raises all sorts of philosophical-type
questions, you know, about the nature of self, about the existence of a
soul. Am I me? Is Malkovich Malkovich?' The same could be said of
the film itself. From philosophical pondering, Craig gives way to
profitable exploitation, a crush on his colleague Maxine (Catherine
Keener) impelling him to go along with her scheme to charge clients
$200 a time for the 15-minute experience inside the actor. Her
response, after consideration of the phenomenon, is: 'We'll sell tickets.'
That may not have been the reaction of those initially approached to
back the film, the script having become famous for its originality but
lack of obvious commercial appeal as it did the rounds in Hollywood.
Craig manages to combine his art with major commercial success after
using his skills in puppetry to gain long-term control of Malkovich,
exploiting the actor's celebrity to launch a high-profile career and
rejuvenate the form. *Being John Malkovich* could be said to have done
something similar (if in less sinister manner!) for Kaufman and first-
time director Spike Jonze, mixing its 'serious' thematic content relating
to the mindset of Craig with a more accessible and comic repertoire
of characteristically indie off-beat humour, although the overall tone
of the piece locates it towards the more independent/alternative end
of the Indiewood spectrum. It largely owed its existence, as Sharon
Waxman suggests, to an accident of timing, the production having
'slipped through the cracks of the Hollywood system' at PolyGram,
after being several times turned down, during an interregnum when
the company was left dangling during a series of corporate takeover
manoeuvres (to which we return below in the case of *Eternal
Sunshine*).[25] By the time of postproduction, the film was within the
orbit of Universal but was left almost entirely unsupervised by
the studio.

A number of devices establish the film's claim to the status of
the comically off-beat, leavening its darker and/or more serious
qualities. Chief of these is the setting in which the portal into
Malkovich's brain is found: the absurdly low-roofed '7½th' floor of the
'Mertin-Flemmer Building', in which characters have to walk around

in a foolish hunched manner and to which access is gained by jamming open the lift doors after pushing the button between the 7th and 8th floors. Within, taking up his new job as a filing clerk, Craig finds a cast of overtly 'wacky' characters: his boss, Dr Lester (Orson Bean), a clear-speaking man convinced he has a speech impediment, an incongruously sex-obsessed figure who turns out to be 105 years old and awaiting the maturation of the Malkovich portal as a new vessel for his own soul; his somewhat crazed and hard-of-hearing 'executive liaison' Floris (Mary Kay Place); and Maxine herself, prickly, scheming and unpredictable in a characteristically 'indie' Keener incarnation. Then there is the portal itself; not just the fact of such a bizarre thing, but its realization as a dark, wet passageway inside an office building and particularly the manner in which the 15-minute Malkovich experience ends, the occupant falling from nowhere in a heap in the incongruously prosaic location of a grassy bank at the edge of the New Jersey turnpike. At home, Craig is surrounded by a menagerie cared for by his wife Lotte (Cameron Diaz), including a chimp undergoing therapy to try to cure an ulcer resulting from repressed childhood trauma.

Being John Malkovich does raise the questions of identity suggested by Craig. In an early meditation on the appeal of his art (acted out by

3. Signifiers of the offbeat: The absurd office setting of ***Being John Malkovich***
© Gramercy Pictures

a puppet of himself in a idealized interchange with a freshly carved Maxine), he celebrates the idea of becoming another person for a time, 'being inside another skin, thinking differently, moving differently, feeling differently'. In his own case, occupation of Malkovich does not lead to such difference but is used in heightened pursuit of his existing drives towards Maxine and gaining recognition for his work. For Lotte and Maxine, however, the experience has rather different results, especially for the former, who finds her entire sexual orientation unhinged; although here, again, any serious resonances are closely combined with the comedy of both the instant nature of her response (after just one Malkovich experience she is already talking about gender reassignment surgery) and the manoeuvres through which various characters seek or achieve sexual contact with one another via the mediation of Malkovich's mind and body.

Through his total colonization of Malkovich, Craig reaches the heights of success, marked in the film by the broadcast of a documentary on his career and a performance of the 'Dance of Despair and Disillusionment'. He gains validation as an 'artist', in various tributes from critics and other figures, as well as popular recognition. His Malkovich is the subject of enormous billboards on the streets and of television coverage, the latter having a particular location in the arts/culture spectrum that can be compared with that of *Being John Malkovich* itself. The programme is framed as an 'American Arts and Culture' presentation of a work by 'John Horatio Malkovich', signifiers of the realm of 'high' culture (American 'Arts and Culture' and the use and resonances of that fictional middle name), but high culture as made accessible to a discriminating portion of the television audience, via the likes of the real-life Public Broadcasting System (PBS) that was one of the chief initial backers of the indie cinema that began to flourish from the mid-1980s. A similar framing routine occurs at the start of *Being John Malkovich*, in which a slippage can be detected between impressions created in and outside the diegetic universe of the film. The film-proper opens, after the USA Films logo of the distributor, with a screen-filling image of a theatrical curtain and stage, to the sounds of an orchestra tuning up. The title 'Gramercy Pictures Presents' is followed by 'A Propaganda/Single Cell Pictures Production' and the title, the latter accompanied by applause. The curtain parts, to

a dramatically urgent orchestral score, and what will prove to be Craig's 'Dance of Despair' begins, performed, as we subsequently learn, in his own workshop, the applause existing only in his imagination.

The theatrical curtain, the presence of an orchestra and the font used for the main title (with 'fancy', embellished initial capitals) are all signifiers of a location relatively high in the cultural-taste spectrum. They apply most obviously to the pretensions of Craig's work, but can also be read as establishing something about *Being John Malkovich* itself. This is implicit in various other aspects of the film, as suggested above, but perhaps more so in this case, given that the space in which it occurs is ambiguous and liminal. If it is soon established as part of the fictional world of the film, it begins outside, as do devices such as studio and other logos more generally, as part of an extra-diegetic regime that contributes to the placing of the film in the wider cultural or cinematic arena.[26] It is noteworthy that the names of the production companies appear against this 'higher culture' background, creating a subliminal association between such entities and the resonance it carries. A similar effect, associating cinema with the prestige of legitimate theatre, has been used in other historical contexts in which an attempt has been made to claim elevated status for the medium, examples including the Biblical spectacular *The Robe* (1953), the first film produced in CinemaScope, which opens with the parting of theatrical curtains within the frame.[27]

Being John Malkovich generally lacks the visual panache found in parts of *Adaptation*, with the exception of two sequences in which stylization is motivated by character experience: a surreal episode in which the actor enters his own portal and finds himself in an entirely Malkoviched universe, and another in which Lotte pursues Maxine into the device and the pair struggle through a number of scenes from his subconscious (prefiguring *Eternal Sunshine*). The ending of the film shares some of the dual effect of *Adaptation*, a mixture of convention and departure from convention, although without the metafictional dimension and with a disturbing last note that contrasts with the upbeat final tone of its successor. Lotte and Maxine have a 'happy ever after', in a 'seven years later' epilogue in which the couple – *as* a couple – are witnessed playing at a pool-side with the latter's young daughter, conceived via Malkovich-as-occupied-by-Lotte. Craig is left imprisoned

helplessly inside the mind of the girl, however, the result of his entry into the portal beyond the deadline after which it was destined to lead to the next-in-line. *Being John Malkovich* closes with his voice, still pleading his love for Maxine, as he looks out through the eyes of the girl, followed by slow-motion shots of the latter swimming underwater. The images of youthful freedom, play and optimism jar disconcertingly with the nightmarish prospect faced by Craig. The disturbing quality of this conclusion was highlighted in some of the responses in Martin Barker's study of British viewers of the film.

A particular level of engagement emerges as necessary for pleasurable consumption of the text, as is suggested by many of the Amazon responses to both *Being John Malkovich* and *Adaptation*. A key requirement among Barker's sample is the requisite mental agility to be able to stay with the film as it unfolds (Bourdieu's process of 'deciphering' and 'decoding'): 'a remarkable swiftness of response, the ability to see that things were happening and to guess ahead in such a way that whatever did then happen had the clear imprint of being "not what I expected".'[28] That is, to be able to appreciate 'the unexpected', which requires moment-by-moment understanding and the development of expectations, rather than being lost and confused: 'It was, if you like, a condition of participation that they stay on their toes for each new twist, transition, as they sought to stay abreast of the film and keep *experiencing* its strange logic.'[29] This cognitive ability, Barker emphasizes, is combined for those who enjoyed the film with a *desire* for such challenging experiences. The film works best, Barker suggests, 'with audiences who are willing to be perpetually unsettled'.[30] The orientation of such viewers towards the film is a part of their broader conception of identity, according to Barker's findings: 'The film identified itself, and with that identified its *audience*, as being at or beyond the margins',[31] a quality in the film identified by viewers as 'off-beat' according to criteria similar to those used above: factors such as the bizarre nature of the 7½th floor and the fact that the central characters defy easy categorization.

For one of Barker's respondents ('Katherine', a woman in her mid-twenties), *Being John Malkovich*, and a wider conception of alternative cinema, is very important to a sense of an 'alternative' world with which she wishes to identify herself. The film is situated in the context

of her return from Surrey (stereotypically associated with conformity) to Brighton (the location of the study, associated with an alternative cultural scene). Her ability to enjoy the film for qualities such as the 'striking' images of puppetry, its narrative twists and the 'likeable unusualness' of the characters is, for this viewer, qualification for self-identification as (in Barker's paraphrase) 'the right kind of person'. Presenting herself to the interviewer as only 'slightly self-mocking', to avoid an appearance of conceit, 'she proclaimed that meeting its demands on her allowed her to feel a "superior" kind of person', along the kinds of lines suggested in the broader approaches to issues of cultural-taste distinction explored in the introduction.[32] As Barker concludes: 'There is a powerful sense in Katherine's answer of her responses to the film being part of a project for herself – to become more of a certain kind of person.'[33] Overall, Barker suggests, responses to the film – sources of self-validating pleasure, or of irritation, dissatisfaction, or combinations of such reactions – are complex and variable, but a picture emerges of requirements for enjoyment that can be linked directly to the kinds of potential audience constituencies and investments outlined above.

Much the same can be said of the responses to the film on Amazon.com.[34] Like *Adaptation*, *Being John Malkovich* is widely described through combinations of phrases such as 'clever', 'inventive' 'innovative' and 'original' (terms used in a proportion of reviews similar to that in the *Adaptation* sample: 157 out of 465, or 33.7 per cent). Some comment on the challenging nature of the film, but this is often combined with gestures in which the enjoyment of such material is associated with particular (implicitly, 'superior') qualities on the part of the viewer. A total of 27 reviewers (5.8 per cent) explicitly observe that the film is not the kind of material likely to appeal to everyone. *Being John Malkovich* is also rejected in much the same terms as *Adaptation* by those who most strongly dislike it (a total of 65 express a generally negative opinion of one kind or another; 13.9 per cent of the sample): as 'boring' and/or pretentious, for some (a total of 15, or 3.2 per cent), and on moral grounds by a smaller number of reviewers (0.8 per cent) who express offence at some of the behaviour of the central characters. That the film is different from the conventional Hollywood feature is a frequent observation. Some label it as an

example of 'art' cinema, but a number of those who respond positively interpret it as a combination of the unusual and the more accessible, as I would suggest of Indiewood more generally. For one reviewer it is 'One of the most unusual mainstream films ever made' (Mons., Stockholm, 29 November 2002); another terms it 'the most outrageously original, absurd, thought provoking and hilarious "mainstream" film released in years' (GZA, London, 21 August 2001). As a third puts it: 'It is weird enough to be interesting, but not weird enough to put off the average multiplex-goer with a reasonable tolerance for something "different". Art-house lite, if you will' (nospam, Chicago, IL, USA, 25 May 2000). One strand in such responses emphasizes the mix of 'entertaining' qualities and more 'arty' or alternative sources of distinctiveness. It is 'something very different from mainstream cinema but still playful and fun' (Shashank Tripathi, Tokyo, Japan, 6 December 2003); 'a really funny and surreal, but very accessible film' (Michael O Mealoid, Dublin, Ireland, 5 October 2000); 'very sad and vaguely disturbing … beautifully metaphorically suggestive [and at the same time] generally very accessible and funny' ('A viewer', no details provided, 4 May 2000). As another suggests: 'this movie does not cross the line into being pretentious, as most heavy art films do. This movie will appeal to a large audience' (Nick Schoenfeld, Woodside, CA, USA, 5 May 2000).

Some similar qualities are offered by *Human Nature* and *Eternal Sunshine of the Spotless Mind*, although space prevents any consideration here of the former, which performed poorly at the box-office and received a very limited release. I am also leaving out the Kaufman-scripted *Confessions of a Dangerous Mind* (2002), based on the book by the former game-show producer Chuck Barris, who claimed to have lived a parallel existence as a CIA hitman, a more straightforward work of adaptation in which Kaufman was not involved (going against his usual practice) after the initial writing stage. *Eternal Sunshine of the Spotless Mind* is another example of an Indiewood production that offers a mixture of ingredients, although relatively more conventional in some respects than *Being John Malkovich* or *Adaptation*. On one level, it is a star-led romantic comedy, featuring Jim Carrey and Kate Winslet. This is blended, however, with a number of more distinctive dimensions including narrative shifts and overlaps and a visual style

that mixes surrealist weirdness, in the sequences in which Joel Barrish (Carrey) travels inside his own memories, and a raw impression, signifying harsh 'realism', created by the use of hand-held camerawork and quite choppy editing.

Narrative form is one of the key markers of distinction from the mainstream in *Eternal Sunshine*. The film has a non-linear structure, beginning at a point that turns out to be much later in the diegesis than is first implied, and including many shifts of narrative time, place and reality-level that create demands on the viewer of the kind considered above in *Adaptation* and *Being John Malkovich*: a requirement, for pleasurable consumption, that viewers stay on their toes if they are to follow, make sense of and *appreciate* the distinctive qualities provided by the film. This is a point emphasized by many of the reviews posted on Amazon.com. *Eternal Sunshine* starts with a series of narrative devices that serve to misdirect the viewer. The opening image is of Joel waking up in bed. This will prove not to be the start of the story, but a development towards the end of the events outlined by the film. Kaufman's script, as realized on screen, plays around with the process through which the *syuzhet*, to use a term coined in Russian Formalist theory, the material as it unfolds on screen, presents the *fabula*, the underlying story as it is meant to be reconstructed and understood by the viewer. One of the markers of narrative structures defined in opposition to the mainstream conventions of 'classical' Hollywood narrative is often to complicate this process, to deny a simple and undemanding access from *syuzhet* to *fabula*, to create more work on the part of the viewer if the two are to be resolved. The opening images of *Eternal Sunshine* misdirect because 'a character waking up' is a conventional narrative-opening device. The film continues to misdirect in the sequences that follow. On what appears to be an impulse or whim, Joel decides not to take his usual commuter train to work, but to head in the opposite direction, to a windswept beach in Montauk (a suggestion, we learn later, that was implanted in his subconscious). 'If only I could meet someone new', he yearns, glimpsing Clementine (Winslet) at the edge of the surf, another deliberate misdirection (narrative developments later reveal that she is not 'someone new' at all, but a woman with whom he has already had a troubled relationship). 'Why do I fall in love with every woman I see

who pays me the least bit of attention', he adds later when she raises a mug to him as the pair sit at separate café tables; misdirection, again (he is *already* in love with this woman, it will be established, although the memories have been erased from his brain). The misdirection appears to be concerted, quite explicitly, as it extends into exchanges between Joel and Clementine after she moves to sit close to him on the train home. 'What are the odds?' she asks when it turns out that they are both getting off at the same stop (they turn out to be fixed); 'well, you don't know me', she retorts to a comment by Joel, the pair having established (wrongly, it turns out) that her sense of his familiarity is the result of his patronage of the bookstore in which she works.

That issues existed during the production of *Eternal Sunshine* about the degree of potential narrative confusion the film might cause for viewers emerges clearly from an interview given by Kaufman to accompany the published version of the screenplay. The studio was 'very concerned' about this, Kaufman suggests. Test screenings were conducted – very much a part of the commercial 'product testing' element of the business – in which 'people often got lost, but for the most part they don't mind it, which is what I always thought. It's like having a moment of epiphany. You're lost, and then it's, like, Oh! to me is the greatest thing in a movie. Some audiences don't want that, but I don't care. I like it so I want to do it in the movies I'm working on.'[35] A recurrent refrain in interviews with Kaufman is the suggestion that movies are a very 'safe' medium because they are essentially 'dead', finished, unlike the theatre 'where anything can happen'.[36] Requiring viewers to work harder to follow the action is, in this account, part of a process of forcing them to engage more in the material themselves, to interact and see things differently, to interpret and reinterpret rather than just being led along by a familiar set of ingredients.[37] What Kaufman is seeking to offer here does appear to match the particular kind of pleasure taken from *Being John Malkovich* by some of Barker's respondents and many of the Amazon reviewers of *Malkovich*, *Adaptation* and *Eternal Sunshine of the Spotless Mind*. A particular issue during the editing of *Eternal Sunshine* concerned the time it might take audiences to understand what was happening in the sequences in which they are taken into Joel's mind for the first time. As Kaufman puts it: 'That was a big discussion with the studio, always. How long can

you keep the audience confused before they turn off, as though there's some kind of mathematical formula to it; are we going to lose people if we hold off this long?'[38]

These are interesting comments, illustrating in some specific detail the kind of tension and explicit negotiation that exists between the 'creative' and 'commercial' processes involved in production in the Indiewood sector. Kaufman is keen, as suggested above, to distance himself from the more calculating strategies of 'the studio' in the construction of product, even if it is, in this case, a speciality division (the language he uses gives no acknowledgement to any difference from dealing with the studio-proper). The pressure that came to bear on the film might be linked quite directly to its precise position in relation to the studio end of the Indiewood realm, although to trace the path of such a project can be to attempt to unravel a complex weave of threads. The pitch was bought, in a bidding war, by Propaganda Films. Propaganda started as an independent producer of films, music videos and commercials. It was taken over in 1992 by PolyGram Filmed Entertainment, part of the empire of the Dutch electronics giant, Philips. Propaganda became part of Universal when PolyGram was bought by the studio in 1998, but the Propaganda film division was sold on to USA Films a year later (the rest of the company regained its independence in a buy-out deal).[39] One of the founders of Propaganda, Steve Golin, who produced *Being John Malkovich*, left to create a new production/management company, Anonymous Content, with a first-look deal to supply features to USA through its Gramercy Pictures label. As part of this agreement, Golin continued to work on several productions he had been developing at Propaganda, including the then-untitled *Eternal Sunshine*, of which he became producer through Anonymous Content.[40] During all of these developments, it appears that Kaufman was left to develop the script without any interference, as had been his practice in the past, although the property came back into the orbit of Universal in December 2000, when USA Networks (owner of USA Films) was merged with the studio's corporate parent, Vivendi. *Eternal Sunshine* was under the aegis of USA Films at the time that Jim Carrey's involvement in the project was first reported, in December 2001, but it was within Universal's new Focus Features that the production was given the green light to

go into production, in September 2002, and was subsequently shot and edited in 2003.[41]

The location of *Eternal Sunshine* shifted, in other words, from positions of relatively greater to relatively lesser autonomy vis-à-vis various Indiewood entities that were, or would at some stage come to be, parts of the Universal empire. The pitch was sold in June 1998, while Propaganda remained part of PolyGram Filmed Entertainment.[42] When it first became a 'property', then, *Eternal Sunshine* was being developed within an entity that was a semi-autonomous component of a large corporation, PolyGram, but one that existed outside the American studio system. It then moved under the influence of Universal, with the sale of PolyGram Filmed Entertainment. The next move took it under the wing of Gramercy/USA Films, part of another large company (USA Networks) but still outside the studio machine, and into an arrangement between USA and Golin's independent entity, Anonymous Content; and then, with the whole of USA Films, back into the embrace of Universal at Focus Features. All projects are more likely to come under scrutiny once they reach the expensive stages of shooting and postproduction, so it is not possible to say with certainty that Kaufman's vision began to be subjected to question specifically because of the involvement of a direct studio subsidiary such as Focus, although that is what Kaufman's comments seem to imply.[43] He does not appear to have made similar remarks about either *Being John Malkovich* or *Adaptation*, each of which was produced by Propaganda, among other companies, in varying arrangements. *Eternal Sunshine* is the highest-budgeted of the three, at an estimated $20 million, which might result in it being given closer attention, but not by a large margin (the budget for *Being John Malkovich* is put at $13 million, that of *Adaptation* at $19 million).[44]

Kaufman's comments also suggest that some viewers are happy to go along with the experience offered by a film such as *Eternal Sunshine*, including periods of confusion for which they later receive pay-off reward. This interpretation is explicitly supported by a number of the Amazon reviews (and implicitly by many more, a significant proportion of the sample, 46 out of 532, or 8.6 per cent, who respond positively to the narrative demands of the film without making this specific point).[45] As one puts it: 'Some parts don't even make sense at

first, but everything comes together when the film concludes' (Bryan Carey, Knoxville, TN, 28 February 2005). Others are resistant to this kind of experience (a smaller number of the Amazon reviewers, 2.4 per cent, who dismiss the film on the grounds of narrative confusion or incoherence), but they are rejected by the screenwriter in favour of an emphasis on the production of the kind of material to which he is drawn himself. The drives of the creative artist are put in the foreground, in Kaufman's take, even if he does express interest in getting right the exact balance between confusion and enlightenment; the negative pole in this account is not so much the response of viewers but anything that might be seen as a mechanical or formulaic attempt to gauge the design. Kaufman reports that some of those involved in the production (exactly who is unspecified) did not like the book-end device outlined above, the beginning that proves to be located towards the end of the *fabula*. This is a structure defended by the writer on the grounds that, if the narrative events were presented in linear fashion, the fact that the two would meet again, after the erasure, would be too obvious: 'I get very upset when people can predict where my movie's going. You know, it's like a badge of shame to me.'[46] The phasing with which this sentiment is expressed ('upset', 'shame') is revealing of the investment the creative figure has here in the demarcation of his work from formulaic, mainstream convention.

Before the true status of the opening scenes is established, *Eternal Sunshine* supplies a number of other auteur-associated elements by this time familiar from Kaufman's previous work. The central characters, especially Joel, are presented as downtrodden and/or frustrated and not conventionally 'appealing' or inviting as potential sources of close allegiance for the viewer. In the case of Joel, a disjunction exists between the role/performance and the qualities primarily associated with Carrey, more so than in his previously best-known 'unconventional' starring role in *The Truman Show* (1998) (in which, despite being a more 'serious' part, Carrey's Truman Burbank, the patsy whose life is really a television show, draws clearly on the 'fresh-faced naïve' component of the performer's established comic persona). There is also the bizarre dimension of the process at the heart of the film, the service from Lacuna Inc. through which characters can have memories of previously loved ones electronic-surgically removed from their brains. This is

Eternal Sunshine's equivalent to the Malkovich portal, a 'weird' plot device that establishes the film in the territory that suggests something like cult or off-beat status, while also providing fertile ground for the exercise of the visual imaginations of advertising/music-video trained directors such as Spike Jonze and Michel Gondry.[47]

The dramatic crux of *Eternal Sunshine* comes when Joel seeks to prevent his memories of Clementine from being erased, changing his mind after initially signing up for the process in retaliation for her erasure of him. A number of memories are revisited in a process that creates surreal visual effects and juxtapositions and a dual focus on the action that has something in common with the metafictionally distanced aspects of *Adaptation*. Scenes from the past unfold during which shifts occur between past event (memory) and present situation (resistance to the erasure of the memory), but each experienced through the medium provided by representation of the original experience. In one case, for example, Joel and Clementine revisit their first meeting, on the margins of a party on the beach at Montauk. Clementine sits down next to Joel and introduces herself, in the original memory. He is eating from a plate of party food. She leans in closer, asking: 'Can I borrow a piece of your chicken?' A cut is made to a closer shot of Joel as she takes a leg, the two shots united, according to continuity convention, by directional consistency and particularly through a match-on-action (her move to take the chicken is more or less continuous across the cut). But Joel's response, voiced in the second of these shots, marks an ontological leap. 'And then you just took it, without waiting for an answer', he comments, shifting the sequence into a strange location both inside and beyond the original scene. 'We were so intimate, like we were already lovers', he adds in a two-shot of the pair, before a cut to a more distant shot in which we are returned to the original meeting, as he introduces himself, followed by another shift back into the occupying-the-memory level of reality in which she points out that it will soon be gone. Numerous such shifts of location are made during this part of the film, the challenging nature of the process lying in the fact that the discontinuity of levels of reality is masked, and made potentially ambiguous or confusing, by the use of cinematic devices that signify seamless continuity. The process, if followed (rather than leading to confusion), might draw attention to

4. Across an ontological divide: the 'chicken leg' memory, revisited in the present, in *Eternal Sunshine of the Spotless Mind* © Focus Features

the constructed nature of the scenes. Or it might create some greater than usual impression of distance from each of the represented levels of the diegesis, neither of which is left as merely self-sufficient and taken-for-granted; each is qualified, potentially, by shifts to the other. In some other instances the impression of distance is liable to be increased, in sequences in which Joel exploring his own memories is present, separately as an onlooker, in scenes in which he earlier took part, able to mouth the dialogue simultaneously with its delivery by himself and other characters, an effect that invites attention to the performed nature of the scene.

Formal qualities are more overtly highlighted in numerous surreal flourishes such as a sequence in which Joel as a young child is represented by the full-sized adult performer rendered diminutive through the use of enlarged props and forced-perspective sets (a kitchen table under which he hides, a sink in which he and Clementine are bathed); or passages in which the fabric of the memory-world begins to disintegrate around the couple (books losing their cover images and titles as the stripping process chases after the characters, a building that dematerializes, figures who disappear or whose faces are wiped blank). These, like the Malkovich-inside-Malkovich world or the flashy narrative false-start bursts in *Adaptation*,

can be understood as *attractions*, in something of the sense in which the term is used by Tom Gunning to refer to early, pre-narrative-dominated cinema and has also been applied to special effects and other sources of spectacle in Hollywood.[48] They are showy visual effects that offer audio-visual pleasure in its own right, even if in these cases of a particular variety – coded as 'weird' or 'surreal' – offered as likely to appeal to particular audience niches. They are also strongly integrated into narrative, however, given clear motivation at the level of plotting and/or character experience rather than being presented as arbitrary impositions, existing only for their own sake. Such effects are, in this sense, 'contained' and made-sense-of, in a manner that locates the work at the more conventional end of the wider alternative/conventional spectrum (the same is true of many visual flourishes found in the broader commercially released independent spectrum, as I have argued elsewhere[49]). This is true also of the shifts between memory and memory-scene-consciously-revisited described above. The effect may be an unusual one, potentially radical in its unsettling use of conventional formal devices, but it is given very clear narrative motivation in the central confection of the process through which Joel and Clementine belatedly seek to save his last traces of their relationship. Strange, disorienting experiences are given realistic motivation, within

5. Surreal flourishes as attractions: Clementine and Joel bathing in the kitchen sink in ***Eternal Sunshine of the Spotless Mind*** © Focus Features

the fictional world on screen, just as the showy and 'fantastic' visuals through which they are presented are balanced by the more 'realistic' texture of the remainder of the film.

The overall tone of *Eternal Sunshine* is one in which stylistic or narrative flourishes, overt markers of its status as distinct from familiar convention, are balanced by focus on plot and character, a point appreciated by a substantial number of the Amazon reviews. Many go out of their way to emphasize the extent to which the 'brilliant', 'original' or eye-catching qualities of the film are balanced by the emotional punch carried by its treatment of the central issues of love and memory. The film appeals to heart and head, as a number of reviewers suggest: 'If you like intelligent, thought-provoking films that also happen to pull at your emotional heart-strings, you will love this film' (William Alexander, Los Angeles, CA, USA, 10 January 2005); 'It's a mind-bending experience, but touching at the same time' (Ian Jones, Portland, OR, USA, 30 December 2004). Ten per cent of the Amazon sample articulate an appreciation of both dimensions (53 respondents), while another 20.8 per cent (111 reviews) include an emphasis on the 'touching' or 'heart-felt' qualities of the film or relate it to their own real-world experiences of romantic difficulty. A much larger number of reviewers highlight this aspect of the film than the pleasures of its unconventional narrative dynamic, in other words, although many cite the 'original' or 'inventive' qualities of the film without developing this into consideration of any specifics. The fact that the character-centred emotional qualities of the film are singled out as a major or significant source of appeal by more than 30 per cent of reviewers can be taken as confirmation of the substantial extent to which the film continues to work on relatively conventional ground, whatever its more distinction-claiming departures (it is worth noting, again, that a figure such as 30 per cent on one specific issue such as this might be taken to bear more weight than is suggested by the raw numbers, given the brief and fragmentary nature of many Amazon reviews and their variable tone and focus overall).

Eternal Sunshine also offers a characteristic Indiewood balance in its take on the familiar conventions of romantic comedy. An initial 'meet cute' sequence is presented, conventionally enough (on Valentine's Day, one of the archetypal settings), but its status is later changed and

another meeting scenario is both introduced and played around within. One of the central signifiers of the crystallization of the central relationship occurs in a typically generic 'magical' setting, apart from the rest of the world: in this case a night's experience on the ice of the frozen Charles river, an overhead image of the couple lying on the ice recurring at significant moments during the film and chosen as part of the key-art in its publicity.[50] Joel and Clementine are, in some respects, a conventional romantic comedy pair, marked by clear-cut differences that provide scope for the formula's usual brand of reconciliation: he drab, unkempt, taciturn and intellectual; she very upfront, but insecure, quirky, unlearned, given to brightly coloured clothes, dyed hair and impulsive behaviour. The conventions of the genre are both under-mined and sustained. At one point, Clementine makes a speech that throws critical light on one of the most familiar dynamics of the form. 'Too many guys think I'm a concept,' she informs Joel, 'or I complete them or I'm going to make them alive. I'm just a fucked-up girl looking for my own peace of mind.' That the 'sparky', 'quirky', 'lively' component in the usual mixture gives life to an otherwise deadened other half (whichever way around the sexual partners are oriented) is a convention that has driven romantic comedy from at least the 1930s to date. Instead, Clementine positions herself as far more ordinary-seeming and self-centred. Yet Joel responds, in the present tense (the speech being revisited in his memories), that he still thought she was going to save his life, despite that cool blast of truth. The film suggests that the differences between the pair remain mutually irritating, in a sustained manner, not so easily overcome. And yet, again, Joel continues this exchange by holding out hope: 'It will be different, if we could just give it another go-round.' She replies that he should try to remember her and maybe they can, sustaining the generic illusion, although then disappearing from the scene as another memory bites the dust.

In the closing scenes, *Eternal Sunshine* maintains this kind of balance between the use and deconstruction of key elements of the romantic comedy template. The full extent of what each character found unacceptable about the other is revealed, in the form of the tape recordings they made ahead of the process of erasure. The experience is painful, humiliating, each reacting with confusion at both the comments made and where they have come from (they have, at this

point, no memory of each other beyond their apparent first meeting shortly before). She repeats the line that she is 'just another fucked-up girl', to which he replies that he sees nothing he does not like. 'You will', she says, adding: 'I'll get bored with you and feel trapped, because that's what happens with me.' 'OK', they concur, in a mixture of laughter and tears as a piano theme comes up on the soundtrack, leading into Beck's closing title rendition of 'Everybody's Gotta Learn Sometime'. The final images are of Joel and Clementine walking along the snowbound beach, gradually whitened-out before the credits roll. Again, what the film offers is a dose of what is presented as 'harsh reality', the recognition that their future will be troubled, mixed with sound and images that have romantic resonances, even if these themselves are coupled with impressions of cold and yearning. The net effect is a balance that seems typically Indiewood, especially with the central presence of star figures, even if uses and abuses of genre are also found in varying proportions more widely in the independent sector.[51]

That Kaufman had considerably less than the final say over how the balance of the ending worked is evident from his comments about another book-end device that existed in the original script, in which the film started with a future location in which the story had been written by a disillusioned ex-employee of Lacuna. In this version, the ending includes a visit by Clementine as an old woman, to have Joel erased *again*, and the revelation that it has happened on numerous occasions over the intervening years; a less conventional conclusion, complete with a futuristic setting, but one described by Kaufman as having been 'taken away', although he does not specify exactly at which stage in the genesis of the project.[52] Kaufman also distances himself, characteristically, from the notion of having created a work that can be understood so clearly as a variation on a more generic theme. In the enthusiastic responses to his and Gondry's pitch for the film, which he protests not to have understood, Kaufman recalls that: 'They'd say things like, "It's a new way to do a romantic comedy, and yet still this thing that people can understand".'[53] 'Kind of silly', is his response, a disavowal of a perspective that seems quite appropriate in capturing a sense of where the film stands in the broader spectrum (that the film does indeed offer a new twist on romantic comedy is an opinion expressed in a number of Amazon responses).

Kaufman, with principal collaborators Jonze and Gondry, has certainly established his own 'brand' identity in this sector, one that establishes the value of his distinct trademarks in the Indiewood economy. This was explicitly acknowledged in a lengthy piece in the trade paper *The Hollywood Reporter* in February 2005, in which he was tipped, correctly, for the Academy Award for best original screenplay for *Eternal Sunshine*, following nominations for *Adaptation* (best adapted screenplay, of course) and *Being John Malkovich*.[54] Awards are a significant currency in this part of the cinematic landscape, as suggested in the introduction. They are part of the process, along with critical praise and presence on annual 'ten best' lists, through which the status of the artist is 'consecrated', as Bourdieu puts it.[55] *Eternal Sunshine* marked a notable change of strategy on the part of Focus Features in the planning of the release strategy for a film viewed as a potential source of awards. The traditional approach is to open such films selectively, in a platform release in major cities, towards the end of the calendar year, to place them into the market (and in the minds of academy members) during the build-up to the post-New-Year season in which the Oscars and other major awards are scheduled, a strategy used in the case of both *Being John Malkovich* and *Adaptation*. *Eternal Sunshine* was released much earlier in the year, in March, and much more widely, on an initial 1,353 screens compared with 25 for *Malkovich* and seven for *Adaptation*. *Eternal Sunshine* started at its widest, playing for three months on a steadily declining number of screens. *Malkovich* opened in November, moving to 591 screens within three weeks; *Adaptation* in December, building to 109 screens in its third week and hitting a maximum of 672 mid-way through a four-month run.

The pattern displayed by *Malkovich* and *Adaptation* is what might be expected of a successful release in the Indiewood sector: a platform opening, but not at its smallest and growing quite quickly to substantial numbers, greater than those achieved by most independent features while not on anything like the scale of the larger Hollywood productions (which typically open in 3,000 to 4,000 engagements). *Eternal Sunshine* was opened on a significantly wider scale, if still considerably less than that of a Hollywood blockbuster, largely on the basis of the star presence of Jim Carrey. How exactly the strategy was

conceived, including how the film was placed in the market, is expressed in an interview by Jack Foley, head of distribution for Focus:

> We considered what the piece was – the brand with Charlie, (director) Michel Gondry's following and Jim Carrey's state as the most influential comedian in America right now – and we looked at where America is in its willingness to access smart films. Taking all of that into mind, we went with an extremely unique and aggressive strategy. Jim Carrey was the crown because Jim brought a sort of commercial accessibility to the film that spoke outside of the confines of the Charlie Kaufman brand – so Jim was our opportunity to go to the actualization of proving the model that we went in with to make this film correct.[56]

The 'Charlie Kaufman brand' is important to the understanding of the film as a commercial product, in other words, with a particular appeal, but one that is considered to have limits in terms of the willingness of audiences 'to access smart films'. The presence of a figure such as Carrey is decisive in the belief of the distributor that a wider audience can also be tapped, even for a film that makes greater than usual demands on the viewer. It is no surprise, then, to see that publicity for the film puts the emphasis firmly on the star, whose face dominates poster and video/DVD cover art in which the name of the screenwriter does not figure at all as a selling point. The latter is also true to a large extent of the other films with which Kaufman is associated. As with the Hollywood mainstream, the tendency is to use other films that have proved successful (critically or commercially) as reference points rather than the names of individual filmmakers. The legend 'from the creators of *Being John Malkovich*' is flagged more often in relation to *Adaptation* and *Human Nature*, for example, than the names of Kaufman and Jonze. The assumption of marketing departments generally appears to be that the presence of stars or direct associations with other films offer more immediate connections for viewers than a route that goes via the names of the filmmaker(s). This appears often to be true of the speciality as well as the mainstream market, although the identity of the filmmaker, and an emphasis on the

filmmaker as the creative source of distinctive qualities, figures quite substantially in critical discourse.

The presence of 'Charlie Kaufman' as a significant identifier in reviews increases with the development of his career, as would be expected, marking the consolidation of a reputation for the creation of a particular kind of fictional universe offering distinctive pleasures.[57] Reviews of *Being John Malkovich* make limited reference to the name of the screenwriter, tending where his name is cited to give it broadly equal prominence with that of the director, Spike Jonze. Roger Ebert's review in the *Chicago Sun-Times* gives Kaufman early and very positive credit, in the opening paragraph, for 'a stream of dazzling inventions, twists and wicked paradoxes'.[58] Jonze is also credited, in the following sentence, although neither is mentioned subsequently. *The Guardian* leaves any reference to the filmmakers until the third paragraph, citing director first and screenwriter second; a subsequent reference to 'Jonze and Kaufman' – relatively equal billing – is the only other mention.[59] *USA Today*, a broader-market publication, refers to 'Charlie Kaufman's script' in the second paragraph, its only further citation being reference to '[d]irector Spike Jonze's overlong fantasy'.[60] The mass-market British publication *The Sun* gives the film a lengthy and very positive review, primarily focused on plot, as might be expected given the constituency of the paper.[61] Jonze gains a late mention as director, interpreted to the readership via his role as director of a Fatboy Slim video, but Kaufman's name does not appear.

Kaufman's presence is considerably greater in reviews of *Adaptation*, partly but not entirely the result of his presence as a character within the diegesis. A number of reviews attribute the film to 'the team' behind *Being John Malkovich*, further demonstrating the frequency with which films are positioned through association with others from the same stable. The names of Kaufman and Jonze signify not alone, or even as a team, but in close conjunction with the titles for which they are best known. There is a striking congruence in the way this process functions across the review spectrum. The names of the two film-makers and comparison between *Adaptation* and *Being John Malkovich* figure quite similarly in the opening paragraphs of reviews in publications as different as *The Sun* and the New York *Village Voice*.[62] Most reviews of *Adaptation* establish a similar connection, although

references to Kaufman tend thereafter to be limited to an outline of the dilemmas of the screenwriter as figured dramatically on the screen more than as an auteur figure behind the production itself.

By the time of *Eternal Sunshine*, Kaufman is firmly established as the primary creative source and given prominent reference across the review sources cited above. An opening line quoted from the film 'could only have come from the pen of Charlie Kaufman, creator of *Being John Malkovich* and *Adaptation*, and one of the very few screenwriters in Hollywood – perhaps the only screenwriter – whose authorial identity supersedes that of the director's', according to the start of the review in *The Guardian*.[63] For Ebert, the film is 'a labyrinth created by Charlie Kaufman, whose "Being John Malkovich" and "Adaptation" were neorealism compared to this'.[64] The reviewer for *USA Today* begins her second paragraph: 'Brilliant screenwriter Charlie Kaufman (*Being John Malkovich, Adaptation*) has given us another quirky film that is difficult to categorize.'[65] For *The Sun*, Jim Carrey and Kate Winslet earn first mention but 'in a movie by one of Hollywood's hottest writers', credited by name below and, again, in relation to the 'brilliant and original' *Malkovich* and *Adaptation*.[66] It is to be expected that major stars would be given prime billing in a 'down-market' mass circulation newspaper (which also ran a lengthy interview feature in which Carrey talks about the film in the context of his own past relationship difficulties, and invested in the film sufficiently to arrange free preview screenings for readers). It is striking, however, to see the extent to which the auteur focus can climb up the agenda and gain such prominence, even in this part of the review spectrum, although this might be a phenomenon limited to work that manages, Indiewood-style, to combine any sense of the bizarre and 'original' with a reasonable level of commercial viability.

A broadly similar pattern is found in citations of Kaufman and/or directors Jonze and Gondry in the Amazon sample. In the case of *Being John Malkovich*, before the establishment of Kaufman's name in other work, references to Jonze outnumber those of the screenwriter by nearly three to one (175 to 62 from 465 reviews), reflecting the usual tendency to favour the director. By the time of *Adaptation* the balance is reversed (87 to 389 citations among 279 reviews), although the figure is inflated by references to Kaufman as character (two Kaufmans,

in fact) as well as writer. Kaufman is clearly established as the primary reference point in relation to *Eternal Sunshine* (356 citations in 532 reviews), although Gondry is also quite extensively cited (156 references) both alongside and separately from his collaborator.

Viewers who choose to see Kaufman films on the basis of that identification might be expected to be investing quite considerably in the sense of distinction offered by consumption of such products, the more so the more prominently the distinctive characteristics of the brand are highlighted in reviews, promotions and other surrounding discourses. This is always likely to be a complex process, however, in which different kinds of investment are far from easy to measure or to separate out, including those relating to star performers. A Kaufman film might be selected on the basis of being 'a Kaufman film' (or a Kaufman/Jonze or Kaufman/Gondry film), or as something 'off-beat' in a more general and unspecified sense. But it might also be chosen on the basis of its lead performers, increasingly so in the progression from *Malkovich* to *Adaptation* and *Eternal Sunshine*, in which case the nature of the investment might be very different. The star factor might be dominant in a manner that still involves a sense of distinction from the mainstream (stars playing against type, or playing downbeat roles), but that is far from necessarily the case. Viewers might choose a film such as *Eternal Sunshine of the Spotless Mind* simply as a Jim Carrey or Carrey/Winslet vehicle, or as a romantic comedy, with no particular sense (conscious or otherwise) of the selection being part of a process of socio-cultural distinction. This is evident from some of the Amazon reviews, a substantial number of which foreground Carrey especially. Thirty-three respondents (6.2 per cent) strongly foreground Carrey, usually as the initial point of departure for the review, while many more include the role of the star (and, to a lesser extent, Winslet) as a substantial component of their response. It is this ability to work on both levels, providing opportunities for the exercise of particular forms of cultural or subcultural capital while also offering wider points of access, that marks a characteristic Indiewood blend.

If the 'Kaufman' brand is marketable, and its distinctive qualities increasingly recognized and attributed to the writer, the degree of autonomy gained by the filmmaker remains limited, as suggested by some of the tensions that existed in the production and postproduction

of *Eternal Sunshine*. In interviews, Kaufman generally attributes the degree of control he has gained over his material to the fact that it has been developed at the relatively low-budget end of the scale, certainly by Hollywood standards. Even his better-known films have not performed particularly well at the box-office, however. *Malkovich* and *Adaptation* earned domestic box-office grosses of around $22 million apiece. *Eternal Sunshine* was the most successful at $34 million, a less than spectacular return once the costs of prints and advertising are added to the $20 million production budget, itself very low considering the star presence. In each of these cases, profits will have been made when overseas and especially home DVD/video revenues are included, the latter tending to produce increasingly large proportions of the income of all films (*Eternal Sunshine* was reported to have sold 'an impressive' total of more than 600,000 copies in DVD and video combined on its first day of release[67]). The scale of such films remains modest, a limit imposed partly by the cognitive demands placed upon the viewer by some of the material, even where these are combined with more accessible dynamics. The same applies to Kaufman's directorial debut, *Synecdoche, New York* (2008), a characteristic blurring of levels of reality and representation in its tale of a troubled theatre director constructing a dramatic parallel universe in miniature inside a vast Manhattan warehouse. Kaufman's capital – critical more than commercial – at this point reached a level at which it could be translated from the role of writer to director (although Spike Jonze was initially slated to direct) on a similar budgetary scale (estimated at $21 million). *Synecdoche* clearly underlined and sustained the distinctive nature of the Kaufman brand, although marking a shift away from the relatively more mainstream ingredients (such as big-star casting) included in *Eternal Sunshine*.[68] In other cases, Indiewood has courted considerably larger audiences, including some rather different constituencies, as will be suggested in the next chapter, in which the focus shifts from the individual filmmaker to the perhaps definitive Indiewood brand name: Miramax.

Notes

1. Details of production companies and distributors for all four films are taken from their entries in the Internet Movie DataBase, www.imdb.com.

2. In one interview, Kaufman observes: 'The movie's pretty accurate in its depiction of my false starts and my confusion, and how I just had to plug away because I was hired and because they had paid me a certain amount of money to proceed, and so I had to'; Rob Feld, 'In Praise of Confusion', *Written By*, the magazine of the Writer's Guild of America, West, December/January 2002/3, accessed via www.wga.org/WrittenBy.

3. For more on this see my *American Independent Cinema*, chapter 2.

4. See my *Film Comedy*, 125–6.

5. Robert Stam, *Reflexivity in Film and Literature: From Don Quixote to Jean-Luc Godard*, 220.

6. For more on this dimension of reflexive cinema, see Stam, *Reflexivity in Film and Literature*.

7. For more on the variety of modernism suggested here, see Robert Philip Kolker, *The Altering Eye: Contemporary International Cinema*.

8. *A Poetics of Postmodernism: History, Theory, Fiction*.

9. For more on this see Patricia Waugh, *Metafiction: The Theory and Practice of Self-Conscious Fiction*.

10. Quoted in Waugh, 9.

11. For more on the complexity of this question generally, see Robert Allen and Douglas Gomery, *Film History: Theory and Practice*.

12. Michael Koresky and Matthew Plouffe, 'Why Charlie Kaufman doesn't watch movies anymore', *Reverse Shot* online, Spring 2005, accessed via www.reverseshot.com.

13. Rob Feld, 'Q & A with Charlie Kaufman', in *The Shooting Script: Eternal Sunshine of the Spotless Mind*, 133.

14. Shari Roman, 'It's just an interview, Charlie Kaufman', *Fade In*, 7, 4, 2004, accessed via copy scanned in at www.beingcharliekaufman.com/index.htm?articles/fadein04.htm&2.

15. *The Unresolvable Plot: Reading Contemporary Fiction*, 9.

16. *Distinction*, 32–3.

17. I use the term 'allegiance' here and throughout this book in the sense suggested by Murray Smith, *Engaging Characters: Fiction, Emotion, and the Cinema*, to suggest a form of relationship between viewer and character that might not go as far as is implied by the often-used term 'identification'.

18. '"Makin' Flippy-Floppy": Postmodernism and the Baby-Boom PMC', in *Another Tale to Tell: Politics and Narrative in Postmodern Culture*, 117.

19. *Reflexivity in Film and Literature*, 252–3, emphasis in original.

20. The *Adaptation* sample, initially accessed 20 November 2005, begins at www.amazon.com/gp/product/customer-reviews/B00005JLRE/ ref=cm_cr_dp_2_1/102–7723053–7255351?%5Fencoding=UTF8& customer-reviews.sort%5Fby=SubmissionDate&n=130.

21. In all quotations from the Amazon.com reviews that follow in this and subsequent chapters, I have kept the original form of self-attribution, along with any misspellings, non-italicization of titles or other oddities of expression.

22. In their repeated format and often assertive, sometimes defensive, nature, such responses can be see as taking the form of what Matt Hills refers to as a 'discursive mantra', 'a relatively stable discursive resource' circulated in particular fora of this kind; *Fan Cultures*, 67.

23. 'Working Title Mark II: A Critique of the Atlanticist Paradigm for British Cinema', *International Journal of Media and Cultural Politics*, 2, 1, January 2006.

24. *American Independent Cinema*, 250–60.

25. Waxman, *Rebels on the Backlot*, 157.

26. For more on this process generally, see Paul Grainge, *Brand Hollywood: Selling Entertainment in a Global Media Age*.

27. In this and other contemporary cases, the resonance of 'theatre' was also designed to increase an impression of presence created by the encompassing wide-screen image, as suggested by John Belton, *Widescreen Cinema*, 191.

28. 'Betokening John Malkovich', manuscript unpublished at the time of writing, ms p.14. This study is based on interviews with 17 viewers, four of which are highlighted in more detailed case studies. No general demographic data is supplied for the respondents.

29. 'Betokening', 14.

30. 'Betokening', 16.

31. 'Betokening', 17.

32. 'Betokening', 8.

33. 'Betokening', 8.

34. Initially accessed 2 December 2005, starting at www.amazon.com/ gp / product / customer-reviews / B00005JLRE / ref = cm_cr_dp_2_1/ 102–7723053–7255351?%5Fencoding=UTF8&customer-reviews.sort %5Fby=SubmissionDate&n=130.

35. Rob Feld, 'Q & A with Charlie Kaufman', 137.

36. Rob Feld, 'Q & A with Charlie Kaufman and Spike Jonze', in *The Shooting Script: Adaptation*, 129.

37. Similar points are made in both of the Rob Feld interviews cited above, among other examples.

38. 'Q & A with Charlie Kaufman', 141.

39. Dana Harris and Cathy Dunkley, 'Propaganda closes', *Variety*, posted at www.variety.com, 8 November 2001.

40. Thom Geier, 'Golin putting out Propaganda pics as citizen of USA', *The Hollywood Reporter*, 30 November 1999, accessed via www. hollywoodreporter.com.

41. Michael Fleming, 'USA Films has Carrey in "Mind"', *Variety*, posted at www.variety.com, 3 December 2001; Claude Brodesser, 'Winslet focused on "Mind"', *Variety*, posted at www.variety.com, 18 September 2002.

42. Nick Madigan, 'Pic pitch plays at Propaganda', *Variety*, posted at www.variety.com, 15 June 1998.

43. This is certainly the inference drawn in another interview; David S. Cohen, 'From Script to Screen: Eternal Sunshine of the Spotless Mind', *Scr(i)pt magazine*, March/April 2004, accessed via www.beingcharlie kaufman.com, May 2005.

44. 'Estimated' figures from www.imdb.com.

45. Sample initially accessed 2 December 2005, starting at www.amazon. com/gp/product/customer-reviews/B0002RGNRU/ref=cm_cr_ dp_2_1/102-7723053-7255351?%5Fencoding=UTF8&customer-reviews.sort%5Fby=-SubmissionDate&n=130.

46. 'Q & A with Charlie Kaufman', 141.

47. The screenwriter/director partnership appears generally to have worked well between Kaufman and Jonze and Gondry, although traces of disagreement can be found. Kaufman expresses a dislike for some of the 'too conceptual' visually imaginative ideas proposed by Gondry for Eternal Sunshine; 'Q & A with Charlie Kaufman', 144.

48. Gunning, 'The Cinema of Attractions: Early Film, Its Spectator and the Avant-Garde', in Thomaes Elsaesser (ed.), *Early Cinema: Space, Frame, Narrative*.

49. *American Independent Cinema*, chapter 3.

50. For more on the conventions of romantic comedy, including this one, see my *Film Comedy*, 50–62.

51. For more on uses of genre more widely, see my *American Independent Cinema*, chapter 4.

52. Rob Feld, 'Q & A with Charlie Kaufman', 143.

53. 'Q & A with Charlie Kaufman', 133.

54. Anne Thompson, 'Original screenplays falling by the wayside', *The Hollywood Reporter East*, 11 February 2005, 6.

55. 'The Field of Cultural Production', 78.

56. Ian Mohr, 'Walking on Sunshine', *The Hollywood Reporter*, 20 April 2004, accessed via www.hollywoodreporter.com.

57. For the purpose of this chapter, I have examined reviews of *Being John Malkovich, Adaptation* and *Eternal Sunshine of the Spotless Mind* in five publications representative of different sectors of the print media spectrum, associated with primary readerships of different socio-cultural–economic status in the USA and UK: *The Village Voice* (New York), *The Guardian* (London), *Chicago Sun-Times*, *USA Today*, *The Sun* (London).

58. 'Being John Malkovich', 29 October 1999, accessed via http://.rogerebert.suntimes.com.

59. Peter Bradshaw, 'Bonkers but brilliant', 17 March 2000, accessed via http://film.guardian.co.uk.

60. Mike Clark, 'The unconventional lightness of "Being"', 29 October 1999, accessed via http://usatoday.com, paid-for archive.

61. Nick Fisher, 'Nutty... but nice', 18 March 2000, accessed via www.thesun.newsint-archive.co.uk, paid-for archive.

62. J. Hoberman, 'The Truths About Charlie', *The Village Voice*, 4–10 December 2002, accessed via www.villagevoice.com; Johnny Vaughan, 'Kauf sweet', *The Sun*, 28 February, accessed via www.thesun.newsint-archive.co.uk, paid-for archive.

63. 'Eternal Sunshine of the Spotless Mind', 30 April 2004, accessed via http://film.guardian.co.uk.

64. 'Eternal Sunshine of the Spotless Mind', *Chicago Sun-Times*, accessed via http://rogerebert.suntimes.com.

65. Claudia Puig, 'Soak up "Eternal Sunshine," and you'll feel warm all over', accessed via http://usatoday.com, paid-for archive.

66. Johnny Vaughan, 'Ray of sunshine', 30 April 2004, accessed via www.thesun.newsint-archive.co.uk, paid-for archive.

67. Brett Sporich, 'Hope Springs "Eternal" with strong Day 1', *The Hollywood Reporter*, 30 September 2004, accessed via www.hollywoodreporter.com.

68. As of summer 2008, when this book was in production, the independent feature did not have a USA distributor listed. Early reviews, at the Cannes film festival, suggested that its ambiguities and complexities were such that it would struggle to other than find a

relatively small niche audience. See, for example, Ray Bennett, 'Film Review: "Synecdoche, New York"', *The Hollywood Reporter*, 23 May 2008, accessed via www.hollywoodreporter.com, and Wendy Ide, 'Synecdoche, New York', *The New York Times*, 24 May 2008, accessed athttp://entertainment.timesonline.co.uk/tol/arts_and_entertainment/film/cannes/article3994891.ece

2

Working both ends
Miramax, from *Shakespeare in Love* to *Kill Bill*

If any single institution can be credited with the creation of the Indiewood phenomenon it is Miramax. Starting in 1979 as a lowly distributor of concert films, Miramax became the biggest name in the world of independent cinema in the early 1990s, embarking on a series of initiatives (including its takeover by Disney in 1993) that drove much of the convergence between studio and indie film towards the end of the decade. It was Miramax that engineered many of the key box-office breakthroughs that raised the bar of expectations for independent cinema, most notably the performances of *sex, lies, and videotape* (1989), *The Crying Game* (1992) and *Pulp Fiction* (1994). In each case, a new benchmark was set and the reach of indie/speciality films into the wider marketplace was increased.

Marketing for the cool, arty and dialogue-based *sex, lies and videotape* drew heavily on the 'sex' element of the title. Rather than just playing in exclusive art houses, the film was pushed out onto 500 or 600 screens, many in venues that had never played speciality titles, extending a strategy used by Miramax with the British production *Scandal* earlier in the same year.[1] *sex, lies* achieved a domestic gross of $24.7 million, unheard of at the time in the indie sector, establishing

the credentials of Miramax as a major independent player, a ceiling itself shattered by the release of another British title, *The Crying Game*, three years later. The success of *The Crying Game*, with a US gross of $62.5 million, pulled the distributor out of financial trouble and established it as an attractive target for studio takeover.[2] The strategy, as with *sex, lies*, was to spend much more heavily than was usual in the independent sector on the marketing and other costs required to support a wider release for selected titles, an approach that reached its apotheosis with *Pulp Fiction*, which opened in 1,100 theatres and broke the $100 million barrier with a domestic take of $107 million. In each of these cases, the films were sold as a combination of distinctive/specialist and more mainstream/exploitation and often controversial material. Publicity emphasized, on the one hand, prestigious awards and awards nominations and, on the other, qualities such as the 'sex' of *sex, lies*, the central (sexual) enigma of *The Crying Game* (emphasized in place of the political dimensions of the film) and the thriller/violence dimension of *Pulp Fiction*.

This was a recipe developed earlier by Miramax co-chairman Harvey Weinstein, whose personal hunger for a mixture of commercial success and the achievement of a sense of intellectual/aesthetic respectability was, as Peter Biskind suggests, one of the driving forces of the company. The formula was crystallized in the handling of a Brazilian film, *Eréndira* (1983), based on a story by Gabriel García Márquez, picked up by Weinstein at Cannes when the company was still a very small player. Asked how he would sell the film, which featured an attractive young actress in the central role, Weinstein replied: 'Easy! You got a Nobel prize winner and you got sex. You work both ends.'[3] The film also generated controversy, García Márquez being unable to visit for the premiere of the film after being refused an entry visa because of his political criticism of the USA, a dimension that helped to generate free media coverage. As Biskind puts it: '*Eréndira* became a modest hit. But more important, with the mix of sex, controversy, and prestige that accompanied the Márquez imprimatur, it became a model for the kinds of films Miramax wanted to distribute and the kinds of marketing campaigns they would use to launch them.'[4]

Miramax continued to work both ends as it grew to dominate the sector, although in versions of the formula aimed at increasingly

broader audiences. Two particular conjunctures will be explored through detailed case studies in this chapter, in the context of the wider significance of Miramax in the Indiewood landscape. The first is the 'quality' or 'prestige' end of the spectrum, combined with more conventional/mainstream dynamics, as manifested by *Shakespeare in Love*, the multi-Oscar-winning success of which marked one of the highpoints in the fortunes of Miramax in the late 1990s. The second is allied to the exploitation strand identified most closely in the history of Miramax with *Pulp Fiction*, examined here in the form of Quentin Tarantino's two *Kill Bill* films (2003, 2004). Between them, *Shakespeare in Love* and *Kill Bill* are representative of major trends in the operations of Miramax and of the Indiewood zone more generally. Each exemplifies the Indiewood brand of cinema that offers a combination of markers of distinction and qualities of potentially wider appeal, although in rather different ways from one another and from the Kaufman-scripted films examined in the previous chapter. If Kaufman's films appeal, at least in part, to an 'intellectual' quality, a need to be worked at more than is usual in the mainstream, *Shakespeare in Love* and *Kill Bill* are less overtly demanding of their viewers and different in the grounds through which they offer potential for the marking of viewer distinctions. The former is situated in a long-standing tradition of historical-drama-with-literary-resonances, markers of a particular notion of 'quality' or 'prestige' conventionally associated with a relatively older, middle-class demographic. The latter aspires to a very different status, at the mainstreamed end of the more youth-oriented 'cool', 'cult' film arena, with its heavily stylized textures and the extent to which it draws overtly on a range of existing cult/exploitation genres and texts. Both offer particular sets of reference points, the recognition of which can be understood as one basis for their appeal to audiences equipped with particular kinds and degrees of distinction-marking cultural capital.

Historical/literary drama and markers of 'quality': *Shakespeare in Love*

With its Elizabethan English setting, period reconstructions and explicit literary resonances, *Shakespeare in Love* fits clearly into the 'quality

costume drama' format that has played a part in the development of Indiewood in recent decades. Such films 'operate at very much the culturally respectable, quality end of the market', as Andrew Higson puts it, appealing to 'a film culture which is closely allied to educational discourses, English literary culture, and the canons of good taste'.[5] This is a tradition particularly associated with British cinema since the 1980s, but often involving American funding or Anglo-American co-productions, as Higson suggests, and targeted at precisely the kind of American cross-over market on which this book is focused. Literary source material 'functions as an important selling point',[6] as a source of cultural prestige, but combined with qualities designed to appeal beyond the limited confines of the speciality market. Such films are part of a longer tradition, dating back to the silent era and through the studio and 'post-studio' eras, in which literary adaptations or films with similar 'quality' resonances have served as markers of prestige for particular filmmakers, studios or for American cinema more generally. Notable examples include a number of Shakespeare and other literary adaptations produced by Vitagraph towards the end of the first decade of the twentieth century in a concerted effort by some sectors of the industry to claim more 'respectable' status at a time of cultural upheaval, a context in which cinema was often seen as fomenting disorder among the 'lower' classes.[7]

The 'prestige' picture remained a prominent feature in the heyday of the Hollywood studios, the 1930s and 1940s, including adaptations of literary classics and biopics, formats that persisted, although perhaps more sporadically, in the years after the industry upheavals of the postwar period.[8] An important role in establishing the trend was played by independent producers such as David Selznick and Samuel Goldwyn, who worked in close collaboration with the studio system to supply expensive 'A-list' features such as *Gone with the Wind* (1939) and *Rebecca* (1940). Such examples were very much in the mainstream and given a high profile, although tending towards what was perceived as the 'higher' end of the market. The appeal they made to viewers, in terms of their position in the cultural-taste spectrum, was similar to that offered by their later Indiewood equivalents, 'explicitly invoking "high" culture referents', as William Uricchio and Roberta Pearson put it in the case of Vitagraph, 'but offering them in a "low" culture venue,

the moving picture shows', the more recent version of which would be the film of 'quality' or 'speciality' leanings encountered at the multiplex (first-run cinemas of the classical studio era would also make claims to 'higher' culture resonance in the décor of the more opulent 'picture palaces').[9] Miramax president Mark Gill identifies a studio abandonment of 'the traditional prestige pictures they used to make' as a key factor in the creation of the distinctly Indiewood space into which the company moved in the latter part of the 1990s.[10] Compared with the classical studio era, the most high-profile Hollywood productions of recent decades have tended to be founded on materials judged by conventional standards to be of 'lower' cultural status, including high-budget treatments of what would previously have been considered 'B-movie' territory such as science fiction, fantasy and action-adventure. The result was to open a gap in the market, with occasional exceptions, that Miramax in particular sought to fill.

Signifiers of 'quality' and 'prestige' directly related to literature are very obviously present in the foreground of *Shakespeare in Love*, along with the broader resonances of the heritage/period drama. The film is not a literary adaptation, a source of many prestige dramas produced or distributed in the Indiewood orbit, from the widespread use of Jane Austen (more or less literally) to the biggest Miramax success of this kind preceding *Shakespeare in Love*, *The English Patient* (1996). Large portions of Shakespearean text are integrated into the film, however, in the course of its speculative narrative about the life and loves of the playwright. The body of the film incorporates lengthy passages from *Romeo and Juliet*, the writing and first production of which forms one of the main axes of the plot. Numerous parallels are drawn between the material of the play and the circumstances of Shakespeare's life at the time of writing, the suggestion being that the final shape of *Romeo and Juliet* was inspired by both his love for Viola (Gwyneth Paltrow) and the circumstances that kept them apart. One of the effects of this is to offer viewers a sizeable chunk of Shakespeare but packaged as something different from, and likely to draw a larger audience than, a movie version of *Romeo and Juliet* itself. It is Shakespeare, but at one remove and in manageable doses combined with more immediately accessible material, a difference that marks the shift from work of primarily art-house appeal to that likely to find success in the suburban

multiplex.[11] The formula is exactly that described by Pierre Bourdieu in relation to his version of a middlebrow culture that combines 'immediate accessibility and the outward signs of cultural legitimacy'.[12] In its second-hand approach to Shakespeare, the film is, as suggested in the introduction, probably a better marker of 'middlebrow' culture than some literary adaptations to which the term has often been attached.[13] *Shakespeare in Love* is one of the examples cited by Herbert Gans of products that appeal across the boundary between upper-middle and lower-middle culture. The film, Gans suggests, 'generated enough Oscars and audience numbers to suggest that it must have attracted some lower-middle publics, in a way that *Rosencrantz and Guildenstern Are Dead* and Kenneth Branagh's four-hour version of *Hamlet* surely did not'.[14]

From the opening scenes, *Shakespeare in Love* offers viewers numerous ways to mark their cultural competence, beyond what is signified by their initial choice of such a film against others in the marketplace, through their ability to recognize Shakespearean/literary and other points of reference. Some of these are more accessible and obvious than others, although most lend themselves to a range of degrees of appreciation, creating a scale of different levels of potential engagement. Numerous fragments of Shakespeare are present, in addition to the more substantial portions of *Romeo and Juliet*. Early reference is made to a new play being written by the fictional version of Shakespeare, 'Romeo and Ethel the Pirate's Daughter'. Most if not all viewers will be expected to receive this with a knowing smile, based on recognition of part of an extremely familiar title, *Romeo and Juliet* sharing with *Hamlet* the status of Shakespeare's best-known works. An activation of cultural capital is required for this response, but one that is not very exclusive. The same might be said of a moment that follows shortly afterwards, in which Shakespeare (Joseph Fiennes) screws up and throws a ball of paper that lands next to a skull, a Shakespearean icon that has broad cultural familiarity, suggesting the 'Alas, poor Yorrick' speech from *Hamlet*. When the theatre owner Philip Henslowe (Geoffrey Rush) comes to ask if 'Romeo and the Pirate's Daughter' is nearly done, or at least started, Shakespeare replies: 'Doubt that the stars are fire, doubt that the sun doth move', a quotation from *Hamlet* likely to be recognizable to a far smaller constituency. To pick

up this reference, exactly, from a speech that has not passed into wider usage (unlike, say, 'To be or not to be' or 'Alas, poor Yorrick'), requires a much more specific and narrowly distributed cultural capital. It is still identifiable as 'Shakespeare-type language', however, even if its exact provenance is unknown, a quality that many viewers might expect to encounter in such a film without being alienated by their inability to pinpoint every source. The same might apply to a number of other fragments, including lines from *Two Gentlemen of Verona* that follow during a subsequent performance for Queen Elizabeth (Judi Dench).

In both of these cases, the 'higher' cultural reference is also undercut, offering a mixture of appeals: those of the 'lofty' Shakespearean speech and more down-to-earth material. In the first example, this effect is achieved through dialogue, in Henslowe's hasty retort of 'No, no, we haven't the time. Talk prose', which might be expected to reflect the response of some viewers (quit the high-flown rhetoric and get on with the plot!). In the latter, the character's speech is interrupted, to the amusement of the Queen and other onlookers, by the 'low' comic business provided by a dog that pulls at one of his costume ribbons, a sequence in which the film viewer is encouraged to join in the laughter, rather than to see it as a distraction from more elevated Shakespearean soliloquy. Material of 'lower', more conventionally popular appeal is also extrapolated from Shakespearean text, as in a sequence in which members of the rival theatrical group based around Richard Burbage (Martin Clunes) march on Shakespeare's venue for a confrontation. Their approach is intercut with the rehearsal of a scene from *Romeo and Juliet* in which rival Montagues and Capulets square-off in the street, one of many sequences in which the lines between the film's diegetic fact and fiction are blurred. The 'real' confrontation results in a 'big, comic punch-up' or 'bar-room brawl' type scene, a formulaic device but one that appears here to grow directly from the more 'elevated' Shakespeare. In some instances, particularly those relating to *Romeo and Juliet*, viewers who do not pick up references first time around are given scope to place them retrospectively, when material from the wider diegetic environment is put to work in the emerging text of the play. When a clergyman railing against the evils of the theatre declares 'a plague on both their houses', referring to two

rival playhouses, some will recognize this from one of the famous lines in the play; if not, they might recall its earlier use when it turns up again, slightly modified, as Mercutio's 'a plague on both your houses' from *Romeo and Juliet*, delivered during the writing and rehearsal process. Some references remain more exclusive and unavailable to the non-cognoscenti. A young boy involved on the periphery of the play-within-the-film expresses a taste for blood and gore. His name is revealed as John Webster, suggesting, to those with sufficient knowledge, that he is destined to grow up to be the Jacobean dramatist best known for the lurid tragedy *The Duchess of Malfi*.

Exactly how accessible the various Shakespearean elements might be for audiences was an issue of direct concern to the filmmakers, as might be expected. For the director, John Madden, one of the merits of the script was that it was 'totally liberated from any kind of academic or inaccessible mode'.[15] He felt that the project had the potential 'to remind people how extraordinarily accessible Shakespeare is if they can only go beyond their preconceptions about him. Of course, not remotely foreseeing that it would have as wide an appeal as it has proved to do.'[16] Shakespeare can be accessible, in this view, but is not recognized as having quite the breadth of audience appeal identified in the project by Miramax. Tom Stoppard, the playwright brought in at an early stage to re-write the original screenplay, puts it slightly differently, suggesting that in the case of Shakespeare 'it is the brand name that is intimidating, not the stories he tells', but also agreeing with an interviewer that audiences might gain pleasure specifically from being 'stretched a little' by the requirements necessary for picking up the Shakespeare references.[17] Madden and Stoppard also brought resonances of their own to the project, those of the writer better known than the director. Madden started out as artistic director of the Oxford and Cambridge Shakespeare Company, going on to direct a number of features including the BBC historical production *Mrs Brown* (1997), also distributed by Miramax. Stoppard brings the associations of a major dramatist, a significant ingredient in the recipe of a production so strongly built around literary points of reference, his oeuvre including the Shakespeare spin-off *Rosencrantz and Guildenstern are Dead* (a film version of which, directed by Stoppard, was released in 1991). That the film offered a mixture of appeals was also recognized

by critics, suggesting that the issue might be in play for many potential viewers in the discourses surrounding the release. Roger Ebert, writing in the *Chicago Sun-Times*, described the quality/comedy blend as making the film 'play like a contest between "Masterpiece Theatre" and Mel Brooks'.[18] *The Guardian* was more analytical, identifying the film as 'a remarkably astute packaging exercise, with in-jokes for the literati and even for fans of director John Madden's last film *Mrs Brown* – Judi Dench knowingly plays Elizabeth I as a variant on that film's Victoria'.[19] *The Sun*, in a brief but approving notice, highlighted star appeal and period drama 'injected with a shot of modern humour and sizzling sexy undertones', placing the film as 'top-drawer entertainment' in a manner that suggested appeal to a wider audience than that likely to be attracted by the intertextual references.[20]

Shakespeare in Love also offers the pleasure for viewers of activating their knowledge of references to various aspects of modern-day culture, most of which are in the widely accessible part of the spectrum. The ball of paper that lands next to the Yorrick-like skull is followed by another pitched into a mug bearing the legend 'A present from Stratford upon Avon', a nod to that most familiar variety of present-day 'Shakespeare Country' souvenir. When Shakespeare visits Dr Moth (Anthony Sher), whose signage describes him, variously, as 'apothecary, alchemist, astrologer', 'priest of psyche' and 'interpreter' of dreams, the sequence that follows is readily appreciable as an anachronistic parody of a session on the psychiatrist's couch, complete with deliberately over-obvious phallic references to the playwright's case of writer's block ('it's as if my quill is broken', etc.). The introduction of a scene located in a tavern is accompanied by the voice of an unseen waiter enthusing 'the special today is a pig's foot marinated in juniper berry vinegar, served on a buckwheat pancake which has been ... [interrupted]'. If the mug is a reference to lower-culture commercial exploitation of literary traditions such as Shakespeare, a dig that seems designed to appeal to those who would identify themselves with higher aspirations, the psychiatry and waiter/menu devices can be read as swipes at more 'pretentious' cultural phenomena that might imply a slightly different positioning from which to be most appreciated.

Much of the film can also can be read as light self-referential satire, one of the original appeals of the project at the writing stage having

been, reportedly, the parallels between the backstabbing worlds of Elizabethan theatre and Hollywood cinema.[21] The world of the film is one in which writers go unpaid for completed projects and take money from more than one source for the same job; in which projects are stolen and the business is a mixture of creativity, craft and a measure of physical bullying. It is tempting to read the latter, in a Miramax production, as reference to the notorious *modus operandi* of Harvey Weinstein, whose heavy-handed ways of dealing with filmmakers and others are documented at length by Biskind (Weinstein took the unusual step of taking a producer credit for the film). References of this kind are also a mixture of the more and less accessible to the general viewer. A very early example appears designed to appeal to those with knowledge of some very specific dubious practices of which Hollywood or Indiewood are often accused. An exchange occurs between Henslowe and the financier Hugh Fennyman (Tom Wilkinson). The latter has previously had Henslowe tortured, his boots forced onto the hot coals of a fire, because of an unpaid debt (not an offence of which Weinstein has yet been accused). Henslowe offers Fennyman a share in his production of 'Romeo and the Pirate's Daughter'. As the finances are discussed, Henslowe mentions paying the actors and the author. 'Share of the profits', replies Fennyman. 'There's never any', says Henslowe, to which he receives the smilingly complacent retort: 'Course not'.

This is a playful reference to the accusation that creative accounting is often used to ensure that seemingly successful features never register net profits, thus ensuring that no payments are made to those with deals based on profit sharing (other than powerful players who are able to insist on a share of the gross). Miramax in particular has been accused of this and similar tactics such as 'bidding up the gross', in which very high promotional spending secures the prestige of larger box-office takings but at the cost of reducing the level of profit that results for the filmmakers. The exchange between Henslowe and Fennyman seems clearly to be drawing on this real-world background, even though its full relevance is unlikely to be understood by anyone other than industry insiders or close followers of the business. To the viewer without such expertise, the sequence might play, among others, as a more general comment on cynical entertainment-business

practice. Sufficient motivation exists for it to work within the fictional world of the film, in other words, without being dependent on the extra-diegetic knowledge available to relatively few; another example of the manner in which different levels and degrees of engagement can be available to viewers equipped with different kinds and quantities of cultural capital.

A more widely accessible example of self-reflexivity is found in the playbill that accompanies the performance of *Romeo and Juliet* that eventually takes place, after the closure of Henslowe's Rose theatre forces it to switch to the previously rival establishment run by Burbage, complicating the necessary list of attributions. It reads as follows: 'By Permission / of / Mr Burbage / a / Hugh Fennyman Production/ of / Mr Henslowe's Presentation / of / The Admirall's Men in Performance / of / The excellent and Lamentable Tragedie / of / Romeo and Juliet.' The camera moves downwards along a copy glued to a post outside the theatre, giving the lines of text the appearance of movie titles scrolling upwards, underlining the play this represents on the tortuous series of corporate, producer/distributor and/or individual credits with which so many contemporary films open. (*Shakespeare in Love* declares itself with the comparatively modest 'Universal Pictures and Miramax Films / and The Bedford Falls Company present'; like the fictional billing of *Romeo and Juliet*, William Shakespeare's name is neglected, despite the amount of his text that is performed on screen.)

6. Reflexive in-joke: The playbill for the production of *Romeo and Juliet* in **Shakespeare in Love** © Miramax Films / Universal Pictures

Shakespeare in Love also contains much that can be read back into the film itself in the form of comments about the balance of serious drama/tragedy and comedy in the plays of Shakespeare and his contemporaries. This forms a running theme, the commercial interests in the theatre stressing the importance of sources of popular attraction, against or alongside the more serious or tragic dimensions of the creative work. The dog that interrupts the royal performance of *Two Gentlemen of Verona* meets with Henslowe's approval. 'You see', as he puts it to Shakespeare, when the audience laughs: 'Comedy. Love and a bit with a dog. That's what they want.' This is another area in which the film plays it several ways at once. *Shakespeare in Love* has comedy, love and, at one remove, that 'bit with a dog'. Its mixture of romantic convention and comedy is highly accessible to a general audience, comedy serving here as often elsewhere to leaven the more seriously affecting parts of the mixture. *Romeo and Juliet*, as it evolves during the film, leans further and further away from comedy. Its love turns tragic, and there is no dog (or pirate's daughter). The speculation offered by the film is that this is the direct result of events in Shakespeare's own love-life, principally the fact that Viola has been promised to another, a fate from which she cannot escape, making their love impossible to sustain. The darkest shades are reserved for *Romeo and Juliet*, the climax of which is enacted on stage within the film in a manner designed to give the scenes their own emotional weight, even within the frame of a production-within-a-production, partly as a result of the freight they carry from the parallels in the surrounding narrative. The play has its own lighter moments as well, both in itself and as seen in fragments in the film, including scenes involving the nurse. Play and film overlap here, as in several other instances, the character who *plays* the nurse also serving as one of a number of sources of comic business in the film. *Shakespeare in Love* is, generally, a lighter work than *Romeo and Juliet*, a factor of direct relevance to its position as an Indiewood feature seeking to reach beyond the limited speciality market. The balance established in the ending is another significant ingredient.

If *Romeo and Juliet* is seen in the film to end in utter tragedy, *Shakespeare in Love* steers a very Indiewood course between up- and down-beat qualities. Shakespeare and Viola do not end up restored to one another, in any conventional sense, as might have been expected.

In one dimension, the film functions as a romantic comedy (a genre of which some of the lighter Shakespeare plays can be seen as predecessors), in the manner in which the attraction between Shakespeare and Viola is signalled, the obstacles put in their way and the disguising of identity that acts as a key catalyst of the plot. It does not offer a conventional romantic comedy resolution, however, in which love prevails over adversity and the couple are united at the end. The final resonances are mixed, in a manner similar to some of the Charlie Kaufman films considered in the previous chapter. At the level of concrete reality, Shakespeare and Viola are separated. She is obliged, by order of the Queen, to leave for the Virginia plantation of her new husband Lord Wessex (Colin Firth). The film confects another, poetic dimension, however, in which the resonances are more positive. At the close, Shakespeare is beginning to write *Twelfth Night*, the initial scenario devised in exchanges between himself and Viola, to mirror their situation. The hero is a love-sick duke; the heroine, to be named after Viola, the sole survivor of a shipwreck during a crossing of the Atlantic after being sold into marriage. As Shakespeare begins to write, images are summoned to the screen. The heroine, first seen indistinctly underwater, has the same long blonde tresses as the film's real-life Viola. The closing images are of the same figure walking on a beach, towards the land, as if towards a new life.

This imaginary extrapolation, in which the two characters will meet again, even though transposed into the realm of fiction-within-the-fiction, creates a final mood in the film that is affirmative and upbeat while avoiding the imposition of a more formulaic and excessively implausible literal 'happy ending'. That the 'real' Viola's fate might in any way match that of her fictional counterpart (*Twelfth Night* ends with a declaration of marriage between Viola and the hero, Duke Orsino, after a series of events triggered by her masquerade as a boy, as in *Shakespeare in Love*) might seem fanciful, but the film offers another get-out clause. 'All ends well', the film's Viola assures Shakespeare before they part, a comment that refers in this context most immediately to *Twelfth Night*, but also by implication to their own situation (not to mention the title of another Shakespeare play). 'How does it', asks Shakespeare, to which she replies: 'I don't know. It's a mystery.' This is a repetition of a refrain that occurs on three other

7. The open vista of an imaginary happy ending: The fictional-within-the-fiction
Viola walks towards a new future © Miramax Films / Universal Pictures

occasions in the film, and in every other case fate intervenes to ensure
a happy resolution. (The first is when Henslowe is about to have his
feet returned to the fire, unable to pay his debts when the theatres are
declared closed, at which moment the order is revoked; two others
are during the production of *Romeo and Juliet*, one when a character
with a pronounced stutter somehow bursts into fluency and is able to
recite the prologue, another when the company's Juliet is lost when the
voice of the boy playing the role breaks and Viola steps into the
breach.) This kind of strategy is found in a number of contemporary
romantic comedies that seek to both maintain and update the
conventions of the form by using oblique or ambiguous forms of
resolution.[22] Magical resolution is hinted at, but displaced both to the
pages of the writer's new drama and, perhaps, to subsequent events in
the lives of the characters. It is teasingly present but without the cliché
of being directly enacted on screen.

The fact that the film has this specific balance in its ending was not
predetermined but a result of struggles and negotiation during
postproduction. Awareness of such processes helps to further our
understanding of the manner in which such products are confected
with particular audience-responses in mind and, with that, a particular
location in the cinematic spectrum. Weinstein is reported to have
pressed for a happier ending than was offered in the shooting script or
the version of the film initially delivered by Madden and shown to
test-screening audiences. He kept arguing, Henslowe-like, for 'more

jokes', while Miramax executive Donna Gigliotti reportedly saw the film as essentially a tear-jerker, closer to the tragic end of the spectrum, in which female viewers were expected to cry at the end.[23] Test scores suggested that the film lacked emotional punch in its ending, findings that led to a number of minor changes. According to Biskind, the eventual ending was worked out by Stoppard, reluctantly, under considerable pressure from Weinstein.[24]

The history of the production is also illustrative of more general tendencies in the operations of Miramax in the late 1990s and the wider industrial context in which it was situated. *Shakespeare in Love* originally went into preproduction at Universal in 1991–2, Stoppard having been brought in to rewrite a screenplay by Marc Norman. Universal decided not to go ahead but, Biskind reports, did not want any other studio to make it either.[25] A forbidding $9 million price was set for anyone who might want to buy the project in 'turnaround', a regular Hollywood procedure in which studios seek to recoup costs already invested in the initial development of projects that are abandoned before going into production. None of the other Hollywood majors was interested in such terms for what appeared to be a product designed for the specialist market. The script was seen by Harvey Weinstein, however, who apparently fell in love with it and sought to establish a deal with Universal. Terms could not be agreed for several years, before Weinstein eventually gained the necessary leverage with Universal: the studio wanted access to the director Peter Jackson, on whose work Miramax had a contractual option, for a remake of *King Kong*; in return for this, Universal agreed to sell the project to Miramax. But, according to Biskind, Universal continued to put obstacles in the way of the Disney subsidiary. Universal asked for $2.25 million of the $9 million up front, compared with the usual requirement of 10 per cent, a figure that was subsequently raised to $4.5 million. The studio also added a clause that forbade Miramax from casting an A-list star in the film (Julia Roberts had been interested at an earlier stage). Universal's precise motivation is not clear. On the one hand, it might not want to see anyone else profit heavily on a project originated at the studio. On the other, once aware of Weinstein's desire for the film, it was able to force him to pay over the odds. By including the clause about major stars, Universal was seeking to ensure that

whatever product Miramax released would not be a direct rival to the studio's own mainstream offerings, although that proved unsuccessful given its eventual box-office triumph.

Weinstein's determination to produce *Shakespeare in Love* is evidence of the strategy that led the company at the time, in several respects. Miramax had moved increasingly into production, in addition to its original focus on picking up completed projects for distribution. Production is a very different business, requiring different skills. As this process began, earlier in the 1990s, the question facing the company was, as Biskind puts it,

> whether the Weinstein's would be as skilful developing, shooting and editing their own films as they had been acquiring those of others, which is to say, it's much easier to recognize in a finished film elements that can be exploited for an effective marketing campaign than it is to develop an idea from scratch and successfully see it through to production.[26]

Acquiring pictures in turnaround is an alternative that offers some of the best of both worlds, a strategy that could not fill the entire Miramax roster, Biskind suggests, but that accounted for many of its most successful films of the 1990s (including *Pulp Fiction*, *The English Patient*, *Good Will Hunting* [1997] and *Shakespeare in Love*).[27]

Shakespeare in Love also held exactly the kind of potential that most attracted Miramax at the time. Weinstein's long-standing ambition had been to acquire or produce 'art films for the multiplex audience'.[28] By the time of *Shakespeare in Love*, screenings in multiplex cinemas in suburban malls were no longer considered to be the icing on the cake, as had been the assumption with more distinctly independent-seeming films such as *sex, lies, and videotape*. This formula was inverted, as Biskind suggests, in the wake of the larger-scale successes of the likes of *Pulp Fiction* and *Good Will Hunting*: 'By 1998, the multiplexes were no longer gravy; they were his company's meat and potatoes.'[29] Films were actively being tailored for the mall audience. In some instances, this meant products little if at all different from mainstream fare, but the Miramax brand was still founded partly on its quality/prestige associations. A key moment, for Biskind, was the critical and

commercial success of *The English Patient*, another historical romance based on a literary source. *The English Patient* tipped the emphasis away from the 'cool', 'hip', 'edgy' qualities of *Pulp Fiction* towards those embodied in productions such as *Shakespeare in Love*: 'high-toned, Masterpiece Theatre-style, Oscar-grabbing pictures often adapted from prestigious literary works'.[30] Miramax continued to court controversy after the Disney takeover, particularly its involvement in projects such as *Priest* (1994) and *Kids* (1995), but these created tensions with Disney without the benefit of large payouts: 'The moral of *Shakespeare in Love* seemed obvious: why get your life threatened over a tiny film like *Priest* with virtually no upside, when you can make pots of money and get showered with praise, including an Oscar, for producing costume dramas [...].'[31]

Shakespeare in Love certainly proved to be Academy Award fodder, an important source of the prestige associations sought by Miramax, and a demonstration of the company's zeal in seeking to achieve nominations and awards as a key part of its marketing strategy. The film opened in December 1998 in a rapidly widening release pattern during the build-up to the 1999 awards: New York and Los Angeles first, expanding to the top 50 markets in the USA two weeks later and wider two weeks after that.[32] It secured a hefty 13 Oscar nominations, giving Miramax a company record total of 23 in one year. The nominations, in February 1999, gave the film an immediate boost at the box-office, as its release was further expanded, by which time its domestic gross had reached $47.1 million.[33] *Shakespeare in Love* eventually won seven awards, including Best Picture, after a close contest with Steven Spielberg's *Saving Private Ryan* (1998), generally considered by the trade press to have been favourite for the top award. Much controversy was generated during the campaign, with public accusations against Miramax in general, and Weinstein in particular, for excessive spending on promotions targeted at academy members and for spreading negative word about its rival. Miramax countered that its spending, estimated at some $5 million, was in support of the general release rather than the Oscar campaign, although the timing of the release was such as to enable some of the promotion to do double duty.[34] The film is a good example of the aggressive stance taken by Miramax towards the Oscars, a phenomenon previously restricted to

the activities of the major studios, nominations and awards being seen by Weinstein since the early 1990s as ways to boost box-office revenues, to attract stars and projects to the company and to establish the credentials of the Miramax brand.[35] Box-office returns for *Shakespeare in Love* shot up by 42 per cent on the Monday after the awards ceremony, compared with the equivalent day in the preceding week, a boost that helped the film go on to a domestic gross of $100.2 million (plus a figure well in excess of that sum from overseas, although Universal retained the foreign rights).[36]

The strategies pursued by Miramax during the 1990s had widespread repercussions for the independent sector in general, forcing many other players to follow suit if they were to remain competitive. This meant the expansion of acquisitions staff and the use of more aggressive tactics with which to try to secure the rights to attractive properties. The costs of acquisitions rocketed, as did those of marketing and wider distribution, for all but the smaller operations (of the speciality divisions associated with the major studios, only Sony Pictures Classics appeared to resist the trend).[37] The Disney takeover gave Miramax big advantages in the marketplace. The existence of guaranteed outlets through the studio's television and video deals enabled Miramax to pay over the odds and to buy up large numbers of films, a select few of which would be chosen for full-scale marketing, distribution and Oscar campaigns. Increasingly little was left for the opposition, as Biskind suggests, a process that drove up prices and often led to hasty acquisitions that ended in box-office failure. Another result was that the independent companies or speciality divisions were forced to invest in the production end of the business, to secure access to products. This involved greater risks, which led in turn to an increasing tendency to favour more conservative or star-led properties.[38] Together, these developments were major factors in the creation of the Indiewood blurring of distinctions between the independent and major studio sectors. And, if much of the independent sector was being 'Miramaxed', as Biskind puts it, Miramax was being Disneyfied: 'Harvey took indie films and he rubbed down their sharp edges, sweetened their voices, just has he had Americanized foreign films in the old days. Miramax became, as it were, a Trojan horse through which studio values came to permeate much of the

indie scene.'[39] The Weinsteins not only transformed independent distribution, Biskind adds:

> they brokered a marriage of indie and mainstream that resulted in a novel kind of picture that did more than just cross over; it exchanged DNA with commercial movies. An amalgam of difference and sameness, personal and commercial, voice and genre, these films played like Hollywood movies while retaining the indie spirit, however vague and hard to define that may be.[40]

This is very much the version of Indiewood around which this book is organized, as manifested in examples such as *Shakespeare in Love*. The film started out as a studio project, suggesting a mainstream appeal, but did not go into production at that level, probably as a result of the failure to attach major stars. Without the latter, it did not appeal to any other studios, although it was hampered by the excessive turnaround price. It offered ideal potential for the Indiewood blend pursued by Miramax, however, sufficiently so for the company to pay the turnaround fee and invest heavily in promotions and other costs involved in a wide release and aggressive Oscar campaign. With a production budget of $24 million – low for the production values of a well-mounted period piece – the formula proved highly successful in this case. Part of the Miramax recipe has been the achievement of studio-scale revenues on lower budgets, although attempts to compete with the majors were not always successful. The early 2000s saw Miramax embarking on higher-budget productions including Martin Scorsese's $97 million *Gangs of New York* (2002), the domestic box-office of which was only $77 million, a disappointment balanced in the same year by the musical *Chicago*, a $45 million production that grossed $170 million and won six Academy Awards. These are star-led, studio-scale pictures in genres (large-scale historical drama and musical) not usually associated with the indie sector.

The mainstreaming of cult: *Kill Bill*

In the wake of the success of features such as *Shakespeare in Love* and the other tendencies described above, it became clear, Biskind suggests,

that Quentin Tarantino, a favoured Miramax son, was no longer the voice of the company. That role had passed, Biskind argues, somewhat rhetorically, to the John Maddens and Lasse Hallströms of the film world, the latter the director of more restrained Miramax releases such as *Chocolat* (2000) and a 'tepid' version of John Irving's *The Cider House Rules* (1999).[41] Tarantino's *Pulp Fiction* played a crucial role in the development of Miramax in the first half of the 1990s, so much so that Harvey Weinstein has often described the company as 'the house that Quentin built'. At that stage, Biskind suggests, 'Tarantino gave Miramax its voice', as well as 'cementing Miramax's place as the reigning indie superpower'.[42] If Tarantino no longer occupied quite so hallowed a position in the early years of the twenty-first century, as a result of developments in the company's overall strategy, he remained a privileged figure. His presence enabled the Miramax brand to maintain something of its earlier associations with 'cool' and 'edgy' as well as more 'elevated/prestige' production, appealing in general to a younger demographic. In return, Tarantino was given an unusual degree of freedom to determine and shape projects through Miramax via A Band Apart, the development/production entity run by his regular producer Lawrence Bender. When it was announced that the unusual step would be taken of releasing *Kill Bill* in two parts, Weinstein repeated that 'Miramax is the house that Quentin Tarantino built' as a justification for giving him 'carte blanche' in the handling of the film(s).[43]

The decision was widely taken to be an indulgence of Tarantino by Weinstein, who is usually associated with very hands-on interventions in which the norm is for cuts to be forced on filmmakers whose work threatens to over-run (although at least one report suggested that the initial idea of splitting the film came from Weinstein rather than Tarantino).[44] The strategy provoked considerable speculation in the trade press. It was considered potentially risky to ask viewers to pay twice to see what could have been one longer film, especially if the first instalment did not do well at the box-office. In the event, it proved highly successful, a measure, as much as anything, of the commercial clout possessed by Tarantino. Both parts topped the box-office in their opening weekend and the video charts in their first week on DVD. *Volume 1*, on an estimated budget of $55 million, grossed $70 million

in the USA and more than another $100 million overseas; *Volume 2*, on a budget put at around $30 million, performed similarly, suggesting that viewers were happy to pay again for the concluding instalment, as was indicated by exit surveys conducted by Miramax during screenings of *Volume 1*.[45] The division of the film into two also created marketing synergy between the theatrical opening of the second part and the DVD release of the first, which occurred within a three-day span (the *Volume 1* DVD sold more than 2 million copies on its first day).[46] Both parts were given studio-sized, large-scale releases into the multiplexes, around the 3,000 screen mark, and were clearly aimed at a substantial rather than a niche audience. *Volume 1* was considered to have found its target audience, shown by exit surveys to be 60 per cent male and 60 per cent in the 21–39 age bracket.[47] Pre-release tracking data, which monitors awareness and desire to see forthcoming features, suggested that the film was more likely to broaden its appeal beyond the young male constituency than its opening week rival, *The Punisher* (2004), which shared with *Kill Bill* a vengeance theme. *Kill Bill* was shown to be tracking better among women and older males, which increased its chances of reaching a wider audience and lasting longer at the box-office.[48] The Tarantino-auteur factor was no doubt a significant aspect of the appeal of the film, the writer–director's first since *Jackie Brown* (1997), and was the basis for much of the surrounding publicity.

The associations carried by the name of the filmmaker are themselves an embodiment of the characteristic Indiewood mixture of wider and more specific bases of appeal. The Tarantino brand at the time was one that implied work that was distinctive, up to a point, but within familiar crime-generic limitations. Attachment to the auteur identity is, in itself, sufficient to mark a claim of distinction on the part of the viewer. When the director is one of the few to have 'superstar' status, the act of consuming via the name is less exclusive than would otherwise be the case, but film consumption in general is not usually oriented primarily around the identification of particular filmmakers. To invest heavily in the auteur identity as such is to position oneself in regard to a film or films in a manner that is not typical of the mainstream. The specific established associations of 'Tarantino' at the time of the release of *Kill Bill* included a mixture of popular appeal and

more exclusive qualities: visceral attractions and other generic frissons – as found in *Reservoir Dogs* (1992), *Pulp Fiction* and *Jackie Brown* – mixed with some formal departures from dominant convention, particularly the use of non-linear narrative structures. The material with which Tarantino works is associated with 'lower' cultural forms, essentially 'pulp' fictions. The revisiting of such forms offers a dual basis of appeal, a synthesis of the more immediate thrills of the original (as in the descriptions of lower culture found in the writings of Bourdieu and Gans) with a more distanced and 'knowing' attitude towards the material. *Kill Bill* offers more of each: more in the way of visceral, pulp-genre-based action than is found in any of his earlier films, but allied with an increased level of stylization and a process of referencing past work that goes into overdrive. The result, very unlike *Shakespeare in Love* in other respects, is similar in the different levels of investment and engagement offered to the viewer.

References to other works – films, TV shows, comic books – are part of the texture of all the Tarantino productions prior to *Kill Bill*, including his screenplay for *True Romance* (1993), directed by Tony Scott. These range from textual marginalia, such as the appearance of film posters in the background, to explicit references in dialogue and more substantial borrowings of plot and other devices. An element of reference-spotting has been established as a feature of Tarantino film consumption for some viewers, whether such borrowings are interpreted as *homage*, pastiche or outright theft (a number of critics put into the latter category, for example, the parallels between *Reservoir Dogs* and Ringo Lam's *City on Fire / Lung fu fong wan* [1987]). As with *Shakespeare in Love*, a scale exists between references that require more or less cultural capital in order to be activated as a source of pleasure for the viewer. In *Pulp Fiction*, for example, the implicit reference to John Travolta's past fame as disco-dancing star of *Saturday Night Fever* (1977), during the sequence in which he does the twist with Uma Thurman, is more broadly accessible, and more likely to be taken up in popular media coverage, than the citation of the relatively obscure film noir *Kiss Me Deadly* (1955) via the strange glow given off by the unseen contents of a briefcase recovered by the henchmen played by Travolta and Samuel L. Jackson. The principal difference between *Kill Bill* and *Shakespeare in Love* is that what is involved in the former is

clearly in the realm of *sub*-cultural capital, the source material involving unconsecrated regions of popular culture (a difference marked by the fact that subcultural capital is generally less easily translated into mainstream economic or social capital). This is increasingly the case in the *Kill Bill* films, which draw heavily on culturally low-status 'grindhouse' genres such as kung fu films, the exploitation end of the Japanese samurai tradition, spaghetti westerns and *yakuza* movies. Large numbers of sources can be identified, ranging from broad templates to more specific detail.

The general template is that of the 'revenge movie', found across various generic territories including samurai films, kung fu and the spaghetti western. More specifically, *Kill Bill* can be placed in the tradition of productions featuring avenging women. More specifically still, the numerous individual examples on which the film draws include *Lady Snowblood / Shurayukihime* (Japan, 1973) and its sequel, featuring a samurai-sword-wielding seeker of vengeance, a direct reference to which is made in the sequence close to the end of *Volume 1* in which The Bride (Uma Thurman) despatches a part-Japanese enemy in a snow-filled garden. The first volume signals its overt celebration of c.1970s grindhouse traditions from the start, the Miramax logo being followed by a claim that the film is shot in 'ShawScope', a reference to the films of the Shaw Brothers, prolific producers of Hong Kong kung fu cinema. Next, to the crackly accompaniment of a 'cheesy' brass-led theme, comes a title card reading 'our feature presentation', against a background of 'psychedelic' swirling colour graphics. The impression sought is a nostalgic recreation of past movie experiences, particularly those enjoyed by the writer–director in his youth, a framing process that functions to place the material that follows in much the same way as the theatrical routine that opens *Being John Malkovich*, even if it situates the film rather differently in the broader field of cultural production. A more elaborate version of this experience was subsequently offered in Tarantino and Robert Rodriguez's *Grindhouse* (2007), an exploitation-style double bill accompanied by its own faux-grindhouse trailers in an attempt to replicate something like the original theatrical programme.

The appeals made by the *Kill Bill* films to particular traditions are

varied in the degree to which they are likely to be overtly apparent to the viewer, an issue of significance to the manner in which they might be consumed. In some instances, they are very clearly marked as intrusions into the diegetic universe of the films. One of the most notable examples is a device used on several occasions to mark points at which The Bride first encounters each of the individuals on her hit list, members of a former assassination squad who left her for dead after a bloody attack during her wedding rehearsal. A striking, high-pitched oscillating sound effect is used to signify the intensity of the moment, accompanied by similarly heightened visual effects in which the screen is tinted red and images from the attack featuring the individual concerned are superimposed upon close shots of The Bride's eyes. The result is an intensified form of flashback, a trope designed to express the controlled fury ('red mist') that drives The Bride in her search for revenge. It is diegetically motivated, but also marked out as 'excessive' and 'over-the-top', drawing attention to its status *as* a corny popular movie confection. The manner in which this device is deployed brackets it, momentarily, from the ongoing events of the fictional world. Its first use is in The Bride's visit to the suburban home of Vernita Green, aka Copperhead (Vivicia A. Fox). As Vernita opens the door to The Bride, a shot of the former's head and shoulders goes into brief freeze frame, a form of parenthesis in the cinematic grammar of the sequence. This is quickly succeeded by a rapid zoom into The Bride's eyes, the impact of which is heightened by the use of an emphatic sound effect, followed by the superimposition of the events from the past. The effect of the crash zoom is another break from standard/conventional grammar, an impression again of the film halting for an instant, hyperbolically to underline the impact of the moment. The sequence ends when the superimposition and tinting is withdrawn, leaving a brief close shot of The Bride's face, from which a cut leads into a high-speed fight sequence inside the house; a resumption of the action. The moment of transition out of flashback/alarm-sound is further marked in the soundtrack by a cornily climactic series of brass notes. The fight sequence that follows shifts into a different register, combining overtly stylized effects (particularly the non-realistically motivated whip sounds made by knife blades) with an

8. Rhetorical excess: The close-up on The Bride's eyes during the first heightened flashback sequence in *Kill Bill: Volume 1* © Miramax Films

aesthetic designed to create an impression of painful impact and immediacy, the latter resulting in part from the use of unsteady camerawork, a conventional signifier of greater proximity to the real.

The flashback/sound-effect advertises its status as a 'cheesy movie device'. It works as a signifier of key moments in the fictional world of the films, while also declaring its status *as* the kind of device associated with particular exploitation-cinema traditions for which fond nostalgia is invited. Pleasure is offered at both levels, within and beyond the diegetic universe. The device is sufficiently overt, heightened and marked as 'over-the-top' to become visible to most if not all viewers. Much more specific detail is also available, however, to those with the requisite subcultural capital, as is the case with most of the texture of the *Kill Bill* films. The cognoscenti will be aware, for example, that the high-pitched sound effect described above is derived originally from the opening notes of the Quincy Jones theme music from the television series *Ironside* (1967–75); or that its deployment in *Kill Bill* owes more to its use in the kung fu feature *King Boxer / Tian xia di yi quan*, also known as *Five Fingers of Death* (1972). The sound is heard only fleetingly in *Ironside*, not in the most familiar part of the theme or in the body of the programme itself, and its notes are shorter and thinner. In *King Boxer* the sound is stretched out further, very much as used in *Kill Bill*, and serves a similar purpose of heightening key dramatic moments in the fight-action, including the glowing red

of the hands of the protagonist when using a special 'iron-fist' technique to defeat his enemies. The cut-in red-tinted flashback is adapted from the spaghetti western *Death Rides a Horse / Da uomo a uomo* (1968), where it is used, similarly, to signify moments in which a man seeking revenge for the murder of his family catches sight of details from his childhood memory such as a tattoo, an earring and a scar that identify the killers. Ennio Morricone's theme from *Death Rides a Horse* is used more than once in *Kill Bill*, which also includes an opening title card 'revenge is a dish best served cold' ('Old Klingon Proverb') that echoes the advice of one of the major characters in the earlier film, Ryan (Lee Van Cleef), that 'revenge is a dish that has to be eaten cold' (variations on the line have also been attributed to Shakespeare, among numerous others). Another *Kill Bill* connection from *King Boxer*, relating especially to the *Five Fingers of Death* title given to the US release, may be found in the 'Five-Point-Palm Exploding Heart Technique' taught to The Bride by the kung fu master Pai Mei (Gordon Liu) and eventually used to despatch Bill (David Carradine). At which point the references begin to multiply (as they might at any place of entry into the film). The figure of Pai Mei, or variations on the name, is a reference to a 'white eyebrow' master who figures prominently in a number of 'classic' kung fu features.[49] The mention of Carradine brings in resonances brought to the project by his iconic role as star of the 1970s series *Kung Fu* (1972–5), a character also referenced – in a typically Tarantino web of associations – in the announcement by Jules (Samuel L. Jackson) in *Pulp Fiction* that he is to abandon his profession as a hitman and intends to 'walk the earth ... you know, like Caine in *Kung Fu*'.

The fight in Vernita Green's house is also replete with points of reference of varying degrees of obscurity, depending on the cultural background of the viewer. The over-emphatic zoom that leads into the flashback is a technique used on numerous occasions in the two films and also associated with both kung fu movies and the spaghetti western, the latter a source of many references across the two episodes of *Kill Bill*, especially on the music track. As a number of commentators have suggested, the process of referencing is built into the fabric of the film itself to a greater extent than is the case in Tarantino's earlier films, instead of occurring most prominently at the level of character

dialogue or in the background of the action. The use of music associated with spaghetti westerns, either from individual films such as *Death Rides a Horse* or more generally, is the most sustained source of intertextural reference, lending to the films a sense of mock-operatic and melodramatic grandeur. They also draw on visual strategies associated with other filmmakers or formats, including the use of directly overhead shots (associated with the work of Alfred Hitchcock and, in more immediately Tarantino-universe territory, the Hitchcock influence on Brian De Palma) and split-screen techniques (also suggestive, in this generic terrain, of De Palma). A more obvious example is the use of anime in telling the back-story of O-Ren Ishii (Lucy Liu), another of The Bride's targets. The fight with Vernita, especially its use of knives, has been compared with sequences in many kung fu films and other exploitation features including *Switchblade Sisters* (1975), directed by Jack Hill, one of a number of 'cult' B-movie directors celebrated by Tarantino. At the more obscure end of the scale, the alias adopted by Vernita in her new, domesticated life, married to a doctor, is Jeannie Bell, the name of an actress who appeared in several blaxploitation features in the 1970s.[50]

That the *Kill Bill* films can be experienced on different levels, depending on viewer access to particular subcultural capital, is acknowledged by Tarantino. Reference points located in Japanese and Chinese popular culture were not expected to be picked up by American viewers, he suggests, while the same applies the other way around.[51] The films were clearly designed to contain much that would appeal to aficionados such as Tarantino himself, as well as working for wider audiences. The question of viewer engagement with less obvious references is not just a static phenomenon, however, in which some are included and some excluded. Films such as these are also surrounded by active processes in which such knowledge is produced and exchanged, especially in online forums in which subcultural capital can be a form of currency. The *Kill Bill* films lend themselves perfectly to this terrain, providing scope for the display and acquisition of subcultural capital of various kinds, including that based on the recognition of films, genres and other popular-cultural reference points. A typical process is that one enthusiast posts a list of references on a fansite web forum and invites others to comment or contribute. One

poster to The Quentin Tarantino Archives forums, for example, starts a thread titled 'Kill Bill references (please contribute)', offering 48 sources, some more specific than others. With what appears to be a typical combination of modesty and ambition, the poster comments: 'I don't claim to have caught them all, but perhaps this list can one day be turned into something pretty complete. Please add, correct and expound on this list however you can.'[52] Added to the list is one reference 'noted elsewhere, but I can't confirm' and an additional 12 titles under 'References listed on IMDB [the Internet Movie DataBase, imdb.com] that I can't figure out'. This particular thread received 311 replies, as of the time of writing, and was listed as having been read 23,858 times (one of only a handful of the many threads related to the films to have received such numbers of readings). Responses include additions, clarifications, queries and debates about the validity of various claims and counter-claims. The tone of discussion ranges from assertive bravado to uncertainty, and much in between. A distinct sense is generated overall of a trading of knowledge among more or less well-qualified members of an in-group, in some cases defined explicitly against the opinions of others. One poster, for example, questions the attribution of the number of Bill's Mexican villa apartment (101) to *The Matrix*, as reportedly suggested by the Internet Movie DataBase, agreeing with another who suggests that the primary source is George Orwell's novel *1984*. This kind of trumping, in which a source wielded by one commentator is out-ranked by that suggested by another, is common currency in such discussions, phrased here in a manner that suggests a hierarchy of specific expertise. It is probably not a *Matrix* reference, the poster suggests, 'but you know the imdb guys. They'd list anything in the movie references section. 60% of all the films they list are probably all coincidental.'[53] The 'imdb guys' are less discriminating, the poster implies, less rich in the specific subcultural capital held by the particular fan-expert community.

Where one poster picks up a single detail, another will sometimes expand, again demonstrating a richer store of the relevant capital. A brief mention of *Death Rides a Horse* in connection with the 'quick zoom' accompanying The Bride's memories is followed, for example, by the comment 'This movie [*Death Rides a Horse*] has a lot more references than that', accompanied by a lengthy and detailed list.[54] The

first poster then replies, keen to clarify that it was the full effect (the flashbacks, not just the zoom) that was the subject of the original post, adding 'I'm aware that QT's use of the zoom was inspired by The Shaw Brothers'. The latter contributes little to the sum of knowledge provided in the thread, that source having already been established by another reply, but is a gesture that serves to reclaim some status for the poster. The relative standing of posters in this forum, like many others, is openly hierarchical. Different star-ratings, and accompanying descriptors, are allocated on the basis of numbers of postings, ranging from 'Starter' to 'Forum Mod-Squad', the above exchange occurring between a one-star Starter and a four-star 'Veteran Tarantino fan'.

Forums such as this also serve to spread the word on source films, encouraging those who have not seen them to track down copies of their own. To be a Tarantino fan is, for many, to share some if not all of the director's own tastes. One section of the archives website, titled 'The Geek Spot', is a weblog dedicated to this process, 'trying to bring you a little bit closer [to being a Tarantino fan] who is a fan of him not only because he makes great movies, but also because he opens our eyes to films we otherwise might never heard of [sic] or watched'.[55] Subcultural capital valued in its own right, as well as that required for a more 'complete' appreciation of *Kill Bill*, can be acquired this way, a process that also expanded in this case beyond the confines of fansites that might be expected to be preaching to an audience ready to be converted. The archives website received a plug in a feature in *The Guardian* newspaper, for example, that offered information on sources for the film to a wider audience.[56] The immediate hook for this piece was a 'Kill Bill Connection' programme at the Institute of Contemporary Arts in London which featured screenings of *The Doll Squad* (1974), *Lady Snowblood*, *Female Convict Scorpion: Jailhouse 41 / Joshuu sasori: Dai-41 zakkyo bô* (Japan, 1972) and *Thriller: A Cruel Picture / Thriller: En Grym Film*, also known in English as *They Call Her One-Eye* (Sweden, 1974), a revenge feature to which *Kill Bill* nods most overtly in the eye-patch worn by Elle Driver (Daryl Hannah). This is another form of dissemination of source materials, although situated in this case through the frame of a 'high culture' institution that marks a significant blurring of cultural hierarchies. Two limited edition 'Kill Bill Style' box sets were also distributed, one featuring *Babycart in the*

Land of Demons / Kozure ÔKami: Meifumando, aka *Lone Wolf and Cub: Baby Cart in the Land of Demons* (Japan, 1973), *Zatoichi's Pilgrimage / Zatôichi umi o wataru* (Japan, 1966) and the *Lady Snowblood* sequel, *Love Song of Vengeance / Shura-yuki-hime: Urami Renga* (Japan, 1974). Tarantino had himself taken part in this process years before the release of the *Kill Bill* films, organizing the theatrical and video release of grindhouse favourites (including *Switchblade Sisters*) and some other neglected films through his Rolling Thunder Pictures company, under the auspices of Miramax, in the late 1990s.

Discussion of the *Kill Bill* films, including reference-spotting or otherwise, can also be found in online forums that are likely to have more inclusive constituencies than Tarantino fansites. The Amazon.com website offers a substantial body of responses to *Volume 1*, a total of 1,079 reviews at the time of writing from which I have taken 1,000 as a sample with which to examine a range of different reactions to the film.[57] The general orientation of the reviews is highly varied, as is the case with the reviews of Kaufman-scripted films cited in the previous chapter. Some are detailed, substantial and/or coherently argued. Others are very brief, sometimes only a few words. They range from wildly enthusiastic to disappointed or appalled, tending in many cases towards either end of the spectrum ('you either love it or hate it' is a frequent sentiment, here as in the Kaufman films), although the sample also includes significant numbers located in the middle ground and/or without strongly expressed views. If this is a much wider constituency than that found in fansites, as seems clearly to be the case, quantitative analysis reveals a significant minority in possession of sufficient subcultural capital to be aware of the reference sources to one degree or another. Some 350 respondents (35 per cent) evidence a greater or lesser degree of awareness, 154 demonstrating some specific or detailed knowledge of sources, 172 some awareness and 24 displaying more substantial investment in the deployment of such capital.[58] Explicit reference to Tarantino by name, or in the context of reference to his other films, runs at a higher level, as might be expected, considerably more so than would be the case for most filmmakers: 420 cite Tarantino (approvingly or otherwise), plus another 229 referring to both writer–director and other Tarantino titles, giving a total of 649 (65 per cent) who situate the film in relation to an auteur source.

Orientation towards cinematic source materials in the Amazon responses is varied, along a scale that runs from valorization of the originals to unawareness of their existence (or, at least, their relevance). Some are critical of Tarantino's handling of the terrain, picking up 'flaws' in his treatment of martial arts action, particularly. Two explicitly refer the viewer to the originals instead on this basis: 'I suggest you check out the films that inspired this one: Yojimbo (or anything by Toshiro Mifune), The Seventh [sic] Samurai and almost any of the Zatoichi films (not the remake!)' (R.N. Bailey, Tacoma, WA, USA, 9 April 2005); 'If you liked this movie then do yourself a favor and check out the japanese and chinese directors and the films that KILL BILL is referencing ... Dead or Alive, Ichi the Killer, Any Chinese language John Woo film and of course any Shaw Bros. martial arts film (Dirty Ho, Invincible Shaolin, Fist of White Lotus just to name a few good ones.)' ('A viewer', no details given, 14 July 2004). Distinction is marked here by preference for the original, which entails pre-acquired familiarity with a less readily or immediately accessible body of work. Others lay down clear markers of distinction in the exercise of cultural capital in relation to *Kill Bill* itself. As one puts it:

> Kill Bill: Volume 1 on the surface looks like a very empty fluff made only to shock the already desensitized viewers, but underneath, it is really a very intelligent piece of art. Intelligent in a sense that it knows the rules of the cinema: it knows it [sic] audiences are and doesn't give a damn thing or two to those who don't want to get involved. (John Albarracin, Toronto, Canada, 16 February 2004)

The rhetoric here establishes a divide between those able to experience the film only at 'empty' or 'surface' level and those, such as the reviewer, equipped to understand the 'intelligent art' that lies underneath. A similar type of articulation, a separation of one type of viewer from another, is found in an account that distinguishes between the responses of the 'cult movie fan' and 'the stereotypical "white" person who only consumes the blockbuster hits of what ever popular trend is out'. The 'beauty of the movie' is that it 'shows us which movie watchers are out there'. As the reviewer continues:

> In the theatres I caught a lot of white people laughing at the asian
> sequences of the film and they were also dumbfounded by the special
> appearances of the actors from Wild Zero, Ichi the Killer, Battle
> Royale, and Suicide Circle to name a few. (i was hoping to see
> Tekashi [sic] Kitano) The only special appearance of a star they
> would know is 'David carra..whats his name ...? the guy from that
> Kung-Fu show ... yeah'. (SERIKON, CA, USA, 10 May 2004)

The figure of the 'ordinary' mainstream viewer, for which this writer
also uses the term 'white' to signify 'the typical stereotyping day by
day american', is caricatured in order for a more knowing position to
be constructed.

A more common strategy for those familiar with many of the
references is to mobilize their cultural capital while at the same time
making a point of not claiming to be able to get them all, in a manner
similar to the first archives poster cited above, as in the following:

> Kill Bill Volume 1 is a film for film lovers all the way through its
> core. It's a 'movie for guys who likes [sic] movies', if you will. I'll also
> be the first to admit that I didn't catch 3/4ths of the references to the
> film and television programs that Tarantino is playing homage to in
> this delightfully tacky and lovingly geeky story. (Seth Miller,
> 'Meechigan', 2 December 2004)

> I was happy I recognized over two dozen of the films on that list
> [cited earlier in the review], and that is not even close to a passing
> score percentage-wise. For all I know every single scene and shot in
> the film is lifted from something else, but the onslaught of references
> is apparently so relentless that everything old becomes new again,
> especially without a commentary track when QT can tell us the
> origin of each and every homage. (Lawrance M. Bernabo, The
> Zenith City: Duluth, MN, USA, 20 April 2004)

Such viewers are happy to admit their own limitations, especially in
comparison with the ultimate geek, as Tarantino is often characterized,
but only in the process of making clear which side they sit of the

divide mapped by the preceding examples. The commercial dimension of this process is also highlighted in the second of these extracts. A 'special edition' of the DVD was widely anticipated at the time of the reviews, an illustration of the process through which subcultural marketplace demand can be translated into economic capital for the distributors. A frequent source of complaint against Miramax was the paucity of extras provided on the initial DVD releases of the two films, widely translated as a cynical attempt to exploit the market by getting enthusiasts to buy twice: once to get their hands on their own copy as soon as possible and again, later, to gain access to extras, the most desirable of which would be the director's commentary that might give the definitive word on the references. A number of posters advised readers not to buy the initial DVD release but to wait.[59]

If these reviewers are happy to get a proportion of references but to miss others, some react with hostility to what they see as a process of in-group exclusion. One, who had high initial expectations of the film, declares it to be 'like a series of "in-jokes" that nobody except critics, Tarantino, and a few others would truly appreciate' ('A viewer', no details given, 23 May 2004). In this case, the viewer accuses others of merely going along with the critics in order not to be excluded, an interpretation that suggests an awareness of the process through which specialist film consumption can involve the constitution of in-groups: 'It is almost like the critics decided that this was a good movie b/c of the in jokes, and everybody who saw this movie says they like it because they are afraid of being left out.' Another suggests that 'the target audience for the film really boils down to the few people in the world who actually study Mr. Tarantino's influences (i.e. all 10 people in the world who have written books about yakuza films or Hong Kong Kung-fu films)' ('A viewer', no details given, 18 May 2004). For those not included, parts of the film make no sense, or have no explanatory logic, their lack of awareness of the references being demonstrated in their complaints, the kind that might be expected to draw scathing responses from fans. One example is based on unfamiliarity with the importance of anime to the film as a whole, one sequence of which is shot anime-style: 'The movie turns into a cartoon which I do not understand at all. Did they not have enough

9. Homage, or just visually striking? The distinctive yellow suit worn by The Bride in *Kill Bill: Volume 1* © Miramax Films

money to preform [sic] these actual stunts so they drew them up?' (Sarah, Florida, 23 February 2005). A thread that can be traced through a number of entries, to illustrate a range of responses, is the significance of the distinctive yellow suits worn by the Bride during the later stages of the film (initially, motorcycle leathers, followed by a tracksuit more appropriate for the final scenes of carnage).

The yellow suit is a very direct homage to the one-piece outfit worn by kung fu legend Bruce Lee in the latter stages of his final feature, *Game of Death* (1972/1978, completed after Lee's death), also used in a number of subsequent Bruce Lee 'clone' films.[60] To the well-credentialled fan, this goes almost without saying. When one 'Newbie' poster in the references thread in The Quentin Tarantino Archives offers it as a tentative suggestion ('I don't know if somebody already said this but here it goes ...'), the response is close to dismissive. 'That's pretty much common knowledge', suggests a five-star forum moderator; 'And yes, as we all know Quentin is a huge fan of Bruce Lee which is where he got the suit', adds a three-star 'Real McCoy' poster.[61] Constructions such as 'pretty much common knowledge' and 'we all know' are deployed in such contexts as boundary markers, seeking to establish a distinct community based on certain minimum levels of (sub)cultural capital. Among the Amazon reviewers, comments about the suit are deployed in a number of different registers from a wider constituency in which such knowledge cannot be assumed. For some it remains a marker of in-group distinction. The

suit is an example singled out by John Albarracin to illustrate his distinction between 'surface' and deeper understandings of the film:

> For instance, The Bride wears a yellow jumpsuit during the last hour
> of the movie. To the uninitiated, it's just a striking sexy vintage
> number. To those in the know, it's a replica of Bruce Lee's tracking
> jumpsuit from his 1979 movie Game of Death.

Another reviewer, perhaps slightly less well initiated, picks up the reference to Bruce Lee, but does not demonstrate knowledge of the film in which the suit was originally worn. In a third case, a reviewer clearly possessing less of the requisite subcultural capital remembers seeing 'another DVD film with someone else wearing the same yellow jumpsuit with the black stripe on it', but cannot remember the title (Andrea, no other details provided, 27 June 2005). This time the context in which the suit is mentioned is very different. The reviewer begins by establishing that the film has become a favourite although she had 'absolutely no interest' in seeing it initially and only went with her boyfriend. The yellow suit comes up in a more general consideration of the 'outfits' in the film, as might stereotypically be expected of a female correspondent. Other Amazon reviewers appreciate the suit on its own merits, with no reference, vague or specific, to its appearance elsewhere. For one: 'The Bride dressed in a yellow track suit? It sure seems to make no sense, but maybe that's the point? Damn, it is just beautiful filmmaking' (T. Williams, San Diego, CA, USA, 3 July 2005). It only really makes any specific sense if the reference is caught, but this viewer is not alone in finding other sources of appeal for such elements of the film. Another was drawn to the film by the trailer, without really being able to identify why: 'Maybe it was the settings? The dialogue? The costumes? The overpour [sic] of blood, contrasted with the yellow of The Bride's jumpsuit?' ('Jagged Little Teen', Leeds, England, 23 May 2004). The suit, here, has an aesthetic appeal of its own, regardless of any other logic, especially when combined with the red blood – a view that can hardly be dismissed given the wider use of the yellow/red colour scheme throughout the texture of the films and their promotional artwork. A similar emphasis on the aesthetics of the suit is found in another response, which concludes that the film is 'a

succession of mostly colorful and pleasing images. Consider the Brides [sic] battle with O-Ren Ishii, the Tungsten film blue of the moonlit garden complimenting [sic] the Bride's orangish yellow outfit' (Mark Keith, Mesa, AZ, USA, 22 May 2004).

The broader point to emphasize here is the extent to which the film works on both levels: as a glorified and deliberately 'cheesy' homage to the grindhouse tradition, including many specific examples and other aspects of popular culture, and as an updated version of a grindhouse film that works according to its own more self-sufficient logics. *Kill Bill* has plenty of the 'immediate accessibility' described by Bourdieu, as is suggested by the responses of many Amazon reviewers who demonstrate no particular awareness of its status as a celebration of past movie traditions. A number of respondents make a point of articulating the fact that their enjoyment of *Volume 1* was in no way diminished by their lack of familiarity with its sources. As one puts it:

> Reading some of the reviews and articles about *Kill Bill*, Tarantino planned this movie as a salute to Japanese martial arts movies of the 1970s, spaghetti westerns, and other forms of 'grind' cinema. Not well versed in those styles didn't hamper one bit my enjoyment of the film. It works on all levels. (J.A.H., Virginia, 15 April 2004)

Another, reacting very positively, declares their status as 'an ordinary, non-cinema buff' (W. Kaplan, Wynnewood, PA, USA, 19 April 2004). A third declares:

> I don't know jack about Kung Fu movies, I haven't seen most of the spaghetti westerns in years, and I'm no cineaste. When I saw this movie, though, I got the reaction I always get from QT's films – I was immediately electrified by the power, the beauty and the originality of his vision. (kevnm, Costa Mesa, CA, USA, 15 April 2004)

If the *Kill Bill* films can work on different levels for different viewers, shifts of register can be identified from one moment to another within the text, as suggested above in the case of the fight with Vernita Green. It is one of the hardest-hitting sequences in the two films, a function partly of the signifiers of 'realism' cited above

(combined with more stylized effects) and its setting in a domestic context. Within this sequence, however, a number of shifts occur. At one point, the pair are squared-off and ready for another phase of the struggle, framed with one figure at each side of the screen, when a school bus is seen drawing up outside through the window behind them, from which Vernita's young daughter emerges. The effect is comic, an intrusion that is incongruous and given a deadpan impression by its introduction into the background and our awareness of the process through which it is noticed by the participants as they exchange glances. A tacit agreement is made for the fight to be put on hold, knives concealed behind their backs. On-screen tension is reduced, and a comic edge continues, as Vernita tries to explain away the chaos they have created in the living room. A dialogue scene ensues between Vernita and The Bride, in the kitchen, during which they exchange insults and re-arrange their fight for the early hours of the next morning. A nod to *Pulp Fiction* is inserted as The Bride marks out a rectangular shape with a finger ('that would be about square ...', she suggests: if she killed Vernita, her daughter and her husband, to make up for the violence at her wedding rehearsal), mirroring a similar device employed with the same performer in the earlier film (although in that case overtly breaking the frame by having the shape drawn in dotted lines onto the screen). Shades of *Reservoir Dogs* follow, when Vernita complains that she should have had The Bride/Black Mamba's codename (cf. the complaints of 'Mr Pink'). Then, just as the viewer has been encouraged to relax (as has Vernita, in The Bride's earlier observation that 'You can relax now'), Vernita suddenly shoots at The Bride with a gun concealed inside a box of cereal. She misses and, with what are displayed as 'lightening reflexes', the latter kicks a cup of coffee at her opponent, followed by a fatal knife throw to the chest. A movement by the Bride, in a low-angle shot, reveals the presence of the daughter at the kitchen door, her act of witness adding considerably to the impact of the abrupt death of her mother.

This sequence displays a number of shifts in the operative modality: different degrees to which the film asserts constructions of 'reality', plausibility or comic and otherwise inventive fantasy.[62] Shifts occur in the extent to which viewers are offered a position of 'implication' in the action, how far they are encouraged to sympathize or empathize with

10. Excessive appropriateness: The 'Kaboom' brand on the cereal box through which Vernita fires at The Bride, before meeting an abrupt end, in **Kill Bill: Volume 1** © Miramax Films

characters and to treat on-screen events as being of some relative consequence, if only within the parameters of a fictional universe.[63] Various elements can function to weaken implication, especially those that have comic effects, are coded as 'over-the-top', overtly stylized or that otherwise bring intertextual references into play. To become aware of intertextual references, for example, existing in a realm beyond the diegetic universe, is to be pulled away, at least to some extent, from a process of vicarious emotional 'involvement' of some kind in the immediate ongoing action (although it seems likely that viewers can often engage at such different levels simultaneously rather than having to choose between one and another; the process of engagement is likely to be a complex one and far from easy to measure). The same often goes for comedy or overt stylization, the modalities of which create space for the enjoyment of actions the implications or consequences of which are not taken too seriously even within the fictional world (slapstick violence, for example, that does not really seem to 'hurt' characters; or stylized/excessive violence, as in *Kill Bill*, although in this case viewer responses are often sharply divided on the question of implication, not to mention the greater pain suffered by fictional protagonists). A recurrent source of controversy in the work of Tarantino is the mixing of these modalities, particularly the creation of an unstable blend of violence and comedy in certain sequences in *Reservoir Dogs* and *Pulp Fiction*.[64] A similar effect occurs in Vernita Green's kitchen, in

which shifts of modality occur in a highly compressed manner that leaves one component hard to separate out from another.

Vernita's gunshot is a sudden betrayal, coded as 'shocking', but simultaneously undermined, in terms of its implication-effect, by the jokiness of the 'Kaboom' brand name on the cereal box. How exactly this is taken will depend, as with other details such as familiarity with the preceding references to *Pulp Fiction* and *Reservoir Dogs*, on the particular stock of cultural capital possessed by the viewer. It might be supposed, in its excessive appropriateness, to be an imaginary brand, like some others that populate the Tarantino-movie universe, although it is in fact a real product of General Mills (one of many such issues on which the visitor to The Quentin Tarantino Archives, and other such sources, may find enlightenment). If the presence of 'Kaboom' and the stylized nature of The Bride's despatch of Vernita suggest the modality of what Tarantino has described as the 'movie, movie' world – that is, a fictional world that has the universe of what is possible in movies as a primary source of orientation – the revelation of the presence of the daughter operates to complicate the effect. A young girl witnessing the violent death of her mother is a breach of socio-cultural taboo, and has an emotional effect likely to increase the implication quotient (it can be contrasted, for example, with the comic quip widely employed after such killings to assert 'not to be taken too seriously' modality in more conventional Hollywood action cinema). It is a breach for The Bride herself, who says, discomforted: 'It was not my intention to do this in front of you.' At the same time, however, the child witnessing the death of a parent is also a familiar revenge-movie trope, given future potential for deployment here in The Bride's comment: 'When you grow up ... if you still feel raw about it ... I'll be waitin'.' The manner in which the presence of the daughter is revealed – a device known precisely as 'the reveal', 'especially prevalent in horror films' – is *also* a convention that might be appreciated as such by some viewers.[65] In this case, then, material that might increase or decrease implication is closely entangled, creating the potential at the textual level for an overlapping of different levels of engagement, further qualified by the orientation of the individual viewer.

In some cases, the violence of *Kill Bill* is located in a more clearly fantastical context from which the viewer is likely to remain more

unambiguously distanced, the most obvious example being the wildly excessive killing of hordes of O-Ren's henchmen and women in the House of Blue Leaves sequence towards the end of *Volume 1*. This sequence leaves little scope to be enjoyed other than on the level of stylized excess and/or in relation to the traditions to which it is homage or parody. It works less well as what is generally likely to be recognized as part of a 'plausible' self-sufficient fictional world, a ground on which it is criticized by some of the Amazon respondents. In many cases, however, *Kill Bill* manages to function on both levels at once, in a manner that might ideally suit its location in the Indiewood terrain. The use of music derived from spaghetti westerns, and some similar themes, offers a number of examples in which devices that might be understood as 'cheesy', clichéd or derivative also function in the orchestration of implication effects, transferring emotion from the fictional world to the responses encouraged on the part of viewers.[66] The anime section that constitutes 'Chapter 3' of the first volume is a striking manifestation of this process, and of a recombination of original reference source material. The first part of the chapter depicts another revenge scenario beginning in childhood, as nine-year-old O-Ren witnesses the slaughter of her parents by Yakuza mobsters. The sequence is explicitly gory in its bloodletting, but this is combined with a sense of grand melodrama created primarily by the accompanying music (as in the literal meaning of melodrama as music-drama). The principal source is 'The Grand Duel' by Luis Bacalov, the main theme of *The Grand Duel / Il Grande duello* (1972), which builds from a mournful harmonica theme to a soaring devotional vocal that marks the melodramatic highpoints, as O-Ren's father and mother are skewered with samurai swords while she cowers in hiding under a bed. Another piece comes in as the camera pans up the sword used to kill the father, Armando Trovajoli's 'slow and stately' trumpet theme from *Long Days of Vengeance / I Lunghi giorni della vendetta* (1966).[67]

Even if the sources are familiar to viewers – generally, as 'typical spaghetti western music', or more specifically – the music is likely to retain its emotional impact for anyone other than the most detached spectator. Other pieces often considered to have become clichéd through over-use are also resuscitated effectively in the films, including

'Don't Let Me Be Misunderstood', the 1970s Latin disco standard by Santa Esmeralda, and various uses of the pan flutes of Zamfir's 'The Lonely Shepherd'. The opening clapping, guitar and brass notes of the former play a key part in establishing the mood of the climactic confrontation between The Bride and O-Ren in *Volume 1*. The clapping alone, first, and then the guitar theme, each extended longer than their original use, create an anticipatory mood as the rivals square off and begin to fight in the snow-filled oriental garden, a sequence cited as a highlight of the film by a number of Amazon reviewers who enjoyed the material on its own terms (without any references to the likes of *Lady Snowblood*; see, for example, Mark Keith, quoted above). This is certainly the effect expressed by a reviewer who singles out the sequence in describing the film as 'so beautiful I felt emotional' because of the quality of the storyline and characters; a respondent who stresses her female identity, in recommending a film that otherwise 'comes off as a male movie' (S.D. Haynie, Carlsbad, NM, USA, 19 August 2004). Some disagree, however. One of the reviewers cited above, complaining at what is seen as a very limited target audience, argues that the in-group referencing 'really detracts from any emotional attachment to the film' ('A viewer', 18 May 2004). Three others offer quite lengthy accounts that identify very clearly the modality shifts that characterize *Kill Bill*, although they are viewed here as shortcomings:

> After the kitchen knife fight I was expecting something along those lines throughout the film. Meaning, the realism of that fight scene made me believe that most of the fight scenes would have that degree of realism to it [sic]. But as the movie went along the scenes just got more and more cartoonish. Like the blood shooting out of every chopped off limb. Maybe it was something QT was aiming for and therefore was done on purpose but it just didn't do much for me. (Tonnie Johnson, Detroit, MI, USA, 16 April 2004)

> Tarantino is sometimes asking the audience to identify, or empathize, with his characters, while other times we are asked to step back and laugh, when the violence is so over the top. One or the other is fine, but putting the two together seems problematic – and I'm not sure

that the movie resolves this issue. ('A viewer', no details given, 9 May 2004)

The third reacts more strongly, citing the painful nature of the opening close shot of the blood-spattered Bride before Bill delivers what is meant to be the *coup de grace*:

> If the whole film is an honorific romp through karate-dom, this opener is inexcusable. Uma's suffering is effectively real, genuinely involving, and repulsively, disgustingly, irrepressibly sadistic as a film invention for this dismissible genre. Tarantino missed that point so badly; the films he's honouring are soap-operatic, superficially involving, and radically forgettable and forgivable. They're also consistent in tone, even dreck like John Woo's Hard Target. (Christopher Wren, Denver, Colorado, USA, 19 May 2004)

Such a reaction from some viewers is not surprising, given the more general potential of modality shifts to create discomfort and alienation (precisely the reasons for their use in some circumstances). In *Kill Bill*, this might be the price that has to paid, in the response of some viewers, for the achievement of the particular blend that is offered between different potential modes of engagement. The shifts of modality, and the challenge they can represent for viewers, are factors that mark the films off to some extent from the mainstream, even if they exist partly to make the film work in other respects for a wider audience. If the films are taken straight by some and as a 'carnival of referentiality'[68] by others, they can also be consumed as a mixture of the two, whether that is a difficult or a pleasurable experience. *Shakespeare in Love* can also be experienced on these different levels, as confirmed by its Amazon.com customer reviews.[69] The film with literary-artistic resonances does not accumulate anything like the degree of fan-related online and published material, however, the result of its different position in the wider field of cultural production. Web-based fan activity in particular, in relatively open-access forums, tends to surround texts rich in subcultural capital to a greater extent (or to figure more importantly in relation to such texts) than those vested with or aspiring to forms of 'higher' cultural capital. The validation of

the latter tends to be provided in the more restricted bastions of 'officially' recognized cultural authorities, including educational institutions, from which the former are often excluded, although a 'middlebrow' product such as *Shakespeare in Love* might fall into a territory somewhere between the two.

If *Shakespeare in Love* and *Kill Bill* are examples of two major poles in the Miramax strategy, they turn out to have more in common than might initially be expected. Each is targeted to a rather different constituency, but each also offers a range of points of access that require the mobilization of differing degrees of cultural or subcultural capital, a range that reaches beyond smaller niches and towards the broader, mainstream audience.[70] *Shakespeare in Love* and *Kill Bill* can also be located in a wider history of cultural borrowings and reinscriptions. If the latter might be seen as an exemplar of 'postmodern' tendencies towards the recombination of existing textual styles and fragments, *Shakespeare in Love* offers reminders of the extent to which even the most 'classic' of texts are often rooted in borrowings from others, a point explicitly addressed in the film, especially in a scene in which Shakespeare admits various 'thefts' from the work of Christopher Marlowe. Closing the circle, it is noteworthy that one fan-oriented study of *Kill Bill* situates Tarantino's magpie tendency not only in the context of the era of music-sampling in which he came of age, but also refers to the filmmaker's view that anything in the culture is 'up for grabs' as 'a very Elizabethan attitude to intellectual property rights'.[71] The concept of the author/auteur remains important to the understanding and reception of such texts, from the work of Shakespeare to that of Tarantino, but it is not only in the latter case that the role of the author should be understood as a matter of the re-articulation of existing materials as well as of individual creativity. Focusing on the more recent period, in the context of proliferating media sources and texts, Jim Collins suggests that 'cinematic authorship now obviously needs to be reconceptualized in reference to directors whose "personal vision" is articulated in terms of their ability to reconfigure genre artefacts as eclectically, but also as individually, as possible'.[72] Whether more or less generally applicable, the formulation captures nicely Tarantino's approach to the *Kill Bill* films, as a highly individual, personally motivated take on a range of existing generic

materials. *Shakespeare in Love* might be understood rather differently, and certainly far less as an 'auteur' production associated with individual filmmakers (very few of the Amazon reviews mention the director John Madden – only 16 out of 476, or 3.3 per cent; three times as many – 47, or 10 per cent – cite Stoppard, by far the better-known of the two). As much as anything, authorship of the film might be ascribed to the Miramax brand itself and its signification of a particular location in the field of cultural production (although the company is not named by many Amazon contributors). The auteur–filmmaker returns to centre-stage in the next chapter, however, in the case of Steven Soderbergh, a figure whose work has both crossed and straddled the indie/Hollywood divide.

Notes

1. Peter Biskind, *Down and Dirty Pictures*, 81–2.
2. Biskind, *Down and Dirty Pictures*, 148.
3. Biskind, *Down and Dirty Pictures*, 47.
4. *Down and Dirty Pictures*, 48.
5. Higson, *English Heritage, English Cinema: Costume Drama Since 1980*, 5. For more on the concept of 'quality', and the grounds on which it offers a process of distinction for viewers, see Jane Feuer, Paul Kerr and Tise Vahimagi, *M.T.M.: Quality Television*.
6. Higson, *English Heritage, English Cinema*, 20.
7. William Uricchio and Roberta Pearson, *Reframing Culture: The Case of the Vitagraph Quality Films*, 5.
8. On the prestige pictures of the 1930s, for example, see Tino Balio, *Grand Design: Hollywood as a Modern Business Enterprise, 1930–1939*, 179–211.
9. *Reframing Culture*, 5.
10. Eugene Hernandez and Mark Rabinowitz, 'Decade: Miramax Ten Years Later – How Do You Spell Indie, part 1', indieWIRE, 22 December 1999, accessed via indiewire.com, an interview specifically framed in terms of the inclusion of Miramax in a broader indie/Indiewood spectrum.
11. A different strategy in pursuit of similar ends is found in Baz Luhrmann's *Romeo + Juliet* (1996), in which an updated version of the play is shot in an MTV style designed to appeal to a youth audience.

12. *Distinction*, 323.
13. See, again, Claire Monk, 'The British heritage-film debate revisited'.
14. *Popular Culture and High Culture*, 150.
15. 'John Madden', *The Hollywood Reporter*, 8 March 1999, uncredited, accessed via www.hollywoodreporter.com.
16. 'John Madden'.
17. Martin Grove, 'Hollywood Report: Shakespeare no surety of a taming of the shrill', *The Hollywood Reporter*, 12 March 1999, accessed via www.hollywoodreporter.com.
18. 'Shakespeare in Love', 25 December 1998, accessed via http://rogerebert.suntimes.com.
19. Jonathan Romney, 'Comedy, love, and a bit with a dog', 29 January 1999, accessed via http://film.guardian.co.uk.
20. Nick Fisher, 'The Source Says; Film', 29 January 1999, accessed via www.thesun.newsint-archive.co.uk, paid-for archive.
21. Biskind, *Down and Dirty Pictures*, 327.
22. For more examples, see my *Film Comedy*, 57–61.
23. Gigliotti interview in Biskind, *Down and Dirty Pictures*, 331.
24. *Down and Dirty Pictures*, 31.
25. This and the following detail is from Biskind, *Down and Dirty Pictures*, 227–9.
26. *Down and Dirty Pictures*, 153.
27. *Down and Dirty Pictures*, 291–2.
28. Biskind, *Down and Dirty Pictures*, 191.
29. Biskind, *Down and Dirty Pictures*, 263.
30. Biskind, *Down and Dirty Pictures*, 277.
31. Biskind, *Down and Dirty Pictures*, 375.
32. Martin Grove, 'Hollywood Report: Miramax plays it smart with a pair of comedies', *The Hollywood Reporter*, 2 December 1998, accessed via www.hollywoodreporter.com.
33. Andrew Hindes, 'Oscar boosts the Bard', *Variety*, posted at variety.com 16 February 1999.
34. 'THR E-MAIL: Miramax has money on its man in Oscar's joust', *The Hollywood Reporter*, 8 March 1999 (uncredited), accessed via www.hollywoodreporter.com; Andrew Hindes, '"Shakespeare" marketed to the "Max"', *Variety*, posted at www.variety.com, 23 March 1999.
35. Biskind, *Down and Dirty Pictures*, 101.
36. Leonard Klady, 'Oscar fave Bard wires the B.O.', *Variety*, posted at www.variety.com, 25 March 1999.
37. Biskind, *Down and Dirty Pictures*, 193, 229.

38. Biskind, *Down and Dirty Pictures*, 159–60.
39. Biskind, *Down and Dirty Pictures*, 375.
40. *Down and Dirty Pictures*, 470.
41. *Down and Dirty Pictures*, 375, 385.
42. *Down and Dirty Pictures*, 189.
43. Eugene Hernandez, 'Tarantino's Latest, "Kill Bill", Split Into Two Films', *indieWIRE*, 15 July 2003, quoting Weinstein from a report in *The New York Times*, accessed via http://indiewire.com.
44. Interview with Lawrence Bender in 'Martin A Grove, Twin killing for "Kill Bill" in theatres, DVD', *The Hollywood Reporter*, 19 March 2004, accessed via www.hollywoodreporter.com.
45. Brian Fuson, '"Kill" fills boxoffice bill', *The Hollywood Reporter*, 13 October 2003, accessed via www.hollywoodreporter.com.
46. Grove, 'Twin killing for "Kill Bill" in theatres, DVD'; Brett Sporich, 'Tarantino's "Bill" makes a killing on DVD', *The Hollywood Reporter*, 15 April 2004, accessed via www.hollywoodreporter.com; Maria Matzer Rose, '"Bill 2" slashes rental, sales competition', *The Hollywood Reporter*, 19 August 2004, accessed via www.hollywoodreporter.com.
47. Fuson, '"Kill' fills boxoffice bill'.
48. David McNary, 'Weekend warriors at box office', *Variety*, posted at www.variety.com, 15 April 2004.
49. For more detail, see Leon Hunt, *Kung Fu Cult Masters: From Bruce Lee to Crouching Tiger*, 65–7.
50. D.K. Holm, *Kill Bill: An Unofficial Casebook*, 25.
51. Tomohiro Machiyama, 'Quentin Tarantino reveals almost everything that inspired Kill Bill', http://Japattack.com, 2003; reprinted in Paul Woods (ed.), *Quentin Tarantino: The Film Geek Files*, 178.
52. Post by 'jmachinder', 19 October, 2003, accessed at www.tarantino.info/forum/index.php?topic=642.0, November 2005–May 2007.
53. Posted by 'Scarface', 21 September 2005, accessed www.tarantino.info/forum/index.php?topic=642.180, November 2005.
54. Posted by 'Ladyback', 20 October 2003, accessed at www.tarantino.info/forum/index.php?topic=642.0, November 2005.
55. 'Welcome to the Geek Spot', 23 October 2005, accessed at www.tarantino.info/index.php?option=com_content&task=blogcategory&id=104&Itemid=58, November 2005.
56. Steve Rose, 'Found: where Tarantino gets his ideas', *The Guardian*, 6 April 2004, accessed via http://film/guardian.co.uk.
57. Customer reviews accessed November 2005, starting at www.amazon.com/gp/product/B00005JMEW/104-7136300-8247120?v=glance&

n=130&s=dvd&v=glance. Similar numbers of 'user comments' were posted on the relatively more specialist Internet Movie DataBase.

58. The exact boundaries between these categories are somewhat imprecise, based on my subjective judgement of the responses given.

59. A new edition titled *Kill Bill: The Whole Bloody Affair* was scheduled for release on DVD in November 2007, although delayed and not available by the summer of 2008; it remained unclear at the time of going to press what new extras would be included. Tarantino has not usually provided commentaries on his own films to date.

60. For more on the film and its clones, see Hunt, *Kung Fu Cult Masters*, chapter 3.

61. These postings accessed at www.tarantino.info/forum/index.php?topic=642.150 and www.tarantino.info/forum/index.php?topic=642.180, November 2005.

62. For a more detailed discussion of modality and modality shifts, see my *Film Comedy*, Introduction.

63. This use of the concept of implication is from Susan Purdie, *Comedy: The Mastery of Discourse*, discussed in my *Film Comedy*, 9.

64. Discussed in detail in my *Film Comedy*, chapter 5.

65. Holm, *Kill Bill: An Unofficial Casebook*, 34.

66. The same could be said of many spaghetti westerns themselves, especially those directed by Sergio Leone, which are also replete with references, including some that also connect with the Eastern traditions cited by Tarantino. *A Fistful of Dollars / Per un pugno dollari* (1964), for example, was based on Akira Kurasawa's *Yojimbo* (1961). The epic *Once Upon a Time in the West* (1968) is described by Christopher Frayling in terms that might easily be applied to *Kill Bill*, as 'the first truly postmodern movie, made by a cinéaste for other cineastes, as well as the wider public, and deeply embedded in a culture of quotations'. Frayling also supplies a lengthy chart of explicit citations of American westerns in the film. See *Sergio Leone: Once Upon a Time in Italy*, 37, 59–65.

67. Soundtrack review by Randall Larson, www.musicfromthemovies.com/review.asp?ID=4605, accessed November 2005.

68. Holm, *Kill Bill: An Unofficial Casebook*, 5.

69. A total of 476 reviews, accessed November 2005 from www.amazon.com/gp/product/B00000JGOH/104-4023652-8299125?v=glance&n=130&s=dvd&v=glance.

70. The existence of in-jokes or other such references only likely to be picked up by particular constituencies is not restricted to Indiewood

features, of course. They might also be found in mainstream Hollywood films, among others, where in some cases they might for some viewers permit similar processes of taste-culture-based distinction from what is perceived to be the norm.

71. Holm, *Kill Bill: An Unofficial Casebook*, 7.
72. *Architectures of Excess: Cultural Life in the Information Age*, 126.

3

Some sort of hybrid

Steven Soderbergh, *Traffic* and *Solaris*

If Miramax is the company that most clearly embodies (and played a key role in creating) Indiewood, Steven Soderbergh is an individual whose work illustrates as well as any the ability of some filmmakers not just to move between Hollywood and the independent sector, but to produce hybrid features that occupy the ground between the two.[1] Since the independent-breakthrough success of *sex, lies, and videotape* in 1989, Soderbergh's career has encompassed a range extending from very low budget to glossy studio fare. After the various personal and/or commercial disappointments of his immediate follow-ups to *sex, lies* – *Kafka* (1991), *King of the Hill* (1993) and *The Underneath* (1995) – Soderbergh retreated to the margins for what he later described as the restorative low-budget production of the zany *Schizopolis* and *Gray's Anatomy*, a filmed version of a Spalding Gray monologue (both 1996). His subsequent career moved with what appeared to be more assurance between different points on the cinematic spectrum, starting with the balance between more and less mainstream qualities found in the two crime-thrillers *Out of Sight* (1998) and *The Limey* (1999). *Out of Sight*, an Elmore Leonard adaptation starring George Clooney and Jennifer Lopez, leans towards the mainstream but with a number of

unconventional touches. *The Limey*, a revenge thriller, tends more towards the independent end of the spectrum, particularly during sequences that play with conventional sound/image continuity.[2] Soderbergh maintained his indie credentials with low-budget alternative productions such as *Full Frontal* (2002), shot primarily in digital video, and *Bubble* (2005), a discomforting digital feature (very much the kind of product that might be expected of a new indie director) produced as part of a package of six to be given simultaneous release in theatres, DVD and cable television, a challenge to conventional distribution strategies.[3] At the same time, he fed the studio machine with solidly mainstream productions such as *Erin Brokovich* (2000) and the all-star ensemble crime-caper remake *Ocean's Eleven* (2001) and its two sequels (2004, 2007).

An institutional manifestation of Soderbergh's attempt to bridge the indie/Hollywood divide was his partnership from 1999 with George Clooney in Section Eight, a production company with a first-look deal at the Warner Brothers studio (with which Clooney had a relationship dating back to his appearances in the television series *ER*). For Soderbergh and Clooney, the aim of Section Eight was to use their industrial clout to provide a sheltered space for emerging directors within the studio system. Its roster included co-production roles in Clooney's own directorial debut *Confessions of a Dangerous Mind*, *Far From Heaven* (Todd Haynes, 2002), *Insomnia* (Christopher Nolan, 2002), *Syriana* (Stephen Gaghan, 2005) and *Good Night, and Good Luck* (Clooney, 2005). From the studio perspective, the arrangement offered an appealing combination of the prestige and Academy Award potential brought by Soderbergh (and other upcoming directors) with the bankability of Clooney's star presence in a number of the films that resulted (including three of the five listed above), mostly on modest budgets. The box-office results were often disappointing, with exceptions including *Insomnia*, but a measure of insurance was provided for the studio by the inclusion of dependably commercial material such as *Ocean's Eleven* and its first sequel. The latter was widely seen as effectively the price to be paid by Soderbergh and Clooney for the freedom they were given to pursue less commercial and in some cases more politically sensitive projects. Section Eight also expanded into television production with Warner before being closed in 2006

to enable the partners to focus on their directing and acting careers (which included the second sequel *Ocean's Thirteen* [2007]).[4]

Soderbergh's name was also prominent in abortive plans from 2001 to 2002 for the creation of a new company, F-64, through which a group of prominent young directors (including Indiewood figures such as Spike Jonze, David O. Russell, Alexander Payne and Sam Mendes) would gain greater control over the production of their own films.[5] Both enterprises earned comparison with initiatives from the Hollywood Renaissance of the late 1960s and early 1970s, one aspect of which was a relative degree of freedom obtained by some directors, albeit briefly, to produce work of an at least partially unconventional nature within or on the edges of the studio system.[6] Soderbergh has commented on several occasions on his ambition to recreate something of the spirit of that era, through such arrangements and by seeking a blend in his own films similar to the mix of Hollywood/ commercial and European/art cinema characteristic of some of the celebrated films associated with the earlier period.

The main focus of this chapter is a close analysis of two films directed by Soderbergh that exemplify an Indiewood combination of mainstream and relatively more indie/alternative qualities: *Traffic*, a wide-ranging and potentially contentious multi-strand exploration of the drug trade, and *Solaris*, a meditation on love and identity that refuses to fulfil the more conventional expectations that might arise from its science fiction setting. Both are adaptations, their sources being, respectively, the British Channel 4 drama series *Traffik* (1989) and the novel *Solaris* by Stanislaw Lem, the basis for Andrei Tarkovsky's art-house classic of 1972. The existence of other versions provides useful reference points against which to measure the positions of the two Soderbergh films in the wider field of cultural production within which they are situated. They are examined here, as with the previous chapters, at the interrelated levels of industrial location, textual qualities and reception. This chapter starts with the evolution of each project in particular sectors of the commercial landscape before considering how *Traffic* and *Solaris* were positioned, sold and distributed. It then examines each text in detail including, in the case of the former, consideration of more explicitly social/political dimensions of Indiewood production than have so far been addressed in this book

(and to which I return in the next chapter). This is followed by analysis of their critical reception, including the extent to which the director is cited as a significant source of orientation, in both formal reviews and online viewer responses.

Prehistory, production

Not only an indie/Hollywood hybrid in its realized form, *Traffic* shifted location in the industrial landscape more than once, during a complex process of gestation, before eventually going into production. The original initiative came not from Soderbergh but his then girlfriend, producer Laura Bickford, who spent two years researching the subject and seeking to translate the Channel 4 series into film.[7] Soderbergh loaned Bickford $10,000 to buy a two-year option on the property in 1997, indicating that he would be interested in directing. Anything other than a simplistic or exploitation-oriented take on the subject matter was difficult to sell in Hollywood, however, and few of the studios were interested in Soderbergh's pitch. An initial deal was established at Twentieth Century Fox after Soderbergh and Bickford identified Stephen Gaghan (a former addict himself) as the preferred screenwriter. By chance, Gaghan was already committed to write on the 'drug wars' subject for the producer Ed Zwick, a concept that had been sold to Fox 2000, a division of the studio created in 1995 with a remit to produce 'character-driven' but mainstream and star-led features.[8] (The principal difference between Fox 2000 and the studio's main production arm appears to be that it avoided involvement in action/effects-oriented blockbuster material and was home to some less conventional director-led projects, including Terrence Malick's *The Thin Red Line* [1998] and David Fincher's adaptation of *Fight Club*.) Agreement was reached for the combination of the two projects and preparations went ahead in earnest.[9] Fox eventually got cold feet, however, partly as a result of its experience with *Fight Club*, which cost far more than its original budget and was savaged by many critics on release. The budget of *Traffic* threatened to follow suit (heading at this stage from an initially planned $24 million to more than $30 million) and concerns were expressed at the studio about the dark tone and episodic nature of the screenplay.[10] Strong interest was

expressed by Fox Searchlight, however, the studio's speciality division, with Michael Douglas considering signing up to play one of the lead characters, the newly appointed drug czar Robert Wakefield. It would have represented 'a major departure' towards higher-budget film-making for Searchlight, as suggested in *Variety*, a marker of the extent to which lines were being blurred at the time in the Indiewood arena.[11] As an as-yet-unrealized project, *Traffic* was pulling in two directions: distinctive qualities for which the natural home would be a speciality unit, combined with a budget heading towards parent-studio proportions. The deal with Searchlight eventually fell apart when Douglas refused to cut his usual rate of $20 million to the $2 million offered by Fox.

At this stage the project was put into turnaround, attracting interest from several quarters as a cast began to take shape, most notably USA Films, created by the former studio executive Barry Diller in 1999 from a combination of PolyGram and October Films, and run by the former Miramax executive Scott Greenstein. USA, destined later to become part of Universal's Focus Features, was another operation seeking to carve out a space between the domains of the fully mainstream and the low-budget independent. Soderbergh and Bickford moved towards an agreement with USA, but Fox was to make an unlikely-seeming reappearance in the saga. The turnaround agreement had a clause of the kind discussed in relation to *Shakespeare in Love* in the previous chapter, designed to prevent any other studio from turning it into too valuable a rival property. A list of lead actors was provided, the involvement of which would require the project to be offered back to the studio. It included Harrison Ford, a figure viewed as singularly unlikely to be interested in the role. But, just as a deal was signed with USA, Ford saw the script and said he wanted to be involved. He agreed to halve his usual $20 million fee and some additions were made to the character of Wakefield as a result of his suggestions, after meetings with Soderbergh. Bickford and Soderbergh were obliged to offer Fox its option, which it readily accepted, just ten weeks before the film was due to go into production. As Sharon Waxman puts it:

> It wasn't a dark little drug movie any more. Financially the movie made sense. With Ford cast in the lead, Fox could raise the entire

budget of the film, now $50 million, from foreign backers. That meant the studio only had to put up funding for movie prints and advertising, which would be approximately $20 million. It seemed guaranteed to at least make its money back and Fox might have a movie they could be proud of at Oscar time.[12]

But then Ford pulled out, choosing instead to appear in the more conventional thriller *What Lies Beneath* (2000). Fox sought to find a replacement and Douglas entered the equation for a second time, partly as a result of the changes made to the role of Wakefield (Douglas saw a later version of the script that was being read by his wife, Catherine Zeta-Jones, who was cast as the wife of a drug trafficker). Douglas did not want to make the film with Fox, however, according to Waxman, feeling slighted by the comparison between the previous offer made to him and the deal agreed with Ford. The studio eventually released Soderbergh and Bickford from their commitment and *Traffic* finally went into production at what had become their favoured venue, USA Films.[13]

What is very clear from the fate of the project is the importance to such works of star casting. *Traffic*, as envisaged by Bickford, Soderbergh and/or the writer Gaghan, was never going to be a very appealing prospect for the studios, for reasons that will become apparent in the textual analysis offered below. Fox had some interest, either in the shape of Fox 2000 or Searchlight, as part of a wider context in which the studios became relatively more open to somewhat unconventional material in the late 1990s (as will be seen in the case studies of *American Beauty* and *Three Kings* in the following chapter). But there were limits to how far they were prepared to take risks in the pursuit of such material. Fox already had *Fight Club*, which proved to be an expensive hot potato, even if it was to gain increased critical reputation with the passage of time, a film on which the studio head Bill Mechanic had expended much of his personal capital in the Murdoch empire. With so big a star as Harrison Ford in place, *Traffic* crossed the line into being a more or less safe bet, on the basis suggested by Waxman, particularly its potential for foreign sales. With Michael Douglas or another reasonably big name, it might have been acceptable, although less so than with Ford. For a company such as USA, it was a relatively bold

move but the kind of eye-catching Indiewood project with which Greenstein wanted to make his mark. It remained important that a star of the stature of Douglas was secured, however, for the project not to have fallen apart after such a series of reversals, particularly in the maintenance of support from the independent financier Initial Entertainment Group, first involved in the film with Fox Searchlight, which put up the lion's share of the budget in return for the overseas rights.[14]

Solaris was destined at one stage to be Soderbergh's first project to fall under the aegis of F-64, in a deal in which the directors involved in the company would make some three films each over a five-year period. USA Films was in talks to handle domestic distribution, an arrangement according to which each director would retain ownership of the copyright, a significant break with conventional business practices and rare even in the independent sector. Studio partners would also be sought, for additional finance, in return for overseas rights. In the event, F-64 came to nothing, for a variety of reasons, including the fact that USA became caught up in the series of corporate manoeuvres that resulted in it becoming part of the Universal empire. *Solaris* came to Soderbergh via more established studio forces. According to the film's website and one of the features provided on the DVD, the initiative came from a Fox employee known personally to Soderbergh.[15] The director was asked if he was interested in science fiction. Giving a less than enthusiastic response, he was asked what kind of science fiction project might entice him, to which he replied *Solaris*, having read the novel and seen the Tarkovsky film in the past. It turned out, by chance according to this account, that the rights to the property had recently been acquired by James Cameron, whose production company Lightstorm Entertainment had a deal at Fox. According to Cameron, he and colleagues at Lightstorm were in the process of wondering how to handle the project – whether he should write it himself, what kind of approach to take to the material – when Soderbergh called to say he wanted to make the film. Cameron said he was delighted and became one of the film's three producers.[16] Soderbergh wanted to write the screenplay on spec, rather than signing a deal in advance, a stance that can be understood as a characteristically Indiewood marker of relative distance from the studio and from

Cameron's mainstream-oriented company. It was a way of ensuring that the production was shaped primarily according to Soderbergh's own, independent/creative take on the material and remained his project rather than one in which he acted simply as writer/director-for-hire within the studio system. After the completion of a second draft, Lightstorm took the script to Fox where it was given the go-ahead – without, it seems, any of the travails that afflicted *Traffic*.

A number of factors might explain Fox's less problematic attitude towards *Solaris*, even at an estimated budget of $47 million, much the same financial territory as that eventually occupied by *Traffic*. The material had nothing like *Traffic*'s potential for controversy, occupying, instead, a fairly reliable genre, even if likely to be given a different spin by a figure such as Soderbergh. Like the earlier *Out of Sight*, a similarly-budgeted Universal production, it offered the prospect of an element of prestige within reasonably popular generic confines (although it is worth noting that *Out of Sight*, a more conventional feature than *Solaris* proved to be, failed to cover its budget in the US theatrical market). It helped that Clooney came on board for his third collaboration with Soderbergh (following *Out of Sight* and *Ocean's Eleven*), giving the project immediate star power without the uncertainties that characterized the pre-production of *Traffic*. The role of Cameron is also important to an understanding of how such a film came to gain space at a major studio. His involvement would be a significant factor for Fox, the filmmaker having become a major Hollywood player, especially after the huge box-office success of *Titanic* (1997). Cameron had an established track record in science fiction, including the two *Terminator* films (1984, 1991) and *Aliens* (1986), and in achieving large grosses on films that pushed back the boundaries of higher-budget, effects-oriented productions (*Terminator 2*, *Titanic*). His reputation for refusing to compromise, and for taking total control over his own work, might not have endeared him to many in the studio hierarchy, but his economic clout, credentials and commercial instincts would have made him an appealing partner to the element of greater 'artistic' prestige brought by Soderbergh – even if the resulting film proved to be far more a product of the latter's sensibility than that of the former.

Traffic continued to blend the characteristics associated with studio and independent features when it went into production, Soderbergh

largely being given free rein and choosing to shoot the film in a manner that took on board the lessons he had taken from the experience of his almost home-movie scale work on the very low budget *Schizopolis*. What resulted was an unusual mixture of the logistics of multi-location, large-cast Hollywood production and the use of a stripped-down indie approach that included Soderbergh acting as his own director of photography and performing much of the (primarily hand-held) camerawork himself. The film was shot in 54 days, very fast for a 147-minute feature involving so many different characters and locations, often with two cameras operating simultaneously and the director encouraging a relaxed and improvisational approach to many sequences. He came under pressure on numerous occasions to hire a separate director of photography, especially given some of the less conventional shooting and processing techniques employed on the film, as detailed below. Most of the footage was shot with available light in existing locations with only one modest set constructed (used for an interrogation scene and a prison visit). A scene in the White House press briefing room was shot on a set hired for the day from the television series *The West Wing* (1999–2006). Some material was 'stolen' on the hoof, shot guerrilla-style without any permission, including one scene featuring the Michael Douglas character emerging onto the street outside the grounds of the White House. A 360-degree camera movement in the Mexican segment, during which the narrative shifts from one strand to another, was shot without any controls, the camera being held in the middle of a busy street and just a few extras added to the background passage of locals and tourists.[17] Soderbergh was also director of photography and handled most of the camerawork himself on *Solaris*, which otherwise experienced a generally more conventional production process, being shot of necessity on purpose-built sets. Both films underwent extensive changes during editing with numerous scenes being added and/or removed at various stages as Soderbergh experimented with longer or shorter, more or less explicit versions (he edited *Solaris* himself, under a pseudonym). Some important sequences in *Solaris* were shot after the end of principal photography, during the postproduction process, an eventuality for which Soderbergh says he had budgeted from the start, another demonstration of his tendency more than usually to shift around the finished form of the product.[18]

11. Uncontrolled shooting on location: Helena (in sunglasses) takes up the narrative thread from Xavier (back to camera) in *Traffic* © USA Films

He came under some pressure from USA to cut *Traffic* to more commercial length, but eventually prevailed after offering a shorter version in which much of the character background, including that of Wakefield, was eliminated.[19]

Marketing and release

Trade press reports ahead of release suggested a combination of box-office promise and potential problems for both films, in keeping with their hybrid status as features offering distinctive/alternative qualities yet seeking access to larger audience constituencies. *Variety* predicted that with 'strong reviews and intelligent marketing', USA was likely to push *Traffic* to at least the box-office ceiling for specialized releases (without specifying any figures), 'with crossover to more mainstream acceptance dependent upon multiple unpredictable factors involving awards, the zeitgeist and so on'.[20] *The Hollywood Reporter* agreed. 'Attracting audiences to this cool take on a hot-button subject won't be easy', but the film would be helped by the critical acclaim it was likely to receive 'for an ambitious, stylist attack on this much–debated subject'.[21] *Traffic* was opened indie–style in just four theatres, where it earned an estimated $500,000 in its first nine days, judged to be a

'strong limited-release showing' that 'coupled with nearly unanimous positive critical notice' was expected to enable it 'to develop significant traction', as it widened onto 1,500 screens and took $15,500,000 in its second full week.[22] It was reported to be 'generating respectable support among male audiences, but very low levels of female interest', which was interpreted as limiting its ultimate potential. It was viewed as prime Academy Award material, however, as marked by the decision to release the film in the Christmas/New Year period, in the immediate run-up to Oscar season. Soderbergh achieved the rare feat of being nominated for two best director awards, for *Traffic* and *Erin Brockovich*, winning for *Traffic*, which received a host of other accolades including Academy Awards for best adapted screenplay, best supporting actor (Benicio Del Toro) and best editing. The film certainly delivered for USA at the level of prestige, in other words, which contributed to its achievement of a very respectable $124 million gross in the domestic market.

Solaris fared much less well, ironically from the point of view of Fox given that it went ahead with this project rather than *Traffic*, being identified from the start as a feature likely to send out mixed messages. For *The Hollywood Reporter*, it 'clearly boasts prestige credentials', with the combination of Cameron, Soderbergh and Clooney, but represented a marketing challenge: 'While its sci-fi setting normally would attract male audiences, as a love story featuring Clooney, it is likely to appeal to older females.'[23] Satisfying both at the same time, as the report suggested, is far from easy, leaving the film in danger of falling between stools. It was given a bigger opening than *Traffic*, on 2,400 screens at Thanksgiving, testament to the greater clout of a major studio release, although its performance was disappointing. *Solaris* grossed $6,750,000 on its first weekend, a figure that dropped by nearly two-thirds the following week, a key measure of its likely future prospects. It finally grossed just under $15 million in the USA, fulfilling the *Variety* reviewer Todd McCarthy's prediction that it would achieve 'distinctly modest B.O. in most situations'.[24] It was, he suggested, 'a pure art film about which mainstream audiences won't have a clue', even though it was likely 'to develop a following among some critics and serious cinephiles who will value the intellectually ambitious and defiantly uncommercial nature of Soderbergh's

undertaking more than they will mind its lack of genuine depth and profundity'. For *The Hollywood Reporter*, the film was 'bound to confound viewers not prepared for a moody, claustrophobic film with ambitions beyond regurgitating the usual genre trappings and special effects-driven action'.[25] James Cameron was identified as 'one sexy name to help entice audiences', but in this case the reviewer was overly optimistic in a conclusion that the film 'should prove commercially stellar in the long haul', even with the aid of overseas box-office and DVD sales. The film had 'considerable Oscar pedigree' for another *Variety* correspondent – and had another winter opening designed to put it in the minds of academy members at the right time – but it went without nominations or, apart from some positive reviews, much other recognition significant in the prestige stakes. Soderbergh suggests in his DVD commentary that the film might have fared better if more time had been devoted to the creation of a publicity campaign that captured the true flavour of the film, which ended up being rushed into an early release soon after the end of postproduction. One of the main sources of attention it gained in advance, which might not have helped to shape appropriate expectations, revolved around the exposure of George Clooney's backside in more than one scene and a consequent row over the MPAA rating. *Solaris* was initially rated R, as a result of the sex scenes, reduced to PG-13 on appeal.

The two films were sold very differently in trailers and posters. Soderbergh's name featured in both cases – selling the imprint of the commercially accessible prestige auteur – but as a relatively minor ingredient in the mix and, in the case of *Solaris*, accompanied by the generally more commercially oriented associations of Cameron. Each film was given at least two theatrical trailers: an early 'teaser' and a full-length trailer, the latter usually shown closer to the time of release. Teaser trailers tend to be relatively brief and are often more enigmatic than their successors, seeking, as the term suggests, to stimulate interest rather than to give a fuller elaboration of the nature of the product. This is the case for many features that lie clearly in the commercial mainstream. In the cases of *Traffic* and *Solaris*, however, a distinction is created between teaser and full trailer that seems more specifically germane to the manner in which each film is located as likely to appear to broader or more specific audiences. The teaser trailer for

Traffic emphasizes the complex and overlapping nature of the texture of the film, considered in its own right below. It opens with multiple lines of text moving across the screen, individual words such as 'informants', 'congressmen', 'dealers' and 'friends' being highlighted in turn, as larger lettering appears, building up to the tagline of the film: 'no-one' / 'gets away' / 'clean'. Images of the heads of central performers appear and disappear, but relatively small scale and located, significantly, behind the text rather than in the foreground. They join together into a briefly held ensemble before the trailer moves into its second phase, a fragmented montage of overlapping sounds and images from the film out of which it is difficult to extract any sense of clear narrative orientation.

The full trailer is very different, seeking to construct an overarching narrative framework through the separation of different components of the film and the imposition of an authoritative extradiegetic commentary, delivered in classic Hollywood movie-trailer intonation. The narrative frame begins with, and is presented in such a way as to revolve largely around, the figure of Wakefield, and hence the star presence of Douglas. 'They brought him to Washington to win a war', declaims the voice, to the accompaniment of images of Wakefield with colleagues and family; 'they took her husband to send a message' (the Catherine Zeta-Jones character, wife of a drugs importer); 'they apprehended a witness to win their case' (a middleman in the same chain); 'and they paid an informant to get the truth' (Mexico scenes involving the character played by Benicio Del Toro); 'but the war they thought they had won' (images of Wakefield's daughter, becoming a drug user) 'is just beginning'. The teaser creates an impression of greater complexity and confusion than the film itself, while the full trailer goes in the opposite direction, making the connections between different strands more explicit through the imposition of an external commentary and a hierarchy that revolves more explicitly and immediately around Wakefield. The longer version fits a pattern found in many trailers used to sell relatively less mainstream/commercial products, employing strategies that tend to emphasize or impose more familiar (and, as in this case, more emphatically melodramatic) routines onto the material. The latter part of the trailer cites Soderbergh, although not by name, 'the director of *Erin Brokovich* and *Out of Sight*',

a choice of references that mixes the social-concern dimension of the former with the more conventional and star-led qualities of each. And it promises some kind of insight, the director taking the viewer 'beyond the slogans' in its portrayal of the issues, closing with brief citation of cast members Douglas, Don Cheadle, Del Toro, Dennis Quaid and Zeta-Jones.

A similar shift of dynamic between teaser and main trailer is identifiable in *Solaris*, in addition to a notable difference at the level of genre emphasis. The *Solaris* teaser is minimal and somewhat forbidding in tone. It opens with a frame-filling shot of what will prove to be the planet surface/atmosphere, a cool blue tone accompanied by dark rumbly sound effects. Text informs us that 'There are some places' / 'Man is not ready to go'. As the camera pulls back, an orbiting space station spins into frame and the soundtrack develops to include pulsating bass notes. A title gives us 'From Academy Award winners James Cameron and Steven Soderbergh', followed by 'George Clooney', the main title, a fade to black and the release date. The film is presented entirely and unambiguously as a work of science fiction, of a dark nature, with Clooney notable for his absence other than in the citation of his name. The full trailer, by contrast, starts off with resonances closer to those of romantic comedy, shifting into the tones of romantic melodrama. Science fiction is relegated largely to the level of background context. The first images are earthbound, with the characters played by Clooney and co-star Natascha McElhone in two-shot on a street, their head-and-shoulders dominating the frame, the background indistinct (concealing any futuristic setting). The music is light, hinting of romantic comedy, as Clooney's character asks, smiling, 'When do you wanna get hitched?' She gives a big smile in reply. Cut, via company titles, to another scene between the two. 'You keep putting this off, 15 or 20 years, I'm going to stop asking', comments Clooney, a quip that, again, leans towards the territory of romantic comedy. Several more shots follow the couple, linked by dissolves, including his additional line: 'You know you're with the right man.' A close examination might reveal their clothes to have a slightly futuristic/SF texture, but this is very much in the background.

The mood then shifts, and the music becomes progressively more sombre. We get a shot of Clooney with back to camera sitting on a bed

in a plain, modernist-seeming (and maybe more distinctly futuristic) room and a voice-over from another male character saying 'your wife, she's dead'. Then Clooney facing screen in head-and-shoulders, looking bereft, as big emotive strings develop on the soundtrack. Titles appear, over an image of blue planetary atmospherics, the first unambiguous indicator of a science fiction setting: 'Sometimes love is so strong' / 'It opens a passageway' / 'To a place' / 'Where the impossible can happen'. Next we see Clooney turning in bed and McElhone is at his side, followed by shots of him startled, asking how she got there and her declaration of love. Titles linking the film to Cameron and Soderbergh follow ('From the Creator of Titanic' / 'And the director of Traffic and Erin Brokovich'), intercut with scenes in which Clooney's character is told the woman is not his wife, that he is dreaming her. The music builds into a guitar break and Clooney declares 'She's alive'. Titles pose the question: 'How far will you go' / 'For a second chance', as scenes from the film show Clooney being warned of unspecified dangers and arguments over whether or not they will take the McElhone character with them. A strong thread of romantic melodrama, beginning on a lighter note, runs throughout the trailer, as the main point of orientation. The science fiction dimension is important, as it develops, but it is presented as a generic factor that provokes a particular kind of romantic/melodramatic dilemma, rather than as the primary framework in its own right. The difference between this and the teaser is striking, especially given the nature of likely pre-existing audience awareness of the property, primarily via the reputation of the Tarkovsky version or the Lem novel. The teaser sells *Solaris* as bleak, distant science fiction, in total contrast to the massively humanized and romanticized – and thus, far more commercially mainstream – version presented in the longer version.

Similar shifts of emphasis can be seen in poster and DVD artwork for *Solaris*, although tending to move in the opposite direction. The poster, like the main trailer, puts the emphasis heavily on romance, the image dominated by a large close up of Clooney and McElhone's faces meeting in a kiss. No contextual detail is visible at all, just a small area of neutral pale background. A poster designed to give a more accurate impression of the nature of the film – or a balance similar to that

provided by the main trailer – might have been expected to have supplied at least some signifiers of science fiction in the margins, but these are conspicuous in their absence. The Cameron/Soderbergh partnership is again signalled, although in relatively small text at the top of the poster, while Clooney's name appears much more prominently above the title. The tagline 'How Far Will You Go For A Second Chance' reads more neutrally than in the trailer, without any reference to travel in space or other dimensions. Of the two, potentially split, constituencies for the film identified above, the poster appeals to the female/romance/Clooney dimension (a substantially mainstream audience) that also figures dominantly if less exclusively in the trailer. A very different strategy was adopted for DVD cover artwork and accompanying posters, a switch back to clear identification as science fiction, which suggests an awareness that the previous approach had sent out the wrong signals to attract the audience to which the film itself was most likely to appeal. Clooney's image remains central, as is his name above the title, but in this case his visage is enclosed within the dome of a space helmet which reflects an array of light-panel details that suggest the interior of a spacecraft (the British release added an image of an alien planetary surface, reinforcing the clear-cut generic identification). The citation of Cameron and Soderbergh remains at the top but is slanted differently, to identify the pair as presenting a 'new version of Stanislaw Lem's sci-fi classic', playing up rather than seeking to ignore the film's relation to its original and less mainstream-oriented sources.

Poster artwork for *Traffic* appears from the start to reflect to a greater degree the overall tone and approach of the film, although identification of the central subject-matter remains only implicit. The main poster, also used as the basis for DVD covers, creates a strong ensemble/montage effect. The dominant feature is a semi-circle of five actor/character heads, beneath which appears the background texture of a map; superimposed onto the map are a few other images from the film, most notably a silhouetted male figure carrying a pistol with arms spread and a body posture that suggests he has been shot from behind. The latter implies a thriller component, with bleak connotations, as supported by the tagline 'No one gets away clean', a play on notions of clean getaways, corruption and (for those more familiar with the

nature of the material) the difficulties of escaping from drug addiction. No specific mention of drugs is made, however, beyond the connotations carried by the title, a key omission that would appear to be motivated by awareness of the potential sensitivity of the material. A generic sense of 'gritty ensemble-cast thriller' is the dominant impression created by the artwork, its claims to a form of realism being located in the choice of a somewhat grainy ochre-tinted finish (the latter reflecting the style of cinematography employed in one strand of the narrative, an issue considered in more detail below). The visages of the cast members are all caught in serious/concerned expressions, signifying a similar attitude on the part of the film itself. Another version, used in some posters, gives centre stage to the silhouetted figure and a large-typeface rendering of the tagline, emphasizing the 'bleak thriller' dimension. It is notable that a stark, more stripped down use of the same image appears on the cover of the two-disc Criterion Collection edition of the DVD, devoid of text other than the title and the company identification. A still-more bleak and art-house leaning effect is created, in keeping with Criterion's more specialist/enthusiast target market. A notable omission from this version, trumpeted on the cover of other DVD releases, is any mention of the film's Academy Award success. The implication is that such a dimension, a key marketing factor in the Indiewood realm but one that remains closely associated with and/or tainted by Hollywood, might be of lesser significance to the more 'serious' niche-audience enthusiast.

The strategies employed in trailers and poster/cover artwork reveal a number of the tensions that exist in the attempt to sell Indiewood products to more or less mainstream audiences. The scope offered by full-length trailers is used in both cases to impose frameworks that pull the films closer to likely grounds of larger-audience appeal. The same is true of the *Solaris* poster and DVD covers, but less so in the *Traffic* poster and covers or the teaser trailers used for each film. Such differences are partly explained by the different capacities of, or conventions associated with, individual promotional elements: the limited scope for the articulation of multiple dimensions in posters and cover artwork, for example, or the enigmatic tendencies of teaser trailers. But they also suggest the existence of rival pulls between the demands of maximizing potential audience appeal and ensuring a

reasonably accurate reflection of the nature of the films themselves. While the former might seem the most pressing to products of this kind of cost and relatively mainstream location, the latter can be important if poor word-of-mouth reaction is not to result from viewers being misled and feeling cheated. What, though, of the films themselves, as exemplars of Indiewood at the textual level? Some of their central characteristics have been indicated already, in the process of highlighting issues key to their genesis, production, marketing and release. These will now be considered in more detail, film by film, both in their own right and in relation to the strategies identified above.

Traffic: A $50 million Dogma movie?[26]

Traffic exhibits a number of qualities that mark it as distinctive in relation to the commercial mainstream, even if combined with some more conventional dynamics. These result from the subject matter and a number of the formal strategies through which the substance of the film is realized. As what is presented as a 'serious' treatment of various facets of the drug trade, *Traffic* is immediately located at a distance from the mainstream of commercial 'entertainment' cinema, as usually understood.[27] It remains consistent in some respects with a minority strain of earnest Hollywood 'social conscience' or 'problem' pictures, a format often associated with postwar features such as *Gentlemen's Agreement* (1947, on anti-Semitism) and *The Man with the Golden Arm* (1955, a treatment of heroin addiction that represented a challenge to the Hollywood self-censorship enacted through the Production Code). Hollywood has continued to make occasional films of this kind, often perceived as potential Oscar bait, more recent examples including *Philadelphia* (1993, AIDS and homophobia) and *The Insider* (1999, on the evils of the tobacco industry). *Traffic* wears its social conscience credentials clearly on its sleeve, seeking to intervene in broader debate on drug policy, in contrast to the many films (Hollywood or independent) that use drugs or drug-taking as devices such as thriller sub-plot material or various sources of dramatic or stylized frisson.[28] The principal defining characteristic of *Traffic*, as suggested above, is its multi-strand narrative structure, employed to give a number of different perspectives that militate against the delivery

of any single or simplistic analysis or prescription. The film revolves around several major threads: the experiences, and critical awakening, of newly appointed White House drug czar Robert Wakefield (Douglas), including the discovery that his own daughter has become an addict; the involvement of Mexican police officer Javier Rodriguez (Del Toro) in the activities of a corrupt army general whose apparent battle against drugs cartels turns out to be a cover for his involvement in one of the two rivals for the territory; the transformation undergone by the wife of an American drugs baron, Helena Ayala (Zeta-Jones), from blindly innocent incomprehension at her husband's arrest to active involvement in order to maintain the business, to ward off death threats against her young son; and the activities of undercover San Diego detectives Montel Gordon (Don Cheadle) and Ray Castro (Luis Guzmán), including the arrest of a middleman who is eventually assassinated, with Castro dying in the process, before being able to give evidence against Ayala (Steven Bauer).

The multi-strand narrative approach is one usually associated with the independent sector more than Hollywood, as I have argued elsewhere.[29] In a manner characteristic of the format, links between the various characters and components emerge and develop as the film progresses, but the balance of the overall dynamic is one that gives more emphasis to separation than to the close integration of strands into a single overriding narrative focus. *Traffic* favours a paradigmatic narrative structure – a plurality of stories, developed primarily in their own ongoing segments, most typically associated with television soap opera – over the syntagmatic structure characteristic of Hollywood and most other forms of commercial cinema, in which a single story is developed in linear fashion from one segment to another, or in which multiple story components are bound tightly together from a relatively early stage. A number of links do exist, and develop, between the different strands, but the paradigmatic approach is a clear marker of distinction from the Hollywood/ mainstream norm in its refusal to offer the conventional pleasure that results from the practice of tying up plot strands in a single overarching solution, thus creating a tidy sense of resolution and (usually) of wrongs having been righted. The typical Hollywood resolution entails a mutual resolving of personal–romantic and generic or thematically

grounded narrative dimensions. Where substantial social issues are raised, even if only implicitly, their resolution is often implied, emotionally (and usually short-circuiting any closer examination), through the dramatization of a resolution at the personal/individual level. *Traffic*, characteristically, steers a middle course between this kind of resolution and more radical narrative strategies.

Traffic opens in Mexican scrubland, where Javier and his partner Manolo (Jacob Vargas) score a major bust, only for the truckload of drugs they apprehend to be spirited away by the forces of General Salazar (Tomas Milian). The narrative then switches to the USA, for a sequence in the court-room presided over by Wakefield, about to take up his new appointment. Then to Montel and Ray about to make their key arrest in San Diego; to the plush Cincinnati suburb where the Wakefields live, for scenes of the daughter Caroline (Erika Christensen) taking drugs with friends; and so on, from one thread to another. The script and the first cut of the film began, more conventionally, with the court-room scene, immediately establishing the star-driven character of Wakefield. Starting in the Mexican thread is a more radical and somewhat disorienting move, especially given the degraded texture of the image used in these sequences (considered further below) and the fact that the Mexican scenes are performed in Spanish with English subtitles, a substantial departure for an American feature aimed initially at the English-speaking market. This is another marker of indie/Indiewood status, any other than fleeting use of subtitles generally being assumed by Hollywood to rule out any chance of reaching a large audience.[30] It is questionable whether even a company such as USA would have signed on for this aspect of the film had it been aware of Soderbergh's intention from the start. The director says in his DVD commentary on the Criterion release that he had 'neglected' to tell USA about the use of subtitles until the company found out only a week before the start of shooting. He resisted suggestions that two versions be shot, one voiced in English, and it seems that USA was left with little choice at so late a stage than to accept his argument that shooting in Spanish was important to the impression of verisimilitude sought by the film.

Transitions between the different narrative threads are in some cases abrupt, sometimes more smoothly articulated through devices such as

the 360-degree pan on a Mexican street cited above, which passes the thread at one stage from Javier to Helena (see fig. 11). The narrative style is often somewhat elliptical, requiring the viewer to do more work than usual to make connections either across or within strands. Examples of the latter include Javier's arrest of the assassin Flores (Clifton Collins Jr), which occurs in the gap between two scenes: at one moment, Javier is acting out a gay pick-up of Flores in a bar; the next, Flores is blindfolded in the back of a car. The dominant message conveyed by the film through the different threads is that the drugs trade is impossible to stop: Wakefield's outgoing predecessor doubts that he has made any difference; for all its claims, the American government 'surrendered this war a long time ago', argues the ill-fated middleman Eduardo (Miguel Ferrer), persuaded to give evidence in return for immunity; the Mexican cartels are 'way beyond us' in terms of intelligence and resources, suggests the head of an American intelligence centre on the border; the sale of drugs on the street is 'an unbeatable market force', such is the demand and such are the profits to be made, says one of Caroline's friends, as Wakefield attempts to track down his daughter after she disappears from a treatment centre. At a policy level, the film does not present any clear alternative, but offers an indictment, through Wakefield, of the rhetoric of the 'war on drugs'. Scheduled to give a press conference in which his role is to outline the president's policy, Wakefield labours and is hesitant, breaking from the script to question how such a war can be waged when the 'enemy' would include members of 'your own family', before walking out from the White House.

A number of local victories are dramatized by the film, balanced against the bleaker general picture. Salazar is eventually apprehended, thanks to the intervention of Javier, following the irony of the former's appointment as Wakefield's equivalent south of the border. Wakefield and his daughter are reunited and she appears to be responding to treatment. Montel plants a bug in the Ayala home after the release of Helena's husband, implying future action to come. And the closing scene is quietly affirmative: Javier attending a children's baseball game in a city park that has now been equipped with the floodlights he requested as his payment for cooperation with the Drug Enforcement Agency, the implication being one of hope for the future (the lights

making the parks safer for the children at night, helping to keep them from the dangers of the streets). The original ending was more downbeat, Caroline's rehab being shown to have failed as she crawls out of her bedroom window to go out to buy drugs, a version reportedly preferred by screenwriter Gaghan but vetoed by Soderbergh as too negative a note on which to close.[31]

In a number of its major plot components *Traffic* remains within the territory of conventional Hollywood-style cinema, one of the key dimensions of the 'classical' Hollywood narrative form (very much still in place in the twenty-first century) being a widespread tendency for any broader issues to be negotiated through a focus on the lives, dilemmas and actions of individuals. A strong vein of character-centred melodrama runs through the film, as is the norm in almost all mainstream and Indiewood cinema and in much of the indie sector. Overtly melodramatic devices, used to create heightened emotional impact, include central plot mechanisms such as the parallel between Wakefield's professional and personal involvement at different ends of the drugs spectrum, one of many direct lifts from the original TV series. Another such device is the death of Ray and its impact on Montel, who realizes moments too late that his partner is about to get into a car that has been booby-trapped. A notable example, used partly to less conventional effect, is the threat made to Helena's son by cartel members seeking payment for previous deliveries to her husband while he is awaiting trial. The use of a threat to a child, as motivation to the mother (in this case heightened by her state of pregnancy), is perhaps as standard a melodramatic device as they come. It is employed here, however, as a component in a narrative structure designed to go some way towards creating multiple perspectives on the action, rather than as part of the one-dimensional moral economy more typical of Hollywood. It serves, along with other aspects of her characterization, to create sympathy for the position of Helena, even though she becomes an active part of the drugs problem by taking on her husband's role during his incarceration. This enables the film to expand its range of perspectives somewhat, although it might be seen as something of a 'cheat'. The wealthy drug importer himself is presented as a smug, callous and entirely negative figure. It would have been more challenging to have given him a sympathetic dimension of some kind

– whatever the nature of his objective role in the suffering caused by drug abuse – rather than to have separated this out onto the more innocent 'threatened mother' figure of his wife. The resulting effect is one that might be taken as symptomatic of Indiewood tendencies more broadly: a careful balancing in which degrees of departure from the norm are kept within the bounds provided by more recognizably familiar routines. A somewhat less conventional effect is achieved in the case of the lower-level crook Eduardo, the figure arrested by Montel and Ray to give evidence against Helena's husband. Eduardo is a source of wry humour, often involved in scenes of pointed banter with the two detectives, but he also gives voice to what are presented as a number of uncomfortable truths about the limitations of anti-drugs policing, including the fact that his captors are in effect themselves in the service of one of the drugs cartels, his arrest having been the result of information provided in the battle of one against the other.

Also on the less-conventional side of the balance sheet, *Traffic* employs a number of formal devices that tone down the degree of emotionally involving melodrama and strengthen its more critical/ analytical or distanced dimension, creating an overall impression rather different from that established in the main trailer considered above. These include the multi-strand narrative structure itself and key aspects of the audio-visual texture of the film. The emotional impact of individual narrative strands is to some extent reduced by the constant process through which the film shifts from one to another, by a pluralization of the focus across a wider range of central characters than is usual in the classical Hollywood form. This is true only up to a point, however, other factors contributing centrally to the way the film establishes greater degrees of distance from character and character-emotion (a higher level of melodramatic charge is developed in the original television series, for example, especially in the latter stages, which if anything deploys more separate narrative strands than the film). Equally if not more significant are some of the strategies employed in shooting, in postproduction processing of the film stock and in the use of the soundtrack music by long-term Soderbergh collaborator Cliff Martinez.

Traffic employs a number of stylized visual effects that create potential for the establishment of aesthetic distance between character-

driven drama and the viewer. This is especially the case in the sequences set south of the border, which are presented in a distinctive degraded and grainy ochre tone, created through the combination of a number of devices. These include the use of coloured filters, a 45-degree shutter angle (which eliminates conventional motion-blur, to create a strobing effect noticeable when the camera moves), digital desaturation of the image and the use of an Ektachrome film stock for the final stages of printing. A different effect is created in the sequences featuring Wakefield in Washington and around the family home in Cincinnati, including the drug-related experiences of Caroline, which are distinguished by the use of a marked blue tinting of the image (created by shooting on tungsten film, usually used for night footage but employed here in daylight without the correcting filter that would normally be required). The effect is less extreme but the steely shades suggest coolness and distance that seems appropriate to the material, one of the implications of the film being that Caroline's propensity to rely on drugs may not be unrelated to a lack of emotional contact with her father.

The San Diego scenes are of more conventional appearance, although Soderbergh employed the risky technique of 'flashing' the negative (exposing it momentarily to white light after shooting), as well as using filters on the lens, to create a desaturated effect and in some cases a blindingly bright background impression of Californian sunlight. This is another arena in which Soderbergh's approach came into conflict with the business end of higher-budget filmmaking, the unpredictable nature of the flashing process resulting in the loss of some footage, including the results of the entire second day of shooting. At one point this led to the bond company that provided insurance for the production visiting the set.[32] In interviews and his DVD commentary, Soderbergh explains the use of different visual textures as a device employed to aid narrative comprehension, to enable viewers easily to identify the strands to which individual scenes belong and thus avoid any confusion created by frequent shifts from one to another. It is, in this sense, a strategy designed to make the film more easily accessible or comprehensible, but the combination of such distinct aesthetics also plays a central role in the creation of the less-mainstream texture of the film. It has a potentially distancing effect in

its own right, regardless of the specific impression created by any particular style, in encouraging greater than usual attention to form, contributing centrally to the effort of the film to offer a dimension of relatively dispassionate (or less than usually passionate) analysis. The degraded image quality of the Mexican sequences also creates potential for an unintentionally ethnocentric impression, in the 'othering' of what is presented as an 'alien' Mexican landscape.

The bulk of the film is also shot using hand-held camerawork, in some cases markedly unsteady, which might be expected to create the opposite impression, one of greater immediacy rather than distance, another tendency often associated with independent production, although also adopted for particular effects in some studio features. The dominant impression constructed through the use of such camerawork leans towards the documentary/*verité* end of the scale, however, a sense of immediacy that generally seeks to present itself as objective rather than as being closely related to character subjectivity and emotional engagement. A major influence cited by the director in this dimension is *The Battle of Algiers* (1966), in which similar strategies are used to create a strong impression of documentary in Gillo Pontecorvo's fictional treatment of the Algerian war of independence, which Soderbergh says he watched many times during the shooting of *Traffic*. A notable characteristic of Pontecorvo's film is the unusually even treatment of the two sides involved in the struggle, sympathetic and less sympathetic dimensions being given to characters involved in both the anti-colonial struggle and its repression. Soderbergh also cites Costa-Gavras' left-leaning political cover-up thriller *Z* (1969), in the DVD commentary and published interviews, thus aligning his film with two landmark examples of politically oriented overseas art cinema. Soderbergh makes additional reference in his DVD commentary to the *verité* impressions created in two films directed by William Friedkin, *The French Connection* (1971) and *Sorcerer* (1977), having previously cited Robert Altman films including *McCabe and Mrs Miller* (1971) and other works of the 1970s in his discussion of the use of flashing. This can be seen in the wider context of comments made by Soderbergh, at various times, to the effect that he has sought something of a return to the kind of filmmaking associated with the Hollywood Renaissance, through his own films and initiatives such as

Section Eight and the abortive F-64; gestures that contribute to the establishment of a particular position within the wider field of cinematic/cultural production.

The use of *verité* effects in *Traffic* is clearly motivated by the film's agenda of seeking/claiming to portray something of the complex 'reality' of the drug problem, a dimension in which the production has considerable investment. Another bid for an extra degree of authenticity, alongside the use of Spanish in the Mexican sequences, is found in a Georgetown reception attended by Wakefield soon after his appointment, where a number of the guests who offer advice on the drugs problems are real-life senators playing themselves and delivering, unscripted, their own opinions. Real locations and officials, the latter sometimes given substantial lines of dialogue, also feature in Wakefield's visit to a drugs intelligence centre at El Paso. The effect of the *verité* aesthetic based around strategies such as hand-held camerawork can be mixed, however. In some instances it creates an impression of objective distance, through the fabrication of an effect similar to that achieved by genuine documentary footage, taken unprepared and having to react to the unfolding of events. Unsteady hand-held camerawork of this kind can also create an impression of viewer proximity to the action, however, an 'up-close-and-personal' effect, a vicarious impression of subjective participation in the on-screen events often used in examples such as the orchestration of perspectives employed in Hollywood action sequences. If the image tone and texture of the Mexican sequences tends to militate against any such effect, in favour of the creation of an impression of greater distance, something along these lines can be detected in some of the sequences otherwise marked visually as relatively more neutral. Examples include the impression of chaos created when the sting operation in which Montel and Ray are involved is upset by the unplanned intervention of local law enforcement (shaky-cam, whip pans, blurring of the image) and a rush of camera movement that accompanies Helena in the midst of the panic surrounding the arrest of her husband. Sequences such as these, in which the *verité* impression is heightened and camera unsteadiness more pronounced, include the use of devices such as jump cuts and temporal elisions, subtle variations

of which are employed more widely in the film, contributing to a more general impression of slight edginess, discomfort and relative distance (compared with the smoother *découpage* usually associated with the continuity editing regimes of the Hollywood mainstream). A small example, barely identifiable at normal speed, occurs during a scene in a seedy hotel room between Caroline and her friend Seth (Topher Grace). At one moment, Seth is kissing Caroline. The next instant, he has already moved back to lie beside her, just a few frames being omitted to create one of numerous such subliminal effects found throughout the film. Such touches are sometimes used in otherwise more conventional Hollywood films, as part of an apparent effort to create a fresh, edgy impression in products designed more unambiguously for a mass market (one example would be *The Bourne Supremacy* [2004], a conspiracy thriller that draws on the background of director Paul Greengrass in drama-documentary in its use of fast, slightly disorienting gestures of camerawork and editing). This is one of many respects in which Hollywood/Indiewood/indie distinctions are often blurred and the differences relative rather than absolute, fluid rather than fixed. Particular conventions can move across such divisions, their capacity to mark particular kinds of distinction being variable, depending on the extent to which they become more widely adopted and/or integrated into more established routines (generally, or within more specific generic confines) or are used, as in the case of *Traffic*, in combination with other audio-visual qualities that mark a distance from dominant norms. What is signified by particular devices is far from always fixed, in other words, often being dependent upon the context in which they are deployed.

One of the strongest sources of distance from the action in *Traffic*, even amid some of the more melodramatic aspects of the plot, is the use Soderbergh makes of the Martinez soundtrack, a series of cool-toned ambient electronic pieces that establish mood rather than tending more directly to reinforce the (melo)dramatic action. A case in point is the effect created in one of the most dramatically heightened sequences of the film, in which Ray is killed by the car bomb intended for the whistle-blower Eduardo. This is a highly emotive moment, as suggested above, the film having invested quite

substantially in the establishment and characterization of the double-act of Ray and Montel. When the car blows up, however, the sound of the explosion is relegated to the far background, only just audible behind the music, which drenches the scene in a rich but cool and distant electronic wash. Montel's anguished reaction is acted out in silence, almost all diegetic sound being removed. A similar effect is created in a montage sequence in which Javier joins a group of Salazar's men in the rounding-up of a number of suspects. Subtitles provide the official version, in the form of news agency wire text, while another sombre Martinez piece takes the place of any diegetic sound, the combination establishing two layers of distance between the viewer and the unfolding of the action. Diegetic sound is also replaced by cool, ambient sounds in the otherwise more conventionally emotive moment when we see Helena in close up at the wheel of her car, driving home from the police headquarters after the arrest of her husband. A tear rolls down her cheek, but the melodramatic impact is muted by the detached nature of the theme and the absence of any sounds from within the fictional world. The effect in each case is a reduction of the dominant tendency of mainstream/Hollywood film music to 'hyperexplicate', as Royal Brown puts it, to impose a one-dimensional reading and emotional

12. Distanced emotion: Montel's anguish, with diegetic sound removed, in *Traffic* © USA Films

response.[33] For Michel Chion, film music can be either 'empathetic' (directly expressing its participation in a scene) or 'anempathetic' (exhibiting 'conspicuous indifference to the situation, by progressing in a steady, undaunted, and ineluctable manner').[34] The use of Martinez described above leans clearly towards the latter, a marker of distinction from general mainstream practice. The dominant impression that results is of these individual moments being woven into a larger fabric, the overall texture of which is as important as the highlighting of individual emotive strands.

The degree of emotional distance created by formal dimensions such as stylized visuals, the removal of diegetic sound and the use of cool, electronically-based music contributes to the sense that *Traffic* establishes of considering the question of drugs from a number of relatively objective and dispassionate perspectives. Some removal from too close an engagement with each strand seems necessary for this to be achieved, although what particularly characterizes *Traffic* as an Indiewood feature is the manner in which this is combined with the maintenance of significant potential for emotional engagement with character. It would be possible to imagine a far more dispassionate treatment of the material, devoid of contrivances such as the coincidence of Wakefield's appointment with the development of his daughter's addiction or what amounts to a kind of specially sympathetic treatment given to Helena. In this respect, *Traffic* has much in common with the source material from which it was adapted for the American market. The practicalities of reducing the narrative to fit the running time of a single feature, even a relatively long one, resulted in the loss of one significant thread, focused on the crop growers located at the start of the drugs chain. The television series also ends on a slightly sharper political note, as might be expected of a production for the 'alternative' Channel 4, its Wakefield equivalent being converted to the view that it is impossible to halt supply and concluding that the only viable alternative is to reduce demand, which means creating a 'decent society' at home, which he concedes will not be easy. Nothing at all specific is advocated here, but it is a recognition of the domestic roots of the problem that is given little explicit address in the film (in both cases what is offered here is a conventional 'big star-character moment', oriented towards the sanctity of 'the family',

up to which much of the text has been building, regardless of the exact content of the speech). Both versions could also be questioned, as far as any more radical social/political agenda is concerned, on the grounds of focusing their consideration of the addiction end of the business largely (*Traffik*) or almost exclusively (*Traffic*) on the plight of individual offspring of the rich and privileged classes, a product of narrative convenience that leaves little space for consideration of its greater impact in other social strata.[35] But, if a Hollywood treatment of the series would be expected to smooth off most of the rough edges, the Indiewood variety establishes distinctive/alternative characteristics of its own, particularly in the formal characteristics outlined above. The latter have a marked tendency to aestheticize the material, an effect that in this case seems largely functional to the social-political orientation of the project, in the creation of a relatively distanced perspective on the action. The result is a film that occupies a space between conventional (melo)drama and a more radical denial of emotional connection with character of the kind considered in relation to *Tout va bien* in chapter 1. Without coming close to the analytical distance of the latter, it is a considerably less mainstream product than Soderbergh's other social-issues-oriented work of the time, *Erin Brokovich*, in which the question of illegal environmental poisoning is central to the plot but used in the service of a far more conventionally shot and structured melodramatic/heroic, star-led single-character-centred drama.

Solaris: Turning a scientific problem into a bedtime story?

The distinctively Indiewood position occupied by *Solaris* can also be understood to a large extent in terms of where it stands in relation to other texts, most obviously the Tarkovsky version, an almost unavoidable point of reference for most commentators given its status as an enshrined landmark of science fiction art cinema. Soderbergh's take clearly occupies more commercial ground, in a number of respects detailed below, including the greater centrality of the romance dimension highlighted in the trailer. Once again, however, it combines

this status with a number of qualities that function to situate the film at some distance from the centre of the Hollywood mainstream.

Soderbergh's *Solaris* is far from being the 'pure art film' suggested by Todd McCarthy, as is amply clear from even a cursory comparison with Tarkovsky's, a much better candidate for the label. Tarkovsky's treatment of the material is in many respects the epitome of the kind of filmmaking for which the term 'art cinema' came to stand in the second half of the twentieth century, in both form and content. Running 160 minutes, it is a very slow-moving, quiet, contemplative and largely cerebral work in which the central narrative confection – the effects of the sentient ocean of the planet Solaris upon the occupants of an orbiting space station – serves as a vehicle for the exploration of what can be read as broadly familiar art-cinema themes such as difficulties of communication (here, a literal alienation) and philosophically-oriented debates such as the relative merits of scientific-rational or more humanist perspectives. A love story lies at the heart of the film: that of a psychologist for a former wife who committed suicide but is resurrected in some form on the space station as a result of the ocean's ability to create simulacra from the minds of those who come into its orbit. The love story is important to Tarkovsky's version, as it is to the original novel, but it is given significantly greater centrality and weight by Soderbergh, both in overall tone and balance and in the development of substantial components of the onscreen material. The most obvious aspect of this is the dramatization of a number of earthbound scenes from the previous lives of the principals, Kris (Clooney) and Rheya (McElhone), scenes that are not presented directly (if at all) in either the Tarkovsky or the Lem versions. The fabric of key parts of the film is woven through shifts back and forth between Kris and Rheya in the past and the former and simulacra of the latter in the Solaris-present, the lines between the two being marked by colour-coding of a kind similar to that used in *Traffic* (cool blues and greys for the space station sequences, warmer browns for the past). Some of the earthbound elements are drawn upon in the trailer discussed above and the film itself mobilizes some of the same resonances: those of romantic drama with occasional dialogue touches in the earlier stages of their relationship that bend towards the more

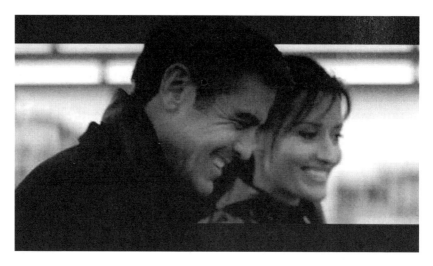

13. Foregrounding the romantic: A lighter moment between Kris and Rheya in one of the flashback sequences in **Solaris** © Twentieth Century Fox

pointed end of romantic comedy. The paralleling of the two strands is sustained throughout the film, climaxing with a sequence that interweaves Kris's discovery of Rheya's original suicide and the equivalent in the Solaris strand, in which her simulacrum is destroyed at her request by a device constructed by another member of the crew.

The Kris of both film versions ends up emphasizing his love for the Solaris Rheya, to the exclusion of all other considerations, prompting the line from a colleague in the Tarkovsky version used in the heading for this section: 'Don't turn a scientific problem into a bedtime story'. Soderbergh arguably does exactly that, to some extent, in his greater foregrounding of the romance, including manifestations such as love-making scenes between Kris and Rheya and the dominant 'heartthrob' star-resonances brought by Clooney, even if his performance is mostly low-key. Soderbergh played up the romance dimension in the final version of the film. A number of longer and more speculative dialogue scenes included in the first edit were cut and the flashback scenes depicting the origins of Kris and Rheya's relationship were shot only at a late stage, during postproduction, to establish a clearer impression of the background to the relationship.[36] The ending is also considerably more affirmative and romance-oriented than is the case in either of the

previous versions. In the novel, Kris remains on the space station after the loss of Rheya, in some kind of expectation but no real hope of her return. Tarkovsky adds a twist that produces a climactic frisson. We return to images similar to those experienced in the opening of the film (languorous shots of weeds shifting under water, a lake) at the home of Kris's father in the countryside, although as he moves toward the house something seems odd, misplaced: rain appears to fall, as it did at the start, but here it is falling indoors. Kris kneels before his father outside and the camera pulls up and away, through shifting clouds, a landscape appearing of trees, a lake, fields, a road – and then the revelation that this is no more than an island in the Solaris ocean; not a return home, but another simulacrum created from the protagonist's mind.

Soderbergh offers a markedly more reconciliatory and romantic version of the same twist. Kris and his rationalist colleague Gordon (Viola Davis) are about to board a spacecraft to escape from Solaris (one of the closest moments the film comes to more conventional Hollywood SF action), the device used to destroy Rheya having in this treatment provoked a situation in which the space station is being pulled in by the planet's increased gravitational field. Cut to Kris, apparently back home, a resigned voice-over suggesting a bleak conclusion in which Earth has become alien, unfamiliar. In the kitchen of his apartment, he cuts a finger and places it under the tap, replicating a scene witnessed at the start of the film – and this time the cut seems to disappear, implying that this version of Kris is a simulacrum, capable of the kind of regeneration witnessed earlier in the film after a suicide attempt by the Solaris Rheya. Cut back to the space station, where we see Kris deciding to stay rather than leaving with Gordon. A young boy appears, previously established as another Solaris 'visitor' (a simulacrum of the son of another character, Gibarian [Ulrich Tukur]), who holds out a hand to Kris. Back to the kitchen and Kris is startled to hear Rheya's voice, calling his name. 'Am I alive or dead?', he asks. Rheya: 'We don't have to think like that any more. We're together now. Everything we've done is forgiven.' They kiss, music rises on the soundtrack, they embrace to increasingly warm tones, and the film ends with a series of dissolves through images of the planet at increasing distances from the camera. The couple now occupy some other Solaris-related plane of existence, it seems, but the cinematic signifiers of a happy romantic ending are more or less intact.

Soderbergh's *Solaris* occupies a distinctly hybrid territory in its general pitch and tone. By Hollywood standards, it is slow and mesmeric, unfolding in quite lengthy sequences that go against the contemporary trend towards faster cutting and increased camera movement.[37] The camera moves only rarely in the space station sequences (in addition to the different colour scheme, the earthbound scenes are distinguished by the use of hand-held camerawork). There is relatively little 'action' of the kind usually associated with Hollywood science fiction, much less than would have been likely had the film been directed by Cameron as a more unambiguously 'Hollywood' product, a subject of banter between himself and Soderbergh in their joint commentary on the DVD. At the same time, this version is far more (melo)dramatic and conventionally shot than Tarkovsky's. If Soderbergh's 94-minute version is slow by commercial standards, it proceeds much more swiftly than its predecessor, which displays Tarkovsky's penchant for highly extended sequences in which little in the way of conventional action occurs, a characteristic found more widely in art cinema as part of an aesthetic designed, in general, to require more active engagement in the meaning-making process on the part of the viewer. Some 40 minutes elapse before the first movement into space and in one sequence, establishing an impression of alienation closer to home, a series of shots of Kris driving in his car is extended for more than 4½ minutes to an accompaniment of increasingly abstract and discomforting sound. Soderbergh's version has an average shot length (ASL) of 11 seconds, about twice the length of the upper end of the Hollywood norm for the period in which it was made, in which the fastest-cut features come in as low in some cases as one shot every two seconds.[38] That puts it in the category of contemporary 'art movies' for David Bordwell, but does not compare with the figure for Tarkovsky's *Solaris*, an ASL of 28 seconds.[39]

In the Soderbergh version, confrontations between characters – principally, between Kris and Gordon – are much more assertive and emphatic, the stuff of 'drama', compared with Tarkovsky's approach, in which such material is largely sublimated into philosophical debate. This is a clear marker of distance between two very different kinds of cinema. Some more overtly dramatic narrative components are added by Soderbergh, although in an oblique manner almost as distant from

Hollywood convention as from the realm of art cinema. A good example is the early revelation that a 'security force' was dispatched to the space station before the arrival of Kris, contact with the force having been lost on its approach, and Kris's discovery of blood stains soon after disembarking from his capsule. This suggests the kind of drama that might be expected in a more conventionally action-oriented science fiction production. Some dangerous but unknown force awaits Kris, it is implied, a familiar-enough generic routine with which to open the film. But the threat, such as it is, is far less clear-cut and the film develops along very different lines, emphasizing inward-looking and emotive dimensions rather than more conventional and external forms of action, crisis and confrontation. Some of the kind of spectacle associated with the genre is offered, obligatory special-effects shots of the planet and the orbiting space station, but for most of the film such imagery is relegated to the background. The planetary vista is often visible through windows, but typically restricted to the margins of the screen, while the potentially spectacular periodic risings and settings of the two suns of Solaris, described in the novel, are reduced to washes of light playing across the faces of the characters on whom the focus of attention remains.

Soderbergh's *Solaris* is shot and edited in a manner that can be understood as establishing its credentials as a 'classy', prestige pro-duction. Its choice of a languid, often somewhat oblique approach is a clear marker of distinction from the frenetic routines associated with the action- and/or blockbuster-oriented end of the Hollywood spectrum, a marker that appears designed to be drawn to the attention of the viewer on that basis, or at least to create a very different impression even where the effect remains implicit rather than explicitly recognized. Sequences involving shifts between the present and past are carefully orchestrated, an impression of aesthetic control and nuance becoming quite overt in some cases, especially in the flashback components. The sequence in which Kris remembers, replays or dreams back to his first meeting with Rheya – catching her eye on a train and then finding her at a party – is a striking example. The visual tones of the party scenes offer a kind of chiaroscuro, carrying 'arty' associations, face tones being lit against warm, dark backgrounds. As Kris passes across a room, shallow focus is maintained on his head and

shoulders, the background blurred in a manner that connotes artful expression (rather than a seemingly more 'normal', 'neutral' depth of field; the blurring of parts of the image is offered to the attention of the viewer) until both camera and protagonist find and focus on their quarry. Diegetic sound is absent, replaced by the rich, dreamy but also insistent and forward-driving strains of another Cliff Martinez score. Kris moves off towards his friend, Gibarian, the character who will subsequently call him to Solaris and start the science fiction component of the narrative in motion. Kris joins Gibarian in conversation, as diegetic sound returns. Some important plot-background material is relayed in Gibarian's contribution to the dialogue, but the focus of both Kris and the camera remains primarily on Rheya (a microcosm of the overall emphasis of the film). He approaches her, in another distinctive move, the hand-held camera following behind his back and head, the focus again reduced to a shallow plane. Rheya moves into focus as he draws up to her and he passes briefly out of focus, walking past to put down a glass, before circling back to face her for a dialogue scene that starts with what seems a conventional over-his-shoulder shot of her face. This might be expected to be the start of a standard shot/reverse-shot series, but no reverse angle is provided; no view of the star, pointedly, in this heightened relationship-establishing moment, before a cut back to one of the interposed shots of Kris asleep in the space station, a return to the same shot of Rheya

14. 'Artily' composed: Shallow planes of focus as Kris approaches Rheya in *Solaris* © Twentieth Century Fox

and a continuation of their initial verbal exchange as the images move forward; to their departure, their return to Kris's apartment and the juxtaposition of their lovemaking with that between Kris and Rheya's simulacrum after she appears at his bedside in space.

The overall impression created by this sequence is one that displays markers of 'sophisticated' cinematic orchestration: eye-catching and distinctive in a number of touches but subtly so and with audio-visual flourishes that remain primarily (and hence conventionally) at the service of character/narrative motivation, rather than existing for their own sake. The on-screen events are clearly focalized through the character of Kris, numerous cutaways to his sleeping head and occasional shots of the firing-synapse-like planetary texture of Solaris establishing their status as memories or reconstructions of some kind. The cinematic texture is reminiscent of that created in a striking central sequence in Soderbergh's *Out of Sight*, in which some similar (seductive) image qualities (shallow focus, warm backlighting, and in this case brief freeze-frames and slight elliptical dissolves) are employed during a movement back and forth a short distance in time between the two central characters in a hotel bar and bedroom. The manner in which temporal shifts are articulated in *Solaris* can thus be seen as part of a distinctive Soderbergh aesthetic, along with the disjunctive effects created in *The Limey*, although used in *Solaris* and *Out of Sight* in the service of relatively more conventional emotional/relationship dynamics. Such effects are grounded, for Soderbergh, in an under-standing of the non-linear nature of human thought processes, manifestations of which are usually more likely to be associated with work at the art-cinema end of the spectrum.[40] *Out of Sight* also employs a system of colour-coding much the same as that used in *Traffic* and *Solaris*, to distinguish between past and present sequences set respectively in Florida (bright yellow tones) and a wintry Detroit (cool blue-greys). Two distinct aesthetics are used again, more self-consciously, in *Full Frontal*, to distinguish between the principal diegetic universe (grainy digital video [DV]) and that of a film-within-the-film (glossy 35mm), further reinforcing the status of such shifts as a trait associated with the particular imprint of the director (in this case, the more clearly independent status of the film is marked by the dominant presence of the low-budget-signifying DV texture). Elements of colour

coding to identify particular narrative/temporal threads are also used in Soderbergh's earlier film noir, *The Underneath*.

The development of such distinctive traits, across a body of work, can be of direct benefit to the director as part of the process of creating a marketable brand identity that helps to ensure continuity of employment. This is an approach encouraged generally by the package system adopted in Hollywood and beyond since the collapse of the production-line version of the studio system in the mid-twentieth century. Soderbergh has repeatedly played down any such tendency in his work, however, seeking to distinguish himself from directors who impose their own style on the subject matter of different films.[41] The identity he has articulated for himself is one in which style is said to follow content, a more open and pragmatic position that claims the status of craftsman (John Huston or Howard Hawks) rather than 'visionary' auteur (Stanley Kubrick, Robert Altman or Frederico Fellini).[42] Such a stance can be seen as a reaction against the tendency for filmmakers to be pigeon-holed by critics, a particular concern for Soderbergh given the landmark indie status gained by *sex, lies, and videotape* so early in his career; a resistance to the concept of becoming imprisoned by a 'brand' and licence to range more freely across the indie/Hollywood divide, even if certain stylistic traits can be identified in works located at very different points in the cinematic spectrum.

Soderbergh's version of *Solaris* addresses some of the broader thematic issues examined in the Tarkovsky film, although more briefly and less centrally, given the primary focus on the romantic/emotional dimensions. Both films present an existential dilemma in the experience of Rheya, a character literally alien-ated from the person of whom she is a reconstruction. She has memories but they are not really her own, an experience that is open to be taken as a metaphor for the human condition more generally (Cameron, in his contributions to the DVD commentary, suggests an implicit feminist dimension, the Solaris Rheya being constructed according to the way she is remembered by Kris rather than having any existence in 'her' own right). In a key passage in the book and the Tarkovsky version, one of the other occupants of the space station, Snow, suggests that what humanity needs is not contact with other worlds but a mirror through

which fully to understand itself, which is essentially what Solaris appears to offer. A disturbing suggestion of the book is that Solaris might provoke manifestations of any aspect of human consciousness, not just real memories but fantasies that might be unpalatable. Exactly what other 'visitors' populate the space station is in both cases left troublingly ambiguous, to a greater extent than in Soderbergh's take on the material. The 'mirror' theme is repeated in Tarkovsky's film, where it retains an important weight. It is included in Soderbergh's version, but much less prominently, reduced, symptomatically, to the status of a largely throw-away phrase heard in a recording left for Kris by Gibarian. Soderbergh also includes some much more Hollywood/conventional-seeming rhetoric among the discussions that do occur on the implications of the Solaris experience. 'I don't believe that we're predetermined to relive our past. I think that we can choose to do it differently', argues Kris, in what is delivered as a more simplistic assertion of individual freedom, in keeping with widespread Hollywood expression of dominant American ideology.

Responses

Press reviews attributed the distinctive qualities of both films primarily and explicitly to the auteur presence of Soderbergh, whether as director, writer-director or in accounts that noted his additional contributions to the cinematography. A clear general tendency exists, in reviews at the relatively 'serious' or 'quality' end of the newspaper spectrum, to place *Traffic* and *Solaris* within the Soderbergh oeuvre, evidence of the importance of the auteurist dimension to the frames through which Indiewood features of this variety are mediated to the potential viewer (the general industry consensus being that reviews figure more importantly in viewing decisions at the specialist end of the spectrum). In the case of *Traffic*, considerable prominence was given by most critics, unsurprisingly, to the issues raised by the drug-trade subject matter, although often blended with attention to the particular narrative and other cinematic qualities through which the issues are articulated. The film was praised by the majority of critics and managed to appeal to a range of different constituencies with more direct investments in the territory. As Sharon Waxman reports, critics

of government drug policy interpreted the film as 'a brilliant statement about how the war on drugs had failed, and they took the film as a calling card for the legalization of drugs'.[43] At the same time, those attending a screening for officials from the Drug Enforcement Agency and US Customs, sources of advice during the production, generally found it to be 'a complimentary portrait of their efforts to stop drugs from penetrating the border, a salute to their success and their devotion to very difficult jobs'.[44] Such responses might have vindicated Soderbergh and Gaghan's commitment to a multi-perspectival approach, evidence of an openness to interpretation that also had a significant commercial dimension in its ability to appeal to a range of existing viewpoints and hence, where possible, avoid giving offence (a strategy typical of many Hollywood treatments of potentially contentious issues). *Traffic* was certainly a catalyst in provoking wider media and political debate on the subject, 'a conduit for looking at these issues', as Waxman terms it.[45] Critics generally agreed that the film was cool and 'level-headed', to use Roger Ebert's phrase, although a number shared the view that even with this approach it offered an indictment of existing policy.[46]

Critical judgements of *Solaris* were more mixed, ranging from the celebratory to the distinctly negative, the more considered often situating the film within the range encompassed by Soderbergh's career at the time, as well as in relation to the Lem novel and the Tarkovsky film. For the *Village Voice*, for example, *The Limey* had been the nearest Soderbergh had previously come to reconciling the tension between his more and less mainstream films, 'but *Solaris* achieves an almost perfect balance of poetry and pulp'.[47] *The Los Angeles Times* describes Soderbergh as 'Hollywood's most gifted chameleon' and the film as 'an example of sophisticated, challenging filmmaking'.[48] Ebert, like most others, compares the film with the Tarkovsky version, finding Soderbergh's film more accessible but still a film of substance; 'more clean and spare, more easily readable, but it pays full attention to the ideas and doesn't compromise'; 'the kind of smart film that has people arguing about it on their way out of the theatre'.[49] Citing the respective roles of Soderbergh and Cameron, *The New York Times* suggests that 'the movie aspires to fuse the mystical intellectual gamesmanship of "2001: A Space Odyssey" with the love-beyond-

the-grave romantic schmaltz of "Titanic"', without really succeeding, concluding that its insistence on remaining 'cerebral and somber' at the expense of any 'action-adventure sequences' might be a sign of integrity but is likely to cost the film dearly at the box-office.[50] For the *San Francisco Chronicle*, *Solaris* is 'a grim-faced stab at artistic importance'.[51] For *USA Today*, in an approving notice, it is 'science fiction drama for those who don't necessarily like science fiction'.[52] No clear consensus emerges as to the judgement to be made of the particular hybrid or 'sophisticated' nature of the film. For some, it appears to be a clear selling point, as it might be for particular audience constituencies, but for others the film is criticized for falling between stools or being dull, contrived and pretentious.

Some of the responses posted at Amazon.com express appreciation for *Traffic* or *Solaris* on the basis of their hybrid status, but only a small number provide elaboration of their taste in quite such specific terms. For one viewer of *Traffic* the film is both 'artsy and accessible' ('A viewer', 27 July 2001). Another makes the point more explicitly, declaring that: 'Its great to see a major American director use the techniques of the Danish collective Dogme 95 (hand-held camera, available light, no fx, location shooting) & integrate them so brilliantly into a major motion picture released by a Hollywood studio' ('A viewer', 22 December 2000). Some similar views are expressed in relation to *Solaris*: 'While it's not an indy flick – in the sense that it's expensive and bankrolled and produced in Hollywood fashion – it feels like a small art film or an indy' (Matthew Wall, Monterey, CA, USA, 14 November 2004); 'Somehow, it comes across as a big-budget movie with an indy feel' (wiredweird, 3 October 2005). Such views are more often expressed through appreciation of Soderbergh-as-auteur. A number of reviews, in each case, demonstrate significant investment in Soderbergh and his name as a marker of distinct quality or position in the cinematic spectrum. As one response to *Traffic* puts it: 'At this point there can be little doubt Soderbergh is one of the major filmmakers of our generation, and any project with his name on it is a must-see' (Jay Smooth, New York, NY, 21 December 2000). Or another, in relation to *Solaris*: 'Steven Soderbergh continues to surprise me. From Sex, Lies, and Videotape to Kafka to the Limey to Out of Sight to Erin Brocovich [sic] to Traffic to Ocean's 11, this guy just

keeps pumping out exceptional movies (lecorel, Atlanta, GA, 2 December 2002).

Demonstrations of this kind of investment are found in only a small minority of reviews: 20 out of 516 responses to *Traffic* and just five out of 294 for *Solaris*.[53] Many more respondents cite the name of the director in some manner, however, demonstrating a wider level of recognition of his significance to the production. A total of 162 cite Soderbergh in relation to *Traffic*; 31 per cent of the sample. Of these, 112 (22 per cent) offer substantial praise to the director at a level of apparently lower overall director-investment than those quoted above (in phrases such as 'brilliantly directed' or praise for successfully weaving together the different narrative strands). A passing name-check occurs in just four, suggesting that most of those who cite the name have something to say in regard to the individual filmmaker, if only briefly in many cases. Broadly similar figures apply to the *Solaris* sample, in which 98 (exactly one-third) mention Soderbergh; 51 (17 per cent) make the less-developed variety of positive comment in relation to his name and eight cite the director only in passing. Soderbergh's name is also cited negatively by some in regard to each film, 14 in the case of *Traffic* (plus two mixed) and 19 for *Solaris* (with four mixed and 11 without any clear value-judgement). One respondent to *Traffic* describes Soderbergh as 'probably one of the most over rated directors working today' (Patrick McDonald, New York, NY, 21 August 2001), while a group of *Solaris* reviewers declare themselves to be fans of the director's other works but not this one.

The leading-star presence looms larger in responses to both films, certainly in relation to sheer number of citations, but not necessarily (and far from always) in terms of prominence or substance of response. A total of 202 (39 per cent) cite Michael Douglas in *Traffic*, 152 (52 per cent) Clooney in *Solaris*. These figures can be adjusted down, however, by removing those which only include passing references to the name, which constitute a larger proportion of the star citations (partly as a result of the performer's name being used by some reviewers in place of the name of the character during plot description). The resulting figures are 112 (21 per cent) for Douglas and 121 (41 per cent) for Clooney. Such figures are not surprising. Douglas scores at a lower level because he is part of an ensemble cast, Clooney occupying a far

more prominent position in *Solaris* than Douglas in *Traffic*. Clooney is also, arguably, a star more likely to attract comment, positive or negative, as a result of the particular nature of his star status (rated as a highly desirable figure for many, especially women, but his acting credentials having often been subjected to question) and the publicity surrounding the showing of his naked backside. Clooney figures more often than Douglas as the primary point of orientation for Amazon reviews, a number of which go so far as to give him what comes close to the 'possessive' credit usually reserved for directors or writer–directors (some seven respondents describe the film in what may be short-hand terms such as 'Clooney's *Solaris*' or 'the Clooney version'). Viewers who describe themselves as initially attracted to the film by Clooney's presence report varying responses. Some were disappointed, as might be expected given the potential clash between heart-throb/star image and a less mainstream film of this kind, although at least two report opposite reactions such as the following: 'I admit, I originally wanted to see this movie because I am a George Clooney fan. Ten or fifteen minutes into the film I forgot all about George Clooney and got caught up in the story. This movie makes you THINK' ('A viewer', 9 March 2003).

A clear, if implicit, articulation of taste/value judgements is made in the response of this self-declared Clooney fan. Star-fandom, here, is something to be 'admitted', as a kind of guilty pleasure of lower status than being 'caught up' in a movie that makes you 'think'. A similar manoeuvre is found in another response. 'Truthfully', it begins, in another admission of 'lower' status motivation, 'I wanted this film because I wanted to see George Clooney's bare bottom and anything else. But if you want this film just to see that great sight, you may be disappointed. Don't get me wrong. I loved this movie. But this is not the usual Clooney vehicle' (Anna M. Allred 'Teacher and Reader' [a notable self-description, in this context], Talbott, TN, USA, 22 August 2003). A considerable number of the *Solaris* reviews engage in the more general (not just Clooney-related) process of making value-led distinctions between this film and various ways of characterizing more conventional Hollywood and/or science fiction films. Twenty-eight respondents make quite pointed rhetorical distinctions, of the kind we have seen in previous chapters, between the different audiences to

which each is likely to appeal, either explicitly or implicitly locating themselves on the more 'discerning' side of the equation. As one of many similar responses put it: 'it's certainly not for everyone, especially those who prefer their films pre-digested & undemanding. But for those who are willing to give themselves over to its rich, subtle rhythms, an astonishing experience awaits' (William Timothy Lukeman, 2 March 2004). Another 23 make much the same point but in slightly more neutral terms such as 'not a film for the ordinary viewer' (indianmade, Minneapolis, 28 April 2004), giving what seems a significant total of 51 (17 per cent) who make a point of spelling out such a distinction unprompted. In a small number of cases, specific allusion is made to the contrast between this film and the more emphatic style typical of many Hollywood products of the 1990s or 2000s, as in the following: 'in a day where modern film is relegated to dishing out fast-paced, spelled-out-for-you, rehashed action plots with crazy camera angles, 30-second editing, and pointless "big-star" cameos, it was a refreshment to see such an elegant film' ('imovestars', Texas, USA, 28 November 2003, who presumably means faster than 30-second edit intervals, as that would be a very long average shot length). Such distinctions are generally made more broadly and implicitly, however, rather than through overt formal grounds of comparison.

Distinctions are also made in the opposite direction by a smaller number of respondents, as was seen in some of the Kaufman and Tarantino responses considered in the previous chapters. If one reviewer quoted above finds Soderbergh 'over rated', some others criticize his work for being 'pretentious' or 'self-indulgent'. Many reviews of *Traffic* express positive appreciation of the formal devices examined above, especially the use of different image qualities for the three main narrative strands. Fifty-five express this in some specific detail, 44 more briefly in passing phrases such as 'brilliant cinematography' or 'stylish visuals', giving a total of 99 (19 per cent) who demonstrate some investment in this dimension of the film as a marker of distinction. Thirty-three respond negatively to the formal qualities of the film, however. For some, the cinematography is 'amateurish' (several), 'really annoying and pointless' (Mr. Censored, Nowhereboro, Maine, 10 November 2001), or, more in keeping with Soderbergh's declared intention, an insult to viewers who do not need such help in

order to follow the narrative (three responses). Three describe the colour scheme as 'racist', for reasons akin to those cited above in relation to the Mexican sequences, while for a number of others the effect is contrived; 'forced artistry is just annoying', as one puts it ('A viewer', 6 August 2001). *Solaris* is described by one reviewer as: 'Suitable for pseudo-intellectuals to ooh and aah over, but normal humans should keep away' (Meekins, Georgia, 25 August 2003); for another it is 'a tiresome, pretentious, vacuous, longwinded bore' (David A. Kemp, Plano, TX, USA, 23 October 2003).

The explicit articulation of distinctions in terms of the types of viewers for whom the films are suitable is found far more often in positive than negative accounts, but both films are rejected quite vigorously by substantial numbers of respondents. *Traffic* receives 109 (21 per cent) soundly negative judgements, *Solaris* 74 (25 per cent). Of these, a sizeable chunk are very hostile, including conclusions that each film is 'boring' (*Traffic* 6 per cent, *Solaris* 9 per cent), and a number in each case that declare the work to be 'the worst film of the year/all time', or some similar rhetorical formulation. It is clear that material of this kind is disliked by a significant number of actual viewers, many of whom do not seem to fit the profile ideally 'implied' by the qualities of the texts. The grounds for rejection vary. In the case of *Solaris*, some find it compares unfavourably with the original and/or the Lem novel, while others are clearly measuring it against the yardstick of more mainstream production (the most common negative verdict, including the 'boring' valuations but also many more, is that it is too slow). In both cases, those who appreciate the films do so to a significant extent on the basis of what are identified as distinctive qualities, broadly in keeping with the analysis offered in this chapter. The terms in which the films are rejected by others throw into relief what is implied at the textual level: the particular and far from universal orientation required for pleasurable viewing (this is one of the values of using resources such as Amazon samples that include significant numbers of negative responses).[54]

In the case of *Traffic* it is important to note that the dominant source of principal focus is the subject matter: either drugs or drugs policy in its own right, or the issues as specifically articulated by the film. This is followed in prominence by variable focus on a combination of

emphasis on the filmmaker and/or on the particular qualities of the film, including cinematography and the articulation of the different narrative strands. As far as these responses are concerned, the more 'arty' or aestheticized qualities of the film do not seem, in general, to eclipse the social–political dimension. On *Solaris*, lacking the consistently dominant point of orientation offered by the tackling of an immediately contentious issue, the focus varies more widely across issues relating to previous versions, content/themes, star presence, director and style. An emphasis on the social–political dimensions of subject matter, and its relationship with the usual bounds found in the Hollywood and indie sectors, will form a central part of the next chapter, which follows *Solaris* in the consideration of Indiewood features positioned at the heart of the operations of the major studios.

Notes

1. The term 'some sort of hybrid', used in the title of this chapter, is from a comment by Soderbergh in Anthony Kaufman, 'Interview: Man of the Year, Steven Soderbergh Traffics in Success', *indieWIRE*, 1 March 2001, accessed via www.indiewire.com.
2. For more detail, see my *American Independent Cinema*, 142–4.
3. Anne Thompson, 'Soderbergh, outsiders, challenge studio model', *The Hollywood Reporter East*, 23 September 2005.
4. Pamela McClintock, 'Sorry, this Section's closed', *Variety*, posted at variety.com, 12 February 2006. Clooney retained a relationship with Warner through a new outfit, Smoke House, in partnership with former Section Eight executive Grant Heslov.
5. For more on this, see Stephen Galloway, 'The Mild Bunch', *The Hollywood Reporter*, 25 June 2002, and Galloway, 'New Direction', *The Hollywood Reporter*, 5 January 2005, accessed via www.hollywoodreporter.com.
6. For more background on the Hollywood Renaissance, see my *New Hollywood Cinema: An Introduction*, chapter 1.
7. For the fullest account of the development of the project, see Sharon Waxman, *Rebels on the Backlot*.
8. Unattributed, '"Day" spikes Fox's year Fox parts total some whole', *Variety*, posted at www.variety.com, 7 January 1997.
9. Waxman, *Rebels on the Backlot*, 220–2; Claude Brodesser and Dana Harris, 'Fox "Traffic" jams', *Variety*, posted at www.variety.com, 16 February 2000.

10. Waxman, *Rebels on the Backlot*, 256–7; Brodesser and Harris, 'Fox "Traffic" jams'.

11. Brodesser and Harris, 'Fox "Traffic" jams'.

12. *Rebels on the Backlot*, 310.

13. In addition to the loss of Ford, Fox was also motivated by continued increases in the budget, which *Variety* put at $50 million to $60 million at this stage; Dana Harris, 'USA Films doubles back into "Traffic"', posted at www.variety.com, 17 March 2000.

14. Martin Grove, 'Initial interest kept "Traffic" from being pulled over', *The Hollywood Reporter*, 7 March 2001, accessed via www.hollywoodreporter.com. Initial was reported to have contributed approximately $40 million towards the budget, which has been put at between $46 million and $56 million; Charles Lyons, 'Inside Move: USA Films hopes "Traffic" will jam', *Variety*, posted at www.variety.com, 17 January 2001.

15. See 'Behind the Scenes' production notes on the website at www.solaristhemovie.com and 'Solaris: Behind the Planet' featurette on Fox Home Entertainment DVD.

16. Cameron interview in 'Solaris: Behind the Planet'. See also James Mottram, *The Sundance Kids*, 369.

17. Details, variously, from Anthony Kaufman, 'Interview: Man of the Year'; Jerry Roberts, 'As d.p., Soderbergh hastens prod'n flow', *Variety,* posted at www.variety.com, 17 January 2001; Waxman, *Rebels on the Backlot*, 319; and the director's commentary on the *Criterion* DVD.

18. Soderbergh, DVD commentary.

19. Biskind, *Down and Dirty Pictures*, 282.

20. Todd McCarthy, 'Traffic', posted at www.variety.com, 12 December 2000.

21. Kirk Honeycutt, 'Traffic', 12 December 2000, accessed via www.hollywoodreporter.com.

22. Roger Cels, '"Traffic" jams busy weekend', *The Hollywood Reporter*, 5 January 2001, accessed via www.hollywoodreporter.com.

23. Gregg Kilday, 'Studios stuffing the megaplex', 27 November 2002, accessed via www.hollywoodreporter.com.

24. 'Solaris', posted at www.variety.com, 20 November 2002.

25. David Hunter, 'Solaris', 25 November 2002, posted at www.hollywoodreporter.com.

26. Soderbergh and commentators have given such labels to the film on several occasions, including Anthony Kaufman, 'Interview: Man of the Year'. The reference is to the Dogme 95 movement, based on a

manifesto written in 1995 by Lars von Trier and Thomas Vinterberg, calling for a stripped-back form of filmmaking employing devices such as hand-held camerawork and shooting exclusively on location. *Traffic* would not qualify, strictly, for various reasons, including its use of filters and other forms of optical manipulation. For the full Dogme 'Vow of Chastity', see www.dogme95.dk/menu/menuset.htm.

27. For what still remains one of the best analyses of what is usually connoted by the term 'entertainment', see Richard Dyer, *Only Entertainment*.

28. Examples of American independent features that use drug-taking as a motivation for visual stylization include *Requiem for a Dream* (2000) and *Spun* (2002).

29. *American Independent Cinema*, chapter 2.

30. An assumption that probably holds up in most cases, although it was at least partly disproved by Traffic and the exceptional case of Mel Gibson's *The Passion of the Christ* (2004).

31. Waxman, *Rebels on the Backlot*, 321.

32. Soderbergh, director's commentary on *Criterion* DVD release.

33. *Overtones and Undertones: Reading Film Music*, 10.

34. *Audio-Vision: Sound on Screen*, 8.

35. *Traffic* also prompted a spin-off of its own, a very differently plotted mini-series produced by USA's own cable television division, a much more thriller-oriented and depoliticized post-9/11 extension of the franchise.

36. As explained by Soderbergh in the commentary by himself and James Cameron on the DVD release.

37. For more detail on these trends, see David Bordwell, *The Way Hollywood Tells It: Story and Style in Modern Movies*.

38. Average shot length is calculated by dividing the running time by the number of individual shots in the finished version. For Soderbergh's *Solaris*, I count 463 shots in a running time of 88 minutes that does not include opening titles or end credits. For an account of typical ASL figures for the period, and a historical tendency towards a quickening of pace, see Bordwell, *The Way Hollywood Tells It*, 121–2.

39. By my count, 331 shots in a non-credits running time of 156 minutes, 30 seconds.

40. Soderbergh discusses the difficulty of evoking such qualities without alienating audiences, in relation to *The Underneath*, in a 1995 interview with Michel Ciment and Hubert Niogret in Anthony Kaufman (ed.), *Steven Soderbergh Interviews*, 75.

41. See Kaufman, *Steven Soderbergh Interviews*, 60, 69, 105, 141.

42. See 1993 interview by Ciment and Niogret in Kaufman, *Steven Soderbergh Interviews*, 60.

43. *Rebels on the Backlot*, 326.

44. Waxman, *Rebels on the Backlot*, 327.

45. *Rebels on the Backlot*, 328.

46. Ebert, 'Traffic', *Chicago Sun-Times*, 1 January 2001, accessed via http://rogerebert.suntimes.com; US reviews that read the film as a critique of policy included those in *The New York Times*, 27 December 2000, and *San Francisco Chronicle*, 5 January 2001. The Los Angeles Times criticized the film for failing to spell out more explicitly its implicit questioning of existing drugs policy.

47. J. Hoberman, 'Space Odysseys: Solaris, Russian Ark', 27 November–3 December 2002, accessed via www.villagevoice.com.

48. Kenneth Turan, 'Soderbergh takes a space walk with "Solaris"', 27 November 2002.

49. 'Solaris', *Chicago Sun-Times*, 22 November 2002, accessed via http://rogerebert.suntimes.com.

50. Stephen Holden, 'Film Review; Their Love Will Go On In Outer Space', 27 November 2002, accessed via http://movies2.nytimes.com.

51. Mick LaSalle, 'Soderbergh's "Solaris" is all surface and cold as Kubrick', 27 November 2002.

52. Claudia Puig, '"Solaris": Cerebral space odyssey', 27 November 2002, accessed via www.usatoday.com.

53. Reviews accessed 5 July 2006, Traffic starting at www.amazon.com/gp / product / customer-reviews / B00003CXN4 / ref = cm_cr_dp_2_1/ 102–7310892–6805733?ie = UTF8&customer-reviews.sort%5Fby = SubmissionDate&n=130, *Solaris* at www.amazon.com/gp/product/ customer-reviews / B00009ATIX / ref = cm_rev_sort / 102–7310892– 6805733?customer-reviews.sort_by=%2BSubmissionDate&s=dvd&x= 14&y=9.

54. For a detailed consideration of the conditions required to be met for positive response to one particular challenging, less-mainstream oriented text, David Cronenberg's *Crash* (1996), see Martin Barker, Jane Arthurs and Ramaswami Harindranath, *The Crash Controversy: Censorship Campaigns and Film Reception*, chapters 4 and 5.

4

Indiewood inside the studios

American Beauty and *Three Kings*

If the period from the late 1960s until the mid-1970s is often viewed as a 'golden era' in Hollywood cinema, widely celebrated as the 'last time' the studios produced a body of challenging, unsettling work, rather than just the occasional isolated exception, 1999 was a year in which Indiewood appeared to come similarly to fruition, if on a considerably smaller scale; when the growth of the independent sector in the 1990s achieved a notable cross-over presence in the output of not just the speciality divisions but some of the major studios themselves, earning numerous comparisons (often overstated) with the earlier period.[1] The year saw the release of a number of striking examples, including *Being John Malkovich* (see chapter 1), *Magnolia* (Paul Thomas Anderson, New Line Cinema), *The Virgin Suicides* (Sofia Coppola, Paramount Classics), *Boys Don't Cry* (Kimberly Peirce, Fox Searchlight), *Election* (Alexander Payne, Paramount), *Fight Club* (David Fincher, Fox), *Three Kings* (David O. Russell, Warner Bros) and *American Beauty* (Sam Mendes, DreamWorks). The last four were distributed by the main divisions of the studios rather than being restricted to separate indie-oriented arms. In two cases, *Fight Club* and *Three Kings*, full studio involvement was a necessity because of scale of

production and budget level, but all four contributed to some blurring of the line dividing Hollywood from the indie sector at the time.

A number of factors help to explain studio involvement in such films, both general and more specific to individual titles. Much of the broader context has already been established, in the introduction and earlier chapters: one in which the studios made investments in certain aspects of indie-oriented production/distribution to buy into the box-office success and award-garnering prestige achieved by a number of indie features during the 1990s. More specific factors to be considered in this chapter include the role played by certain individual senior executives who had a personal investment in widening the bounds of what was permissible, to some extent, within the studio machine. Industry commentators speculated on other possible reasons for an upsurge of what were defined as more adult-focused films at the time, including their greater appeal to leading performers and uncertainty about the box-office reliability of some higher-budget 'event' movies and star vehicles.[2] It is hardly the case that the latter varieties were in any significant or long-term manner displaced by Indiewood products, however, in this or any other year, the majority of which continued to occupy a relatively marginal position in the broader studio economy. It is worth remembering, to keep the place of Indiewood in perspective, that 1999 also saw the release of solidly mainstream hits such as *Star Wars: Episode One – The Phantom Menace*, *The Mummy*, *Toy Story 2*, *The Matrix*, *Tarzan* and *Austin Powers: The Spy Who Shagged Me*, in addition to the less obvious box-office breakthroughs achieved by *The Sixth Sense* (distributed by the Disney arm, Buena Vista) and the independent *The Blair Witch Project*.

The main focus of this chapter will be on two of the wholly studio produced and distributed Indiewood examples from 1999, *American Beauty* and *Three Kings*, starting with an examination of the circumstances in which each film was able to gain space inside the studios – DreamWorks and Warner Bros, respectively. This includes a consideration of local and pragmatic factors that contribute to the development of particular products in particular shapes at particular places and times, in addition to broader and more concerted tendencies that might have been at work in the creation of the more eye-catching aspects of the release slate of 1999. Beyond the details of production

history, and what these tell us of the broader dynamics of Indiewood, much of this chapter will focus on the social-cultural and political dimensions of *American Beauty* and *Three Kings*, picking up a thread established in relation to *Traffic* in the previous chapter. Both films received positive responses from critics, rooted to a significant extent in the celebration of what were seen as critiques of aspects of American life: domestic social satire in the case of *American Beauty* and a questioning of foreign policy in Iraq in *Three Kings*. One of the central questions to be considered in this chapter is how far such films go in offering an alternative to the Hollywood norm at this level. Do they represent a significant challenge to more conventional Hollywood material, or does the studio location impose constraints greater than might be expected in the indie sector with which each of these examples has at least some connection? Questions of form will not be ignored, and are never entirely separable from issues of 'content', but the latter is given centre stage in this chapter, in both textual analysis and consideration of the responses of critics and other viewers.

Before moving on to the case study examples in more detail, it is necessary to situate them in some wider contexts of less-than-conventional production/distribution in the studio system. *American Beauty* might be associated with the longer tradition of the Hollywood 'social problem' film, as suggested in the case of *Traffic* in the previous chapter. Particular social-historical or industrial conjunctures, often a combination of the two, can give rise to greater than usual numbers of such films (or otherwise less affirmative portraits of America). Prominent examples include the immediate post-1945 era and the period of the Hollywood Renaissance cited above and elsewhere in this book as a recurrent Indiewood point of reference. *Three Kings* might be associated more specifically with a strain of production that has emerged in recent history, if only occasionally, in periods in which American foreign policy interventions have come into question. This was much less the case in any overt sense during the Renaissance period, during which the Vietnam war was an implicit more often than an explicit point of reference, but more typical of some productions set in south and central America during the Ronald Reagan era. Whether or not the late 1990s qualifies at these levels in socio-political terms might be open to debate. Ben Dickenson situates

a number of films of the period in the context of liberal disillusion with the Bill Clinton Democratic administration and the subsequent rise of more radical anti-capitalism/globalization movements. For Dickenson, such developments played directly into the content of films such as *Erin Brokovich*, *Traffic* and *American Beauty*, particularly in their foregrounding of 'protagonists socially rooted in a complete social matrix' (even if, as he concludes, such characters continue to act primarily as individuals rather than as part of collectives engaged in social struggle).[3] What kind of mechanism might be responsible for the translation of such movements into cinema is left unexplored by Dickenson, however, who seems to assume an immediate and unproblematic (and as a result rather simplistic) equation between one and the other.[4] The process through which socio-historical phenomena are converted into identifiable and sustained movements in the cinema is far from transparent and immediate in any cases, even in the most heightened circumstances. Events of a certain scale can be expected to achieve a critical mass where this is likely to occur, however, even if precise mechanisms often remain difficult to identify, a ground on which the impact of the upheavals of the immediate postwar years and the late 1960s/early 1970s seem considerably stronger candidates than Dickenson's assertions in relation to the politics of the late 1990s. A somewhat better case might be made for the context of the following decade, in the aftermath of the destruction of the World Trade Center and growing opposition to the subsequent occupation of Iraq, elements of the politics of which seem to be reflected in films such as *Syriana, Good Night, and Good Luck* and a number of releases in 2007–8.

A long history also exists of certain individual filmmakers being given, or carving out, greater than usual degrees of freedom within the studio system. Notable examples of recent decades would include Stanley Kubrick's arms-length relationship with Warner Bros and Woody Allen's multiple-film deals with several distributors. A number of special arrangements were created during the Hollywood Renaissance period, such as the Director's Company (Francis Coppola, William Friedkin and Peter Bogdanovic) created at Paramount, although these proved short-lived. In some cases, 'maverick' individuals have used a measure of freedom, usually rooted in a degree of prior box-office success, to pursue politically controversial studio-oriented

projects such as Oliver Stone's *JFK* (1991) and *Nixon* (1995).[5] Individual executives have, likewise, been able in certain circumstances to champion films that might otherwise have had little chance of receiving the studio green-light, a notable example cited in the previous chapter being Bill Mechanic's support for *Fight Club* at Fox (a similar situation underlay the existence of *Three Kings* at Warner Bros, as will be seen below). The major studio regimes of the 'classical' Hollywood era also provided varying degrees of relative autonomy, at certain moments and locations and within particular limits, for executive/producer-led units, or for individuals who had established reliable track records. In all these respects, it would be wrong to see the Indiewood films of 1999 as an entirely new phenomenon in the sense of the possible existence of relatively challenging and/or unconventional work (individually or collectively) within the output of the major studios. A particular conjuncture existed at this time, which created a certain amount of space for particular kinds of relative departure from what are usually understood to be the dominant norms of Hollywood. This was a significant development, but it is important not to overstate either its extent or the degree to which such a situation was unique in the history of Hollywood or its relationship with other regions of the cinematic spectrum.

At home in the studios

The stories behind the location of *American Beauty* and *Three Kings* as studio productions are rather different, the latter experiencing a much rougher ride than the former, as might be expected given its larger scale of production (an eventual budget of $48 million) and the subject matter's greater potential for overtly political controversy. *American Beauty* came in on a budget of $15 million, modest by studio standards and situated at the time on what one institution considered to be the cusp between what did or did not qualify, on financial grounds, for indie status. It was declared ineligible for consideration in the Independent Spirit Awards, the indie equivalent of the Academy Awards, presented by the Los Angeles branch of the Independent Feature Project (the branch disassociated from the rest of the IFP in 2005, rebranding itself as Film Independent). In what the organization

usually admits is a somewhat arbitrary exercise, a budget line is drawn each year above which productions are ruled out of contention (the 2000 award for best feature, for films released in 1999, was won by *Election*, which qualified on a budget of $8.5 million despite its major studio location, while *Being John Malkovich*, budget $13 million, won the prize for best first feature costing more than $500,000). *American Beauty* started out as a significantly smaller-scale project, however, initially budgeted in the region of $6–8 million, more distinctly in the financial arena of the speciality divisions. It originated as a spec script by Alan Ball, an established playwright and television writer who went on to create the critically praised HBO series *Six Feet Under* (2001–5). Ball's agent sent the script to the producing team of Bruce Cohen and Dan Jinks, among others, and *American Beauty* became the first film produced through their newly established Jinks/Cohen outfit (the pair had separate track records on productions for a number of studios).[6] Five companies expressed interest in the project, from differing positions in the industrial spectrum: DreamWorks (a newcomer among the majors and an independent agent in the sense of not being owned by any larger corporation), Fox Searchlight, October (at that stage attached to Universal), the independent Samuel Goldwyn Films and Lake Shore Entertainment (a substantial independent production company the subsequent output of which included studio projects ranging from *Runaway Bride* [1999] and *Million Dollar Baby* [2004] to *Arlington Road* [1999] and *The Mothman Prophecies* [2004]).[7] The project was viewed as having potential, this suggests, across the range from the fully independent Samuel Goldwyn to Indiewood divisions, an independent closely integrated into mainstream production and the smaller end of the majors. DreamWorks was the highest bidder and secured the property, in what *Variety* reported as a move by the studio towards lower-budget production and the future prospect of creating its own speciality arm (a development eventually realized in 2003, two years before the studio was sold to Viacom, the parent of Paramount Pictures).[8]

The process through which DreamWorks considered the *American Beauty* script is one that suggests a distinction from the manner in which the major studios tended to operate at the time, a studio procedure often blamed for a perceived lack of creativity or

challenging material in Hollywood. The script was taken to DreamWorks creative executive Glenn Williamson, according to Jinks, with instructions that: 'No matter what the coverage says, you have to read this yourself.'[9] He did, apparently, as, in turn, did head of production Bob Cooper and Steven Spielberg, one of the owners of the studio and the figure whose personal authority and enthusiasm ensured the green-lighting of the project. This implies a direct, hands-on decision-making process on the part of senior executives, rather than reliance on committees and second-hand procedures such as dependence on 'coverage', a term used to denote the reports of script-readers that act as initial gatekeepers for the studios. Decision-making by committee and reliance on script reports are widely seen as forces of conservatism in Hollywood, exacerbating existing tendencies for the studios to be unadventurous in their choice of projects that make it into production. A similar direct involvement by individual executives was an important factor in the genesis of *Three Kings*, as will be seen below. In the case of *American Beauty*, such investment on the part of the most senior executives, particularly Spielberg, appears to have cleared the way for the production to proceed with little interference from the studio, beyond the maintenance of a particular (if higher than originally anticipated) budget ceiling. Such an approach can also be seen as a manifestation of the claim of DreamWorks on its inception to be a 'different kind' of Hollywood studio, free from the pressures experienced by the rest of the majors as a result of their ownership by larger media-oriented corporations. One significant element of such pressure, typically associated with Hollywood in the age of corporate location, is the tendency for marketing departments to dominate over creative executives in decisions about which projects get studio approval, and for completed films to be subjected to preview screenings and potential reshaping on the basis of test-audience responses.[10] It is notable that the three ruling partners of DreamWorks (Spielberg, Jeffrey Katzenberg and David Geffen) are reported to have cancelled its preview screenings after viewing the final cut, 'taking the position that their film was both very special and very delicate. It would either play for audiences or it would fail miserably.'[11]

From its inception as a project, then, *American Beauty* was treated and positioned as something special, as an individual creative work that

needed to be handled as such rather than as just another commercial/ industrial 'product'. It was written on spec and 'from the heart', according to Ball, a concept inspired by the media coverage of a murder trial that he had previously tried to write as a play and had lived with for a number of years, rather than being commissioned or fashioned with the dictates of the marketplace directly in mind, unlike two previous scripts he had written that had languished in studio 'development hell'.[12] In return, the script was treated by DreamWorks as a piece of work that had to be considered by senior executives on its own terms, in full, rather than through the process of initial reduction to script department coverage. This is a process that implies the kinds of values more often associated with the indie sector than the operations of the studios, although it is easily romanticized, as if what is involved is not still a commercially-oriented endeavour. It creates more space, potentially, for projects to be treated as organic 'artistic' works, rather than as moveable assemblages of marketable components, even if a certain threshold of marketability is assumed by decision-makers in cases where the go-ahead is given. *American Beauty* continued to exhibit markers of distinction as it took shape at the studio. Sam Mendes was signed on to direct, choosing the project for his film debut and bringing prestige and 'quality' resonances from his critically acclaimed career in the theatre. Kevin Spacey was cast in the central role, also bringing theatrical credentials to the production and contributing further to the establishment of *American Beauty* as 'serious' and substantial drama.

On release, *American Beauty* was handled in a manner that suggested the kind of longer-run nurturing associated with the indie/specialist sector, although combined with what quickly became a larger-scale operation than had initially been anticipated. It was the kind of film that would be likely to find favour with critics, a dimension exploited through an early sneak preview given to a correspondent from *The New York Times*.[13] Additional screenings ahead of release were kept to a minimum, a deliberate ploy designed to maintain a higher than usual state of anticipation. A well-received premiere was held at the Toronto film festival in September, one of the major events in the indie film calendar, followed by a platform opening a week later on six screens, three in New York and three in Los Angeles. A further ten screens

were added a few days later. The second weekend saw a much wider spread, to 429 screens, a move that came earlier than had been planned, in response to the impressive early box-office performance, an average of almost $54,000 per screen (the kind of screen average achieved by the surprise big hit of that summer, *The Blair Witch Project*). By early November the film was on more than 1,500 screens nationwide, supported by advance showings for opinion-makers in major cities, and remained on some 500 during December, by which time it was established as a favourite for the Academy Awards. After eight nominations were received the release was scaled up to a peak of nearly 2,000 screens, to take advantage of the publicity boost. *American Beauty* eventually took five awards, including best picture, and achieved a total domestic gross of $130 million that represented an extremely good return on the budget. This was a significant boost to DreamWorks, which had enjoyed only patchy box-office success since its inception in 1994 and relatively little to mark its distinction from the operations of the established majors.

The release strategy overall was a very Indiewood hybrid, a combination of platform and wider release that seemed highly successful in maximizing the film's potential returns across a substantial period of time, taking full benefit from the recognition provided by critics and academy members. The marketing campaign included an emphasis on sexual content, particularly in the art-exploitation style naked female midriff that featured centrally in the poster. The film's more obvious mature-adult qualities were sold in combination with appeals to teenage audiences, based on the film's younger secondary characters, including the use of targeted TV spots on channels such as MTV, a strategy that appeared vindicated by polling that showed a wide range of age groups among the opening weekend audience.[14] This may have been a key factor in the scale of its eventual box-office success, the limited threshold faced by many indie/speciality films in broadly similar territory (satirical portraits of contemporary American suburban life, often featuring or including teenage characters) often being attributed to a tendency not to be able to combine separate grounds of appeal to mature-adult and more youthful audiences.

If *American Beauty* had much in common with works from the indie/speciality realm, from budget and handling to textual qualities

that will be considered below, the project that became *Three Kings* bore greater resemblance on several counts to more mainstream studio material, including its deployment of a number of large-scale action sequences. Its development at Warner Bros relied on some factors similar to those involved in *American Beauty*, however, particularly the hands-on involvement and commitment of individual senior executives, a dimension that seems essential in most cases if less obviously conventional projects are to make progress in the contemporary studio environment.[15] The initial impetus in this case came from the studio end, via interest in David O. Russell as an upcoming filmmaker. It was directly rooted in the indie/speciality sector, where Russell had made his mark in two productions: the distinctly off-beat and transgressive comedy *Spanking the Monkey* (1994, an independent production distributed by the New Line subsidiary, Fine Line Features), with its themes of family dysfunction, masturbation and incest, and the relatively more conventional but still prickly comedy of coupling and search for parental roots, *Flirting with Disaster* (1996, produced and distributed by Miramax). If Russell was part of a new generation of filmmaking talent that had been nurtured in the indie sector, his entrée to a major studio division was the result of what has been seen as the coming to the fore of another new generation in the senior studio executive ranks.

Warner Bros in the 1990s was by most accounts a model of the well-oiled studio machine, run on what had become perceived to be tried-and-tested lines with an unusual degree of stability by the long-running partnership of Robert Daly and Terry Semel. Key ingredients of the prevailing recipe for success were reliance on established stars and experienced directors. A younger generation of executives began to come of age in the mid-1990s, however, and was given increased influence in the green-lighting process. The two new forces seeking to make their mark at Warner were Bill Gerber and Lorenzo di Bonaventura, figures without whose influence *Three Kings* is unlikely ever to have existed. (Di Bonaventura also played a key role in driving the studio's production of *The Matrix*, another project that had little resonance for the older studio heads; the unexpected scale of its success significantly increased his influence at the studio.) Equivalent roles were performed at other studios, Peter Biskind suggests, by Amy Pascal

at Sony, Stacey Snider at Universal and Mike de Luca at New Line (and subsequently DreamWorks), executives who were 'to some extent, moving away from the we-know-best, anti-filmmaker arrogance of the generation that preceded them, the [Michael] Eisners, [Sherry] Lansings, Semels, and Daleys [sic], and trying their hands at Indiewood films, either directly or through their indie divisions'.[16] De Luca, for example, championed Paul Thomas Anderson's *Boogie Nights* (1997) and *Magnolia* (1999) against the inclinations of his superiors at New Line, having failed in previous efforts to back Wes Anderson and Spike Jonze. Steven Soderbergh benefited similarly from a relationship with Casey Silver at Universal. Silver hired the director for his second feature, *King of the Hill*, and, by then promoted to studio head, helped to revive Soderbergh's career by pushing him for *Out of Sight*.[17] The connection made between some of the films of the late 1990s and unconventional studio output in the late 1960s and early 1970s is not an arbitrary one, even if sometimes exaggerated, the earlier body of work providing key reference points for many in the new generation of executives as well as for filmmakers such as Russell and Mendes.

Warner's interest in Russell began, according to Sharon Waxman, when Gerber saw an early copy of *Flirting with Disaster*, distribution rights for which had been sold to Miramax as part of a two-picture deal that gave the Disney subsidiary first right of refusal on his next screenplay.[18] Gerber invited Russell to the studio to look through its log of script properties to see if anything might catch his interest, in the knowledge that the director's obligation to Miramax would not be a factor in any production resulting from an existing project. Russell's interest was piqued by the one-line summary of a script by John Ridley, titled *Spoils of War*, which contained the basic scenario of what came to be *Three Kings*: a group of American soldiers involved in a heist in Iraq during the Gulf War of 1991. Russell had a long-standing critical interest in foreign policy, having lived in Central America during the early 1980s, a time when the USA was backing attacks on the Sandinista regime in Nicaragua and supporting right-wing dictatorships in Guatemala and El Salvador. He was brought in again to meet di Bonaventura, who agreed 'that Russell was just the kind of young talent Warner needed to recharge itself creatively'.[19] They came to an arrangement according to which Russell would write his own

version of the scenario before a final studio decision on whether or not the film would go into production. During that period, some 18 months of writing and research, Gerber departed from the studio, leaving di Bonaventura as sole guardian of a project that was unlikely to see the light of day without a strong source of senior executive support. Neither Daly or Semel apparently thought much of the script. Di Bonaventura agreed that it was a risky venture, unconventional in many respects and likely to be politically controversial. He wanted to make it, however, and his clout was sufficient for it to be given the go-ahead, subject to what turned out to be a series of rewrites by Russell.

In a lengthy *Variety* feature that stressed the difficulty of getting studio projects approved in a contemporary context of 'shrinking margins and rising production costs', a piece that highlighted the increased role played by marketing and exhibition executives rather than heads of production, *Three Kings* was singled out as one of a number of exceptions to the rule, 'an unusual example of a story-driven movie that largely ignored [market] research in favor of story'.[20] The same article noted the Warner procedure of allowing creative rather than marketing executives 'to steer the greenlight process', even if the final say remained with the heads of the studio. A particular combination of the enthusiasm of two senior executives and a studio regime that gave their creative instincts more influence than was usual at the time enabled the production to go ahead without, it appears, reliance on prior public testing of the concept, another of the prevailing studio mechanisms often cited as a discouragement to originality in Hollywood. It was still considered a risky proposition, however, and not financed by Warner alone. *Three Kings* proceeded as one of a number of titles produced jointly with Village Roadshow Pictures, a division of an Australian media company, as part of a long-term partnership deal, the kind of arrangement through which the majors often share the costs and potential risks of individual pictures.[21]

Once given the go-ahead, Russell and his film remained subject to a number of constraints imposed by the studio context. Controversy surrounded successive rewrites of the script. George Clooney, cast in the central role, later accused Russell of watering down his second draft as a result of studio pressure, a claim rejected by the latter. According to Waxman, the changes included the toning down of a rape scene and

the clothing of a group of Iraqi prisoners originally presented as naked, although she suggests that a third, penultimate, draft moved closer to the spirit of the original.[22] Whatever the reasons for the changes, arguments about the script were only the beginning of tensions between Russell, Clooney and Warner that demonstrate the difficulties often involved in the pursuit of less conventional projects within the studios. Clooney was far from Russell's choice for the lead role of Archie Gates but effectively foisted upon the filmmaker as a condition of the project being given the green light, the studio having an expensive deal with the actor from which it wanted a pay-off. Additional sources of tension included Russell's insistence on the casting of some of the other parts, including his friend Spike Jonze, who had never acted before, and the employment of Greg Goodman, a figure from the indie world, in the important day-to-day role of line producer. The studio was also nervous about Russell's plan to shoot parts of the film on Ektachrome stock, to create a particular visual effect to which we return below. It was increasingly uncomfortable as the project geared up for production, Waxman suggests, the more so when a number of related political issues returned to the headlines, including American cruise missile attacks on alleged 'terrorist' targets in Sudan and Afghanistan and the subsequent bombing of a Planet Hollywood restaurant in Cape Town. At this point, shortly before the start of shooting, an attempt was apparently made to spike the film behind di Bonaventura's back. With the supportive executive on a week's holiday, Clooney was called to a meeting with another senior studio figure who tried to persuade him to pull out of the film, which would effectively scupper the production, on the basis that it would lead to Muslim threats on his life and hostility from the American right.[23] Clooney refused, however, and smoothed over the row that broke out when di Bonaventura returned, found out what had happened and threatened to quit the studio if the film did not go ahead.

Difficulties continued once shooting began, Russell being unable to gain the ease achieved by Soderbergh's *Traffic* in the blending of large-scale and indie-style approaches. Russell inherited a traditional studio crew, the expectations of which clashed with his desire to work in an improvisational manner.[24] Differences between director and crew increased the tension between Russell and Clooney, which culminated

towards the end of the shoot in an on-set shouting match and a physical scuffle involving the two. Russell also reports resorting to subterfuge in order to be able to gain sufficient shooting time to retain the density of background detail and action that occurs in many scenes.[25] His script was subjected to standard Warner practice of being reformatted in the studio style, the resulting number of pages providing the measure of how many days shooting would be required. In studio format, *Three Kings* appeared longer than the original draft, and thus a more expensive proposition, which led to suggestions that some scenes be cut. To circumvent the problem, Russell says, he condensed some material on the page of the official script while a more detailed 'secret script' was given to the crew. He wanted 80 days of shooting and was initially given only 68, but eventually had 78 days, having to submit to a process in which the additional days were permitted one at a time, as he was able to prove himself capable of mounting such a production on the ground.

Waxman suggests that the studio did not really know how to promote or market the film when it went on release, a mainstream-scale opening on 2,942 screens in October. This seems true of the poster artwork, the limited scope of which creates a straightforward war-movie/star-led impression with nothing to suggest the film's less conventional dimensions. The same cannot be said of the theatrical trailer, however, which gives a reasonable impression of the overall mixture of tones employed by the film, including a dialogue extract that overtly criticizes Bush Sr's policy on Iraq. The critical response was generally positive, partly on the grounds of the film's stance on such issues, but the studio did not lobby for the film in the Academy Awards, a necessary part of the procedure required for success, which suggests an overall lack of investment and/or belief in the production, and no nominations were received. *Three Kings* eventually took a disappointing $60 million in the USA. Exit polls conducted during the opening weekend indicated that it was drawing an 'older-than-expected' audience, which suggests that the film was reaching those more likely to be attracted by critical praise and/or elements of the production other than the more conventional war/action-movie ingredients. It could be expected to sustain what was viewed as a solid initial performance 'if the muscular tale can draw young males and

attract female viewers', concluded a writer for *Variety*, a direction in which it appears to have succeeded at most only to a limited extent.[26]

Mixing convention and critique

At the level of their substantive content, and its broader social-cultural/political implications, *American Beauty* and *Three Kings* are further examples of a characteristic Indiewood blend of the more and less conventional. Each has a clear agenda, a critical point to be made that has overtly (rather than just implicit) social/political resonance, a dimension that distinguishes them from the norm for Hollywood and also for many independent films. *American Beauty* fits into a tradition of satirical treatments of suburbia found to some extent on both sides of the Hollywood/indie divide. It was praised by major critics as a pointed and heartfelt, if not entirely original, approach to such material. Its social critique includes a number of rather easy pot-shots, however, as a minority of critics acknowledged, and it is arguable that the film maintains and invests in as many prevailing ideological complexes as it seeks to question. While *American Beauty* establishes a single, dominant tone, a dark and avowedly serious humour, *Three Kings* offers a considerably more unstable mix of ingredients in its effort to introduce critical material into a large-scale studio production, including action-adventure, farcical humour, conventional mechanisms of emotional melodrama and more substantial engagements in some of the issues surrounding American involvement in the 1991 war against Iraq.

Buying into the anti-consumer critique: American Beauty

American Beauty revolves around what is depicted as the mid-life crisis and re-awakening undergone by its central character, Lester Burnham (Spacey). Alienated from a comfortably suburban life and a wife (Annette Bening) who appears to embody its aspiration towards superficial perfection, a glum and downtrodden Lester gains rejuvenating new purpose through the catalyst of his infatuation with the Lolita-like figure represented by his teenage daughter's friend, Angela (Mena Suvari). Lester 'drops out', deliberately sabotaging any chance of holding onto his job during corporate restructuring, discovering a

taste for high-grade marijuana through a new friendship with neighbouring teenage dealer Ricky Fitts (Wes Bentley), exchanging his sensible car for the dream vehicle of his youth, a red 1970 Pontiac Firebird, working out (in an attempt to impress Angela), and taking a low-level McJob in a burger restaurant as a way of escaping responsibility and revisiting the most carefree time of his youth. Against the position defined by Lester, the film sets a number of somewhat crude opposites. These include a tightly wound wife, Carolyn, a real estate agent who stands for materialism and a concern with appearances and only partially transcends the level of caricature through the revelation of her own underlying misery; and the patriarch next door, 'Col. Frank Fitts of the US Marine Corps' (Chris Cooper), a Nazi-admiring advocate of the importance of 'structure' and 'discipline', who turns out (rather stereotypically) to be a repressed homosexual. Sharing Lester's position on the positively-coded side of the equation are his daughter Jane (Thora Birch), from whom he has become distanced, and her newly established boyfriend Ricky, who finds (and videotapes) beauty in the world in unlikely sources such as dead bodies and the dance of a plastic bag caught in the wind. Angela, Lester's transforming object of desire, proves to be shallow and conventional, bent on a career in modelling, although ultimately given sympathetic portrayal as a vulnerable and insecure child, despite her bluster and a façade of greater sexual maturity.

At the heart of *American Beauty* is a critique of shallow materialism as manifested by immaculate and imprisoning suburban interiors, issues previously explored in Ball's work for the stage.[27] The state of both the Burnham and Fitts households is encapsulated in images of polished, symmetrical and deadening interiors, against which Lester, in particular, begins to rebel. A defining scene comes after Lester has lost his job and traded cars, when he attempts a physical rapprochement with Carolyn, to recapture something of their past relationship, a moment broken by her concern that he is about to spill beer on a $4,000 Italian-silk-covered sofa. 'This isn't life', he rails, 'this is just stuff, and it's become more important to you than living'. This is a form of social criticism, more than is found in most Hollywood films, but it is relatively familiar territory. If *American Beauty* is one of the Indiewood films that has been associated with the earlier period of

15. Immaculate, imprisoning interiors: At the dinner table in *American Beauty*
© DreamWorks

the Hollywood Renaissance, that is no accident, as it shares central
thematic strands with some of the counterculturally-oriented films of
that time, most notably, perhaps, *The Graduate* (1967), a connection
identified by some critics at the time of release.[28] Even where such
inheritances were noted, and the film was not therefore seen as entirely
original, the critical reaction was overwhelmingly positive, local detail
or character treatment being identified among other markers of a fresh
and distinctive take on the material.[29] *American Beauty* can also be
located within a broader tradition of representations of American
suburban life, another perspective from which its stance appears more
conventional and familiar than is implied in the close-to-breathless
tones employed by some of the most positive reviews.[30]

For Robert Beuka, in a study of images of suburbia in American
fiction and film, *American Beauty* is situated clearly at one pole of
a 'restrictive, binary system' through which suburbia has been
represented as either an idealized model of community or its dystopian
opposite.[31] The former is a largely dated view, associated with situation
comedies such as *Leave it to Beaver* (1957–63), while the latter is
familiar currency in the indie sector and a minority strand of
Hollywood films. From this perspective, *American Beauty* invokes
'essentially traditional, dated critiques of suburban life':

> Both the presentation of a protagonist as a beleaguered, emasculated
> head of household and the publicizing of his illicit sexual desires have

a distinctly postwar feel; the caricatured depiction of his wife as an aggressively driven real estate agent amounts to 1980s'-style antifeminist backlash masquerading as contemporary satire; and the nod to sexual plurality in the suburbs offered through a positive depiction of the protagonist's gay neighbours is undercut by the film's conclusion [the shooting of Lester by Col. Fitts after the former resists the latter's unexpected homosexual overture].[32]

American Beauty is perhaps at its most conventional in its use of the figure of the wife as a negative point of reference, part of a wider historical tendency to associate many of the ills of suburban life with its allegedly emasculating qualities.[33] Apart from the initial triggering of his infatuation with Angela, Lester's rebirth and growing self-possession are marked by successive instances in which he stands up to and confronts Carolyn, although she also gains a degree of renewed fulfilment through the development of a sexual relationship with her real-estate rival, Buddy Kane (Peter Gallagher).

Why, then, should the film have been received quite so positively, even among critics who expressed what were usually relatively minor reservations? The implication is that leading critics, and with them many subsequent viewers who made the film such a box-office success, shared something of the central value-structure embodied in the film; and that it could act as a vehicle for their own assertions of opposition to its vision of shallow suburban materialism and their openness to the more positive values the film propounds. This seems to be supported by viewer responses as measured by Amazon.com customer reviews. From a sample of 1,000 reviews, 309 articulate substantial investment in what might be seen as the 'message' of the film, its view of contemporary American suburbia/society and its broad prescription for renewal, many of these describing the film in terms such as 'insightful' or 'life-changing'.[34] Another 251 give less developed but intensely positive responses the tone of which suggests a similar sharing of the values expressed by the film, making a total of 56 per cent of the sample, a large proportion given the varied nature and substance of Amazon reviews. An additional 143 offer more general positive responses, taking the total of clearly positive reviews to slightly more than 70 per cent.[35] Some Amazon respondents join

Beuka in finding the film's portrayal of suburbia to be clichéd, but these are in the minority (49 respondents, or 4.9 per cent of the sample; 133 respond negatively more generally or in other ways). We are returned here to the notion of the selling and commodification of 'alternative' countercultural values considered in the introduction via the work of Thomas Frank. This is an issue directly addressed in relation to *American Beauty* in an updating of Frank's argument by Joseph Heath and Andrew Potter.[36] As they suggest:

> One can see quite clearly the power that countercultural analysis still
> exerts [although heavily commodified] in the exceptionally positive
> (and uncritical) response to the movie *American Beauty*. The film is, in
> essence, a completely uncompromising recitation of '60s
> countercultural ideology. It's the hippies versus the fascists, still
> slugging it out three decades after Woodstock. Yet despite the
> occasional reviewer who happened to notice just how tired the
> central ideas were, the film went on to take the world by storm [...].[37]

Two of the Amazon respondents who criticize the film for the use of clichés make a similar connection. *American Beauty* itself can be understood, then, as a commodified version of certain countercultural values, initially constructed (the apparent creative freedom of writer and director notwithstanding) to fit a particular market niche that it eventually transcended. This is consistent with the manner in which Frank, Heath and Potter suggest that manifestations of the counter-culture have gained a place in the marketing mainstream. Films of this variety are designed, if only implicitly, to flatter more than to challenge the existing assumptions of their target (and, potentially, wider) audiences, a process that functions through a combination of thematic emphasis and aesthetic qualities, the two often linked, as is the case in *American Beauty*.

An important role is played in the film by the videotapes produced by Ricky, and their openness to the capturing of a beauty still to be found in quotidian details within this fallen suburban world: a key source of transcendence offered as the consoling message of *American Beauty*. They offer what is presented as a simple, plain 'found art' aesthetic, even if Ricky's use of his video camera is first seen as

somewhat sinister and intrusive, in his initially surreptitious filming of Jane. The sequence featuring the plastic bag is particularly significant, both within the diegesis and in the situation of *American Beauty* in the wider field of cinematic production. It appears to be a direct lift from an avant-garde work by Nathaniel Dorsky, *Variations* (1992–8), in both the type of image – a plastic bag caught in the wind – and the meaning attributed to it, in which meditation on such fleeting moments, immortalized by the camera, is offered as a source of human renewal.[38] In the work of Dorsky such images are presented in silence and removed from any narrative context. The same is true of Ricky's plastic bag video, although it clearly serves a substantial narrative purpose in the frame provided by *American Beauty*. The aesthetically more radical, abstract text is contained – motivated, explained, its implications developed into a major explicit theme – by the more familiar and accessible dynamics of the narrative feature.[39] The use of contained/motivated versions of what would otherwise be more avant-garde formal devices is not uncommon in some works of indie cinema, as I have argued elsewhere.[40] The connection between *Variations* and *American Beauty* may have been a coincidence rather than the outcome of any direct influence. Ball suggests in interviews that the sequence was inspired by an experience of his own and no reference to Dorsky is made in the credits of *American Beauty* or the DVD commentary by Mendes and Ball (although Dorsky reports having received a telephone call from DreamWorks enquiring about

16. The more abstract work contained within the frame: The plastic bag video, as viewed in the narrative world of ***American Beauty*** © DreamWorks

the availability of his film). Whatever its origins (Dorksy or Ball-via-Fitts), the film gets the best of both worlds by effectively taking credit for the aesthetic, and its meaning, while presenting it second-hand, as the work of one of the fictional characters who explains its basis, rather than confronting the viewer with the experience more immediately. This seems a strategy characteristic of the marketplace location of the film, as a work that seeks to buy into certain notions of artistically marked distinction but in a manner that is rendered accessible to a broad audience.

What, then, of the aesthetic of *American Beauty* itself? It is very different from the impoverished visual quality exhibited by Ricky's work, especially when the low-resolution tape is blown up to fill our screen rather than seen as images viewed inside the fictional world. The cinematography by Conrad Hall, repeatedly singled out for praise by Mendes in his DVD commentary, is far more luxurious, characterized by subtleties of lighting and reflection, and explicitly appreciated – whether attributed to Mendes or Hall – by many critics, including 109 members of the Amazon sample (just under 11 per cent). It is, for the most part, restrained, typically described by critics in terms such as 'exquisite' or 'luminous'. Mendes comments on the tendency of many films to make excessive use of close-ups, associating his own work with a nuanced approach in which meanings and emotions are left more implicit. These can all be understood as markers of the status of prestige, 'quality' production to which the film aspires, and clearly achieved in general critical, audience and awards-garnering reception. In some cases this includes the creation of a more overtly 'theatrical' impression, grounded in Mendes' stage background, in the use of devices such as the sudden shift of lighting and staging that occurs to isolate Lester and emphasize the fantasy nature of the sequence in which his obsession with Angela is sparked. *American Beauty* implicitly offers its own audio-visual qualities – its own 'beauty' – as a source of solace and attraction for the viewer, as markers of distinction. This involves something of a contradiction with the stance taken within the diegesis. The film itself embodies the kind of carefully controlled and manufactured 'quality' aesthetic, a distinction-claiming consumer product in its own arena (whatever the impression of more immediate artistic creativity emphasized in the accounts of those

involved in the production), against which its narrative sets the apparent immediacy of Ricky's work and the more direct engagement it offers with a supposedly natural form of transcendent beauty.

Ricky's video recorder often seems to observe somewhat coldly and objectively, as underlined in a sequence in which it continues to produce off-kilter images on a television screen after being knocked from his grasp during one of his periodic assaults at the hands of his father. *American Beauty* itself adopts a more variable position. At times, Mendes' own camera also seems withdrawn, as befitting a satirical mode that calls for greater than usual critical distance from the material, as in the high overhead perspective on the suburban neighbourhood provided at the start and in moments of chapter-style punctuation of the narrative.[41] These sequences and overhead shots of Lester lying on his bed are often accompanied by an internal narrative voice-over that is also detached, in the sense of belonging to some reflective moment in time after his death. The symmetrical compositions of some of the sequences in the Burnham and Fitts households suggest a formal, distanced point of view. The film's aesthetic also sets out to be seductive and appealing in many instances, however, to draw the viewer into its world. This is partly a matter of the general quality of the image, as suggested above, which includes a great deal of subtle side- and back-lighting, in addition to the flourishes found in the Angela-fantasy sequences. The soundtrack also plays an important role, especially in the teasing quality of the percussive main theme by Thomas Newman, as does the quality of the performances, particularly the establishment of a growing sense of glee in the development of Burnham's rebellion. The seductive dimension of the film is particularly pertinent to the stance it takes in regard to Lester's sexual desire for Angela, and how this positions *American Beauty* in the pull between relatively mainstream or alternative qualities. The film seems to aestheticize Lester's obsession more than to satirize it, despite the biting nature of some of Jane's comments on the subject. His desire provides the motivation for the film's most overtly expressive sequences: the fantasy component of the cheerleader routine in which Angela first comes to his attention and additional instances such as her imagined appearance all-but naked on a background of red rose petals, the latter forming a recurrent sexual motif throughout the film. This

aestheticization seems designed to implicate the viewer, to at least some extent, in an unhealthy attraction to a girl marked as too young to be an appropriate object of Lester's desire. A recurrent device is the use of small reverse jump-cuts, in which key actions (the unbuttoning of Angela's blouse in the cheerleader sequence, the movement of her arm to caress Lester in his kitchen and the reaching of his arm down between her legs in a masturbatory bathroom fantasy) are repeated, usually more than once. The effect is to draw out these moments in a lingering, luxuriating and somewhat fetishistic manner. This quality might be attributed to the fantasy or dream status of the sequences involved, but a slippage seems to occur between this and the manner in which they are offered more directly as a source of audio-visual pleasure for the viewer.

How this implication of the viewer might be interpreted is open to debate. From one perspective, it makes the film complicit in a broader cultural complex that might be considered questionable and that has roots in a conjunction of dominant/prevailing ideologies. Lester's sexual desire for a Lolita figure, his mid-life crisis/rebellion in pursuit of freedom and the film's structural hostility in many respects towards the ambitious career woman can all be read as consistent with wider (broadly reactionary) tendencies in contemporary American culture, as suggested by Kathleen Rowe Karlyn.[42] *American Beauty* is certainly very limited as any kind of socio-political critique. Its offer of an internal 'beauty' available to those who 'look closer' is based on a self-affirming romantic individualism in tune with a long-standing thread of American ideology that offers no meaningful prescription for social change. Implication in Lester's desire also has the capacity to make the viewer uncomfortable, however, in a manner that can be a marker of a more radical/alternative stance in some respects. Discomfort is likely to be created for many viewers in the sequence in which Lester appears to be about to have sex with Angela, or for one moment appears already to have begun the process. (His body looms over hers at the start of a shot, as if the act has begun, and it still seems imminent when he proves merely to be about to remove her jeans; this might be taken at the time to be another moment of fantasy, however, employing a more subtle version of the reverse jump-cut described above.) This proves to be something of a tease on

the part of the filmmakers, but it is likely to generate unease. Lester unbuttons Angela's shirt, revealing her breasts, and she appears very small and child-like beneath his relative bulk. The act goes no further, as it turns out, after Angela reveals that, contrary to previous impressions, she is a virgin rather than the seductive temptress of the film's fantasy sequences. Lester's attitude shifts from erotic interest to paternal concern (and it is through Angela, shortly afterwards, that he is presented as coming to an understanding of his own daughter, contributing further to the status of this shift as an important epiphany).

If *American Beauty* was seeking to create genuine discomfort in its viewers, this might be considered a cop-out. It lets the viewer off the hook, which seems retrospectively to license the earlier indulgence in the sexual fantasy, safely removed from any eventual consummation. To have taken the fantasy to its logical conclusion might have been to have treated its disturbing qualities more seriously. But that would entail a complication of the mainstream narrative assumption that the central character, however quirky or at times difficult, remains (or is designed to be) an ultimately unproblematic source of sympathetic audience allegiance. This is as clear a marker as any of the Indiewood rather than more radically indie leanings of the film. It is notable that this was a change from the first draft of the script, in which Lester does make love to Angela. It is tempting to see the shift as the result of studio pressure. Ball says he got 'a note from the studio' in relation to the scene, to which he says his initial response was 'oh, they just want to make it "nicer"', the kind of pressure he associates with the restrictions imposed on his previous work in network television.[43] He maintains that the change was his own decision, however, the original version having been 'a really wrong choice' on his part, the result of the state of anger (generated by his experiences in television) in which he wrote the screenplay. Any suggestion that such a key shift was the result of institutional pressure is disavowed, an important part (whatever the reality of the situation) of the process of sustaining the notion that the film was the outcome of a distinction-marking process of largely unbridled creativity.

A useful point of comparison is the handling of paedophilia in *Happiness* (1998), released the year before *American Beauty*. One of

the central characters of Todd Solondz's ensemble production is an unreconstructed paedophile, an issue the film confronts head-on by making him neither especially likeable nor dislikeable; just what is presented uncomfortably as an 'ordinary' man who happens also to be a paedophile who preys on the friends of his own son. *Happiness* has some points of resemblance to *American Beauty*, as another suburban satire that leans towards familiar convention in its tendency to take rather easy pot-shots at some of its women characters. Its treatment of paedophilia, however, marks a point of sharp distinction (as does its much plainer texture, not reaching for the overtly aestheticized, 'quality' imprint sought by *American Beauty*), as evidenced by the difficulty the film faced at the point of distribution. *Happiness* was an indie production, from New York independent stalwarts Good Machine and Killer Films. It was due to have moved into the Indiewood realm via distribution by the Universal subsidiary October Films, but proved too contentious to be handled by a studio division, eventually being released by Good Machine itself – an experience in which the sometimes blurry distinction between indie/independent and Indiewood was thrown into sharp relief.[44] A number of other indie films have also offered complex and/or less judgemental portrayals of paedophile characters, including *L.I.E.* (2001) and *The Woodsman* (2004), not to suggest a pro-paedophile agenda but as a rejection of the simplistic moral economy and demonization of such figures usually associated with Hollywood or other mainstream media products. *American Beauty* steers a middle course, its central narrative mechanism and some of its aesthetics buying into Lester's fantasy, without being willing to pay the price at the level of what its consummation might imply for both the character, the experience of the viewer and the resultant positioning of the film in the marketplace. In this and other respects, including its aesthetic strategies, the film has become something of an Indiewood touchstone: for some, it is a marker of the contemporary existence of a strain of quality/prestige/sophisticated production within the studios, while for others it is a leading example of a form of co-optation that involves an inauthentic watering down of an alternative/independent sensibility.[45]

Mixing it up: Three Kings

Three Kings starts in an off-kilter, destabilizing manner. Opening titles reading 'March 1991. The war just ended' are followed by what initially appears to be first-person footage moving across the desert floor to the sound of footfall. An American soldier moves into shot from the lower edge of the frame, relocating the perspective as more objective although still closely allied to his position. As he and the camera shift direction, turning to the left, a mound comes into view on top of which stands a figure, waving. The composition is decentred to an extreme, a wide-angle shot with the mound in the upper left corner of the screen, the helmet of the soldier in the lower right. 'Are we shooting?', he asks. 'Are we shooting people, or what?' As an equally uncertain answer comes from a colleague, the camera whip-pans to the left, quickly zooming in to a group of three soldiers; it pauses and whip-pans left again to another pair, one inspecting a grain of sand in the eye of the other. The overall impression is one of confusion and a disorientation that is both literal, in the use of irregular framing and abrupt camera movement, and marked in relation to broader and more familiar war-movie conventions (in which, for example, uncertainty would not usually be expected on such a crucial issue as whether or not the protagonists are meant to be shooting the enemy). The first soldier, later identified as Troy Barlow (Mark Wahlberg), shoots and kills the figure on the mound, an Iraqi who appears to be attempting to surrender, and is visibly upset when he sees the results at close quarters. A few comments follow from his colleagues ('I didn't think I'd get to see anyone get shot in this war'), then a freeze frame, the main title and an incongruously abrupt cut to loud music and raucous scenes of American troops dancing in celebration of the end of the war. The opening sequence establishes one of the dominant tendencies of *Three Kings*, a pointed and fresh take on the American war film that in several respects demonstrates a distinctly un-Hollywood sensibility. As the main plot-line develops, the film moves into more familiar territory: that of a cynical action-adventure romp involving an unofficial 'behind the lines' heist mission by a group of soldiers in pursuit of a fortune in Kuwaiti gold stolen during the Iraqi invasion of 1990. A number of predecessors have been cited as templates for this

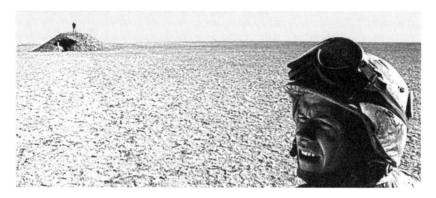

17. Off-kilter images: Extreme decentred composition at the start of *Three Kings* © Warner Bros

dimension of the film, most obviously *Kelly's Heroes* (1970), set during the Second World War. *Three Kings* continues to blend this central narrative premise with unsettling material and incongruous shifts of focus and tone, raising a number of awkward questions about the American-led operation in Iraq, before eventually reaching a more conventionally affirmative and melodramatic conclusion.

The criticism of American foreign policy offered by the film is direct and quite substantial, if still limited in some respects by the confines of a more conventional narrative frame. When troops loyal to Saddam Hussein threaten a group of Iraqi civilians who are implicated in an anti-Saddam uprising, the situation is spelled out clearly by the central character, special forces officer Archie Gates (Clooney): 'Bush told the people to rise up against Saddam. They thought they have our support; they don't. Now they're getting slaughtered.' A central dynamic established by the film is the rival pull between the desire of Gates and his team to pursue the gold and their growing feeling of obligation to help the dissident Iraqis. The reasons for American involvement in Iraq are questioned on more than one occasion. 'I don't even know what we did here', says a disillusioned Gates at the start. It was to protect Kuwait, Barlow argues later, while facing torture after being captured by Saddam's surviving forces, but his captor suggests otherwise, pouring oil into Barlow's mouth to make the point. The interaction between Barlow and this antagonist, Said (Said

Taghmaoui), is a clear marker of the unconventional stance taken by the film, certainly by Hollywood standards, in its representation of both character and some of the central issues. Said is torturing Barlow, an act that might seem to conform to anti-Iraqi or broader racist stereotypes, a department in which Hollywood has an unenviable track record. He is treated in a largely sympathetic manner, however. The point he makes about American motivation is essentially correct: that whatever the wrongs might have been of the Iraqi invasion of Kuwait (itself a more complex matter than is often suggested), American interest in Kuwait or the larger stability of the region was and continues to be predicated on its importance as a source of oil. In addition to what he has to say about the broader context, Said is also given an unusual degree of grounds for sympathy at the personal-melodramatic level on which mainstream/conventional films tend to operate, usually reserved for only one side in any such confrontation. His wife was crippled in the American bombardment of Iraq, he tells Barlow, and his one-year-old child was killed, the latter incident dramatized – realized – in a brief insert sequence that shows a chunk of roof debris falling onto the baby's cot. When Said asks Barlow how he would feel if the same happened to his newborn daughter, a similar (although this time imaginary) insert is provided: a fiery blast through his wife and child in their kitchen, a literal 'bringing home' of the implications of the destruction wrought in the American-led assault on Iraq. Said's character is given a dignity, motivation and source of justification that brings unusual complexity to the whole sequence, particularly notable because it is in the context of the torture of one of the central characters, the kind of material in which Hollywood would usually offer entirely one-sided allegiance.

Three Kings shifts frequently from emphasis on serious issues to its own incongruous portrayal of the postwar landscape. It blends impressions of chaos, ambivalence and pop-cultural reference points in a manner reminiscent of aspects of *Apocalypse Now* (1979), a late addition to the canon of the Hollywood Renaissance. Images in which Gates and his team set off on their mission – taking pot-shots at brightly coloured American footballs, a Bart Simpson doll attached to the front of their vehicle, Bach playing on the stereo, later replaced by the Beach Boys – are reminiscent of the scene in which a spaced-out

recruit water-skis behind a patrol boat to the strains of the Rolling Stones in Francis Coppola's Vietnam epic. They did not get to see any action, complains one of the youthful soldiers in *Three Kings*, only to be brought up short by a tonal shift in which Gates shows them the charred remains of a burnt Iraqi body (the kind of image kept from American television screens during coverage of the war), commenting: 'We dropped a lot of bombs out here. We also buried a lot of guys alive.' A key part of Russell's strategy seems to be to try to wrong-foot the viewer, to prevent the film from settling into a single tone, whether serious, comic, action-adventure oriented or melodramatic. Background issues of relevance to the broader context of the war are brought into play, often in the midst of lighter material: a discussion of suitable terms for the denotation of Iraqis, for example, that deems 'dune coon' and 'sand nigger' to be out of order – as a source of offence to black American troops – while 'towel-head' and 'camel-jockey' are approved. Race-related issues are also inserted in other forms, including the presence among the Kuwaiti loot of a television playing a video of the police beating of Rodney King, pointedly catching the eye of Gates' black colleague Chief Elgin (Ice Cube).

A key part of the overall effect created by the film lies in its distinctive visual texture, from the widespread use of decentred, low and wide angles, composition in depth and devices such as sudden whip-pans, as discussed above, to the employment of different film stocks and processing techniques. Much of the negative was subjected to the bleach-bypass process, in which unused silver usually bleached out of the footage is retained, which creates a high-contrast and desaturated appearance, used to evoke what Russell refers to as the 'bright, blown-out' quality of the desert location. Another unconventional impression was created by the use in some sequences of Ektachrome stock, a type of film usually found in still cameras, treated in such a way as to destabilize the colour balance of the emulsion. The result is that bright colours stand out in hyper-real intensity, most notably in the scenes in which Gates and his team first visit the settlement where the gold is hidden: the intense blue of the sky, the green and red of a milk tanker, the wash of white that results when a hole is blown in its side, the deep blacks of the robes of Iraqi women who scramble to rescue some of the contents. In both cases,

Russell says he was striving to capture the visual impression created in Gulf war photojournalism, and to give his take on the war film a look distinctive from those more conventionally associated with the genre.[46]

The move into Ektachrome comes when the principals have left the security of the American base and face the confusion and moral uncertainty of the events in the Iraqi village. The visual quality that results is unstable, the colour balance shifting with the quality of light, an unpredictability described by cinematographer Newton Thomas Sigel as expressing the disorientation of the protagonists, and thus conventional – like some of the visual effects seen in previous chapters – to the extent that it is given narrative motivation via the subjective state of the central characters.[47] Like USA in the case of *Traffic*, Warner Bros was far from happy with the proposal to use such irregular and technically risky procedures, especially when they led to problems with some of the early footage returned from laboratories. Russell credits the studio for giving him the freedom to make such aesthetic choices, however – another marker of the relative autonomy that permitted this kind of production to find space within the industrial main- stream.[48] The impression created by the combination of visual techniques is a mix of the immediate responsiveness of news footage and the hyper-stylized aesthetic of music video or advertising, a kind of heightened and expressive construction of realism. Striking flourishes that seek the attention of the viewer, as additional markers of a fresh perspective on the more conventional dimensions of the action, include two sequences in which the effects of bullet wounds are shown on the organs inside the body, a literal surpassing of the usual bounds of representation at the time (although subsequently adopted elsewhere). Russell speaks in his DVD commentary of his desire to re-sensitize viewers to the kind of violence often displayed in Hollywood, another marker of distinction; to make felt something closer to the real impact of bullets.

At the level of narrative development, however, *Three Kings* remains more conventional, deploying a number of familiar melodramatic mechanisms to shift the orientation of the principals away from their initially selfish intentions. At first, Gates and his team plan to abandon Iraqi dissidents and/or their families to their fate at the hands of

Saddam loyalists. A stand-off develops, after their pursuit of the gold in an underground bunker leads to the release of one of the leaders of the anti-Saddam uprising. The shooting of the rebel's wife, who pleads for the Americans not to leave, is marked as a turning point, sparking a brief exchange of gunfire that leads Gates to order that the threatened Iraqis be taken with them. A subsequent agreement is reached according to which the Iraqis will help the Americans to transport the gold and rescue the captured Barlow (a standard war-movie convention, in which captured buddies have to be saved for reasons of personal loyalty), in return for a share in the booty and protection in their journey to safety across the border with Iran (the latter in violation of American policy). A balance is achieved, at this point, between the narrative imperatives of personal greed and humanitarian duty. When they reach the border, however, the 'official' American military intervenes, having caught up with Gates, forcing the refugees to be left corralled at the mercy of Iraqi troops. What are coded as 'significant' looks are exchanged between Gates, Elgin and Barlow as they reach what is presented as the inescapable conclusion: that they have to surrender the location of the gold, which they have hidden in the desert, as the only way to persuade their colleagues to intervene and ensure the passage of the Iraqis across the border. The melodramatic nature of the process is underlined by the film's deployment of the figures of suffering mothers and children, from the initial shooting of the leader's wife in front of her young daughter to the insert scenes involving Said and Barlow and the climactic moments

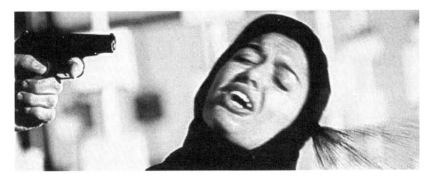

18. A key narrative turning point: The shooting of the wife of a rebel leader in *Three Kings* © Warner Bros

before and during the border crossing. The dominant impression is one of heroic individual action on the part of the central characters in the face of official heartlessness (the latter stages of the film are also shot more conventionally, including the use of warmer tones designed to reflect the growing confidence and moral certainty of the central characters[49]). This is a mechanism that seems to work at the expense rather than in support of any understanding of the specific political-historical context of the official position.

The ending of the film is very 'Hollywood' in character, the emphasis being put strongly on the individual-emotional level rather than the political context. It creates the impression of an emotional righting of American wrongs, rather than suggesting any need to address the broader context through which such wrongs might be understood. The manner in which the central characters are presented as securing the safety of the anti-Saddam Iraqis also implicates the film in a number of broader reactionary ideological complexes. As Lina Khatib suggests, the fact that the Americans are required to rescue Iraqi civilians from their domestic oppressors makes the film complicit with prevailing Orientalist assumptions (racist and reductive), according to which the Orient is dependent on the Occident in order to be rescued from itself.[50] The West is thus presented as protector and carer, rather than as imperialist or neo-imperialist aggressor, a source of legitimation for foreign policy initiatives such as the American interventions in Iraq. This is complicated to some extent in *Three Kings* by the degree of mutuality implied in the narrative, the fact that at another key moment the Iraqi dissidents come to the rescue of the American protagonists, a point ignored by Khatib along with the other more critical dimensions of the film. The trajectory of the film can also be seen as consistent with a wider trend identified in Hollywood constructions of masculinity in the 1990s and 2000s, a relative move away from the aggressive muscular bodies associated with high-profile action films of the 1980s and towards more sensitive/caring constructions.[51] These might also help to provide legitimation for overseas interventions in the post-Cold-War context. *Three Kings* provides a critique of official American action (and inaction) in Iraq in 1990, but it also implies that the stance taken by the central characters, and celebrated by the film, is more truly representative of (ultimately

redeemable) American values. That this position mixes overt criticism with an underlying investment in intervention-legitimating discourses such as those considered above is characteristic of the contrary gravitational pulls exerted on a studio production of this kind.

The manner in which these processes are dramatized in *Three Kings* – through the actions of what are presented as 'special' individuals, the typical protagonists of Hollywood films – is entirely in keeping with the norms not just of Hollywood but of a dominant American ideology in which transformative individual action is celebrated in place of any wider collective response.[52] It is a typical Hollywood procedure, as suggested in the previous chapter, for issues of a potentially or explicitly social-political nature to be given what amounts to an imaginary form of resolution through displacement onto the level of personal-individual dilemma. This is a reading that owes much to structuralist approaches to Hollywood films, often applied at the level of genre analysis, with its roots in Claude Lévi-Strauss' structural reading of mythologies.[53] The function of dominant myths, according to this approach, is precisely to offer imaginary reconciliations of oppositions that cannot so easily be resolved in reality, a process that might be understood as having ideological effect where it operates in favour of particular, dominant interests. In relation to the case of *Three Kings*, these would be the powerful corporate and political classes with vested interests in the concealment of the real grounds of much of American foreign policy, including the various interventions in Iraq of the 1990s and 2000s.

Three Kings offers a clearer and less ambiguous sense of recon-ciliation at the individual level than *Traffic*, the example considered in these terms in the previous chapter, largely because of the tighter focus and more melodramatic emphasis of its narrative dynamics. How far eventual reconciliation, or something like a reversion to Hollywood type, undermines the more critical material that has gone before remains subject to debate. *Three Kings* can be seen as an example of an attempt to insert critical material into a more conventional narrative framework, the latter helping to maximize its audience potential. It can be located in this respect in the context of long-standing debates about the most effective tactics to be used by those seeking to contest dominant social-political assumptions: the use of prevailing forms and

conventions as vehicles, in order to attract larger audiences at the risk of compromising what can be said; or the employment of more radical approaches that might permit wider bounds of expression, but often at the cost of reducing the constituency they are likely to reach. *Three Kings* situates itself largely at the former end of the scale, creating an impression of 'smuggling' its more radical elements into a more conventional studio production. In this respect it can be seen as part of a tradition that includes other critiques of US foreign policy such as Costa-Gavras' *Missing* (1982, a Universal release), critical of American complicity in the coup that unseated the Allende regime in Chile in 1973, and Oliver Stone's *Salvador* (1986, produced and distributed by the independent Hemdale), a more outspoken attack on American support for the repressive right-wing regime in El Salvador at the start of Ronald Reagan's first term in office. Each of these examples roots its political points in melodramatic, character-centred frameworks of a broadly conventional/mainstream kind that place limits on the nature and depth of analysis that is offered. Such films tend, by their nature, only to gesture towards broader underlying causal factors. The politics of American involvement in Iraq, and its wider Middle-East policy, is addressed only fleetingly in *Three Kings*, in moments such as the pouring of oil into Barlow's mouth and exchanges between Gates and the resistance leader Amir Abdullah (Cliff Curtis) about 'the big army of democracy' saving 'the rich Kuwaitis', but not being able to help the victims of Iraqi oppression. Much greater substance of background context would be difficult to include in a large-budget studio production of this kind, explicitly political material generally being viewed in Hollywood as box-office poison because of its assumed tendency to alienate the majority of viewers (and/or to distract from narrative/action momentum). To go significantly further would imply the creation of a very different kind of cinema, with a basis in critical analysis rather than action-adventure and emotive character-allegiance. The foreign-policy position of *Three Kings* is also ambivalent in the sense that the film could be taken as implying either that the American involvement in Iraq was wrong or, more prominently, that the main problem was a failure to see the job to its conclusion by not supporting the dissident forces encouraged to rise up against Saddam at the end of the war. Such a position might

be understood as functional for a production of this kind by avoiding nailing its colours too specifically to any particular mast.

To expect any more substantial consideration of historical context and the underlying reasons for American intervention in Iraq, however desirable that might be, would be unrealistic in a Hollywood production, even one of a relatively radical nature such as *Three Kings*. An expectation of this kind is established by Trevor McCrisken and Andrew Pepper, in a study of recent Hollywood treatments of a variety of historical issues, including the Gulf War of 1991 and other American military interventions. McCrisken and Pepper set up a somewhat false opposition between the Hollywood provision of 'the visceral spectacle of violent conflict' and 'any sustained critical engagement with the wider consequences of American history', as if the latter were ever likely to exist within mainstream Hollywood production.[54] They buy too easily into superficial claims that contemporary Hollywood is dominated by the production of spectacle at the expense of narrative, a position that tends to ignore the continued existence of familiar narrative frameworks in even the most spectacular of Hollywood films.[55] This is important because it is at the level of narrative every bit as much as an emphasis on spectacle that conventionally uncritical dynamics continue to prevail in most films based around issues such as American foreign policy interventions, including more reactionary productions such as *Black Hawk Down* (2001), an example used by McCrisken and Pepper as a point of contrast to *Three Kings*. A more appropriate basis of evaluative assessment offered by these writers is the celebration of films that offer questions and incoherencies in place of the more comfortable and reassuring dynamics usually associated with Hollywood production. *Three Kings* can be included here, despite the reconciliatory leanings of its narrative climax, both in the confusions apparent within the narrative (the frequent uncertainties of central characters in relation to what they are doing and why) and the film's own sometimes abrupt and destabilizing shifts of tone.[56]

The latter, along with the film's general mix of more and less mainstream qualities, is a source of praise for some of its Amazon reviewers, although also a basis of criticism for a smaller number of those who comment on the issue, on grounds of incoherence.[57] Some

reviewers demonstrate explicitly their appreciation of the blend offered by the film. For one, *Three Kings* offers 'the Perfect Combination of the Hollywood Blockbuster and the Anti-Hollywood Independent Film' (Bradley Tobin, Penrich, Sydney, NSW, Australia, 4 June 2001). For another, and several similar, the film has 'some really cool action sequences, but at the same time had some incredible social commentary about the gulf war' (Daniel Zuccarelli, Mount Laurel, New Jersey, USA, 14 July 2000). That the film achieves a blend unusual for a Hollywood studio production is noted by a number of reviewers, but as with other case studies examined in this book the proportion who articulate an opinion in such specifics remains relatively small. (Of a total of 386 respondents, only 14 comment explicitly on the studio/indie dimensions of the film; of 30 who comment on its shifts of tone or ingredients, 21 respond positively and nine negatively; 15 reviewers explicitly articulate a distinction between *Three Kings* and the norms of the Hollywood war movie, although this is implicit in many more.) Thirteen complain that the film is 'too Hollywood' in its approach, nine of these directing their criticism at the ending discussed above. For one critic: 'As a serious statement about the Gulf War, this movie is a failure because of its utter dependence on sentimentality and commercialism' (Mark Cederholm, Flagstaff, AZ, USA, 30 June 2002).

Larger numbers of Amazon reviewers respond more directly to the foreign policy politics of *Three Kings*, as might be expected given the prominence of this dimension (both in the film itself and media reviews) as a marker of the film's difference from the norm for the kind of generic territory in which it is situated. Seventy-nine make some substantial reference to the criticisms implicit in the film, the vast majority mostly or entirely positive in tone, while another 39 include passing or implied references that suggest a similar orientation – a total of 118, or just over 30 per cent of the sample. Social/political issues figure significantly in responses to the film, in other words, but to a lesser extent than is the case with reviews of *American Beauty*, a difference that can be taken as a reflection of the more varied mix of qualities, and therefore of likely points of focus, offered by *Three Kings*. A substantial minority comment explicitly on the formal qualities of *Three Kings*, for example (89, or 23 per cent), while many focus their attention on dimensions such as performers/performance, the film's

relationship with other war movies or more general (in some cases very brief) descriptive or evaluative accounts. A number also orient their consideration of 'serious' thematic issues towards general questions of 'morality' rather than anything specific to the politics of the Gulf War situation, an outcome that might be understood in relation to the film's more ideologically conservative focus on individual character behaviour/redemption.

The existence of examples such as *American Beauty* and *Three Kings* demonstrates, as does *Solaris*, that films with Indiewood textual qualities can be found in the orbit of the main arms of the studios as well as the semi-autonomous realm of their speciality divisions.[58] In each case, particular historical and industrial/institutional factors created a space for distinctive work to exist in this domain. *American Beauty* and *Three Kings* were each given 'protected' status of some kind within the studio environment, a standing they owed to the industrial clout of individual senior executives or studio heads and that enabled them to proceed without being subjected to the full array of processes usually associated with the operations of the majors at the turn of the twentieth century. Acknowledgement of the potential existence of such space, however limited it might be, is important to our understanding of contemporary Hollywood as something other than an entirely seamless monolith of impersonal heteronomous business practices. The studios are run by individuals who retain a measure of freedom, if they are so inclined and especially if a particular studio's structure and practice provides encouragement, to support some projects on the basis at least partly of their own social/political or personal/artistic leanings, in pursuit of a measure of cultural/artistic distinction from what is usually associated with mainstream studio output, and as a way of making their own mark on the business. Such projects often occur in the interstices of the studio system, finding a space as a result of particular local conjunctions of forces and relationships – sometimes what might be rather arbitrary factors – rather than necessarily being actively encouraged as part of any broader rationale. The margin available to higher-placed individual executives is best understood as a component of the system rather than as an embodiment of romantic individual freedom against the prevailing field. The nature of the operations of the studios is such that a degree

of arbitrariness remains in the decision-making process, however much they aspire to a more 'rationalized' business approach. Any such space or freedom is constrained by a number of factors, however, most obviously the commercial bottom line. Space for the pursuit of relatively unconventional projects is strongly related to the track record of any individual executive, just as it is for the individual filmmaker. Only a limited reserve of personal/political capital exists even for figures associated with highly successful productions, as demonstrated by the fate of Bill Mechanic at Fox. Mechanic was able to see *Fight Club* to the screen, against the odds, having previously played a central role in the studio's production of Warren Beatty's *Bulworth* (1998), a political satire the specific targets of which include media corporations such as Fox owner Rupert Murdoch's News Corporation. In return, his tenure as studio chairman included major box-office hits such as *Titanic* and *Star Wars: Episode I – The Phantom Menace*. The opprobrium with which *Fight Club* was initially greeted was sufficient, however, effectively to end his career at the studio when his contract was not renewed in 2000.[59] Di Bonaventura, who played the Mechanic role in the case of *Three Kings*, chose voluntarily to leave his senior studio post two years later, moving into independent production with a deal initially at Warner Bros and subsequently at Paramount, complaining in parting that 'the more corporate the job became the less creative it became'.[60]

Space of the kind found by *American Beauty* and *Three Kings* still depends to a large extent on the existence of a broader historical conjuncture in which such work has proved viable economically and/or as a source of studio prestige, as was the case at the end of the 1990s. *American Beauty* was certainly a successful production in these terms for DreamWorks, both commercially and in appearing to validate the company's (otherwise questionable) claim to offer something different from the productions of the corporate-owned established studios. A clear logic was in place at the time to explain the studio commitment to the project, which had the credentials that would have been considered necessary to reach the kind of substantial niche market required for profitability on a modest budget, a market the film eventually transcended in the scale of its box-office takings and cultural prominence. *Three Kings* remained a greater risk, on the

basis of its larger budget and the deployment of a less stable mixture of ingredients that threatened to pull in contrary directions at the level of audience appeal. It was a good deal less successful at the box-office, unsurprisingly, and in securing the prestige associated with major awards, even if it could be held up as evidence of some greater than usual commitment on the part of Warner Bros to the potential support of more challenging work.

Particular contextual factors have to be taken into account if the existence of such films within the studio environment is to be explained, given the tendency of such institutions to avoid the risks thought to be entailed by less conventional productions in usual circumstances (especially when it occurs within large, bureaucratic enterprises).[61] Risks are generally more likely to be taken during times of perceived crisis, as Joseph Turow suggests, when existing routines are considered not to be working.[62] This was the case at the time of the Hollywood Renaissance, when some of the studios were in serious financial difficulty and more willing than usual to experiment with alternative approaches. A similar situation did not exist in the late 1990s or early 2000s, despite regular industry complaints about rising costs, which might explain the relatively less radical departures generally characteristic of Indiewood features. (If some of the films associated with the Hollywood Renaissance drew, in part, on aspects of a more radical contemporary art cinema, some Indiewood films might be said to do so at one further remove, through the mediation provided by examples from the Hollywood Renaissance.)

The particular blends of qualities found in *American Beauty* and *Three Kings* highlight some of the limitations placed on the extent to which difference, in this case particularly at the social-cultural-political level, was permitted in studio productions of the time. Even if somewhat radical by Hollywood standards, the social/political critique found in each film is limited in scope and balanced by the deployment of ideologically more conservative and conventional mechanisms and underlying discursive components. The same might also be said of many films produced and/or distributed in the fully independent sector, however, relatively few of which adopt radical politically alternative stances.[63] The difference is generally one of degree, although the bounds of possibility are generally likely to be more

tightly drawn at the studio and Indiewood ends of the spectrum. Exactly what range of production is encompassed by Indiewood is one of the main issues to be considered in the next chapter, which centres around an examination of a wider slate of titles released by one of the speciality divisions, Universal's Focus Features.

Notes

1. Many commentators have referred to the 1960s/1970s period in such terms. For a survey, which also argues that such nostalgia is justified, see Noel King, "'The Last Good Time We Ever Had": Remembering the New Hollywood Cinema', in Thomas Elsaesser, Alexander Horwath and Noel King (eds), *The Last Great American Picture Show: New Hollywood Cinema in the 1970s*. Accounts of the films of 1999 that describe them in some similar terms include Mottram, *The Sundance Kids*, who refers to 'a celluloid renaissance' in an 'Annus Mirabilis', 257, and Waxman, *Rebels on the Backlot*, 251.
2. See, for example, Stephen Galloway, 'Movies for Grown-ups', *The Hollywood Reporter*, 21 December 1999, accessed via www.hollywoodreporter.com.
3. *Hollywood's New Radicalism: War, Globalisation and the Movies from Reagan to George W. Bush*, 97, 103.
4. For the definitive account of the problem of assuming films immediately to reflect historical context, see Robert Allen and Douglas Gomery, *Film History: Theory and Practice*.
5. Even maverick figures who find the organized art world unacceptably constraining tend to orient themselves towards the world of 'canonical and conventional art', however, changing 'some of its conventions and more or less unwillingly accept[ing] the rest', according to Howard Becker, *Art Worlds*, 244.
6. Unattributed, 'Hollywood Report Sacrifices', *The Hollywood Reporter*, 1 October 1999, accessed via www.hollywoodreporter.com.
7. Dan Cox, 'D'Works courts "Beauty" spec', *Variety*, posted at www.variety.com, 14 April 1998.
8. Cox, 'D'Works courts "Beauty" spec'.
9. Unattributed, 'Hollywood Report Sacrifices'.
10. For more on the increased influence of marketing executives over the green-lighting process, see Mark Litwak, *Reel Power: The Struggle for Influence and Success in the New Hollywood*, 97–8, 232.

11. Peter Bart and Peter Gruber, *Shoot Out: Surviving Fame and (Mis)Fortune in Hollywood*, 238–9.

12. Jonathan Bing and Susanne Ault, 'Nominees speak out', *Variety*, posted at www.variety.com, 15 February 2000. For a lengthy consideration of the writing process, see extracts from a talk by Ball in unattributed, 'American Beauty screenwriter Alan Ball conducts case study at the IFP/West Screenwriters Conference,' Inside Film Magazine Online, undated archive article, accessed at www.insidefilm.com/alan_ball.html.

13. Gregg Kilday, 'Road to best pic: An "American" dream', *Variety*, posted at variety.com, 8 January 2001. The detail that follows is from a combination of Kilday and Richard Natale, 'A Thing of Rare "Beauty" for Marketers', *Los Angeles Times*, Calendar, 29 September 1999, accessed via www.atimes.com.

14. Natale, 'A Thing of Rare "Beauty" for Marketers'.

15. The presence of an executive who can act as advocate for a project is important to all productions in a studio context in which decisions are often taken collectively, according to sources quoted by Litwak, *Reel Power*, 76. But this is especially the case for what might otherwise be viewed as more risky projects.

16. *Down and Dirty Pictures*, 386. For more on the situation at Warner Bros, see Waxman, *Rebels on the Backlot*, 211–17. Waxman is a major source of the background detail about the origins of *Three Kings* that follows.

17. On de Luca, see Waxman, *Rebels on the Backlot*, 119–21; on Soderbergh, 108–9.

18. This and most of the following detail is from *Rebels on the Backlot*, 216–83, supplemented by some detail from Russell's commentary on the *Three Kings* DVD.

19. Waxman, *Rebels on the Backlot*, 217.

20. Christian Moerk and Claude Brodesser, 'The green team', posted at www.variety.com, 29 September 1999.

21. For more on Warner's relationship with Village Roadshow at the time, see Michael Fleming, 'Village hits road with $125 million in 7 WB pix', *Variety*, posted at www.variety.com, 15 September 1998.

22. *Rebels on the Backlot*, 219.

23. Waxman, *Rebels on the Backlot*, 234; see also Claudia Eller, 'Three Kings Strikes Indie Tone on Studio's Dime', *Los Angeles Times*, Business section, 28 September 1999, accessed via www.latimes.com.

24. For more detail, see Waxman, *Rebels on the Backlot*, 237.

25. The following is from Russell's DVD commentary.

26. Leonard Klady, '"Double" decks "Kings" at B.O.', posted at www.variety.com, 4 October 1999.

27. See Thomas Fahy, 'Sexuality, Death, and the American Dream in the Works of Alan Ball: An Introduction', in Fahy (ed.), *Considering Alan Ball: Essays on Sexuality, Death and America in the Television and Film Writings.*

28. See, for example, Janet Maslin, '"American Beauty": Dad's Dead, and He's Still a Funny Guy', *The New York Times*, 15 September 1999, accessed via www.nytimes.com, and Jonathan Rosenbaum, 'Getting it Both Ways', *Chicago Reader*, 24 September 1999, accessed via www.chicagoreader.com.

29. Very much the approach taken by Maslin and a point made in similar terms by Kenneth Turan, 'The Rose's Thorns', *Los Angeles Times*, Calendar, 15 September 1999, accessed via www.latimes.com. It is worth noting that Maslin and Turan are generally considered to be among the most powerful and agenda-setting film critics in America.

30. See, for example, Edward Guthmann, 'Breathtaking "Beauty"', *San Francisco Chronicle*, 17 September 1999, accessed via www.sfgate.com, which describes it as 'a wonder of a film', filled with 'amazements'. Trade press reviews were more level-headed, including Kirk Honeycut in *The Hollywood Reporter*, who asked 'does any target have a larger bull's eye' than the version of the American Dream questioned by the film; 'Film Review: "American Beauty"', 13 September 1999, accessed via www.hollywoodreporter.com.

31. *SuburbiaNation: Reading Suburban Landscape in Twentieth-Century American Fiction and Film*, 11.

32. Beuka, *SuburbiaNation*, 242.

33. Beuka, *SuburbiaNation*, 110, 139.

34. The sample was taken from a total of 1,102 reviews accessed on 9 October 2006, starting at www.amazon.com/gp/product/customer-reviews/B00003CWL6/ref=cm_rev_sort/102–9829944–2372160?customer-reviews.sort_by=%2BSubmissionDate&s=dvd&x=12&y=6.

35. As in some previous examples, the categories into which these reviews have been placed are on the basis of my subjective interpretation, the division between one and another not always being clear cut.

36. *The Rebel Sell: How the Counterculture became Consumer Culture.*

37. *The Rebel Sell*, 54.

38. For a discussion by Dorsky of the sequence and its use in American Beauty, see Ed Halter, 'Interview: True Independents; Brakhage and

Dorsky Hash Out the Realities of Poetic Cinema', *indieWIRE*, 30 April 2001, accessed via www.indiewire.com. Dorsky sets out his approach to filmmaking, although not to this particular example, in *Devotional Cinema*.

39. The kind of poetic avant-garde cinema pursued by Dorsky has conventions of its own, of course, including previous use of images of floating bags, as acknowledged by the filmmaker in Halter, 'Interview'.

40. *American Independent Cinema*, chapter 3.

41. For more on the importance of distance in satire, see my *Film Comedy*, 103–4.

42. '"Too Close for Comfort": *American Beauty* and the Incest Motiff', *Cinema Journal*, 44:1, 2004. In this account, Lester's attraction to Angela is one of many such phenomena interpreted as displaced manifestations of incest.

43. Ball as quoted in unattributed, 'American Beauty screenwriter Alan Ball conducts case study'.

44. For more detail, see my *American Independent Cinema*, 43.

45. For an example of the latter, see Benjamin Halligan, 'What is the Neo-Underground and what isn't: A first consideration of Harmony Korine', in Xavier Mendik and Steven Jay Schneider (eds), *Underground U.S.A.: Filmmaking Beyond the Hollywood Canon*.

46. See commentary on DVD release of the film.

47. Interview with Sigel on DVD release.

48. Russell, DVD commentary.

49. Sigel, interview on DVD.

50. *Filming the Modern Middle East: Politics in the Cinemas of Hollywood and the Arab World*, 5, 75. For the original conception of Orientalism on which Khatib draws, see Edward Said, *Orientalism*.

51. Khatib, *Filming the Modern Middle East*, 12, 65, drawing on Susan Jeffords, 'Can Masculinity Be Terminated?', in Steven Cohan and Ina Rae Hark (eds), *Screening the Male: Exploring Masculinities in Hollywood Cinema*.

52. For more on this, see Dickenson, *Hollywood's New Radicalism*.

53. For the classic articulation in genre theory, see Thomas Schatz, *Hollywood Genres: Formulas, Filmmaking, and the Studio System*, with references to Lévi-Strauss 262–3. See also Lévi-Strauss, 'The Structural Study of Myth', in *Structural Anthropology*. For further discussion of this way of reading films, including a number of qualifications and complications involved in the process, see my *Spectacular Narratives: Hollywood in the Age of the Blockbuster*, Introduction.

54. *American History and Contemporary Hollywood Film*, 205.

55. A point I have argued at length in *Spectacular Narratives* and *New Hollywood Cinema*, chapter 6.

56. Other examples suggested by McCrisken and Pepper include *Revolution* (1985) and Oliver Stone's *JFK* and *Nixon*.

57. Reviews accessed 23 October 2006, starting at www.amazon.com/ gp/product/customer-reviews/B00003CX74/ref=cm_rev_sort/102–0540247–1452133?cust omer-reviews.sort_by=%2BSubmissionDate&s=dvd&x=10&y=7.

58. Neither of the studios involved had a specialist division of its own at the time, DreamWorks' Go Fish and Warner Independent Pictures not being established until 2003. *Three Kings* would still have been likely to fall clearly within the remit of the main studio operation, even if WIP had already existed, for reasons of scale and budget. Much the same might have applied to *American Beauty*, given its prestige status and the fact that Go Fish was primarily used as an outlet for imported animation features. Moves towards wider involvement in the speciality market on the part of Go Fish were reported in 2005, after which its future became uncertain following the purchase of DreamWorks by Paramount.

59. Mottram, *The Sundance Kids*, 276; Waxman, *Rebels on the Backlot*, 302.

60. Dana Harris, 'New avventura for Lorenzo', *Variety*, posted at www.variety.com, 3 September 2002.

61. For more on this in media institutions in general, see Joseph Turow, *Media Systems and Society: Understanding Industries, Strategies, and Power*, 230–2.

62. *Media Systems and Society*, 232.

63. For more on this, see my *American Independent Cinema*, chapter 5. The same could be said, probably to a greater extent, of the films associated with the Hollywood Renaissance.

5

Indiewood in Focus

A number of characteristics typical of films produced and/or distributed in the Indiewood sector can be identified from the case studies examined in this book so far, despite distinct differences in some cases at the levels of both textual qualities and primary target audiences. This concluding chapter begins with a summary of some of these before considering a larger sample, the output of one of the studio speciality divisions, Universal's Focus Features, from its inception in 2002 to 2005. Brief consideration is also given to the range of material handled by the other studio subsidiaries. Analysis of individual films distributed by Focus in this period is combined with consideration of the articulation of what sets out to be a distinctive brand image for the division, an issue that returns us to some of the broader questions raised in the introduction and throughout this book about the nature of cultural production in arenas such as Indiewood, in which an overt mixture is offered of the commercial/entertaining and that which claims the status of more 'creative/artistic' prestige.

Each of the films analysed so far combines largely conventional cinematic structures or devices with some markers of difference or distinction: twists or variations on established norms that offer

particular pleasures or sources of potential distinction-marking on the part of the viewer. These can be recapitulated as follows:

Adaptation: Highly self-reflexive with some visual flourishes, but in pursuit of a conventional individual quest for (artistic as well as personal-life) fulfilment, and turning some degrees back towards the norm in the late narrative twists.

Being John Malkovich: Weird narrative-content dimensions and a dark outlook, but also in pursuit of an individual quest for (artistic as well as personal-life) fulfilment.

Eternal Sunshine of the Spotless Mind: Play with narrative sequence and some weird content, verging on science fiction, but largely conventional (if troubled) romantic comedy at heart.

Shakespeare in Love: Conventional period, literary-oriented romance/romantic-comedy blend.

Kill Bill: Temporal shifts, hyper-stylized sequences, but underpinned by conventional revenge quest.

Traffic: Multi-strand narrative, formal distinction, controversial subject matter and approach, but also conventional if muted melodramatic dimensions.

Solaris: Muted, slow-paced, largely action-free science fiction, but romance at heart.

American Beauty: Some satirical bite, but broadly conventional narrative of male awakening/rebellion against suburban conformity.

Three Kings: Controversial politics, stylized textures, shifts of modality, but underpinned by conventional group-quest structure coupled with doses of melodrama.

I would suggest that, despite a number of differences between these films, the general balance of conventional vs. somewhat different or challenging is broadly consistent in a manner that characterizes a significant zone within the landscape of contemporary American

cinema. This is not to say that a mix of more and less conventional ingredients is not found elsewhere, either in American film or other national/international cinemas. The same can be said to some extent of much American 'indie' or 'independent' cinema, and there is a danger that such a formulation as 'a mix of the more and less conventional' can become vague to the point of lacking much capacity for closer discrimination. It is important to be specific, both about the particular qualities brought into play in particular examples and the manner in which they are balanced, and how this might be related to the logic of a particular industrial and viewing context, which is what I have sought to achieve in the preceding chapters. If the general Indiewood context helps to explain the broad parameters within which these films are situated, particular factors account for specific details and variations of balance. *Shakespeare in Love*, for example, stands out as the most consistently conventional of the nine case studies, at the levels of both form and substantive/narrative content. Its place as an Indiewood film is owed to a combination of its industrial locale – as an example that marks an important strand in the repertoire of Miramax – and its position in relation to articulations of literary-oriented prestige production (a factor that would still have been in play if the film had gone ahead at one of the major studio divisions). *Being John Malkovich*, by contrast, leans a good deal closer to the fully indie/independent end of the Indiewood spectrum.

Some degree of formal departure from Hollywood norms is found in many of the case-study examples, but these are generally quite limited and balanced by other factors that keep the films located relatively close to the commercial mainstream. The Kaufman collaborations with Jonze and Gondry offer the most radical formal strategies but the strongest examples in this dimension – *Adaptation* and *Eternal Sunshine of the Spotless Mind* – draw for most of their audio-visual flourishes on devices that have primarily playful (rather than 'serious art') resonances and that are likely to be familiar to many viewers from the mainstream realms of advertising and music video. *Adaptation* is highly self-reflexive in narrative terms, but also in a manner that is playful (if somewhat manic). *Kill Bill* exhibits a number of shifts from linear narrative sequence, some of which appear more logically motivated than others, but the most arbitrary-seeming of

which also occupy a realm of playful flourish rather than inviting any serious interrogation of conventional form. *Solaris* also moves backwards and forwards in time, but in a far more conventionally romantically-motivated manner. *Shakespeare in Love* appears entirely in keeping with Hollywood norms in its fluid articulation of shifts between the levels of story, story-being-written-within-the-story, rehearsal-of-story-being-written-within-the-story and eventual production of same. *Kill Bill* includes numerous overt formal flourishes in a spirit of intertextual celebration. *Traffic* and *Three Kings* offer striking shifts in visual texture, largely motivated via narrative and character experience. In the former, these contribute to a sense of relative distance from the melodramatic dimensions of the film. In the latter, they help to create an impression of incongruity and disorientation. But, in both cases, the visual textures themselves are not unfamiliar ingredients in the contemporary commercial audio-visual landscape. *Solaris* and *American Beauty* are generally more conventional in texture, relying on subtle departures from certain dominant Hollywood trends (particularly fast-paced cutting and camera movement) as markers of 'quality' or 'prestige'.

Another characteristic found in the majority of these films – if, again, not exclusive to them – is a compromise form of narrative resolution, a dimension on which I have commented in regard to several examples in the preceding chapters. There is a marked tendency to occupy a space somewhere between the conventional Hollywood 'happy ending' and the more downbeat resolution often associated with less mainstream forms of art or indie cinema. Clearly mixed resonances of one variety or another are found in seven of the nine films and some mixture characterizes the two others (*Being John Malkovich* has a nightmarish conclusion for Craig, but happy for the coupled Lotte and Maxine; *Kill Bill* has a happy end for The Bride, reunited with her child at the denouement of the second instalment, but only via much slaughter of other, potentially appealing or interesting characters, including Bill himself).

But how representative are these films of the broader Indiewood output? They are only a selective group of case studies, even if they have been chosen to highlight some key components – individual and institutional – of the Indiewood landscape. The work of a number of

other filmmakers could also be considered, including such figures as Alexander Payne, Paul Thomas Anderson, Wes Anderson and Joel and Ethan Coen, as could many individual films that offer a distinctly Indiewood blend. A more objective way to test the extent to which the films analysed so far are representative of a wider phenomenon is to view them in the light of a larger sample such as the Focus Features distribution slate considered in this chapter, a total of 34 films released in the four years from 2002 to 2005. This includes a number of films broadly similar to those examined so far, but also widens the scope of analysis to consider others including imported as well as domestic releases within the Indiewood orbit. Before moving on to the sample in detail, some background is required on the formation and market strategy of Focus Features, elements of which have been considered in relation to some of the case studies examined so far.

Focus Features: 'original, compelling cinema' ... for a mainstream audience

Focus Features (www.focusfeatures.com) is a motion picture production, financing and worldwide distribution company committed to bringing moviegoers the most original stories from the world's most innovative filmmakers.

Focus Features is part of NBC Universal, one of the world's leading media and entertainment companies in the development, production, and marketing of entertainment, news, and information to a global audience. Formed in May 2004 through the combination of NBC and Vivendi Universal Entertainment, NBC Universal owns and operates a valuable portfolio of picture company, significant television production operations, a leading television stations group, and world-renowned theme parks. NBC Universal is 80% owned by General Electric, with 20% controlled by Vivendi Universal.

A distinct shift of emphasis is found in the move from the first to a subsequent paragraph in the 'Company Profile' section of the Focus Features website quoted above.[1] If Focus is situated initially in relation to 'the most original stories from the world's most innovative

filmmakers', it is in the denser retailing of detail that its broader place is established in the corporate topography of American-led multi-national business. Not just a division of a major studio, Focus Features is part of a cross-media entity (NBC Universal) that is itself majority owned by a major diversified multinational (General Electric) with interests ranging from jet engines and power generation to financial services and plastics.[2] It also has less autonomy from its studio parent than rivals such as Miramax (under the Weinsteins at least) and Sony Pictures Classics, its own productions being required to go through the same approval process as those at Universal (although the heads of the division were quoted in 2004 as saying the studio had in no case blocked a project Focus wanted to pursue).[3]

The advent of Focus Features was the outcome of a convoluted series of relationships through which Universal came to establish its relationship with the indie/speciality sector.[4] It bought the notable speciality distributor October Films in 1997 and was also involved in Gramercy Pictures, as a joint venture with PolyGram Filmed Entertainment. Gramercy subsequently became part of USA Films, a division of USA Networks, as did October; they all came back together under the same umbrella in December 2000, when USA Networks was merged with Universal's then corporate parent, Vivendi. In the meantime, the 'Focus' identity came into its first incarnation as the speciality unit, Universal Focus. In 2002 Universal bought another noted independent outfit, Good Machine, and folded it and USA Films into the new-look Focus Features. The resulting creation had a strong indie/speciality pedigree, manifested most clearly in the presence at the head of the unit of David Linde and James Schamus, two of the three partners in Good Machine, which was, along with October, one of the leading lights in the New York independent film scene from the 1990s. To the Vivendi/Universal empire at the time, Linde and Schamus brought knowledge and experience of the speciality market and relationships with a number of noted inter-national filmmakers. Linde's subsequent promotion in 2006 to co-chairman of Universal was interpreted as an indication of the value placed on the speciality divisions by their studio parents.[5]

The deployment of Linde and Schamus at the head of Focus followed the pattern established in the 1990s in which the Weinstein

brothers were retained at the head of Miramax under Disney and Bob Shaye remained in place at New Line after it was taken over by Turner and subsequently Time-Warner. Unlike Miramax and New Line, however, whose subsequent operations included very large-budget productions such as *Gangs of New York* and the *Lord of the Rings* trilogy (2001–3), Focus was designed to be an operation of modest scale, handling a relatively small number of films to be marked off from the mainstream by their 'quality' or 'prestige' imprint (a strategy broadly similar to that adopted by predecessors such as Sony Pictures Classics and Paramount Classics, although some significant differences between the three operations are considered below). Exactly how this market position is defined in the case of Focus is an issue to which we will return in the process of examining its output, but it is useful to note the kinds of articulations used in statements on the subject made by Schamus and Linde. For the former, the aim of the division is to handle films addressed at 'specific but pretty substantial audiences'.[6] Along similar lines, Linde identifies a mission to reach 'a mainstream audience with original, compelling cinema'.[7] In both cases, an attempt is made to identify a position somewhere between Hollywood and the farther reaches of independence: something 'specific' that involves 'original, compelling cinema' (read: not generally the same as Hollywood), but that can also reach 'mainstream' or 'pretty substantial' audiences (in other words, not *too* far away).

After two years of operations, Focus was judged by *Variety* to have 'emerged as one of the brightest stars of the speciality distribution arena', having 'strung together an impressive roster of upscale hits' such as *Far From Heaven*, *The Pianist* (2002) and *Lost in Translation* (2003).[8] The company had 'developed a reputation for taking artistic risks' in examples such as the casting of Jim Carrey in *Eternal Sunshine of the Spotless Mind*, Reese Witherspoon in *Vanity Fair* (2004) and the pairing of Jake Gyllenhaal and Heath Ledger as gay cowboy lovers in *Brokeback Mountain* (2005), films in which Focus was involved as producer as well as distributor. At a time when Miramax was perceived to be moving closer to major studio terrain, the question asked by *Variety* was whether Focus would inherit the mantle of the Weinstein brothers, a question in response to which Schamus gave another example of the kind of dual articulation of position cited above. The

rise of Miramax as a studio cleared a space, Schamus suggests, 'for a truly specialized but still aggressive independent studio, and that's where we like to be'.[9] He expands further:

> One of the things we've done is to treat the specialized market as a business, not an excuse on one hand to throw parties and win awards and on the other, to try to get into the studio business. We are extremely aggressive when we have to be, but we are never going to be aggressive to the point of taking ourselves out of this business.[10]

The emphasis here is on carving out a space that remains primarily a business, but a particular kind of business. The aim that is implied is not purely to seek the artistic recognition and prestige of the autonomous sector ('to throw parties and win awards') or to abandon any such ambitions in pursuit only of the heteronomous financial bottom line (being aggressive 'to the point of taking ourselves out of this business'). Schamus is keen to emphasize the 'aggressive' nature of the Focus strategy up to a point, presumably as a guard against any suspicion that the speciality sector might be financially 'soft' or 'weak', but only up to a certain point, a boundary that is not clearly specified in any of these accounts. A closer look at the company's output in its first four years helps to put some flesh on the bones.

Focus Features: the first four years

For the purposes of this argument, I am considering 34 films distributed by Focus in the USA.[11] This does not include a smaller number in which the company was involved only as a non-US distributor. The total breaks down year-by-year as follows: 2002, seven films; 2003, seven films; 2004, nine films; 2005, 11 films. This section begins with a brief characterization of each, followed by an analysis of some trends that can be identified across the sample. The films are US productions unless otherwise indicated.

2002

8 Femmes / Eight Women (dir. François Ozon, France, Italy): French-language murder-mystery with a twist. Very theatrical and melodramatic in tone, with Technicolour-style period setting, movie references and

occasional bursts into song. Multi-star-led, including Catherine Deneuve and Isabelle Huppert.

The Kid Stays in the Picture (dir. Nanette Burstein, Brett Morgen): Hollywood autobiographical history documentary tracing career of actor turned Paramount executive Robert Evans.

Ash Wednesday (dir. Edward Burns). Brooding, downplayed drama of past crimes, allegiances and redemption.

The Pianist (dir. Roman Polanski, France, Germany, UK, Poland): 'Worthy' fact-based period drama set during Nazi oppression of Jews in Warsaw. Major-name director.

Possession (dir. Neil La Bute, USA, UK): Literary adaptation, from A.S. Byatt novel, with contemporary and historical narrative strands, parallel romances, much 'heritage' background. Star-led by Gwyneth Paltrow.

Far From Heaven (Todd Haynes, France, USA): Auteur-led 1950s period piece, impossible-love melodrama, pastiche of cinema of Douglas Sirk. Julianne Moore.

The Guys (dir. Jim Simpson): Post-9/11 emotional drama, talk-heavy theatrical adaptation. Sigourney Weaver.

2003

My Little Eye (dir. Marc Evans, UK, USA, France, Canada): Psychological horror with reality TV/webcast spin.

The Shape of Things (dir. Neil La Bute): Two-couples romance drama with very La Bute-style manipulative sting in the tail.

Deliver Us from Eva (dir. Gary Hardwick): Routine romantic comedy with black, middle-class milieu.

Swimming Pool (dir. François Ozon, France, UK): Languid, literary-oriented character-piece that appears to turn into murder thriller towards end. French director's first English-language film. Charlotte Rampling.

Lost in Translation (dir. Sophia Coppola): Bill Murray star-led reduced-narrative unfulfilled romance in Tokyo hotel setting.

21 Grams (dir. Alejandro González Iñárritu): Melodramatic tragedy/romance marked by complex multi-strand-narrative articulation and hyper-realist stylized visuals. Sean Penn, Naomi Watts.

Sylvia (dir. Christine Jeffs, UK): Sylvia Plath literary biopic, star-led by Gwyneth Paltrow.

2004

Monsoon Wedding (Mira Nair, India, USA, France, Italy, Germany): Multi-character 'colourful' Indian-set family/emotional drama surrounding preparations for daughter's wedding.

Ned Kelly (dir. Gregor Jordan, Australia, UK, France): Australian-set outlaw western, treated as heavy-handed melodrama. Heath Ledger, Orlando Bloom.

Diarios de Motocicleta / The Motorcycle Diaries (dir. Walter Salles, USA, Germany, UK, Argentina, Chile, Peru, France): Early years Che Guevara biography, road movie, journey of political awakening. Gael García Bernal.

Eternal Sunshine of the Spotless Mind (dir. Michel Gondry): See above.

Shaun of the Dead (dir. Edgar Wright, UK, France). British-set zombie comedy-horror.

The Door in the Floor (dir. Todd Williams): Contemporary literary adaptation drama (John Irving). Jeff Bridges, Kim Basinger.

Saint Ange / House of Voices (dir. Pascal Laugier, France): Chiller ghost story shot simultaneously in English and French; English version distributed by Focus in the USA.

Vanity Fair (dir. Mira Nair, UK, USA): Classic literary adaptation with quality/heritage resonances. Reese Witherspoon.

Inside I'm Dancing (dir. Damien O'Donnell, UK, Ireland, France): Disability-themed 'inspirational' drama with some comedy.

2005

My Summer of Love (dir. Pawel Pawlikowski, UK): British import, sharp take on 'odd couple' format with rich girl/poor girl lovers.

Brødre / Brothers (dir. Susanne Bier, Denmark): Danish-language tough emotional drama, harsh and unromanticized.

Danny the Dog aka *Unleashed* (dir. Louis Leterrier, France, UK, USA): Hybrid blending hard-hitting fighting/crime genre with awakening-to-culture of previously oppressed central character. Jet Li, Morgan Freeman.

Broken Flowers (dir. Jim Jarmusch). Auteur and star-led (Bill Murray) quirky non-romance.

The Constant Gardener (dir. Fernando Meirelles, Germany, UK): Corporate conspiracy thriller with 'exotic' African setting.

Brokeback Mountain (dir. Ang Lee): Emotional drama with gay modern-western milieu, literary source. Heath Ledger, Jake Gyllenhaal.

The Ice Harvest (dir. Harold Ramis): Small-time post-crime caper, wry genre piece.

Pride and Prejudice (dir. Joe Wright, France, UK): Classic literary adaptation with heavy heritage/quality resonances.

Cry Wolf (dir. Jeff Wadlow): Teen slasher-type with twists.

Prime (dir. Ben Younger): Romantic comedy with age-difference twist. Meryl Streep, Uma Thurman.

La Tigre e la neve / The Tiger and the Snow (dir. Roberto Benigni, Italy): Italian-language Benigni vehicle, comedy-drama that does for the Iraq war c.2003 what *La Vita è bella / Life is Beautiful* (1997) did for the holocaust.

A number of trends can be identified within this four-year slate, although it can be broken down along several different axes. Most of the films can be understood as falling into the 'speciality' category, broadly conceived, although generally towards the relatively commercial end of the scale. The least specialist films, I would suggest, are the following nine: *My Little Eye, Deliver Us from Eva, Ned Kelly, Shaun of the Dead, Danny the Dog, The Constant Gardener, The Ice Harvest, Cry Wolf* and *Prime*, although some of these might retain grounds for distinction when measured against what might be characterized as more typical Hollywood fare (none of these boundaries being absolute). There is nothing in the sample that could be described unambiguously as art cinema in any very challenging or radical sense. Several examples might be categorized as a form of art-cinema-lite, in terms of how they are likely to be positioned and received in the US market, but these all have strongly conventional narrative-and-character frameworks. (Bids for this status might be made on the grounds of, for example, the grim-reality setting of *The Pianist*, the centrality of Sirkian pastiche to *Far From Heaven*, the filmed-play qualities of *The Guys*, the languid nature of *Swimming Pool*, the complex narrative articulation of *21 Grams*, the subtitles and political dimensions of *The Motorcycle Diaries* and the subtitles and harsh qualities of *Brothers*.) *21 Grams* is perhaps the most cognitively demanding, but its fragmented multi-strand narrative is underlain by a highly melodramatic confection.[12] None involves the degree of formal reflexivity found in *Adaptation*, even if the Kaufman/Jonze production is itself at some distance from being a work of modernist alienation. Strong markers of formal distinction are a somewhat rare quality in the sample, more so than in the previous case studies, found only in *Eight Women, 21 Grams* and *Eternal Sunshine of the Spotless Mind*. Much the same goes for distinction on overt socio-political grounds, which is present in a number of examples but generally in the context of more mainstream-oriented emotional drama: most clearly *The*

Constant Gardener (exposé of political implication in corporate drug-testing on poor Africans), *The Motorcycle Diaries* (exploitation of workers as an important background context), *Far From Heaven* (central critique of 1950s racism and, to a lesser extent, homophobia) and *Brokeback Mountain* (in its entirely sympathetic treatment of gay lovers). Typical of these and the rest of the sample is what I have described throughout this book as a characteristically Indiewood blend of more and less commercially conventional ingredients, some of which I will consider below in more detail.

To characterize the sample further, it is useful to consider the various categories into which the individual films might be placed, even if these often overlap. The less specialist-seeming films tend to fall quite clearly into familiar and relatively mainstream genre categories, primarily those conventionally associated with 'lower' cultural taste patterns. Of the nine cited above, three are horror/chiller/slasher related, two are romantic comedies, one is a displaced western, one a crime-caper film, one partly an action-fighting film and one a conspiracy thriller. Among the seven examples of potentially 'art-lite' films cited above, the dominant tendency is towards a broader and more 'seriously' coded variety of emotional drama (although *The Constant Gardener* seems to straddle this division, its conspiracy-genre dimension being mixed with similar markers of the seriously dramatic). In the films considered in previous chapters, clear-cut genre markers are found in several cases, but usually combined with other distinguishing qualities: a new twist on romantic comedy in *Eternal Sunshine of the Spotless Kind*, science fiction but brooding and largely action-free in *Solaris*, the war movie but with disorienting shifts of tone in *Three Kings*, crime-revenge but operatically over-the-top and crammed with intertextual references in *Kill Bill*. A number of other categories can be identified in the Focus sample that carry associations of, or make claims towards, the status of 'quality' or 'prestige', although no single category of this kind occupies a dominant position. The sample includes five films the primary identifiers of which are likely to include their status as literary adaptations, three contemporary (*Possession*, *The Door in the Floor* and *Brokeback Mountain*), and two 'classical' (*Vanity Fair* and *Pride and Prejudice*). I use the term 'primary identifiers' here to suggest that the allocation of films to such categories

is an inexact and relative process, depending on the extent to which particular aspects of any individual title are used as selling points, explicitly or implicitly, and potential audience awareness of their salience to the overall qualities of the example in question.

The same difficulty exists in the attribution of another category: films in which the identity of the filmmaker as a distinctively creative 'auteur' is likely to be among the factors to the fore in the attribution of individual works. According to my reading, this applies to at least ten or 11 titles from the Focus sample, possibly several more. Examples of US-based auteurs would include Todd Haynes, Neil La Bute (as auteur in the case of *The Shape of Things*, which seems to bear his distinctive mark, but not *Possession*), Jim Jarmusch and Sophia Coppola: all figures who carry associations from the American indie sector. An important part of the strategy of speciality divisions such as Focus has also been to attract 'name' overseas filmmakers, often figures whose previous work has proved unusually successful in the specialist market and who offer cachet in either the same territory or some degrees closer to the mainstream. Examples in this sample include Roman Polanski, with long-term auteur status and previous Hollywood experience, and more recent recruits such as the Latin American triumvirate Alejandro González Iñárritu (who made his name with *Amores perros* [2000]), Walter Salles (*Central do Brasil / Central Station* [1998]) and Fernando Meirelles (*Cidade de Deus / City of God* [2002]). In the case studies examined in the previous chapters, auteur-identity appears to be central to the selling of *Kill Bill*, increasingly a factor but only one among others for the Kaufman-scripted examples, a significant factor but again mixed with others in the Steven Soderbergh films, of minor import to *Shakespeare in Love*, and also to have figured to a relatively modest extent in *American Beauty* and *Three Kings* even if it was a major factor in the gestation of the two studio projects. Overall, Indiewood appears to be an arena in which the figure of the auteur plays an important role in many cases – in either the development or selling of projects – but far from all, and often in combination with other major points of orientation.

Another marker of specialist status in many cases, sometimes but far from always connected with indications of auteurism, is overseas origin. Only 11 of the 34 films distributed in the USA by Focus from

2002 to 2005 were solely domestic productions. Another ten were co-productions, involving the USA and one or more foreign partner, which leaves 13 of entirely overseas status, the majority of which were co-productions of one kind or another. National status is another ground on which lines are often blurred, particularly the distinction between what might be termed the national 'feel' created by a film (through factors such as setting, performers and type of material) and its 'official' designation (particularly involving financial backing). Five films from the sample appear very 'British', for example, although of these three are listed as co-productions (*Possession, Shaun of the Dead* and *Inside I'm Dancing*).[13] Fifteen examples involve the UK, the largest single presence after the USA, either singly or among other co-producers, followed by France, present in 13 cases. Europe is dominant among overseas sources, the only non-European overseas involvement being co-productions with Canada (*My Little Eye*), Japan (*Lost in Translation*), Argentina, Chile and Peru in the seven-country international production of *The Motorcycle Diaries*, and India among the five countries involved in *Monsoon Wedding*. What is most striking, however, is the heavy dominance of English-language features. The sample includes 15 English-language international co-productions and only four subtitled foreign language films (one each in French, Spanish, Danish and Italian, not including some subtitled passages in *Monsoon Wedding*). This factor, as much as anything else, marks the Focus output as chiefly the middle-market material of Indiewood rather than the stuff of art or speciality cinema as it might have been conceived in the heyday of the international art cinema of the 1950s, 1960s and 1970s, before such material became displaced to a significant extent by the rise of the American indie sector.[14]

The Focus sample can also be characterized according to some less conventional categories. If a relatively small number are literary adaptations, it seems significant that a far larger proportion exhibit artistic, literary or intellectual dimensions of one kind of another that seem clearly available to viewers as markers of prestige/distinction for both themselves and the work in question. Ten of the 34 films include such elements in their own diegetic material: the central character in *The Pianist* is a talented musician; the historical parallel romance narrative of *Possession* involves two Victorian poets; a key dimension

of *The Guys* is the effort of a middle-class journalist to help to find the right words to express the characters of firemen killed on 9/11; one of the principals in *The Shape of Things* is an unconventional artist; the leading character in *Swimming Pool* is an author; the female lead in *Lost in Translation* is a recent philosophy graduate whose outlook on life is directly contrasted with the world of popular culture occupied by her husband; *Sylvia* is the biography of a major poet; the Jim Carrey character in *Eternal Sunshine of the Spotless Mind* is literarily and artistically oriented; the main character in *The Door in the Floor* is an established writer, his assistant a young aspirant; the awakening of the protagonist of *Danny the Dog* is brought about through exposure to classical music (similar diegetic elements are found in five of the nine case studies examined in the earlier chapters: *Being John Malkovich*, *Adaptation*, *Eternal Sunshine* again, *Shakespeare in Love*, *American Beauty*). To these might be added others that address the worlds of arts or film at different levels: the pastiche of Sirk in *Far From Heaven* and of a blend of 1950s Technicolor, musical and theatrical detective conventions in *Eight Women*; the foregrounding of a celebrated era of Hollywood history in *The Kid Stays in the Picture*. Add to these the literary adaptations not included in the above and the total reaches 17 out of 34. With the further addition of auteur-oriented films not already included, it comes to some 22, a figure that does not include three out of the four subtitled features (or another six films with no US production dimension). Though an agglomeration of such factors, it becomes apparent that a large proportion of the Focus release slate includes one or other of the qualities that might be considered most likely to appeal on the grounds of offering relatively clear markers of distinction of one variety or another.

Where films in the sample fall into recognizable genre categories, it is notable that many include unconventional twists or combinations with other ingredients. The major exception to this is the use of horror/chiller-type formats, to which I return below. A striking manifestation of various deployments of genre components is found in examples that draw on elements of crime. Five films fit this category to a substantial extent but most include some clear markers of distinction (along with *Kill Bill* from the earlier examples). The two that come closest to 'straight' treatments of the subject matter are *The Ice Harvest*

and *Ash Wednesday*. The former, cited above as one of the more conventional films in the sample, features John Cusack as a shady Kansas lawyer betrayed by his partner after the pair steal $2 million from the local mob. Deadpan comic elements are mixed with darker tones, wry and relatively low-key, as he faces a number of reversals before eventually surviving against the odds and getting away with the money. It could quite easily be imagined as a low-budget studio film ($16 million), firmly rooted in the small-time-crime-inevitably-goes-wrong subgenre, although it has a primarily unsentimental tenor less typical of Hollywood, particularly given its Christmas setting ('Christmas Eve. Ho fuckin' ho'). *Ash Wednesday* is several notches less mainstream in tone, a sombre and brooding drama revolving around the legacy of a past crime committed in the tight-knit Irish-American community of New York's Hell's Kitchen in the 1980s, generally downplayed and non-melodramatic in its inevitable working out of a tragic end.

Swimming Pool introduces an element of crime towards the end of what can generally be situated as a film strongly characteristic of the

19. Selling the 'sex' and 'mystery' elements: The poster for *Swimming Pool*
© Fidélité, Headforce Ltd, France 2 Cinéma, Gimages, Foz

commercial end of US-imported overseas art-cinema (or art-lite, as suggested above) in its literary orientation, its unhurried pace, its primarily French rural (but English-language) setting and its liberal supply of nudity. What seems to be the murder of a local man gives the film the appearance of an additional edge and genre-oriented direction in its latter stages (played upon heavily in the film's trailer), but a final twist reorients the narrative towards the literary in the suggestion that the killing occurred only in the fictional pages being composed by the author-protagonist. A murder-that-wasn't is also central to *Eight Women*, from the same director, as the motivating device of a very mannered and self-conscious play with the country-house murder-mystery. The worlds of the crime movie and the quirky are brought together again in *Danny the Dog*, although here the two components are more separately articulated in a form of international hybrid that appears designed to appeal to a range of potential audience constituencies.

Danny the Dog begins in a gangster world in which the title character, a virtual fighting machine, is kept in animal-like captivity to do the violent bidding of his boss in sequences characterized by frenetic state-of-the-art-Hollywood-style visuals (abrupt cutting and camera movement, manipulation of film speed) and a soundtrack by Massive Attack. He escapes, however, and the film shifts gear into a quieter more indie-style 'offbeat' mode as he is taken in, and taken in-hand, by a kindly blind piano tuner and his music-student step-daughter. The film then moves between the two modes, the world of higher culture associated with the piano tuner and classical music eventually winning out in Danny's re-awakening to what is presented as a more fully human status. The status of the film itself is notable, a $43 million French-originated 'blockbuster' aimed at the international marketplace, part of what was identified at the time as a trend towards larger-budget Gallic productions reliant on overseas co-finance.[15] The 'fighting' dimension of the film is backed up by impressive credentials, with Hong Kong action star Jet Li playing Danny and the action staged by the noted choreographer Yuen Wo Ping (recruited to Hollywood for *The Matrix* series [1999–2003] and *Kill Bill*). Written and produced by the noted French director Luc Besson, it was shot primarily in London with other international cast members including Bob Hoskins

as the head gangster and Morgan Freeman as the piano tuner, each playing more or less to established type. The film is clearly designed to appeal across national boundaries but also offers a mix of ingredients that seem rooted to some extent in different film cultures.

Danny the Dog has an unambiguously upbeat ending that can be taken, more reflexively, as a victory of the values represented by one type of cinema over another, even if the film owes much of its funded existence to its more popular-genre-oriented dimensions. The upbeat ending is untypical of the Focus sample as a whole, however, a characteristic in which the wider slate is broadly in keeping with the case studies considered in earlier chapters. Nine of the 34 have happy endings, nine have unhappy and 16, almost half, have some form of the compromise ending discussed above (that is to say, 25 out of 34 have something other than a simply upbeat ending). A good example of the compromise ending is found in *Lost in Translation*, a feature that might in several respects be regarded as a quintessentially Indiewood product, including its ability to earn widespread positive reviews and numerous awards such as an Academy Award for best original screenplay and Independent Spirit Awards for best film, director, screenplay and male lead: the kind of critical and industry recognition that often translates into Indiewood success. *Lost in Translation* positions itself clearly in the 'quality', specialist arena at the level of its overall tone, mood and the absence of any conventionally strong narrative drive. The story of two individuals, Charlotte (Scarlett Johansson) and Bob (Bill Murray), who find solace in each other's company during enforced periods of residence in a luxury Tokyo hotel, the film is primarily a mood piece, a wry and quite touching observation of fleeting moments of human connection amid the various alienating aspects of each character's life: he an actor being overpaid to endorse a Japanese whisky, she the philosophy-graduate wife of a photographer with whom she seems to have little in common. The film faintly begins to sketch the possibility of romance between the two, but pulls back from anything like a consummation, leaving the pair heading their separate ways although only after an inaudible (thus ambiguous) final exchange that leaves a partially open-ended impression. At the same time, *Lost in Translation* also displays some more conventional dynamics. The impression of two lost souls finding one another is a

familiar trope, even if not fully developed. Much of the humour offered by the film is reliant on somewhat stereotypical meetings of East and West and the star presence of Bill Murray is central to the selling of the film, even if the phenomenon of stardom is subjected to gentle mockery around his character within the narrative. *Lost in Translation* is also keen to include its own diegetic markers of distinction, to underline the position it seeks to take up in the wider cultural field, primarily through the negative reference point provided by a minor character, a Hollywood actress presented as a crass and superficial figure who represents the cinematic pole opposite to that with which Coppola's film wishes to be associated.

Selling the brand

Lost in Translation also features among a number of titles singled out by Focus in its efforts to articulate the specific qualities the company seeks to associate with its brand name. It is noteworthy that Focus has sought overtly to push a brand image, as a distributor, in the wider public realm as well as in comments made in the pages of the trade press. The most obvious manifestations of this have been corporate trailers presented on DVD releases and on the Focus website. The company has also deployed its own branded display racks in Virgin Megastores as a way of building a distinctive identity for its past and current output.[16] A composite trailer opens the region 1 DVD release of *Lost in Translation* and it is significant that the trailer begins to play automatically once the disc has been loaded (the viewer can fast-forward to avoid watching but it comes on as a default, as is the case with many trailers attached to DVDs, and cannot usually be stopped or paused). The trailer presents clips from Focus releases including *Lost in Translation, The Pianist, Far From Heaven, The Kid Stays in the Picture, Eternal Sunshine of the Spotless Mind, Monsoon Wedding* and one film theatrically distributed pre-Focus by Universal's USA Films, *Gosford Park* (2001). These are accompanied by a clear voice-over statement of where the company seeks to situate its output in the cinematic spectrum:

> If the world is such a diverse place, why are so many movies the same? At Focus Features we're dedicated to making superior quality films that are as rich and distinct as the world around us, that defy

20. A marker of distinction? The Focus Features logo as it appears on screen
© Focus Features

conventions and dare to be extraordinary. That's why we've become
the destination for the world's biggest movie stars and most acclaimed
filmmakers, a home for their most personal and passionate projects.

This is followed by a 'coming soon' roll-call of *Lost in Translation,
21 Grams, Sylvia, Ned Kelly, Eternal Sunshine of the Spotless Mind, The
Door in the Floor* and *Vanity Fair,* and the pay-off line: 'So, if you crave
movies that take you where you haven't been, show you what you
haven't seen and always give you something more, we bring it all into
Focus', after which are included the full trailers for *21 Grams, Eternal
Sunshine* and *Swimming Pool.*

Similar claims are found on the 'Focus Reel' available in the 'About
Focus' section on the company website. A series of single-word
adjectival declarations are made, each followed by a film clip: 'Innovative'
(*Eternal Sunshine*), 'Extraordinary' (*Pride and Prejudice*), 'Original' (*Lost in
Translation*), 'Provocative' (*The Constant Gardener*), 'Unforgettable' (*The
Motorcycle Diaries*), 'Oscar Winning' (*Brokeback Mountain*), followed by
trailers for three upcoming features and additional text proclaiming:
'Focus Features brings you the most exciting stars and filmmakers of
tomorrow and the greatest cinematic artists of today. This year, if you're
looking for something more, we bring it all into Focus.'[17]

A strong pitch is made for the distinctive, 'superior' and artistic
qualities of the Focus slate; for the defying of conventions, for original
and provocative work, and for the status of Focus as a privileged space
for the 'most acclaimed' filmmakers and 'cinematic artists'. How

representative these claims are of the reality is not the main reason to quote them here, the important point being the effort made in such fora to stake a claim to a particular high-quality status. If the claims are to be put to the test, briefly, though, we might look at the adjectival series and judge it reasonable to describe *Eternal Sunshine* as 'innovative' in some respects but unconvincing to label *Pride and Prejudice* 'extraordinary'. *Lost in Translation* might be 'original' to a degree, but far from entirely. *The Constant Gardener* may be a little 'provocative' at a corporate-political level but we might question how far *The Motorcycle Diaries*, even if admired, is really 'unforgettable'. The safest bet is the factual statement, even if taken to imply so much more, that *Brokeback Mountain* is 'Oscar winning'. Hyperbole is certainly to be expected in any such promotional formulations. Some of the claims seem less specifically tailored to the qualities championed by advocates of the speciality/Indiewood sector. This is particularly the case with familiar movie-hype chestnuts such as being 'taken where you haven't been, shown what you haven't seen', which might apply equally to products of mainstream Hollywood blockbuster fantasy. The key point, however, is that an active process of market positioning is entailed by the direction in which most of the claims are inclined, a claim to specialness, distinction and quality. In the longer version accompanying *Lost in Translation* this is modulated, however, by the presence of star billing (in the roll call, each title is followed by 'starring' or 'with' and the names of key talent) and the use of clip-fragments that tend towards the dramatic and/or eye-catching in emphasis. What is offered, ultimately, is the promise of superiority and prestige mixed with more commercial, visually striking and dramatically engaging qualities.

Further evidence of the importance of brand image to Focus was the launch in 2004 of a separate division, Rogue Pictures, to handle genre films of lower cultural prestige. In this respect, Focus was following directly in the footsteps of Miramax and its creation of Dimension Films for a similar purpose in 1992, to enable the company to profit from the release of such features without the risk of damaging the more prestigious associations built around the main brand identity (Dimension subsequently became the most profitable part of the company). In this manner, Focus was able to avoid the creation of the kind of mixed message that might have resulted from the presence

of its logo, pre-Rogue, at the opening of the remake of *The Texas Chainsaw Massacre* (2003), one of the films for which the company gained overseas distribution rights. The Rogue identity was used in the release of films from the 2002–5 sample including *Cry Wolf*, *Sean of the Dead* and *Danny the Dog*, reflecting their points of greater youth-genre market orientation. Other Rogue releases in the period not included in my sample were the horror prequel *Seed of Chucky* (2004) and the crime-thriller remake *Assault on Precinct 13* (2005).[18] The existence of the Rogue brand provides one explanation for the fact noted above that the largest number of the more conventional genre films in the Focus sample fall into the horror or related genres; an outlet has been created within which this makes sense without undermining the status of the principal brand (horror probably being the mainstream 'low culture' genre most likely to have this negative potential for what is positioned as a 'quality' identity). This was described by one senior executive, president of production John Lyons, as an expansion beyond 'the classic Focus film', a formulation that again implies a core brand identity that would encapsulate the kinds of films singled out by the division for inclusion in its corporate show-reels.[19] The separation of the Rogue and Focus identities was completed in 2005, when the former was expanded and promoted to the status of a stand-alone division of Universal alongside the latter.

A substantial correlation exists between films that might fit the 'classic Focus' bill and those among the minority of the sample (a total of nine) in which the company acted as producer as well as distributor; the films in which it had the greatest initial investment. Focus productions include strong candidates for 'classic' status such as *Brokeback Mountain*, *Broken Flowers* (a co-production with Paramount, although the rival studio appears to have played no role in distribution), *Eternal Sunshine of the Spotless Mind*, *Pride and Prejudice*, *Vanity Fair*, *Possession* (co-produced with Warner Bros, which had overseas distribution rights) and *The Door in the Floor*. *Far From Heaven* can also be included in this list, its roll-call of producers including the Focus predecessor at Universal, USA Films. The one less obvious example is *The Ice Harvest*. Focus was also involved in the co-production of *Imagine Me and You* (2005, USA, UK, Germany), a London-set romantic comedy with a lesbian twist, although in this case the distributor was

the Indiewood rival, Fox Searchlight. The major example of 'classic Focus film' in which the company had no production stake is *Lost in Translation*, the producers of which were the director's father Francis Coppola's American Zoetrope, Elemental Films (a company that appears to have existed for this production alone) and the Japanese partner Tohokashinsha Film Company.

Examination of the Focus sample and the manner in which the brand has been sold suggests a clear leaning towards the territory of Indiewood, as a particular kind of hybrid form, as opposed to the wider independent/speciality landscape. In this respect, the Focus strategy can be contrasted particularly with that of Sony Pictures Classics (SPC), the studio division that has established a reputation for remaining closest in spirit to the art and independent cinema roots of the original classics divisions of the 1980s. SPC has handled some distinctly Indiewood-type features such as *Capote* (2005) and the breakthrough success *Wo hu cang long / Crouching Tiger, Hidden Dragon* (2000), but its distribution slate evidences a much wider scope than that of Focus, including more challenging art-cinema-oriented works such as Michael Haneke's *Caché / Hidden* (2005) and many examples of lower-budget indie and lower-profile imported film.[20] One broad measure of distance from the mainstream is the proportion of subtitled imports handled by the speciality divisions, a ground on which the output of SPC from 2002–5 is strikingly different from that of Focus. While Focus distributed four subtitled features out of a total of 34 (11.7 per cent), the SPC slate included 37 subtitled out of 79 (46.8 per cent, or nearly half). Some subtitled features may have more obvious potential for commercial cross-over than others, including a number of additional Hong Kong martial-arts-oriented features distributed by SPC, most notably Zhang Yimou's *Shi mian mai fu / House of Flying Daggers* (2004, distributed overseas by Focus), but the division's slate embraces a considerably wider range of material from more diverse sources than those of Focus. More obviously niche-marketable features (such as the work of internationally recognized auteurs Haneke and Pedro Almodóvar) are mixed with numerous smaller, less well-known titles, not likely to be in any way clearly pre-sold in the USA, even for specialist audiences, other than via the particular 'art-house quality' associations created in this way through the establishment of the

subsidiary's own brand. This wider variety of output can be attributed to two main factors: the personal commitment of long-standing co-presidents Michael Barker and Tom Bernard to the art-house and foreign-language markets; and, the basis for this, the near-total autonomy they gained from the studio parent when they signed up with Sony in 1992 (having previously established a reputation for success in the speciality market while jointly running United Artists Classics and Orion Classics). Their autonomy was subsequently maintained, up to the time of writing, on the basis of a track record for stability, modest spending and consistent profitability; a successful recipe that evaded much of the contemporary pressure to focus on films with greater cross-over potential.

The Sony subsidiary has joined Focus and Fox Searchlight as one of the three speciality divisions generally considered, in their own ways, to have created the most stable relationships with their studio parents by the mid-2000s, a quality sometimes threatened by the blurring of lines or potential lack of harmony between the two. The general consensus, among industry commentators, is that the divisions that have proved most successful are those in which the studio has interfered least and where longer-term stability has proved possible.[21] Less certain has been the status of subsidiaries that have been subject to frequent change and/or less clarity of identity. Such was widely viewed to be the situation at Paramount in the mid-2000s and Warner towards the end of the decade. Paramount launched a new entity, Paramount Vantage, in 2006, defined as 'the speciality film division of Paramount Pictures', while retaining the previous Paramount Classics identity as a label within Vantage to 'focus on smaller, review-driven films including foreign-language acquisitions and documentaries', a move that suggests in this case an explicit attempt to separate out to some extent the Indiewood and indie/art-cinema dimensions.[22] The future of Warner's commitment to the speciality market was thrown into doubt with the announcement in 2008 of the closure of Warner Independent Pictures, created in 2003, a move that underlined the potentially unstable nature of the relationship between studios and their less mainstream divisions. Warner Independent was folded, along with Picturehouse, the speciality wing of New Line at the time, following a decision to absorb New Line entirely into the studio.

Warner's claim that the move, designed to reduce duplication of infrastructure, did not represent an abandonment of the indie marketplace was met with scepticism by industry commentators.[23]

As far as the ratio of subtitled to non-subtitled features from 2002 to 2005 is concerned, Focus occupies a place similar to that of Miramax (13 out of 101 releases, or 12.8 per cent), which says much about its general position in the Indiewood landscape. Warner Independent has a slightly higher ratio, but on the basis of relatively small numbers (two out of 12, or 16.6 per cent). Fox Searchlight demonstrates the least commitment to subtitled imports (three out of 45, or 6.6 per cent), while the division that comes closest to SPC on this measure is Paramount Classics (eight out of 29, or 27.5 per cent).[24]

Of the latter three, Searchlight appears to lean most clearly towards Indiewood in the general tenor of a brand typified by titles such as *Sideways* (2004), *I Heart Huckabees* (2004) and the darker but (Robin Williams) star-led *One Hour Photo* (2002), relatively high-profile indies such as *Napoleon Dynamite* (2004) and *Garden State* (2004), and quite commercially-leaning English-language imports including *Bend It Like Beckham* (2002) and *28 Days Later* (2002, distributed in the USA in 2003). Warner Independent's 2002–5 slate is a little more uneven in emphasis, including the clearly Indiewood-seeming *Good Night, and Good Luck*, the dark life/death alternative reality chiller/war drama *The Jacket* (2005), the breakout documentary hit *March of the Penguins* (2005) and the low-budget indie *A Home at the End of the World* (2004). The latter is an interesting case, having had some of its more challenging edges smoothed away during editing as a result of pressure from the studio division, material that gave more emphasis to the gay dimension of its central relationship structure and that was seen by executives as likely to narrow the potential audience constituency. For producer Christine Vachon, a key figure in the more radical end of the New York indie scene since the 1990s, the two minutes involved 'can tell you a lot about the conflicted nature of "independent" filmmaking when studios, producers, and directors, all with competing visions for a film, become interdependent'.[25] For Vachon, 'big-picture studio scrutiny' was being given, inappropriately, to an 'offbeat little picture', the kind of experience likely to confirm the worst expectations of those critical of the impact of studio involvement in this part of the cinematic

spectrum.[26] *A Home at the End of the World* remains a distinctly indie feature, however, particularly in the subtle manner through which the modulations in its central three-way relationship are evoked (at least one of the cuts, a rooftop kiss between the two male protagonists, was restored for the DVD release). The process undergone by the film was not a simple matter of the studio division insisting on changes. Vachon's company, Killer Films, had final cut, which gave the filmmakers the option to insist on having it their way. As Vachon explains, the key issue in such cases is not the contractual right to final cut itself, which might appear to be a guarantor of independence at the textual level, but the need to maintain the full backing of the distributor if a film is to gain any other than a very limited and unsupported opening: the decision on this occasion was reluctantly to accept the Warner Independent line because, as Vachon puts it, 'a positive relationship with the distributor is the most essential condition for a successful indie release'.[27] Another example of a less mainstream, commercially more risky production in the Warner slate is the Arabic-language import *Paradise Now* (2005), a sympathetic portrayal of two would-be Palestinian suicide bombers, which is ambiguous in some aspects of its stance, but strongly critical of Israel. For Paramount Classics, the balance is chiefly between indie titles ranging from the rap-oriented *Hustle and Flow* (2005) to *The United States of Leland* (2003) and *Northfork* (2003), and low-profile imports tending to lean towards comedy and/or romance, but also including less obviously commercial examples such as the South Korean ('heart-warming') rural emotional drama *Jibeuro / The Way Home* (2002) and Andrei Konchalovsky's *Dom durakov / The House of Fools* (2002, Russia, France), a striking drama set in an asylum during the Russo-Chechen conflict.

In addition to the two *Kill Bill* films and the larger-budget *Gangs of New York* and *Chicago*, cited in chapter 2, the broader Miramax slate for the same period embraces (among others) additional expensive 'prestige' productions such as Anthony Minghella's *Cold Mountain* (2003) and Martin Scorsese's *The Aviator* (2004), along with 'quirky' indie productions such as Soderbergh's *Full Frontal*, *The Station Agent* (2003) and the digital production *Tadpole* (2002). Miramax imports include relatively higher-profile subtitled films such as *Cidade de Deus* and *Tsotsi / Thug* (2005), the latter winning an Oscar for best foreign

language film. These examples offer an interesting combination of the kinds of third-world-poverty scenarios characteristic of one strain of international art cinema with more mainstream/commercial thriller-generic ingredients (with its narrative and other stylistic flourishes, the position of *Cidade de Deus* in the US market is akin to that of a Latin American *Pulp Fiction*; *Tsotsi* mixes some similar elements). Most of the imports are relatively modest in scope, in terms of distance from the mainstream, but they include a number of lower-profile works, usually packaged (using English titles) to make less obvious their overseas origins. Examples of this approach include *Io non ho paura / I'm Not Scared* (2003), an Italian-language production that also blends more traditional art-house qualities (a lushly photographed idyllic Italian rural setting, a story revolving around the experiences of a young boy) with thriller features that form the main selling point (tagline 'Secrets. Betrayal. Murder. Who can you trust when everyone's a suspect?').

Overall, then, even when considered very briefly, the slates of the other speciality divisions appear to embrace a quite considerable range, including many features that remain conventionally identifiable as 'indie' rather than Indiewood, in addition to imports that also mix the more with the less obviously easy to market beyond the smallest of niche audiences. Products of the Indiewood variety are likely to account for the larger share of financial returns in many cases, however, even if their relative prominence in the release slate varies from one division to another. For Focus, Fox Searchlight and Miramax, Indiewood features are those around which the speciality brand appears most clearly to be structured. This has been less evidently the case for Warner Independent and Paramount Classics, while Sony Pictures Classics, as suggested above, has created an identity based explicitly on the inclusion of a more distinctly art-house dimension.

Situating Focus/Indiewood

How, then, should we situate the Focus slate, and Indiewood more generally, in the broader landscape of cultural production and consumption? We return here, briefly, to some of the issues raised in the introduction. Focus Features, like the other studio speciality

divisions, remains very clearly a part of a broader corporate capitalist media and wider commercial enterprise. Its primary function, in this environment, appears to be two-fold. One is to maximize the extent to which a larger film industry unit is able to exploit a particular range of relatively or potentially substantial niche markets; not, generally, the smallest, most radical or marginal reaches of art or indie cinema, but those which carry the potential to break through to relatively larger audiences, even if in most cases these are unlikely to match the scale of the larger-grossing Hollywood features. In the case of Focus, the emphasis is firmly on the likes of *Lost in Translation*, *Brokeback Mountain* and *Eternal Sunshine*, rather than smaller indie films or imports with less cross-over potential. There is, here, a quite substantial business imperative. Added to this is the second factor, the potential this realm has for the acquisition of prestige, although the two are far from separate. Prestige, of the kind sought by Indiewood divisions such as Focus, is a key component of the substantial-niche market strategy, an important ingredient in the recipe; a quality that is marketed to audiences as a source of distinction-marking appeal, as well as something that can accrue to the studio itself. Prestige might have some value to the industry in its own right, as suggested in the introduction, but it seems likely that the primary motivation for its pursuit is its relevance to the particular commercial imperative at work in this part of the cinematic spectrum.

Bourdieu provides another framework in which this can be considered, a distinction between two extremes of cultural production (neither of which is ever attained in pure state) characterized as the 'short production cycle' and the 'long production cycle'.[28] A short production cycle, in Bourdieu's account, involves the production of works that respond to pre-existing demand in pre-established forms as a way of minimizing risks. A long production cycle, by contrast, is 'founded on the acceptance of risk inherent in cultural investments' in works that have no market value in the immediate present.[29] The bulk of mainstream Hollywood production would be an obvious example of the former; much avant-garde or experimental work might fit into the latter. A great deal of indie and Indiewood cinema would seem also to fall into the short-term category, although this might not always be the case, or not entirely so. Some indie, Indiewood and earlier

examples of relatively unconventional Hollywood production has proved of greater commercial worth in the longer than in the short term, even if little or no work in these categories would ever have been produced and distributed with the expectation of having *no* immediate market value. Many of the more celebrated films of the Hollywood Renaissance could be included here, a number of which contributed to the prestige value of particular filmmakers, studios or that particular period in Hollywood history more generally without having proved of other than marginal market value at the time of release; they have also contributed a longer-term source of value via their continued availability, and reissue in new editions, on video and DVD (only a relative few, including *The Graduate* and *Easy Rider* [1969] were box-office hits on release). The same could be said of some Indiewood features, the most prominent example being *Fight Club*. If we look at some further examples from the Focus slate, a mixture is apparent to some extent, but it is one that still seems overall clearly to favour the shorter-term imperative to respond to what appear to be existing demands through a reliance on pre-established forms.

Take, for example, the British-rooted 'inspirational' drama *Inside I'm Dancing* and a similarly located film released by Focus in the USA in 2006, *On A Clear Day* (2005), the story of a redundant shipyard worker who regains his sense of purpose by swimming the English Channel. Each of these films offers potentially 'awkward' and downbeat elements that might be seen as a commercial challenge. But they each also fit very clearly into a pre-existing template with a past track record of box-office success in the US speciality market. The two have elements broadly in common in the 'British inspirational' mould, but they also have clear individual precedents: *My Left Foot* (1989) in the case of the former, an important early success for Miramax, and *The Full Monty* (1997) (and others that followed it) in the case of the latter, a Fox Searchlight release that achieved a US gross of $45 million on a budget of just $3.5 million. The release of Roberto Benigni's *The Tiger and the Snow* might be viewed, likewise, as an attempt (unsuccessful, as it proved) to repeat something on the scale of the unexpected $57 million US box-office success of the Miramax-distributed *Life is Beautiful*, a record for an overseas feature at the time. Most of the 34 films in the Focus sample fit quite readily into existing and proven

templates of one variety or another. One example that stands out to some extent is Susanne Bier's *Brothers*, which revolves around the opposition between two siblings, one (initially negatively-coded) just out of prison, the other (presented positively) reported dead and forced to kill a colleague to survive after being imprisoned during military service in Afghanistan. The narrative set-up is somewhat contrived, the initial positions of the brothers eventually becoming inverted, but the film is shot and played in a quite harsh, unromanticized manner. It opened on two screens and widened to 26, achieving a very modest gross of $384,982 in the USA, and seems unlikely to have produced expectations for anything hugely significant in terms of financial return. It still remains a largely conventional narrative feature, however, based around forms of emotional melodrama, even if given a 'raw' quality, and devoid of anything that might constitute the kind of formal or political challenge associated with some examples of art cinema.[30]

If Indiewood films can, in general, be situated in relation to existing/proven templates, the same can be said of much of the output of the wider indie sector, including templates of its own creation such as particular constructions of the 'geeky youth' as hero (see, for example, *Napoleon Dynamite*, a low-budget feature that was generally well received and a box-office success, but viewed by certain critics as somewhat indie-clichéd in its celebration of an awkward-yet-eventually-triumphant bespectacled high school protagonist). This was probably true in many cases even before the growth of the perception during the 1990s that 'indie' or 'independent' had become a marketable brand rather than (or as well as) a collective term for a more disparate range of non-mainstream filmmaking. What is specific to Indiewood, as far as any hard-and-fast lines can be drawn, is the prevalence not just of particular templates in some cases – such as the literary/heritage strain or the mixed-resonance ending – but a particular and generally limited range of scope within which more familiar models are most likely to be combined with departures from established mainstream convention. And this is, ultimately, a somewhat fuzzy notion, a question of relative degrees rather than clear-cut distinctions. In the year after the period covered by my sample, for example, the Focus release slate included Rian Johnson's *Brick* (2006), a film that would appear from its textual characteristics to be solidly in the indie rather than the

Indiewood camp, like some of those found in the slates of the other specialist divisions considered above, even if it might be viewed as an indie film that fits a template in the very knowingness of the way it plays with a combination of geeky high school and detective/noir formats. The fact that Focus chose to distribute *Brick* might be understood as an attempt on its part to maintain its credentials, selectively, in the more indie-specific arena. The same might be said of *Being John Malkovich* among the Kaufman-scripted features examined in chapter 1, the overt quirkiness and darkness of which seems more indie than Indiewood in general tenor, even if *so* wilfully quirky as to seem to fit a kind of indie template on that ground itself.

If some have celebrated Indiewood, as a potentially fruitful blend of qualities associated with both Hollywood and the indie sector, the dominant tendency has been to question or attack it as a threat to the existence of what is presented as a more genuinely independent realm. This is understandable in some respects, particularly from the perspective of those suspicious of the narrowing of the range of expression often associated with the spread of the tentacles of corporate media organizations such as those within which the major studios are located. Concentration and oligopoly in the culture industries can lead to a reduction in diversity and product innovation, but the correlation between the two is far from absolute. The music industry offers an interesting point of comparison. A strategy in which the major record companies incorporated former independents through the creation of their own label divisions (along with the creation of relationships with smaller labels that remained independent) has, according to one study, enabled the dominant players to remain open to a significant level of diversity in recent decades, despite an increase in market concentration.[31] This use of 'speciality' music divisions and other links between major and independent operations is similar in some respects to the situation in the film industry. Indiewood divisions provide a mechanism through which the major studios can increase their openness to emerging filmmaking talent or to established practitioners from overseas, or otherwise less mainstream regions of the cinematic spectrum. Speciality divisions have also forged links with companies that remain formally independent. When Good Machine moved to Universal/Focus, for example, the third partner in the company, Ted

Hope, created a new company, This is That, with the intention of maintaining a greater level of autonomy than would be possible under a studio wing. The first move of This is That, however, was to sign a three-year first-look deal with Focus, the initial product of which was a co-producer role in *21 Grams, Eternal Sunshine of the Spotless Mind* and *The Door in the Floor*. It is probably the case that such links are of less centrality and importance to Hollywood than they are to the major record companies, however. The mainstream end of the film industry is generally less subject to major shifts and trends than the popular music business. Little equivalent exists in the film industry of the ability of once-marginal musical formats to leap into positions of major commercial centrality, even if in some cases toned-down, as in the case of the cross-over achieved by rap in the 1980s and 1990s.[32] There appears to be more at stake, and for more immediately commercial reasons, for the music industry in establishing divisional/label structures that permit the incorporation of potential sources of innovation and diversity. A more apt parallel in the film industry might be the cross-over potential demonstrated by the horror genre since the 1970s, in which respect the most significant studio divisions of more recent years would be the genre-oriented labels such as Dimension and Rogue.

Whether or not the speciality divisions of the music industry allow for greater diversity than those of the Hollywood studios is an issue beyond the scope of this book. The range encompassed by the Indiewood divisions is generally narrower – almost by definition – than that of the regions of the indie sector that have no direct studio affiliation, although the extent to which this is the case varies from one studio subsidiary to another. Merely to attack Indiewood as a source of co-optation and dilution of independence by Hollywood is to risk an over-simplification of the nature of the wider cinematic spectrum within which both are located, however. In this respect the position of Indiewood is consistent with that from which some other cultural products have come under question, particularly through the use of the label 'middlebrow'. The middlebrow was formed as a category, as Janice Radway suggests, 'by processes of literary and cultural mixing whereby forms and values associated with one form of cultural production were wed to forms and values usually connected with another', a definition

according to which Indiewood, as a Hollywood/indie hybrid, would generally qualify.[33] 'Middlebrow', like Indiewood, is more often used as a term of abuse than one of praise, and perhaps for much the same reason. The 'scandal of the middlebrow', as Radway puts it, is 'a function of its failure to maintain the fences cordoning off culture from commerce, the sacred from the profane, and the low from the high'.[34] Radway's argument, developed in relation to the formation of the Book-of-the-Month Club in America in the 1920s, seems equally applicable in some respects to the situation of Indiewood in the late twentieth and early twenty-first centuries.

The term middlebrow would probably be avoided by most of those working in the Indiewood arena, having gained primarily negative connotations in its association with works that advertise their belonging to a 'respectable' (and therefore 'safe' and unchallenging) variety of prestige/quality production. The middlebrow is often characterized as sharing none of the virtues of either lower ('honest', 'vigorous') or higher ('genuinely' innovative) forms of cultural production.[35] Its connotations tend to exclude the claims made by some Indiewood products to 'cooler' or more 'edgy' qualities, although many Indiewood films display a tendency towards a certain complacency about their own status that has also been associated with the middlebrow (in, for example, the tendency to contain internal markers of distinction between some forms of cultural production and others with which they implicitly associate themselves, as in the case of *Lost in Translation*). To attack Indiewood, on the grounds of some kind of betrayal or abandonment of 'true' independence, is to imply the existence of a purer or more autonomous realm. This might be defensible in some cases, in relation to the farther reaches of independent cinema that do not include the use of the dominant commercial networks of distribution and exhibition. As far as the commercially distributed 'indie' or 'independent' sectors are concerned, however, such an attack can be seen as an attempt to enact the kind of cordoning-off described by Radway, in a territory better understood as considerably more variable and dynamic than the erection of such borders would suggest. It can have the effect of denying the extent to which the indie/independent is itself subject to its own forms of institutionalization and commercialization, shading

into, rather than being entirely separable from, Indiewood. Such articulations can also be viewed as part of a process of defensive distinction-maintenance on the part of those who wish to associate themselves with the qualities ascribed to independent cinema, an activity primarily rooted as Michael Newman suggests in a white, middle-class 'elite' audience.[36]

It is undoubtedly the case that the development of Indiewood institutions and practices has exerted pressures on and helped to shape aspects of the wider indie sector, elements of which have been obliged to play Indiewood at its own game in order to compete and avoid relegation to a position closer to the margins. This is one of the more compelling grounds on which Indiewood has been criticized, particularly for exacerbating certain practices that might increase tendencies to play safe and avoid more challenging material (as suggested in chapter 2 in the case of the Miramax-led move towards greater investment in production, and in individual examples such as the treatment of *A Home at the End of the World* at Warner Independent). It is notable that when the more radical independents Killer Films and Think Films announced a partnership deal in 2007 they framed it as an attempt to increase their stability by replicating 'the structure of a specialty division', in creating a link between the production of the former and the distribution slate of the latter.[37] This was presented as an arrangement beneficial to each but also as a requirement if 'the real indies' were to address some of the advantages enjoyed by the studio-backed competition, one of the key differences between the studio divisions and fully independent distributors being the lower level of involvement in production that tends to characterize the latter. The speciality divisions also gain more generally from the financial muscle and scale of operations of their studio parents, including their ability to orchestrate wide releases where necessary and to profit most effectively in the post-theatrical market. A number of developments such as the Killer/Think Films arrangement have contributed to the blurring of boundaries in these regions of the cinematic spectrum, but it would be mistaken to imagine that they had ever been entirely clear-cut or one-dimensional.

The bounds of what is permissible or achievable in Indiewood may be more limited than is the case in the wider independent arena. In

general, Indiewood producers and/or distributors seek access to audiences at a threshold level that disinclines them to push very far in the offering of challenging material. There is a general tendency to play safe, ultimately, to rely on proven templates and to combine material that might be challenging in some respects with more easily marketable components such as stars, 'name' filmmakers and strong, broadly familiar narrative and emotional hooks. Indiewood is often accused of sharing with Hollywood a reliance on the creation of soft-centred 'feel-good' effects, rather than more difficult resonances, although these are often muted, as suggested by the prevalence of the compromise endings in the films considered in this book. A prominent target of such criticism at the time of writing was *Little Miss Sunshine* (2006), a lightly satirical Fox Searchlight release that embraces a range of (rather studiedly) 'oddball', 'quirky' characters, a dysfunctional family that eventually comes together against adversity. The film does appear to fit what had by the time become a familiar indie template, in its general tone and character, rather than breaking new ground, with an ending that leaves a distinctly cosy, feel-good impression. But much the same criticism could be made of many films produced and distributed in the more fully independent sector (and a key factor in *Little Miss Sunshine* being singled out for attention was the simple fact that it was a breakout box-office success, taking just under $60 million in the USA).

James English offers a compelling articulation that might apply to the situation of Indiewood in his study of the world of literary, film and other artistic prizes, a growth arena in which, as he suggests, a variety of exchanges are performed between economic and cultural capitals:

> The game they [administrators, judges, sponsors and artists involved in the prize-giving process] are playing is not to be reduced to a field of battle on which the forces of genuine art defend with the weapons of pure symbolic capital a small (and probably shrinking) strip of 'independent' terrain against the imperial forces of commerce (or of 'political correctness' and so on), the one force engaging the other along a single borderline, across which attempts are continually made to insinuate false art, like a Trojan horse, onto the terrain of the genuine. This all-too-familiar scenario obscures far more than it reveals about prizes and about cultural life in general. We should

think, rather, of a game that is being played at every point of position on the field, the entire field of cultural production a full-contact marketplace or zone of [capital] intraconversion on which the (economic) instruments and practices of engagement keep getting more various and more complex.[38]

To argue that a similar view might be taken of the status of Indiewood, often viewed as performing a role akin to that of a Trojan horse, is not to suggest the existence of an open field of forces but to move away from the notion that a simple binary opposition can be asserted between the commercial mainstream and all points of relative departure and difference.[39] Hollywood can, on occasion, be hospitable to more than usually radical material, if perhaps mostly by default or in very particular circumstances, or through the ability of particular individuals to carve out spaces that might not actively be encouraged by the studio system. Fully independent features can also pursue resolutely commercial agendas, not least in the various realms of more or less well-funded independent 'exploitation' cinema. Indiewood is taken in this book to denote a particular region characterized primarily by a form of studio/indie hybridity that I would suggest is distinctive, in broad terms, without being subject to any single detailed definition. Its most clear-cut ground of demarcation is industrial–institutional, in the form of the output of the studio-owned speciality divisions, but this also includes some films that remain more distinctly 'indie' in character and Indiewood can also be taken to embrace some work produced on occasion from within the main studio operations themselves. The question of what constitutes Indiewood cinema at the textual level is, as I hope to have shown, a good deal more variable in detail, but can still be answered through close analysis of the specific blends of qualities, and potential grounds for audience appeal, offered by particular examples of the form.

It is doubtful that anything as specific as a distinct set of Indiewood norms can be identified, to answer a question posed in the introduction. Some features recur quite often, such as the mixed resonance ending discussed above and the tendency to draw at least in part on artistic/cultural resonances in the fictional worlds depicted on screen. But Indiewood is characterized more by a particular balancing of

position in the mainstream/alternative scale, however imprecise that might sometimes seem, than by the identification of specific trademark features. And, either in general or particular instances, this does appear to be a balance appreciated by the target audience, the likely social basis of which was considered in the introduction. Among the wide-ranging Amazon responses to the main case studies considered in this book, a significant minority engage in overt acts of distinction-marking in which they and like-minded individuals are valorized in opposition to others who are positioned as less discriminating and thus less able to appreciate the particular qualities of the films concerned. Many more appear to do something similar in a less explicit manner. If those who respond with hostility and/or dislike are clearly not the target audience in most cases, judging by the grounds on which their opposition is marked, the existence of their responses plays an important part in the process through which space is created for the articulation of distinctions by those who post favourable comments. But, in general, these films are not appreciated solely on the basis of their least mainstream-inclined components. Substantial numbers of those who respond positively do so on the basis of more conventional dimensions of narrative, character, performance and the like, often in combination with appreciation of features that depart to some degree from the Hollywood norm.

Radway's account of the Book-of-the-Month Club offers an interesting parallel in some central respects. The formula of the club is one in which commercial and specifically literary considerations are held in close balance, neither being entirely privileged over the other. Radway identifies two intersecting axes of value in the internal debates conducted within the club over which books should be selected for its lists. One measures the success of 'the writerly act of creation', taken on its own terms and measured against 'preestablished aesthetic norms'. The other 'measures a book's capacity to satisfy its reader's practical demands'.[40] The latter involves meeting a desire, located in what Radway characterizes as a professional-managerial class formation (akin to that considered among others in the introduction), for a mixture that offers markers of intellectual distinction, but in which 'intense affective response and reaction' remains essential.[41] This seems very close to the basis of the appeal offered by many of the Indiewood features

considered in this book, produced in a context in which the avowedly creative/artistic and the commercial are blended in broadly similar measure. In both cases, a clear distance is established from more radical approaches such as the element of modernism found in some instances of art cinema, described by Robert Kolker as an attempt 'to prevent the spectator from slipping easily through the structures of presentation into an emotional world of character and action'.[42] The 'emotional world of character and action' remains central to Indiewood production, distribution and consumption, even if in some cases combined with dimensions that invite (relatively) more detached modes of engagement. This is not a ground on which Indiewood is clearly distinguishable from indie, however. The latter also tends in many cases to revolve around the world of character and action, although it includes greater potential for departures, including the centrality to some features of inactive central protagonists and/or the presence of markedly de-dramatized narrative frameworks.[43] The indie position in this respect is situated, characteristically, somewhere between the poles of Indiewood and the more radical end of the art-cinema spectrum.

What we might make of the Indiewood blend from an evaluative point of view is not the main concern of this book, the aim of which has been to analyse Indiewood rather than to judge. A degree of caution might be in order, however, before any rush to criticize Indiewood in the kind of language that has often been applied to instances of the middlebrow such as the Book-of-the-Month-Club, or to Indiewood itself by some of those who position themselves as defenders of the independent faith. Indiewood features might be viewed as getting the best of both worlds, or as falling between stools and possessing the virtues of neither end of the indie/Hollywood spectrum. The development of Indiewood might be criticized particularly for playing a part in the overall narrowing of the bounds of what is likely to gain commercial distribution in the USA, although the extent to which this has been the case (or to which the bounds were ever very much wider) is easily overstated. It is questionable how far the development of Indiewood has reduced the number of genuinely radical or disturbing independent productions that achieve distribution, given how limited their numbers have always been in any kind of significant commercial release. It is easy, on the one hand, to

romanticize a previous moment of supposedly greater 'purity', and also, on the other, to overlook the continued production of innovative, low-budget indies, such as the oblique science fiction of *Primer*, the expressive autobiographical documentary of Jonathan Caoutte's *Tarnation*, or the ongoing provocations of Todd Solondz in films such as *Palindromes* (to name three films attributed to the same year, 2004, distributed from outside the speciality divisions), even if such titles often struggle to gain more than marginal release. The existence of Indiewood, and its naming as such, has also provided a new point of departure against which such less mainstream-oriented independent work can be defined, as part of an ongoing process through which distinctions are marked across the cinematic spectrum.

The fact that Indiewood (or 'indie' taken more widely) exists as, or has become, a largely marketing-driven niche need not mean that it is *only* that, a slippage implied by some critical commentators. Some of its products might be quite cynically targeted at a particular blend of niche and cross-over potential, but that does not mean they are as a result evacuated of any interest or significance beyond their commercial status. They are commercially positioned, as are most feature-length films, but can also be works of inherent interest, merit, quality, or whatever such term is employed to define them from one perspective or another. The same can be said of all commercially distributed cinema, although the balance between one dimension and another is varied. Even the most cynically fabricated Hollywood franchise/blockbuster release, however over-determined by commercial factors, is not solely characterized by its function within an industrial nexus. And neither is a work of serious 'art' cinema, or strongly art-leaning indie, entirely freed from commercial imperatives, even if reliance on a much smaller audience might reduce the extent of their impact. Indiewood is a particularly good terrain in which to explore this kind of balancing or combination of the commercial and the more avowedly creative or expressive because the balance between the two is relatively even, especially when compared with the two extremes cited above, but it can be understood in this respect as highlighting a broader phenomenon. Indiewood cinema may have limitations, but it also has a particular appeal that needs to be understood, for the individual viewer, for audiences conceived in broader terms of

particular taste-culture communities of consumption, as well as for the immediate and wider industrial conjunctures to which it owes its existence. Rather than evaluation, what I have sought to offer is a more objective analysis of Indiewood: its characteristic texts and institutions and the factors that have contributed to the creation of this particular region of the American film landscape.

Notes

1. Available at www.focusfeatures.com/home/php.
2. For more detail see the 'Our Company' section at www.ge.com/en/company/index.htm.
3. David Rooney, 'Sharp Focus', *Variety*, posted at www.variety.com, 23 November 2003.
4. A precursor from an earlier era was the creation by Universal of the Prestige Picture Program, a joint venture with the British producer J. Arthur Rank, which achieved a cross-over from the art-house market with its first US release, *Brief Encounter* (1945); Wilinsky, *Sure Seaters*, 75.
5. Eugene Hernandez, 'With Indiewood Films Riding High, David Linde Named a Top Exec at Focus' Hollywood Parent', *indieWIRE*, 16 March 2006, accessed via www.indiewire.com.
6. Quoted in Rooney, 'Sharp Focus'.
7. Quoted in Ian Mohr, 'Strictly Business', *The Hollywood Reporter*, 5 August 2003, accessed via www.hollywoodreporter.com.
8. David Rooney, 'Niche biz comes into Focus', *Variety*, posted at www.variety.com, 1 August 2004.
9. Rooney, 'Niche biz comes into Focus'.
10. Rooney, 'Niche biz comes into Focus'.
11. I am relying here on the list of features attributed to Focus as distributor by the Internet Movie Database (IMDb), www.imdb.com, which may or may not be definitive in scope. The dates used for this exercise are dates of US release, which are in some cases different from the year of production, particularly for overseas imports.
12. For more on *21 Grams* in this context, see my 'Weighing Up the Qualities of Independence: 21 Grams in Focus', *Film Studies: An International Review*, 5, November 2004, an essay on which this chapter draws for some of the general background on Focus.
13. I am relying here on attributions given by the IMDb.

14. It is, of course, easy to romanticize the earlier period, the exact balance of imports during which would merit further examination.

15. Alison James, 'Gauls are big pic spenders', *Variety*, posted at www.variety.com, 27 April 2003.

16. Gregg Kilday, 'Uni's Rogue given solo spot', *The Hollywood Reporter East*, 19 May 2005.

17. Accessed at www.focusfeatures.com/home/php, this particular selection being flagged in January 2007.

18. Neither of the latter two were included in the IMDb list of Focus releases used as the basis for my sample.

19. Rooney, 'Niche biz comes into Focus'.

20. For the full list I have used see the IMDb, www.imdb.com/company/co0014453.

21. See, for example, Anne Thompson, 'Risky Business: Speciality of the House: Mix of autonomy, time', *The Hollywood Reporter East*, 25 February 2005; Ian Mohr, 'Too big for their niches', *Variety*, posted at www.variety.com, 20 March 2005.

22. Announcement on the division's website at www.paramountvantage.com/blog/?p=5. See also Mohr, 'Too big for their niches'.

23. Borys Kit and Gregg Goldstein, 'Niche is ditched at Warners', *The Hollywood Reporter East*, 9 May 2008, 1, 4; Eric Kohn, 'Sign of the Times? Insiders React to Picturehouse, Warner Indie Closure', *indieWIRE*, 8 May 2008, accessed via indiewire.com.

24. This data is, again, based on the distribution slates listed on the IMDb.

25. *A Killer Life: How an Independent Producer Survives Deals and Disasters in Hollywood and Beyond*, 214.

26. *A Killer Life*, 230.

27. *A Killer Life*, 226. Not that the film's release was judged to be a success on either part, with a US gross of just over $1 million on a budget estimated at $6.5 million.

28. *The Rules of Art*, 142–3.

29. *The Rules of Art*, 142.

30. It is worth noting that art cinema itself has often tended more overtly towards the 'aesthetic' than the 'political' in the challenge it has offered to more commercial-mainstream production (even if the two dimensions are often closely entangled). Even more politically oriented work such as that associated with 'Third Cinema' has often been consumed outside its area of origin in terms that foreground the expressive qualities of the filmmaker more than the politics, as suggested

by Paul Willemen, 'The Third Cinema Question: Notes and Reflections', in Jim Pines and Willemen, *Questions of Third Cinema*.

31. Paul Lopes, 'Innovation and Diversity in the Popular Music Industry, 1969 to 1990', *American Sociological Review*, vol. 57, 1992.

32. For more on the example of rap, see Lopes, 'Innovation and Diversity'.

33. *A Feeling for Books: The Book-of-the-Month Club, Literary Taste, and Middle-Class Desire*, 152.

34. *A Feeling for Books*, 152.

35. For a recent articulation of such oppositions, in relation to videogames, see Henry Jenkins, 'Games, the New Lively Art', in *The Wow Climax: Tracing the Emotional Impact of Popular Culture*.

36. 'Indie Culture: In Pursuit of the Authentic Autonomous Alternative', Society for Cinema and Media Studies conference, Chicago, March 2007.

37. Eugene Hernandez, 'Film Interdependence: Killer/Think Deal Boosts Leading Indie Outfits', indieWIRE, 22 February 2007, accessed via www.indiewire.com.

38. *The Economy of Prestige: Prizes, Awards, and the Circulation of Cultural Value*, 11.

39. The 'Trojan horse' image is used, for example, in one of the quotations from Peter Biskind in relation to Miramax in chapter 2.

40. *A Feeling for Books*, 86.

41. *A Feeling for Books*, 262.

42. *The Altering Eye*, 159.

43. For examples, see my *American Independent Cinema*, chapter 2.

Select bibliography

Allen, Robert, and Douglas Gomery, *Film History: Theory and Practice*, New York: McGraw-Hill, 1985.

Amin, Ash, 'Post-Fordism: Models, Fantasies and Phantoms of Transition', in Amin (ed.), *Post-Fordism: A Reader*, Oxford: Blackwell, 1994.

Anderson, Chris, *The Long Tail: How Endless Choice is Creating Unlimited Demand*, London: Random House, 2006.

Askoy, Asu, and Kevin Robins, 'Hollywood for the 21st century: global competition for critical mass in image markets', *Cambridge Journal of Economics*, 16, 1992.

Austin, Thomas, *Watching the World: Screen Documentary and Audiences*, Manchester: Manchester University Press, 2007.

Balio, Tino, *Grand Design: Hollywood as a Modern Business Enterprise, 1930–1939*, Berkeley: University of California Press, 1996.

Barker, Martin, 'Betokening John Malkovich', unpublished manuscript.

Barker, Martin, with Thomas Austin, *From Antz to Titanic: Reinventing Film Studies*, London: Pluto, 2000.

Barker, Martin, and Kate Brooks, *Knowing Audiences: Judge Dredd, Its Friends, Fans and Foes*, Luton: University of Luton Press, 1998.

Barker, Martin, and Kate Brooks, 'On looking into Bourdieu's black box', in Roger Dickinson *et al.* (eds), *Approaches to Audiences*, London: Hodder Arnold, 1998.

Barker, Martin, Jane Arthurs and Ramaswami Harindranath, *The Crash Controversy: Censorship Campaigns and Film Reception*, London: Wallflower Press, 2001.

Bart, Peter, and Peter Gruber, *Shoot Out: Surviving Fame and (Mis)Fortune in Hollywood*, London: Faber, 2003.

Baudrillard, Jean, *For a Critique of the Political Economy of the Sign*, New York: Telos Press, 1983.

Becker, Howard, *Art Worlds*, Berkeley: University of California Press, 1982.

Belton, John, *Widescreen Cinema*, Cambridge, MA: Harvard University Press, 1993.

Beuka, Robert, *SuburbiaNation: Reading Suburban Landscape in Twentieth-Century American Fiction and Film*, New York: Palgrave Macmillan, 2004.

Biskind, Peter, *Down and Dirty Pictures: Miramax, Sundance and the Rise of Independent Film*, New York: Simon & Schuster, 2004.

Blau, Judith, *The Shape of Culture: A Study of Contemporary Cultural Patterns in the United States*, Cambridge: Cambridge University Press, 1989.

Bocock, Robert, *Consumption*, London: Routledge, 2004.

Bordwell, David, 'Part One: The classical Hollywood style, 1917–60', in Bordwell, Janet Staiger and Kristin Thompson, *The Classical Hollywood Style: Film Style and Mode of Production to 1960*, London: Routledge, 1985.

Bordwell, David, *The Way Hollywood Tells It: Story and Style in Modern Movies*, Berkeley: University of California Press, 2006.

Bourdieu, Pierre, *Outline of a Theory of Practice*, Cambridge: Cambridge University Press, 1977.

Bourdieu, Pierre, *Distinction: A Social Critique of the Judgement of Taste*, London: Routledge, 1984. First published 1979.

Bourdieu, Pierre, 'The Field of Cultural Production', in *The Field of Cultural Production*, Cambridge: Polity, 1993. First published 1986.

Bourdieu, Pierre, 'The Production of Belief: Contribution to an Economy of Symbolic Goods', in *The Field of Cultural Production*, Cambridge: Polity, 1993. First published 1986.

Brooks, David, *Bobos in Paradise*, New York: Simon & Schuster, 2000.

Brown, Royal, *Overtones and Undertones: Reading Film Music*, Berkeley, University of California Press, 1994.

Chion, Michel, *Audio-Vision: Sound on Screen*, New York, Columbia University Press, 1994.

Collins, Jim, *Architectures of Excess: Cultural Life in the Information Age*, London: Routledge, 2002.

Collins, Jim, *High-Pop: Making Culture into Popular Entertainment*, Oxford: Blackwell, 2002.

Dickenson, Ben, *Hollywood's New Radicalism: War, Globalisation and the Movies from Reagan to George W. Bush*, London: I.B.Tauris, 2006.

Dipple, Elizabeth, *The Unresolvable Plot: Reading Contemporary Fiction*, London: Routledge, 1988.

Docherty, David, David Morrison and Michael Tracey, *The Last Picture Show? Britain's Changing Film Audiences*, London: BFI, 1987.

Dorsky, Nathaniel, *Devotional Cinema*, Berkeley, CA: Tuumba Press, 2003.

Douglas, Mary, and Baron Isherwood, *The World of Goods: Towards an Anthropology of Consumption*, London: Routledge, 1996.

Dyer, Richard, *Only Entertainment*, London: BFI, 1992.

Ehrenreich, Barbara, *Fear of Falling: The Inner Life of the Middle Class*, New York: Pantheon, 1989.

Elam, Mark, 'Puzzling out the Post-Fordist Debate: Technology, Markets and Institutions', in Ash Amin (ed.), *Post-Fordism: A Reader*, Oxford: Blackwell, 1994.

English, James, *The Economy of Prestige: Prizes, Awards, and the Circulation of Cultural Value*, Cambridge, MA: Harvard University Press, 2005.

Ettema, James, and D. Charles Whitney, 'The Money Arrow: An Introduction to Audiencemaking', in Ettema and Whitney (eds), *Audiencemaking: How the Media Create the Audience*, Thousand Oaks: Sage, 1994.

Fahy, Thomas, 'Sexuality, Death, and the American Dream in the Works of Alan Ball: An Introduction', in Fahy (ed.), *Considering Alan Ball: Essays on Sexuality, Death and America in the Television and Film Writings*, Jefferson, NC: McFarland, 2006.

Featherstone, Mike, *Consumer Culture and Postmodernism*, London: Sage, 1990.

Feuer, Jane, Paul Kerr and Tise Vahimagi, *M.T.M.: Quality Television*, London: BFI, 1984.

Florida, Richard, *The Rise of the Creative Class*, New York: Basic Books, 2003.

Fowler, Bridget, *Pierre Bourdieu and Cultural Theory: Critical Investigations*, London: Sage, 1977.

Frank, Thomas, *The Conquest of Cool: Business Culture, Counterculture, and the Rise of Hip Consumerism*, Chicago: University of Chicago Press, 1997.

Frayling, Christopher, *Sergio Leone: Once Upon a Time in Italy*, London: Thames & Hudson, 2005.

Frow, John, *Cultural Studies and Cultural Value*, Oxford: Clarendon, 1995.

Gans, Herbert, *Popular Culture and High Culture: An Analysis and Evaluation of Taste*, New York: Basic Books, 1999, revised and updated edition.

Grainge, Paul, *Brand Hollywood: Selling Entertainment in a Global Media Age*, London: Routledge, 2007.

Gunning, Tom, 'The Cinema of Attractions: Early Film, Its Spectator and the Avant-Garde', in Thomas Elsaesser (ed.), *Early Cinema: Space, Frame, Narrative*, London: BFI, 1989.

Halligan, Benjamin, 'What is the Neo-Underground and what isn't: A first consideration of Harmony Korine', in Xavier Mendik and Steven Jay Schneider (eds), *Underground U.S.A.: Filmmaking Beyond the Hollywood Canon*, London: Wallflower, 2002.

Hanson, Peter, *The Cinema of Generation X: A Critical Study*, Jefferson, NC: McFarland, 2002.

Harvey, David, *The Condition of Postmodernity*, Oxford: Blackwell, 1991.

Heath, Joseph, and Andrew Potter, *The Rebel Sell: How the Counterculture became Consumer Culture*, Chichester: Capstone, 2005.

Heffernan, Nick, *Capital, Class and Technology in Contemporary American Culture*, London: Pluto, 2000.

Higson, Andrew, *English Heritage, English Cinema: Costume Drama Since 1980*, Oxford: Oxford University Press, 2003.

Hills, Matt, *Fan Cultures*, London: Routledge, 2002.

Hills, Matt, *The Pleasures of Horror*, London: Continuum, 2005.

Hunt, Leon, *Kung Fu Cult Masters: From Bruce Lee to Crouching Tiger*, London: Wallflower Press, 2003.

Hutcheon, Linda, *A Poetics of Postmodernism: History, Theory, Fiction*, New York: Routledge, 1988.

Jancovich, Mark, 'Cult Fictions: Cult Movies, Subcultural Capital and the Production of Cultural Distinctions', *Cultural Studies*, 16:2, 2002.

Jeffords, Susan, 'Can Masculinity Be Terminated?', in Steven Cohan and Ina Rae Hark (eds), *Screening the Male: Exploring Masculinities in Hollywood Cinema*, London: Routledge, 1993.

Jenkins, Henry, 'Historical Poetics', in Joanne Hollows and Mark Jancovich (eds), *Approaches to Popular Film*, Manchester: Manchester University Press, 1995.

Jenkins, Henry, 'Games, the New Lively Art', in *The Wow Climax: Tracing the Emotional Impact of Popular Culture*, New York: New York University Press, 2007.

Kammen, Michael, *American Culture, American Tastes: Social Change and the 20th Century*, New York: Basic Books, 1999.

Karlyn, Kathleen Rowe, '"Too Close for Comfort": *American Beauty* and the Incest Motif', *Cinema Journal*, 44:1, 2004.

Khatib, Lina, *Filming the Modern Middle East: Politics in the Cinemas of Hollywood and the Arab World*, London: I.B.Tauris, 2006.

King, Geoff, *Spectacular Narratives: Hollywood in the Age of the Blockbuster*, London: I.B.Tauris, 2000.

King, Geoff, *Film Comedy*, London: Wallflower Press, 2002.

King, Geoff, *New Hollywood Cinema: An Introduction*, London: I.B.Tauris, 2002.

King, Geoff, 'Weighing Up the Qualities of Independence: *21 Grams* in Focus', *Film Studies: An International Review*, 5, November 2004.

King, Geoff, *American Independent Cinema*, London: I.B.Tauris, 2005.

King, Noel, '"The Last Good Time We Ever Had": Remembering the New Hollywood Cinema', in Thomas Elsaesser, Alexander Horwath and King (eds), *The Last Great American Picture Show: New Hollywood Cinema in the 1970s*, Amsterdam: Amsterdam University Press, 2004.

Kolker, Robert Philip, *The Altering Eye: Contemporary International Cinema*, Oxford: Oxford University Press, 1983.

Lamont, Michele, *Money, Morals and Manners: The Culture of the French and the American Upper-Middle Class*, Chicago: University of Chicago Press, 1992.

Lee, Martyn J., *Consumer Culture Reborn: The Cultural Politics of Consumption*, London: Routledge, 1993.

Levine, Lawrence, *Highbrow/Lowbrow: The Emergence of Cultural Hierarchy in America*, Cambridge, MA: Harvard University Press, 1988.

Lévi-Strauss, Claude, 'The Structural Study of Myth', in *Structural Anthropology*, Harmondsworth: Penguin, 1968.

Lewis, George, 'Taste cultures and their composition: towards a new theoretical perspective', in E. Katz and T. Szecsko (eds), *Mass Media and Social Change*, London: Sage, 1981.

Litwak, Mark, *Reel Power: The Struggle for Influence and Success in the New Hollywood*, Los Angeles: Silman-James Press, 1986.

Lopes, Paul, 'Innovation and Diversity in the Popular Music Industry, 1969 to 1990', *American Sociological Review*, 57, 1992.

Lukk, Tiiu, *Movie Marketing: Opening the Picture and Giving it Legs*, Los Angeles: Silman-James, 1997.

Mayshark, Jesse Fox, *Post-Pop Cinema: The Search for Meaning in New American Film*, Westport, CT: Praeger, 2007.

McCrisken, Trevor, and Andrew Pepper, *American History and Contemporary Hollywood Film*, Edinburgh: Edinburgh University Press, 2005.

Monk, Claire, 'The British heritage-film debate revisited', in Monk and Amy Sargeant (eds), *British Historical Cinema*, London: Routledge, 2002.

Mottram, James, *The Sundance Kids: How The Mavericks Took Over Hollywood*, London: Faber, 2006.

Mukarovsky, Jan, 'The Aesthetic Norm', in John Burbank and Peter Steiner (eds), *Structure, Sign and Function*, New Haven, CT: Yale University Press, 1977.

Neale, Steve, 'Art Cinema as Institution', *Screen*, 22:1, 1981.

Newman, Michael, 'Indie Culture: In Pursuit of the Authentic Autonomous Alternative', Society for Cinema and Media Studies conference, Chicago, March 2007.

Nixon, Sean, 'Circulating Culture', in Paul du Gay (ed.), *Production of Culture/Cultures of Production*, London: Sage, 1997.

Peterson, Richard, 'Measured markets and unknown audiences: case studies from the production and consumption of music', in J. Ettema and D. Whitney (eds), *Audiencemaking: How the Media Create the Audience*, Thousand Oaks: Sage, 1994.

Pfeil, Fred, '"Makin' Flippy-Floppy": Postmodernism and the Baby Boom Professional-Managerial Class', in Pfeil (ed), *Another Tale to Tell: Politics and Narrative in Postmodern Culture*, London: Verso, 1990.

Purdie, Susan, *Comedy: The Mastery of Discourse*, Toronto: University of Toronto Press, 1993.

Radway, Janice, *A Feeling for Books: The Book-of-the-Month Club, Literary Taste, and Middle-Class Desire*, Chapel Hill: University of North Carolina Press, 1999.

Rose, Nikolas, *Governing the Soul: The Shaping of the Private Self*, London: Free Association Books, 1999.

Schatz, Thomas, *Hollywood Genres: Formulas, Filmmaking, and the Studio System*, New York: McGraw Hill, 1981.

Sconce, Jeffrey, 'Irony, nihilism and the new American "smart" film', *Screen*, 43:4, Winter 2002.

Smith, Murray, *Engaging Characters: Fiction, Emotion, and the Cinema*, Oxford: Clarendon Press, 1995.

Staiger, Janet, *Perverse Spectators: The Practices of Film Reception*, New York: New York University Press, 2000.

Stam, Robert, *Reflexivity in Film and Literature: From Don Quixote to Jean-Luc Godard*, New York: Columbia University Press, 1985/1992.

Thornton, Sarah, *Club Cultures: Music, Media and Subcultural Capital*, Cambridge: Polity, 1995.

Turow, Joseph, *Media Systems and Society: Understanding Industries, Strategies, and Power*, New York: Longman, second edition, 1997.

Tzioumakis, Yannis, *American Independent Cinema: An Introduction*, Edinburgh: Edinburgh University Press, 2006.

Uricchio, William, and Roberta Pearson, *Reframing Culture: The Case of the Vitagraph Quality Films*, Princeton: Princeton University Press, 1993.

Vachon, Christine, *A Killer Life: How an Independent Film Producer Survives Deals and Disasters in Hollywood and Beyond*, New York: Simon & Schuster, 2006.

Waugh, Patricia, *Metafiction: The Theory and Practice of Self-Conscious Fiction*, London: Methuen, 1984.

Waxman, Sharon, *Rebels on the Backlot: Six Maverick Directors and How They Conquered the Hollywood Studio System*, New York: Harper, 2005.

Wayne, Mike, *Marxism and Media Studies: Key Concepts and Contemporary Trends*, London: Pluto, 2003.

Wayne, Mike, 'Working Title Mark II: A Critique of the Atlanticist Paradigm for British Cinema', *International Journal of Media and Cultural Politics*, 2:1, January 2006.

Weiss, Michael J., *The Clustering of America*, New York: Tilden, 1988.

Wilinsky, Barbara, *Sure Seaters: The Emergence of Art House Cinema*, Minneapolis: University of Minnesota Press, 2001.

Willemen, Paul, 'The Third Cinema Question: Notes and Reflections', in Jim Pines and Willemen (eds), *Questions of Third Cinema*, London: BFI, 1989.

Index